50

STAFFORD CLIFF

TRADE SECRETS OF GREAT DESIGN

RETAIL SPACES

GLOUCESTER MASSACHUSETTS

ROCKPORT PUBLISHERS

A QUINTET BOOK

First published in the United States of America by:
Rockport Publishers, Inc.
33 Commercial Street
Gloucester, Massachusetts 01930
Telephone (978) 282-9590
Fax: (978) 283-2742

ISBN 1-56496-599-6

10 9 8 7 6 5 4 3 2 1

This book was designed and produced by
Quintet Publishing Limited
6 Blundell Street, London N7 9BH
Creative Director: Richard Dewing
Designers: Stuart Smith, Stafford Cliff, Keith Bambury
Project Editors: Anna Southgate, Victoria Leitch,
Doreen Palamartschuk, Diana Steedman

Manufactured in Malaysia by C.H. Colourscan Sdn Bhd
Printed in China by Leefung-Asco Printers Ltd

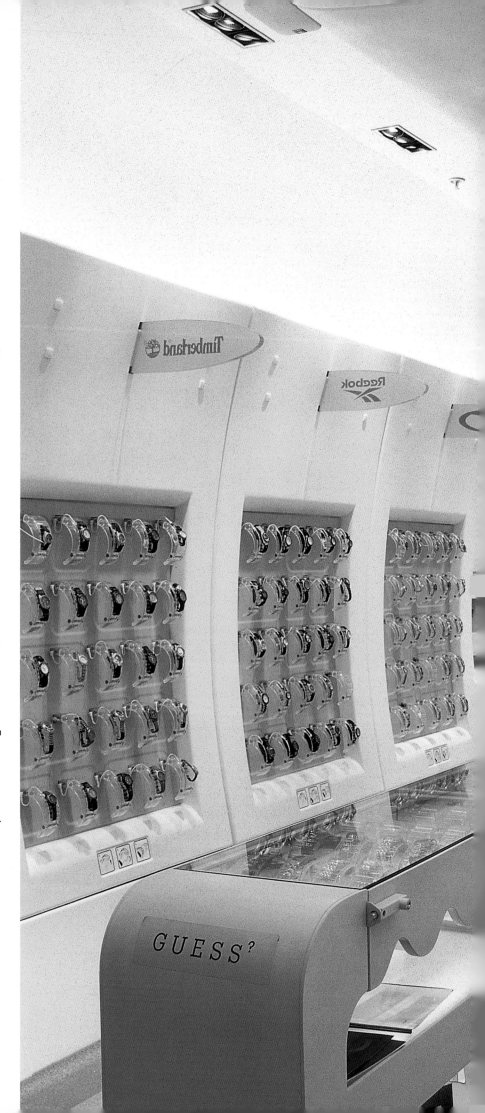

COVER PHOTOGRAPHS: see pages 26-29.
RIGHT Watch2Watch retail concept as devised and developed
by the U.K. marketing and communications group Cobalt, as a
totally new way to sell watches. This is the first of what they see
as "a massive roll out program" across Britain and Europe (see
page 214).

Among the material suppied by the designers are roughs and
presentation boards used to illustrate an approach or focus on a
market position. These images are taken from available
sources. By reproducing them it is not our intention to infringe
copyright. Every effort has been made to acknowledge these
sources fully. In the event of omissions, we apologise and
would be pleased to include acknowledgment in future editions.

ACKNOWLEDGMENTS

Linda O'Keeffe Bill Hanson
Natasha Grigorov Susan Scrymgour
Brooke Stoddard Virginia Pepper
Michael Steinberg Daniel Rozensztroch
Malcolm Pym Arlene Hirst
Amanda Dixon Suzanne Slesin
John Scott Lydia Darbyshire

and the dozens of designers, marketing managers, and
company executives, who gave up their time, and without
whose knowledge, patience, and cooperation, this book would
not have been possible.

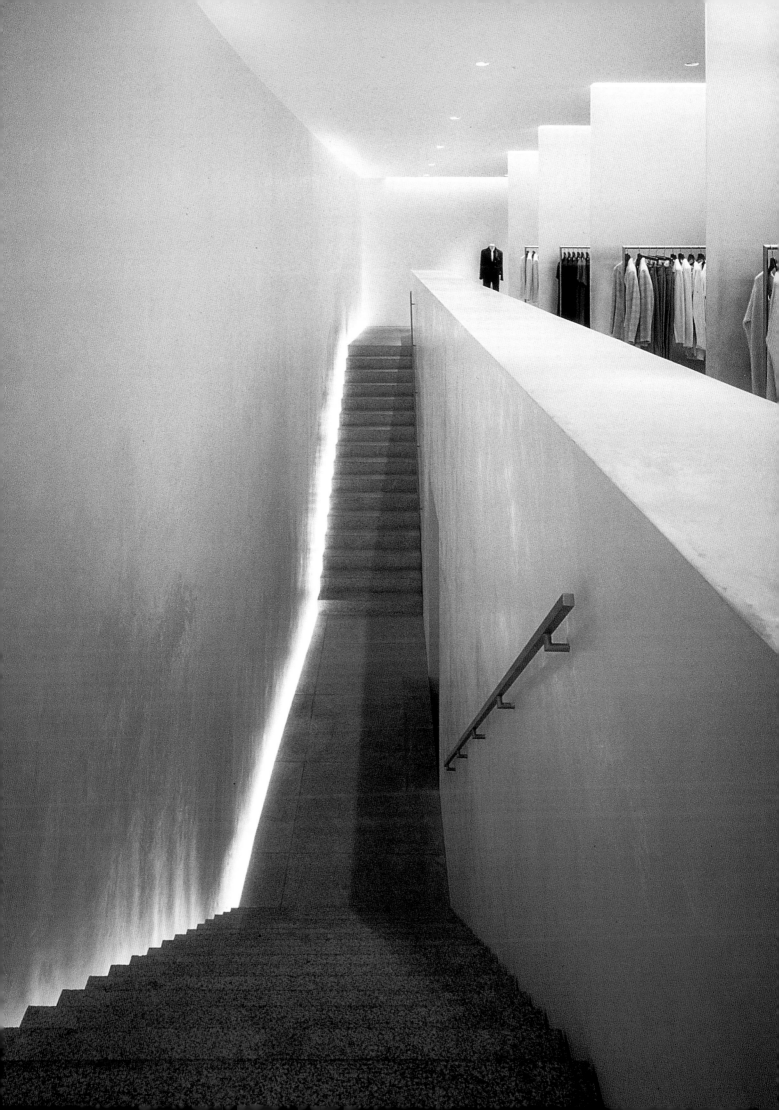

Knickerbox

When they begin a new project, the designers at 20/20 Ltd all switch desks and regroup at one of several large tables, with computers on hand and tension wires above, on which they clip the giant visual collages that represent the genesis of a scheme. In this case, dealing exclusively with female lingerie, **it might have been an all-girl team**

THREE PAGES FROM THE STRATEGY REVIEW AND BRAND AUDIT CARRIED OUT BY 20/20. THIS FORMED THE BRIEF, AND INCLUDED SOME OF THE SNAPS TAKEN DURING THE RECONNAISSANCE TRIP TO THE UNITED STATES.

THE CONCEPT OF "LAYERING THE ENVIRONMENT" STARTED FROM GRAPHICS BOARDS, LIKE THIS ONE BY BETTY SOLDI AT 20/20.

But there was one guy, more to balance the expertise than to contribute hands-on experience. Bill Cumming, project director, explains: "Knickerbox had just been through a bad patch when Mike Nicholson and Len Swain, the new directors, came to see us. They were setting out to turn the company around and were intending to hit it on three fronts: financially it was weak; the product had deteriorated; and the brand lacked investment and looked tired." They approached three design companies to give credentials presentations in the spring of 1997, and 20/20 got the job. Larraine Chapman, Caroline Wigart, Hannah Stafford and Betty Soldi (who were all aged between 18 and 30, like the target customer) formed the team.

Almost every 20/20 job starts with a period of research, and in this case a field trip to look for best practice (good examples of merchandizing in various aspects of retail design) in New York, Chicago, Paris, and Florence was considered essential. In fact, the client took his new fashion designer Arabella Lewis along too. The 20/20 team also did a visual review of the client's stores in the UK, particularly those around London, and they were pleasantly surprised at the loyalty of the staff. "It was the most eroded identity I had ever seen," recalls Stafford. "One site had several versions of the logotype from different periods." One shop had fitting rooms that were situated in plain view of passengers on double-decker buses, and another shop with no fitting rooms sent customers next door to use those of a competitor. After four weeks, 20/20's findings were collated into a brand audit, which formed the design brief.

The document included among others things "moodboards", the brand values, and consumer research.

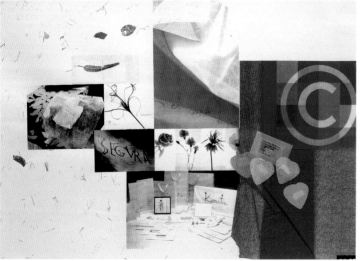

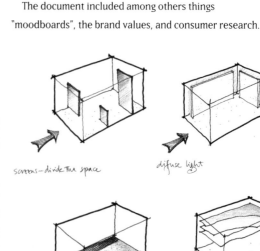

STEP BY STEP, A SERIES OF LITTLE BOXES SHOWED HOW THE LAYERING APPROACH MIGHT BE APPLIED TO THE INTERIOR, WITH SCREENS TO DIVIDE THE SPACE, DIFFUSE THE LIGHT, HARD AND SOFT FLOOR SURFACES, AND SEVERAL SOFTLY LIT CEILING LAYERS.

"All the weaknesses of the site were in areas where you would want them to be," says Southgate, who created a series of hanging rails down the left-hand side, which he hung from the ribs that supported the stone ceiling. "The most important thing in the shop is the clothes." To add drama to the entrance and to reflect the interior height, he put in full-height door and a whole new porch area, "to give it a decent entrance." Inside the window they defined the display area with a large piece of matting. "You don't want to feel you're walking into a window display," observes Southgate.

The right-hand wall became the real show-stopper. To cover up two blocked-in doorways and a very "tatty" wall, the designers did something "quite organic and flowing—she's a very fluid person." Bentheim continues: "An organic curved plaster wall would have cost a fortune, but the budget was as small as the schedule was tight, so instead they used rubber, a very durable material that is available in dozens of colors and that is normally used on ceilings. In fact, the supplier did not know how it would respond to this vertical treatment, especially when it was to be punctuated by four unicorn horns made from polished stainless steel.

The lighting in this small space was also important, but again the ceiling was inviolate. Inspired by Joan Miro, Southgate created a series of "floating" shapes, suspended on fine cables, to perform three functions: they uplit the ceiling; they held spotlights that lit the clothing; and they enclosed downlighters that illuminated the shelves.

But perhaps color was the boldest flourish of all. Most of the paintwork and the rubber wall were in shades of pale green and white, but the carpet—specially dyed to match Pam Francis's lipstick—was bright pink, and the walls in the changing rooms were scarlet to match the single mannequin.

Outside the changing rooms, the three-sided space that was left was covered in mirrors—even the doors. "It encourages people to come out to see how they look—an important selling technique—without having to brave it into the body of the shop, and the doors can be angled so that customers get a unique, all-round view," explains Southgate.

"If the shop is very over the top, so is the client," says Bentheim. "Every job we do, we try to tailor the result to the client. Most clients don't know what they want. They might have an idea, but you have to steer them. If you just did what they wanted, they wouldn't like it anyway."

MORE SKETCHES, SOMETIMES DONE DURING DISCUSSIONS WITH THE CLIENT, SHOW THE LEFT-HAND WALL OF THE SHOP WITH AND WITHOUT MIRRORED DOORS, AS THE DESIGNERS CONSIDERED THE ALTERNATIVES. "THE PAINTED TIMBER PANEL SEEMED A SYMPATHETIC BACKDROP TO THE CLOTHES," SAYS SOUTHGATE.

THE LIGHTING "RAFTS" AND "PEANUT" SHELVES ARE IN PLACE IN THIS DRAWING, ALTHOUGH THE DESIGNERS WERE, WITH THE CLIENT, STILL CONSIDERING OTHER COLORS FOR THE WALLS. "IN THE END," ADMITS THE DESIGNER, "THERE WAS TOO MUCH GOING ON AND WE DIDN'T NEED IT. THE COLOR STARTED TO OVERTAKE THE CLOTHES, SO WE USED VARYING SHADES OF GREEN FOR MOST ELEMENTS."

AT ONE STAGE THE RIGHT-HAND WALL WAS SHOWN AS A FLOOR-TO-CEILING CURTAIN, AND THE MANNEQUIN WAS RAISED ON A COVERED PLINTH.

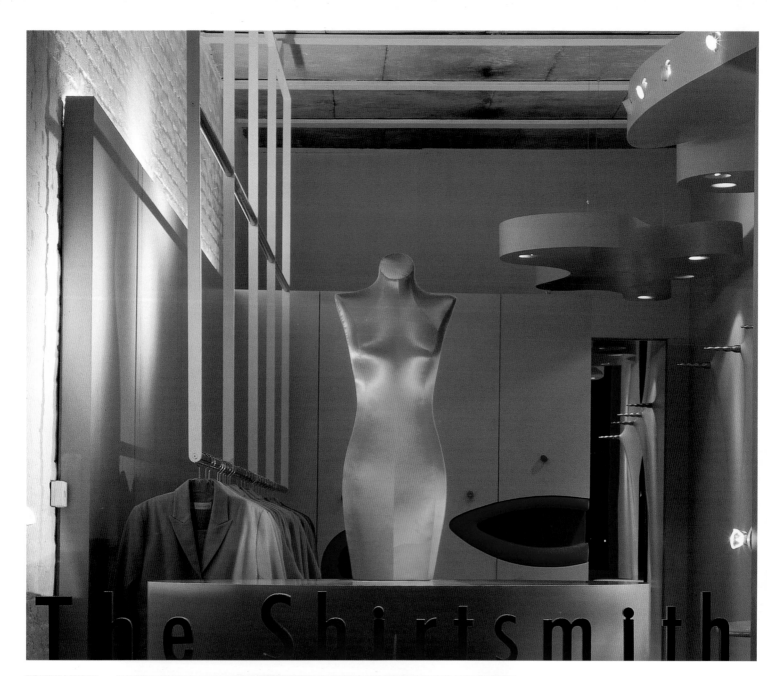

The Shirtsmith

THE HIERARCHY OF THE
DESIGN STATEMENTS
SHOULD LINK THROUGH
TO THE IMPORTANCE OF
EACH ELEMENT,"
EXPLAINS SOUTHGATE.
"FROM SIGNAGE, TO
DISPLAY, TO PRODUCT."
PUTTING THE NAME OF
THE SHOP ALONG THE
BOTTOM OF THE WINDOW
ENCOURAGES THE EYE
DOWN TO THE LEVEL OF
THE DISPLAY, WHICH
WOULD NORMALLY
FEATURE A GARMENT. THE
PALE GREEN RUBBER
WALL ON THE RIGHT
LOOKS SOLID, BUT
"PEOPLE WHO TOUCH IT
GET A SURPRISE WHEN
THEY FIND OUT IT'S SOFT."
THE UNICORN HORNS
ALSO DOUBLE AS HOOKS
FOR EXTRA DISPLAY.

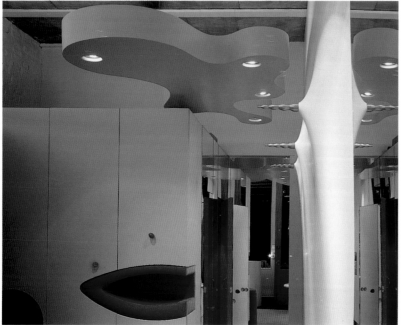

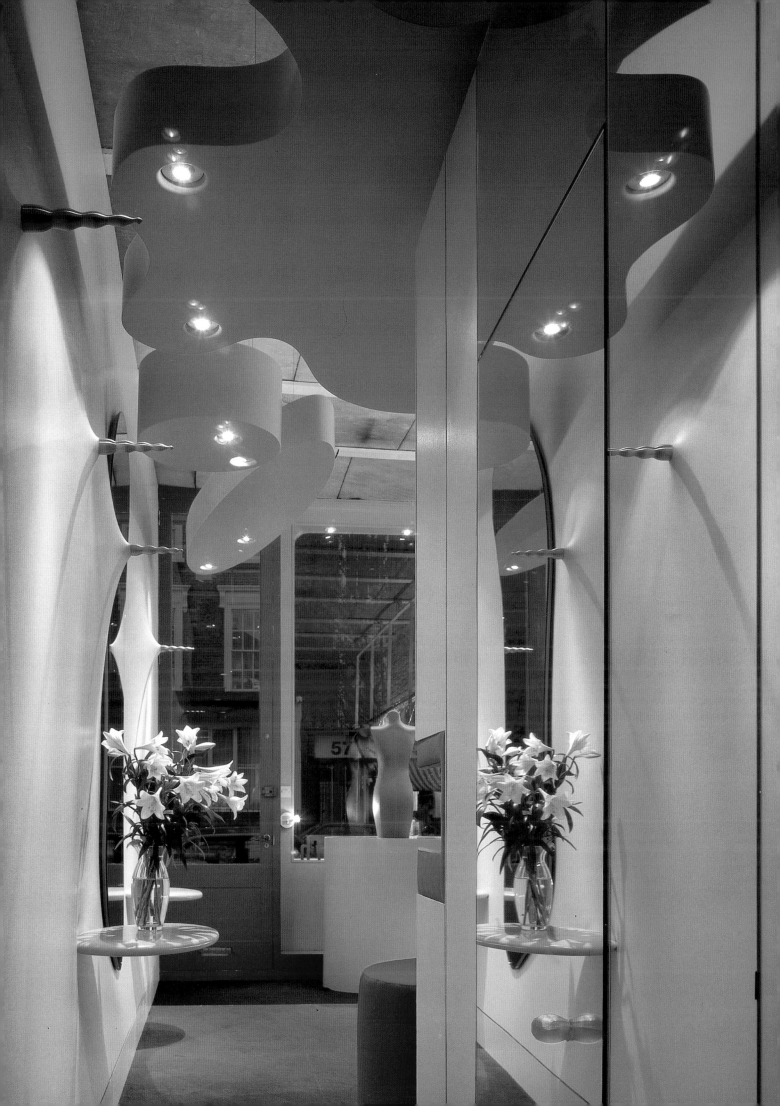

WH Smith is the largest retailer of newspapers, magazines and books in the U.K. with stores in almost every town, railway station and airport in the country. Davies Baron had been working for the company on various projects when the clients Airport Stores Division came to them and said: "Given a completely free hand, an unlimited budget, and plenty of time, what would you do?" They called it the

Blue Skies project

At the same time, W.H.Smith said, since it is not a "perfect world," if there were limitations on the time and money, what sort of shop would you propose? David Davies, one of the two founding partners of the London design company (which is now part of the U.S. group Diefenbach Elkins), had already completed various store development programs, including ideas for the WHS store of the future. This requirement, however, was more urgent. The contract for the prestige space WHS occupied at Gatwick Airport's North Terminal was due to be renewed, and in line with the British Airport Authority refurbishment of the whole space, BAA wanted a new look for WHS, too. Davies Baron had a big advantage: not only did they know the WHS business well by then, but they also knew that, given this type of pressure, the project would be able to sidestep the normal committee decision process that was necessary on any major new store program.

"So we locked ourselves in a room for a half day," says Davies, "with all the key WHS people who could make decisions, from the store manager to the head of operations, Simon Marinker, and the property manager, John Cave." They also went to look at the site, part of the departures area in

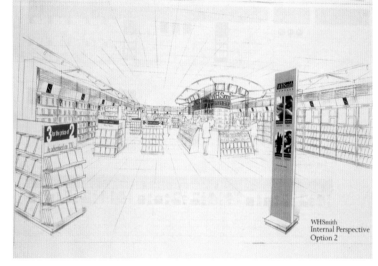

WHSmith
Internal Perspective
Option 2

THESE TWO INTERNAL PERSPECTIVE DRAWINGS SHOW THE DESIGN THEMES—A MIXTURE OF STEEL AND TIMBER—WHICH TOOK THEIR REFERENCES FROM MODERN ARCHITECTURE. OPTION ONE USED THE ADDITIONAL CEILING HEIGHT AVAILABLE IN AIRPORTS TO ADD DRAMA, BUT BOTH HAD THE CENTRAL SERVICE DESK AS AN ALTERNATIVE TO INDIVIDUAL CHECKOUTS.

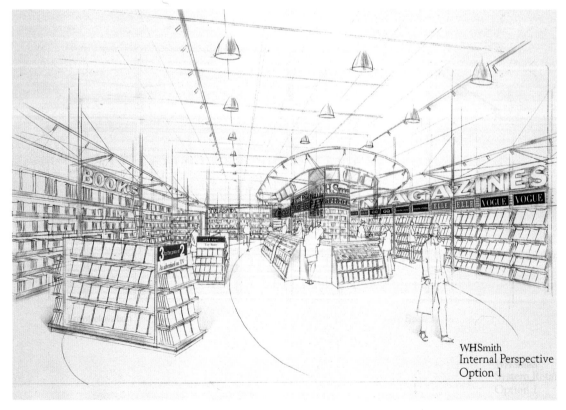

WHSmith
Internal Perspective
Option 1

THE PARABOLIC
DIFFUSER AND THE
SIMPLE SHELVING
MODULE CAN BE SEEN TO
BEST EFFECT IN THE
TALLER SCHEME FOR
OPTION ONE, IN WHICH
THE SHELVES COULD BE
NARROWER AND
FARTHER APART. IN
OPTION TWO, *(BELOW
RIGHT)* A GRAPHIC PANEL,
USED TO FOCUS
ATTENTION ON
INDIVIDUAL TITLES, WAS
ANGLED ABOVE EACH BAY.

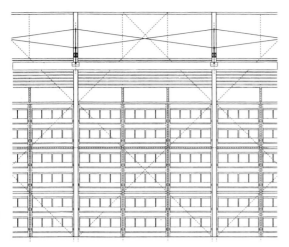

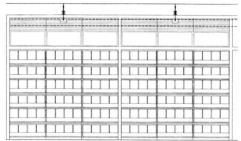

London's second-largest airport, which at peak times handles thousands of people a day.

"We looked at what was wrong with the store in design and retail terms, and at ways we could improve it," explains Mark Staton, director of interior design at Davies Baron, who led the project. "In particular, there was a problem with the position of the door—you couldn't see the entrance from the main thoroughfare—and the lighting was dull, the ceiling seemed low, and long line-ups formed at the five independent cash tills."

Together with the client, Davies Baron drew up a list of issues that needed to be addressed. WHS agreed to analyze the products they sold, looking at which of them were relevant to an airport site in order to reduce and refocus the merchandise on offer.

Back at the studio, the Davies Baron team, David Davies, Staton, and senior designer Jason Pollard, sat down and started to brainstorm. Even though it was called a Blue Skies project, they had to bear in mind certain practicalities if the scheme was to be applied to other stores later. In addition, there were restrictions on how long BAA would let the store close down while it was refitted and how long WHS would accept a loss of revenue. In a week, they presented their two schemes and, perhaps not surprisingly, everyone wanted the more radical solution, or, at least, as much of it as possible.

To discuss the details, Staton went to talk to the WHS Property and Store Systems Divisions to check the practical aspects of both schemes. It was going to have to be a quick program, so they realized that rather than discard the fittings, the designers might need to convert the innovative lighting and shelving ideas to the existing shelf frames.

The most radical—and least practicable—aspect of the Blue Skies scheme was to get rid of the false ceilings and open the space up as high as possible, adding a lighting gantry, reminiscent of early aircraft construction. Conversely, common to the both schemes, was the adoption of a central service desk with up to eight cash tills operating from an oval bar. In fact, reasons Staton, "at the end of the day, all we really stood to lose was the extra height." Everyone was very excited, and "with this as the spur, we'd produced a

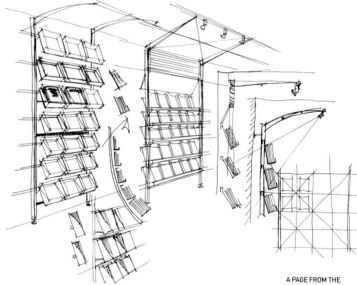

A PAGE FROM THE DESIGNER'S SKETCHPAD DEALS WITH MAGAZINE SHELVING. IT INCLUDES INDIVIDUAL TRAYS FOR EACH TITLES, IN SOME CASES CURVED TOWARD THE SHOPPER.

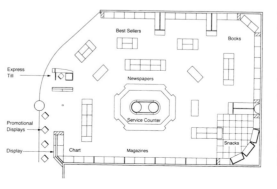

THE BLUE SKIES SCHEME WAS SHOWN IN PLAN FORM AS PART OF THE FIRST PRESENTATION. EVERY ELEMENT SEEMS TO REVOLVE AROUND THE SERVICE COUNTER, A RADICAL INNOVATION THAT STEMMED MORE FROM OPERATIONAL STREAMLINING THAN DESIGN IMPETUS.

IN THESE FIVE FASCIA SCHEMES THE DESIGNERS USED ALTERNATIVE LETTERING AND NAMING IDEAS AGAINST A SIMILAR SILVERY BACKGROUND.

(RIGHT) SEVERAL VIEWS OF THE FINAL SHOP. A COMBINATION OF BLUE SKIES INNOVATIONS AND PRACTICAL SOLUTIONS, WHICH WERE DESIGNED TO BE IMPLEMENTED ACROSS THE CHAIN. THE CENTRAL COUNTER GAVE AN IMPORTANT FOCUS TO THE SPACE AND ELIMINATED UNMANNED CHECKOUTS AND LONG DELAYS FOR CUSTOMERS.

totally new concept, and we were well on the way to implementing it."

A week later everyone got together again to report on progress, including systems costings, quantity surveyors' costings and a timetable from the airport manager. "Our task was to formulate which scheme was achievable in the time scale and to produce budget figures," says Staton. But even at this stage, they were having to specify floor finishes and order samples of lighting fixtures. "At this point we were still playing with the schemes." Nevertheless, Staton had to decide what an achievable compromise would be without making any radical changes. Certain modifications would have made it feel very different.

After that meeting, they produced the final sketch designs for every element (there was no time for detailed drawings) and chose all the finishes. These were passed on to the WHS systems management to implement. "We knew the people," says Staton, "so we knew they'd do a good job, and we continued to have weekly meetings for the next few months, faxing details back and forth and responding to their queries."

A "quick prototype" was built of a single shelving bay in the new color—silver—and with the new lighting gantry. "It was very close to where we wanted to be," remembers Staton.

In the meantime, work had already started onsite to remove the lowered ceiling and expose the higher roof of the airport building. The store would be closed for a total of only two weeks. Initially, Davies Baron had considered giving the shop a new name, and the first presentation had included several alternatives, shown on shopfront options. But the client decided to use an alternative fascia that Davies Baron had done as part of their earlier work.

Of the final solution, Staton says: "In the end, we got the feel we wanted—the shop had a fresh, clean, "fast-track" look, the staff enjoyed working there, and sales shot up by 25 percent. The original Blue Skies scheme is probably now a white elephant. This solution is more achievable, and we've got something that can be implemented across the whole chain. I'm very happy—and proud."

(BELOW) ADDITIONAL LEVELS OF INFORMATION HELPED FOCUS ON PRODUCTS, FROM THE BROAD CATEGORIES AT HIGH LEVEL, TO SPECIFIC PUBLICATIONS ON THE LOWER SHELVES.

Diesel

When the Italian company that specializes in denim and young fashion clothing found a site on the corner of 60th Street and Lexington Avenue in Manhattan, one of the most important aspects of the brief was the name and its size on the fascia: "To get it big, opposite Bloomingdales, would be **worth a million dollars"**

Diesel also had a number of other specific requests to make of the New York architect Ciuffarin Fegan,

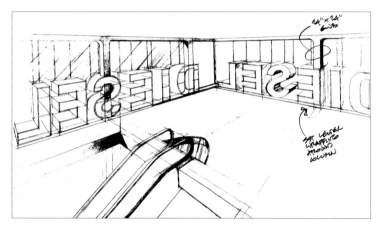

particularly types of materials and finishes. "In the end," says William Fegan (partner in the small New York practice), "we just had to ignore them. There had to be a cut-off point so we could get the work done." But in the beginning, there was the site, an awkward corner that had a small first floor, 2,500 square feet area and a much larger—10,000 square feet area—on the second floor. So one of the first tasks was to position an escalator to encourage customers to go upstairs as soon as possible. "The flow of the space was a very big thing for us," admits Fegan, "but we directed the client on all the practical aspects."

In return, the architects had to understand what Diesel was about. "We discussed their philosophy, went to Italy several times, looked at all their product and met the people who worked there. There was no hierarchy in the company— no ties, no shirts even. The only thing they can't wear are Levis, of course."

THE TWO-STORY STORE EXTERIOR, WHICH EXTENDED FOR OVER 200 FEET ON BOTH STREETS, HAD A BRUSHED STAINLESS STEEL STORE FRONT WITH DISPLAY WINDOWS ON THE FIRST FLOOR, AND GREEN SLATE CLADDING AND FLOOR-TO-CEILING DISPLAY WINDOWS ON THE SECOND FLOOR. THE COMPANY'S LOGO ON BOTH SIDES OF THE STORE'S FAÇADE WAS COMPOSED OF A SERIES OF PAINTED STEEL LETTERING BOXES, EACH 4 FEET HIGH AND 12 INCHES DEEP, WITH A RED-LIT LOUVERED FACE, ALL INDEPENDENTLY ANCHORED TO THE STORE'S EXTERIOR BY VERTICAL GALVANIZED METAL PIPES. FROM INSIDE (*ABOVE*) THE GIANT LETTERS BECAME SHELVING UNITS FOR MERCHANDISE.

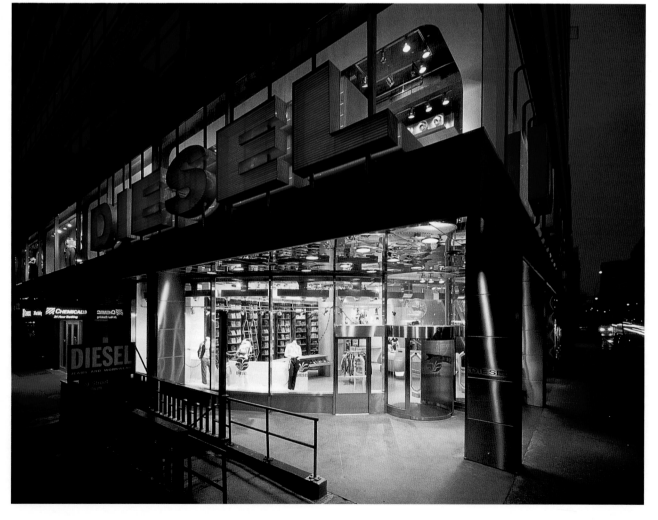

This was Diesel's first New York store, so it had to make an important first impression, both with customers, who would have already seen the company through its radical advertising approach, and with the competition. They wanted the shop to provide a fun experience, with a coffee lounge, a live DJ, and a lot of 1960s' elements. "The more 'hicky' the better," says Fegan.

In fact, some of the shop-fitting units had already been designed for other stores, and they were to be shipped over from Italy. "So we got to work, sending sketch plans and visuals back and forth to Italy. We discussed them, they made notes on them, and every two weeks they came to New York or we went to Trevisan," recalls Fegan.

Over the next nine months, the plan slowly took shape. "We used a lot of curves, cylinders, and references to motion, and we carried those themes throughout the space," he says. "We used the elements of color, motion, tone values, and textures." Putting the wood veneer in the café was the client's idea. "I had a lot of trouble with it," admits Fegan. "I never liked it in the 1960s, and I don't like it now. But we felt that the whole concept was a good one, so we adjusted to it."

As the program progressed, the architects kept walking, metaphorically, through the scheme, asking themselves "where are the dangerous surfaces?" and looking at and checking every detail, such as the sharp corner of a stair rail. "I'd duck out on Sunday morning to do some more work on it," confides Fegan. "It was that sort of job."

There's a feeling of motion throughout the store. The signature drums that hold jeans on the first floor near the entrance can be revolved to reveal more product behind. The cash desk, which is almost the first thing you see when you enter, looks like a racing car or a space craft. The escalator is designed to reveal its cogs, wheels, and motor, and nautical themes, such as portholes and ladders, crop up throughout women's wear on the second floor. There is even a frieze of "life tiles" set into the wall next to the stairs, which seems to move as you pass. In the coffee lounge the furniture is all original 1960s, bought by the client during a trip to Miami.

"This was my first retail job," admits Fegan, "and I got so much pleasure out of it. When you go through architecture school, it tends to knock the edges off you, but working with 19- and 20-year-old clients freshened us up again."

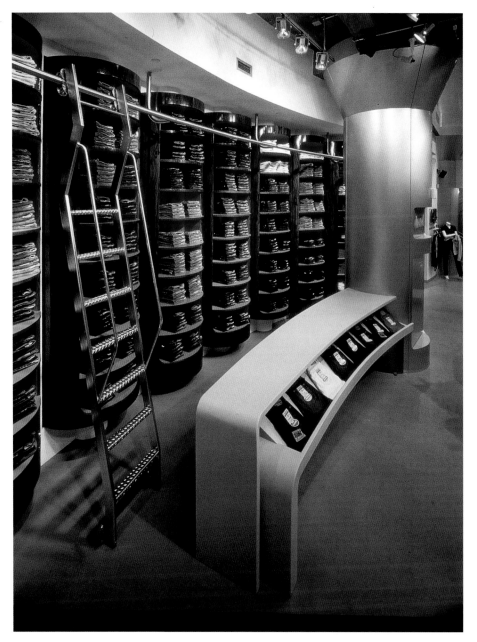

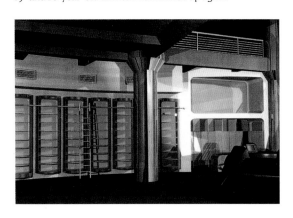

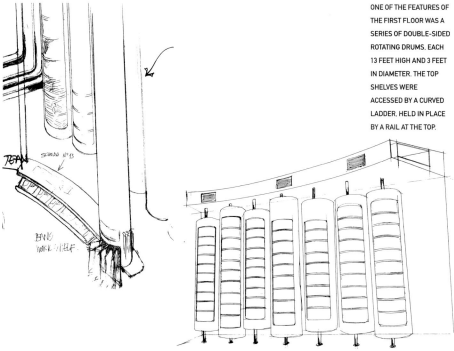

ONE OF THE FEATURES OF THE FIRST FLOOR WAS A SERIES OF DOUBLE-SIDED ROTATING DRUMS, EACH 13 FEET HIGH AND 3 FEET IN DIAMETER. THE TOP SHELVES WERE ACCESSED BY A CURVED LADDER, HELD IN PLACE BY A RAIL AT THE TOP.

INSPIRED BY A DONUT OR
A FLYING SAUCER. THE
CIRCULAR CASH DESK
STOOD CENTER STAGE ON
THE FIRST FLOOR BELOW
THE ESCALATOR. MADE
FROM STEEL AND
FIBERGLASS. IT WAS
PREFABRICATED IN ITALY
AND SHIPPED OVER. AN
EARLY DRAWING (RIGHT)
SHOWS IT IN SILVER WITH
THREE RAILS FOR
SHOPPING BAGS.

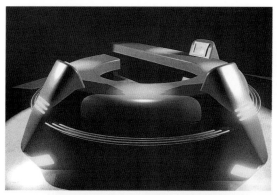

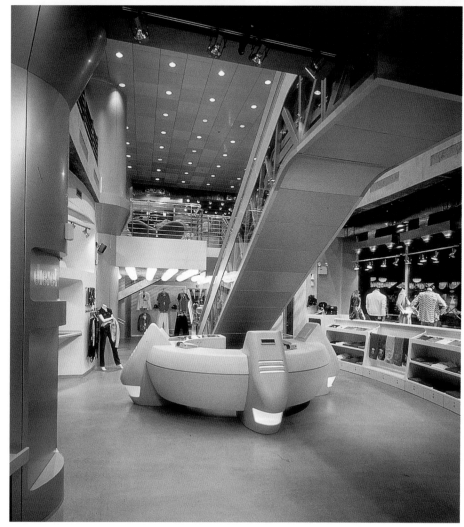

SKETCHES FOR THE
SHELVING AND WALL
UNITS ON THE SECOND
FLOOR INCLUDE
NAUTICAL-STYLE DOORS
AND LADDERS. (BELOW
LEFT) PIVOTING SHELF
AND HANGING UNITS,
AND A CURVING WALL
(BOTTOM) THAT
CONCEALED STORAGE
AND SERVICE AREAS AND
CONTINUED THE THEME
OF "MOTION" THAT BEGAN
DOWNSTAIRS.

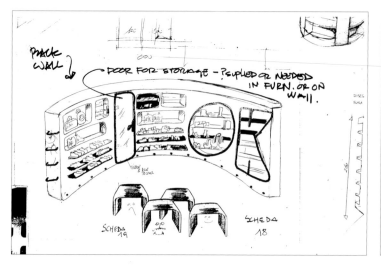

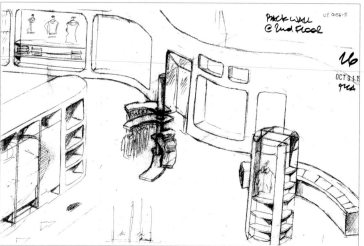

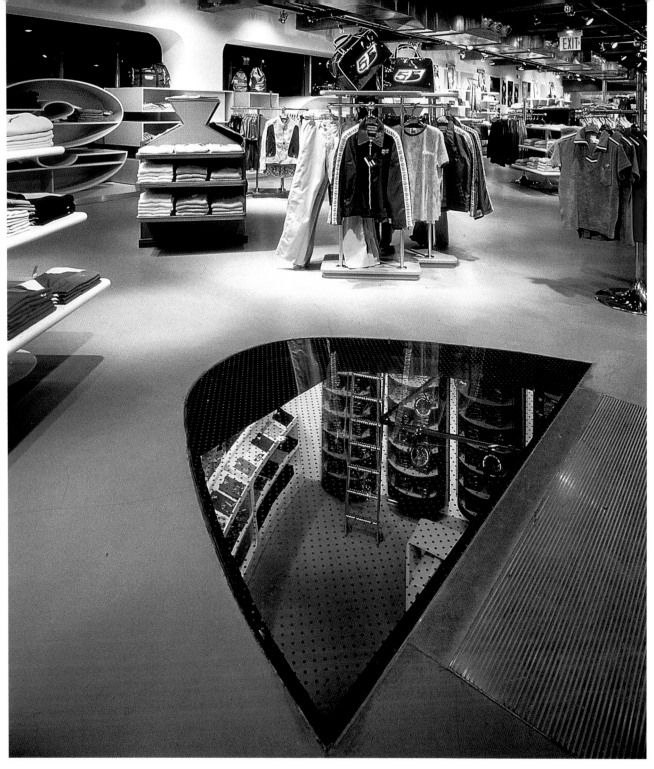

ONE OF THE MOST UNUSUAL AND UNDENIABLY JUVENILE ASPECTS OF THE INTERIOR WAS THE CLIENT'S INSISTENCE ON HAVING AN AREA OF GLASS FLOOR DIRECTLY AS CUSTOMERS STEP OFF THE ESCALATOR ON THE SECOND FLOOR. AN IDEAL VIEWING OPPORTUNITY FOR GUYS ON THE GROUND FLOOR, THE $14,000, 25 SQUARE FOOT THREE-LAYER GLASS PANEL HAD TO WITHSTAND A LIVE LOAD OF 300LB PER SQUARE FOOT. IT WAS MADE IN AUSTRIA.

MORE GIANT LETTERS DOUBLING AS SHELVES. WERE LOCATED ON THE SECOND FLOOR, NEXT TO THE ELEVATOR.

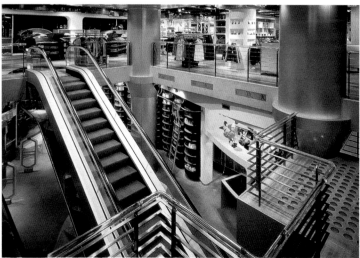

ALMOST THE ENTIRE STORE CAN BE SEEN FROM THE SECOND-FLOOR COFFEE LOUNGE. THE REVOLVING DRUMS ARE SEEN IN THE CENTER AND ABOVE ARE THE YELLOW "LIFE TILES," WHICH SEEM TO MOVE AS YOU PASS BY.

Royal Bank of Scotland

The defining moment of this scheme may have been the creation of the "service stream," a series of zones to accommodate an hierarchy of selling requirements, each one defined by a subtle change of atmosphere achieved through the use of furniture, finishes, and lighting

The idea evolved during a series of initial brainstorming sessions involving all the directors at Davies Baron and the design team, including project director Paul Haftke and senior designer Rik Zygmunt. As David Davies says, "It's not rocket science—there are any number of creative routes to any problem. Conceptually we talked around the subject. It was quite relaxing. There were sweets on the table. We come at these things with a very objective point of view, rather than bringing any existing baggage. The moment happens on every project—the ideas come together and you know it's right. The eclipse happens!"

But this was no ordinary retail project. The Royal Bank of Scotland had seen Davies Baron's other high-street work and approached the partnership, along with three other consultancies in the fall of 1994. The extremely ambitious task was to re-invent the bank as a retail brand, because, following a study by McKinsey & Co, it was intending to re-engineer the process of selling the bank's products—mortgages and financial services—in an environment that was comfortable, welcoming and relaxing, and that placed emphasis on making people feel motivated to "shop" in the outlet in a way they do not normally do in a bank.

After a number of preliminary briefing sessions, the designers were asked to make both a credentials and a concept presentation for the two types of outlet, and they started to prepare their thoughts. "We looked at a number of competing banks and building societies, both here and abroad, and at other types of retail outlets such as supermarkets and fashion stores, for direction," says Haftke. "We also made a vox-pop of people's attitudes to banks and building societies—a sort of word-association game. For instance, we asked them what four words popped into their heads when we gave them a phrase—bank manager or building society, for example—to see if it suggested what we already thought. I was surprised by how little people know about mortgages and pensions. Most tend to choose a bank

(RIGHT) AN OVERHEAD PERSPECTIVE, BASED ON THE LONG, THIN SPACE AT ABERDEEN, SHOWED THE PRINCIPLES UNDERLYING THE PLANNING AND CIRCULATION, THE POSITION OF THE POINT OF SALE, AND ACTIVE, INFORMAL, AND CONSULTING SPACES.

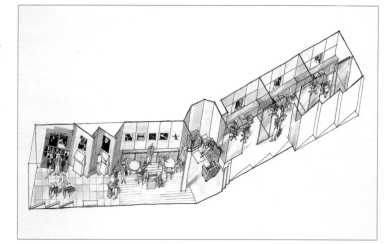

DAVID DAVIES CONCEIVED THE EXTERIOR VIEW OF THE SHOP "LIKE A SPREAD FROM A MAGAZINE LAID OUT IN FRONT OF YOU". QUICK SCRIBBLES LIKE THIS HELPED HIM EXPLAIN HIS IDEAS DURING BRIEFING MEETINGS AND BRAIN-STORMING SESSIONS.

PROJECTED INTO AN AXONOMETRIC DRAWING, THE PLAN WAS REMARKABLE FOR ITS RESEMBLANCE TO THE FINAL SCHEME. THE FRONT DISPLAY PANELS HAD BEEN ANGLED FROM THE WALL AT 45° — "LIKE THEATER FLATS, SO THAT PEOPLE COULD SEE WHAT THEY WERE GOING FOR," EXPLAINS DAVIES.

on the basis of its location, and, having chosen, the greater their potential to be a profitable customer, the lower their propensity to go in there.

"People tend to regard financial services as 'distress purchases'," continues Haftke, "which are taken on, out of need, at different stages in their lives."

When they made their presentation to the bank, Davies Baron gave it three ingredients for successful retailing:

- stand out
- show through
- pull through

"There are examples of retailers who have got it right. They stand out on the high street, you can see what they offer clearly from the front door, and they draw you inside and around the products. The fact that our partnership hadn't worked on the design of these made our selection of these as examples more, rather than less, convincing and persuasive."

Crucially, the presentation featured a long, thin floor plan, which the designers used to demonstrate the "service stream"—designated zones—from an active selling area at the front, through to a series of quiet meeting rooms at the far end. In an axonometric drawing of the same space and in the

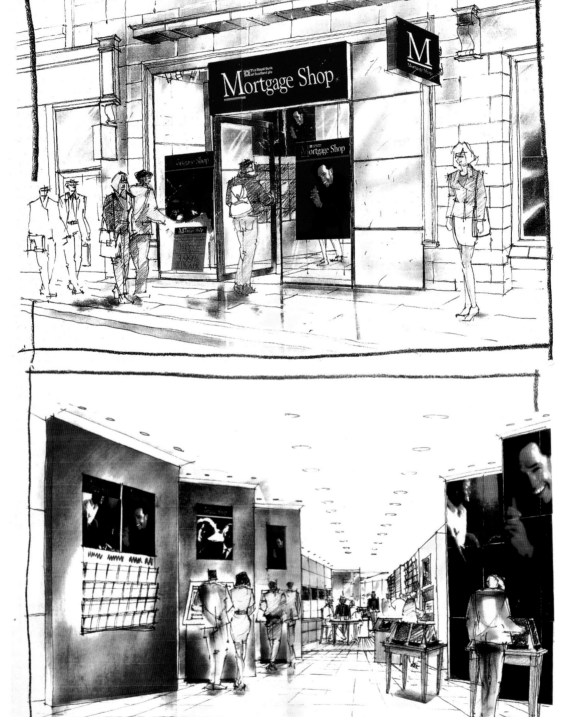

DEMONSTRATING THE DESIGNERS' IDEAS FOR THE NEW SHOPFRONT. SPECIFICALLY: "FULL-HEIGHT GLAZING; THE FASCIA SIGN, WHICH FORMS AN INTEGRAL PART OF THE SHOPFRONT AND IS INTERNALLY LIT; THE RETAIL IDENTITY, WHICH DEVELOPS A SERVICE-SPECIFIC NAME UNDERPINNED BY THE ROYAL BANK OF SCOTLAND IDENTITY; THE PROJECTING SIGN, WHICH USES A BOLD ELEMENT FROM THE RETAIL IDENTITY; AND STRONG, LIFE-SIZE IMAGES, WHICH ARE DISPLAYED DRAMATICALLY IN THE WINDOW AND GENERATE INTEREST BY INCLUDING PRIMARILY OFFER-LED INFORMATION."

INSIDE THE DOOR, THE THRESHOLD PERSPECTIVE ILLUSTRATED HOW FORWARD-FACING ANGLED WALL PANELS OFFERED FACE-ON GRAPHICS, INFORMATION AND ATMS; HARD SURFACES CREATED AN ACTIVE LOBBY FEEL; VISTAS WERE PROVIDED INTO NON-INTIMIDATING SALES SPACES; THE POSITION OF THE RECEPTION LECTERN AT THE END OF THE THRESHOLD, WHERE SALES ADVICE WOULD BE CONSTANTLY OFFERED IN A NON-THREATENING WAY; AND "BRIGHT AND CHEERFUL LIGHTING".

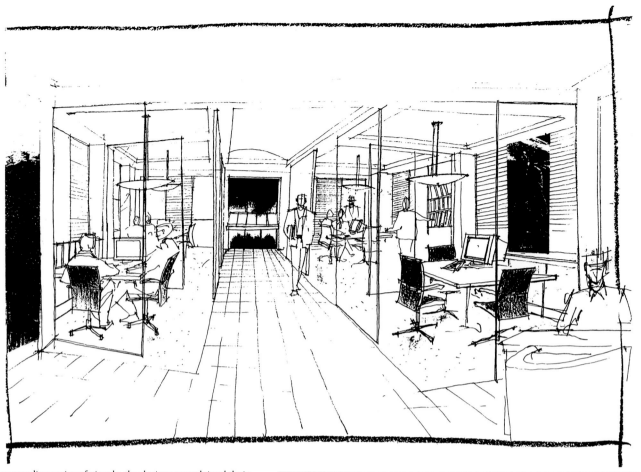

A TYPICAL VIEW OF THE CONSULTATION ROOMS SCHEME, WHERE MODULAR MEETING SPACES PROVIDE PRIVATE SELLING AREAS; A CIRCULAR TABLE TIED TO A PERIMETER BUREAU ARRANGEMENT CREATED A SHARED SELLING SPACE; SOFT FINISHES AND SOFT CONTROLLED LIGHTING LEVELS INTRODUCED A FEELING OF CALM; ACOUSTIC WALL PANEL SYSTEMS INTEGRATED POINT OF SALE, GRAPHICS AND STORAGE; SERVICES REQUIREMENTS WERE RUN WITHIN PERIMETER-ACCESSIBLE TRUNKING SYSTEMS; AND MOBILE AND UPHOLSTERED CHAIRS COMPLIED WITH EC DIRECTIVES.

succeeding series of visuals, the designers explained their concept. The task in the first area was to create a visible product, which they did with a series of user-friendly posters and product leaflets. Farther in, the finishes and details had a distinctly (and deliberately) domestic feeling—framed posters, timber floors, informal chairs around tables, upholstered chairs and sofas, and even a focal-point aquarium. It is possible to see the consultancy's experience with the British Airways' Premium Passenger lounges coming through here. At every stage, they gave priority to creating vistas and promoting visual accessibility.

The second stage of the presentation was devoted to the brand. Should there be a different brand for each offer—The Mortgage Shop and so on—as the brief had suggested, or should it be a sub-brand such as Vector or Liquid Gold? "Can we afford to explain what it is to consumers?" said the presentation documents "and do we have time?" Their recommendation was to use the Bank's core brand identity small—(20–30 percent)—in relation to a descriptive or family name, in this case "Mortgage Shop". The presentation continued through typographic alternatives, poster and leaflet cover ideas, price promotions and a series of more decorative, photographic images, all of which were prepared by Terry Diver, the graphics director.

The reaction of the Columbus team, as the project had been code-named, was positive, and a few days later Gerry O'Neil, Head of Distribution Strategy, telephoned with the good news. Davies Baron had got the job to design the Mortgage Shops, while another consultancy was doing the

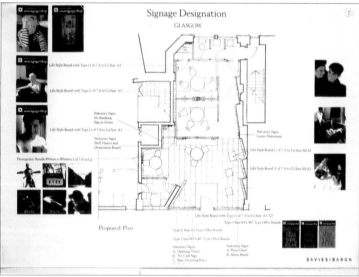

THIS VARIATION, BASED ON THE PLAN FOR THE GLASGOW STORE, SHOWS HOW THE ELEMENTS AND "SERVICE STREAM" COULD BE MODIFIED TO ANY FORMAT. BY ADDING AN ANGLED PANEL ON THE FRONT LEFT AND TUCKING OFFICES IN BEHIND, THE LAYOUT IS SEEN TO BE SMALLER THAN IT IS. THE DESIGNATION OF SIGNAGE, FROM SPECIAL OFFERS TO LIFESTYLE PHOTOGRAPHS, WAS ALSO DEMONSTRATED.

(RIGHT) TRUE TO THE ORIGINAL IDEA, THIS VIEW SHOWS HOW THE DESIGNERS GAVE THE SHOP A "VERY RESIDENTIAL FEEL," WITH GIANT PHOTOGRAPHIC IMAGES AND EXPLANATORY BROCHURES, ALL CREATED BY THE CONSULTANCY, WHICH ALSO PROVIDED A DESIGN MANUAL FOR THE CLIENT'S TEAM TO FOLLOW.

financial services division. The program slipped into top gear. The first two sites were in Aberdeen and Glasgow, with Edinburgh to follow.

Remarkably, although David Davies says it is often the case, the completed interiors closely resemble the initial visuals. There was a tight schedule—four months to the opening of the first two, but, as Zygmunt recalls: "We knew we could do it, provided we got quick decisions at each stage." They produced a package of working drawings and spent a lot of time (two or three days a week) on site, monitoring every step and adjusting the elements as they developed. Four or five designers worked on it. "There was a lot of work to do, but we had anticipated it," says Zygmunt, who also says: "The minimal amount of fiddling was remarkable. I know of very few other examples." The speed was a significant factor, says Davies: "There wasn't time to overdesign or research and potentially ruin it. It turned out to be a good example of powerful category branding," he adds. "Very focused, everyone knows what it's about."

Within months of opening, the new shops were already among the banks' top performing outlets for mortgage sales. The designers went on to work on the financial services branches and, ultimately, on the Bank's main banking outlets, a multi-million pound capital expenditure program.

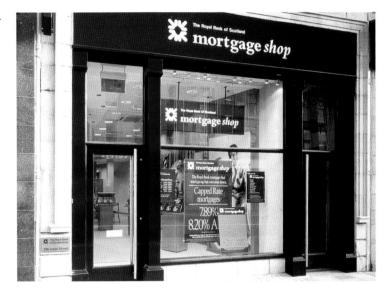

ONE OF THE FIRST BRANCHES TO OPEN WAS ABERDEEN. AND IT WAS TYPICAL OF THE MAJORITY OF PROBLEMS THE SCHEME WOULD OVERCOME: A TALL WINDOW WITH THE FASCIA GRAPHICS REPEATED AGAIN INSIDE THE GLASS. AND THE POINT-OF-SALE MATERIAL USED "AS BUILDING BLOCKS TO REPRESENT THIS THING YOU'RE BUYING—A FINANCIAL SERVICE".

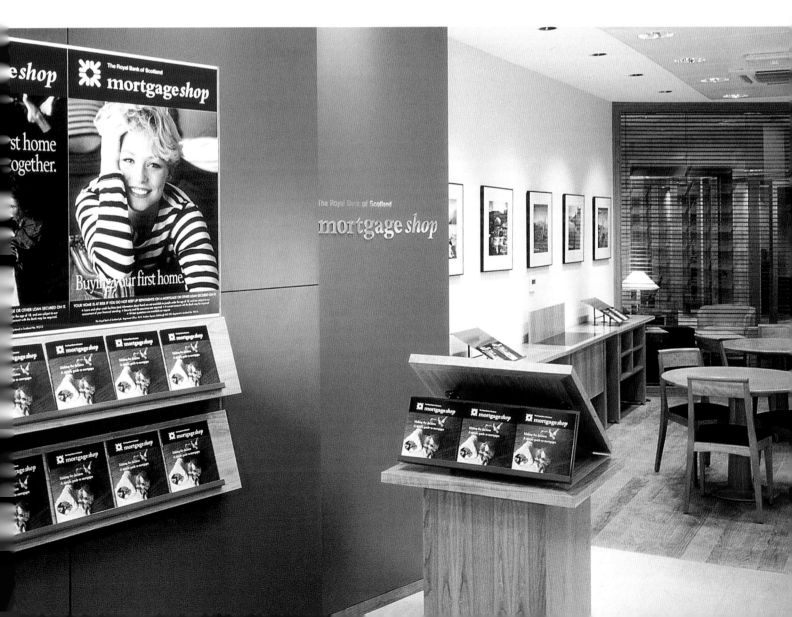

Valentino

When they are working with this client on retail design, the designers never start completely from scratch. Each store has standard features, and each idea evolves from something they may have tried on a previous occasion or from something that reflects the city in which the store is based. **They know that, with Valentino, almost anything can be done.** In Moscow, though, it

might be different Peter Kent, senior partner of Hosker, Moore & Kent (HMK) in London, had worked with Valentino on all the flagship stores—London, Paris, and Tokyo—as well as on numerous smaller concessions around the world, but he had never been to Moscow. In mid-1996, however, during the final fitting out stages of the new Valentino shop in Knightsbridge, Bruce Hoeksema, vice president of Valentino, mentioned the possibility of a new flagship store in Russia. "Can you fly to Moscow next week?" Kent remembers him asking. "But he was always dangling new projects in front of us." A few days later a fax arrived. It was a plan of a shop, showing the fire escape routes, that had been peeled off the back of the door of a building on Moscow's Kuznetsky Most.

Valentino has an established procedure for looking for new sites, and in Moscow it had entered into a partnership with Vladislav Doronin of the Capital Group, which had associations with a local contractor who could work on the project. For a week the designers at HMK produced planning ideas based on this rather inadequate plan "to prove it could be an exciting place and not just a warren of little rooms."

"For Valentino that's the most important thing," explains Kent, who found it quite refreshing to work free of the usual details and to be able to consider what he would do "in a perfect world." But Moscow wasn't a perfect world, and in his head he had two questions: "Can it be done and how can we do it?" Fortunately, Hoeksema is "plan literate," so when Kent

(FAR LEFT) THE STARTING POINT FOR THE PROJECT WAS THIS PLAN OF THE FIRE ESCAPES, WHICH ARRIVED BY FAX FROM MOSCOW. "CAN YOU LOOK AT THIS AND SEE IF IT WORKS AS A VALENTINO STORE," SAID BRUCE HOEKSEMA. BY RETURN OF FAX (LEFT), THE DESIGNERS SENT BACK THEIR FIRST NOTION OF PRODUCT PLACEMENT.

"NORMALLY WE DON'T DO MAJOR VISUALS FOR PRESENTATIONS FOR THIS CLIENT," NOTES PETER KENT. THIS, HOWEVER, IS ONE OF THE THREE THEY PRODUCED HALFWAY THROUGH THE PROJECT. (RIGHT) IT SHOWS A SIGNATURE RED RUG AND GOLD CEILING IN THE ACCESSORIES AREA, WHERE THE PANELED PERFUME DISPLAY WALL BEHIND THE COUNTER WAS TO BE GOLD LEAF.

THIS VERY EARLY PENCIL SKETCH SHOWS THE CENTER OF THE SPACE BEFORE THE VAULTED CEILING WENT IN.

sent back his plan, Hoeksema was able to interpret it and envisage how it would look, and at least he had the advantage of having seen the building. The store was to include the whole Valentino collection—the Boutique line, Miss Valentino, men's wear and accessories—and a new department for which the merchandise had not yet been designed. In addition, Hoeksema had stipulated "the more accessories the better, and a large evening wear department. These people are going to want a big range."

Following the plan, Kent had been sent a photograph of the building, at that time an art gallery, but formerly an office of the KGB. Kent was asked to do a sketch scheme for the exterior "to see if we could make it 'Valentino'," which he had to send to Moscow so it could be submitted for planning approval. Eventually, he flew over to see the site for himself. "I really regret not having gone there five years ago—before it all changed," Kent admits, but arriving as part of the Valentino team "my feet never touched the pavement. I had limousines and body guards, and was treated like a billionaire."

Together with Hoeksema he went to see the building, but could not take any pictures or measurements because the gallery owners were not aware why they were there. In fact, the second time they went back, they were thrown out for acting suspiciously. "Can you imagine, the vice president of Valentino!" So Kent got a sense of the city. "I felt more terrified about the project than ever." He knew they would have to have people on site who had worked there before, and he went to see an English architect in Moscow to ask

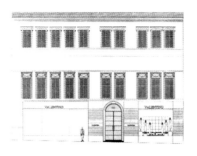

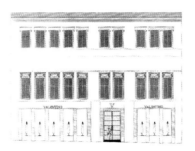

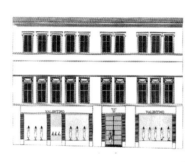

ALTHOUGH THE POSITION OF THE DOOR HAD BEEN FIXED, THE DESIGNERS CONSIDERED A NUMBER OF ALTERNATIVE WAYS OF TREATING THE EXTERIOR AND DIVIDING THE WINDOWS—AND, IN CONSEQUENCE, OF DISPLAYING THE MERCHANDISE. IN THE FIRST OPTION (*TOP LEFT*) THEY FELT THAT THE ROUND-TOPPED DOOR SAT UNCOMFORTABLY WITH THE BUILDING; IN OPTION TWO (*MIDDLE LEFT*) THEY INTRODUCED MORE VERTICALITY BY ECHOING THE LINE OF THE WINDOWS ABOVE, BUT THOUGHT IT LOOKED "TOO BUSY." THE THIRD SCHEME (*BOTTOM LEFT*), WHICH WAS FINALLY ADOPTED, SPLIT THE LEFT-HAND WINDOW INTO MEN'S AND WOMEN'S OR EVENING AND DAY WEAR OPTIONS.

THIS IS THE "QUICK SKETCH" THAT WAS DONE TO SUBMIT TO THE RUSSIAN AUTHORITIES FOR PLANNING PERMISSION, EVEN BEFORE THE EXTERIOR HAD BEEN CONSIDERED.

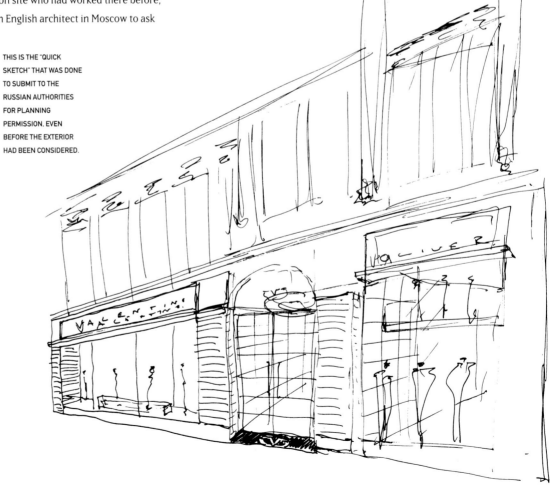

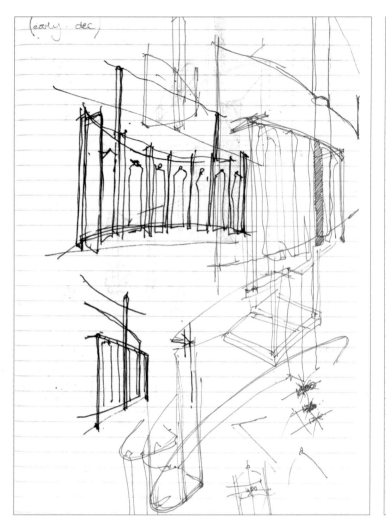

(early . dec)

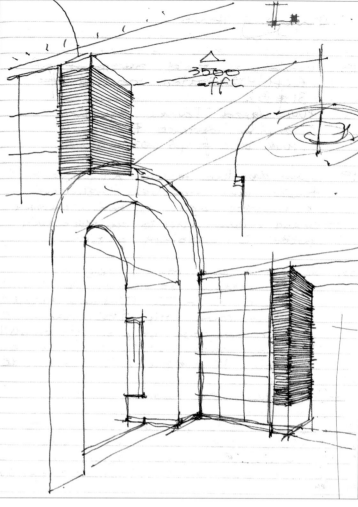

3500
aff.L

TWO PAGES FROM
CHRISTIAN PAPA'S
SKETCHBOOK SHOW THE
EMERGENCE OF THE
CURVED SCREEN IDEA,
WHICH WAS EVENTUALLY
USED IN WOMEN'S
EVENING WEAR AND
COULD BE SEEN FROM
THE FRONT DOOR AT THE
OPPOSITE END OF THE
SPACE. ON ANOTHER
PAGE (*ABOVE FAR RIGHT*)
IS A SKETCH OF THE NEW
ARCHED ENTRANCE INTO
ACCESSORIES AND THE
RIBBED LIMESTONE USED
TO EMPHASIZE THE
UNUSUALLY THICK
INTERNAL WALLS.

about planning, electrics, air-conditioning —how does it all work? The news was not good.

"Whatever your expectations, the truth is worse. There are no craftsmen left and not even enough electricity to light a Western-style store," Kent was told. "They painted the blackest picture you could imagine." There and then Kent decided to build as much as possible in Italy and to ship it in. Even so, what about structural people, building contractors, power, draining, wall finishes, and things that would have to be done onsite? Nevertheless, he was not totally discouraged. When he returned to London he decided to change some of the things he had drawn on the first plan. The site had originally been built as a row of five houses, Kent decided that the space needed to be opened up more by removing some of the internal walls.

During frequent conversations with the client and with fellow designer, Christian Papa, Kent started to work up the internal wall elevations. Thoughtfully he had taken a sample board of materials during the first trip, and he asked the contractors to provide their own local versions of marble, wood, carpets, and so on. But when he went back four weeks later, there was nothing to see. Together with the local contractors, he visited a joinery factory, but it was hopeless— "just a workshop in the forest." It was no better at the stone agents. The tiny showroom had only eight samples to choose

from, and none of these were limestone. Under pressure, Kent felt compelled to choose one, even though he knew he might regret it later. Nevertheless, he was still buoyed up by working with such a powerful company as Valentino, which was very optimistic that it could get whatever it wanted. When the prices were sent in, the stone Kent had had to choose was so expensive at Russian prices that it was cheaper to transport the correct limestone by trucks from Spain. In London they began to finalize the plan, not knowing if the survey notes they had been sent were accurate and wondering if anyone in Moscow would be able to interpret— or even understand—their specifications.

They had hoped to put the stockroom in the basement, but during the second trip they discovered that, years before, all the basements in the street had been filled up with sand as part of the KGB's attempts to discourage subversive activities. They had to dig out a new basement at the rear of the store.

There would not be sufficient power to have both heating and air-conditioning, and the glazed windows had to be increased from double to triple glazing to keep out the intense cold in winter. In fact, the windows were the subject of considerable arguments. Their cost so shocked the franchisee that he wanted them protected against night-time attacks—it was an ex-KGB building, after all—by unsightly roller shutters. Valentino said "no." "Everything special was a problem," says

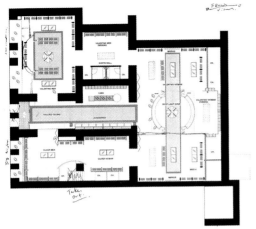

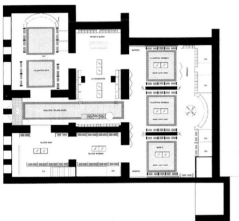

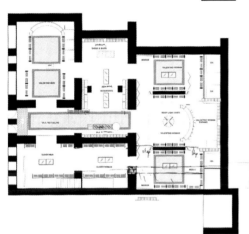

THE EVOLUTION OF THE PLAN. THE IMPORTANT LONG CORRIDOR WAS IN PLACE EARLY ON, BUT SOME WALLS WERE REMOVED AND DEPARTMENTS MOVED AROUND AS A WHOLE NEW PRODUCT RANGE WAS INTRODUCED. THE DESIGNERS ALWAYS SAW THE PLAN IN TERMS OF ITS VOLUME AND ITS THREE-DIMENSIONAL POSSIBILITIES.

Kent, "but for Valentino, everything had to be special."

There was a time in the middle of the process when everything came to a grinding halt. The designers had "quite quickly" come up with the final plan, introducing a long corridor through the center of the space. During this stage Kent and Papa were dealing more with images than with product, Kent recalls. "In my mind I wanted it to have a sense of place, interpreting the character of the building but adding some Russian touches—a vaulted, gold-leaf ceiling, large, angular openings lined in ribbed limestone, black marble floors, and red carpets. Echoes of Tsarist imperialism and Anna Karenina." But they were still worried that the Russian contractors would not understand, let alone produce, the detail in their working drawings.

Keeping to the original plan, the Italian shopfitters made all the furniture, all the lacquered work, and even the wall panels. But that still left the floors, ceilings, lighting, and heating to be done by the local contractors. When Christian Papa went over to Moscow three months into the project, "the place was in chaos."

"There was water everywhere. No sign of any electrical work having been done, and it was a complete mess. All our months spent doing detailed drawing were a waste of time," Papa realized. "They were looking at the drawings upside-down and had built walls in the wrong places." Wearing his gloves—it was 1.4°F outside—Papa had to mark out all the dimensions on the floors and walls, with the instructions written out in Russian and all the details drawn out so that the builders could understand them. "One day, if anyone ever removes all the wall panels and floors, they'll find all my manic scrawls there like some ancient fresco," he says.

Walls that had just been built had to be knocked down, including the fitting rooms, where some of the workmen who were living onsite had been sleeping. Peter Kent takes up the story. "After that, it was like a light bulb had been switched on. Suddenly they understood the importance of all the information we had given them, and the shop appeared from nowhere. The workmanship was fantastic. It's the best-finished shop in the whole chain." But there were more problems still to come. The gold ceiling and the screen across the back of the shop could not be done—not because there

SALVAGED FROM AN EARLY MEETING, THIS ROUGH SKETCH IN CRAYON WAS DRAWN ONSITE BY THE ELECTRICAL CONTRACTOR—"A BABUSHKA WOMAN WITH A FUR WRAP"—TO DESCRIBE THE AIR-CONDITIONING.

A MORE DETAILED PLAN, FRIGHTENINGLY VAGUE, OF THE MECHANICAL LAYOUT OF THE AIR-CONDITIONING THAT WAS PRODUCED BY THE LOCAL CONTRACTORS.

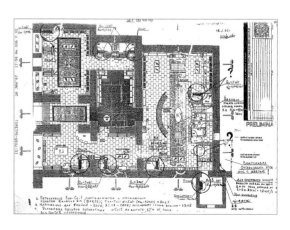

was no gold leaf available but because of the incredible amount of paperwork to get it from the state. In addition, it would have to be obtained, they said, as a lump of gold and beaten down. Suddenly they found two craftsmen who had just finished restoration work on one of the domes in Red Square. Working in shifts around the clock, they finished the Valentino ceiling in four days.

Meanwhile one of the three trucks bringing all the shopfittings from Bologna broke an axle. "Every time something happened, we got the blame," says Kent. The store was going to be a month late, but Valentino accepted the delay and a new opening date was fixed for May 15. Gradually the shop took shape. The builders laid the stone floor in stages, while the shopfitters followed behind. The whole exercise took five days and nights.

"Even if we worked in Russia again, we would probably have to work in the same way," confesses Kent. "It was only through our ignorance that we got the standard we wanted. If we had anticipated the difficulty and down-detailed to suit, it would be quite a different store." Kent went over for the handover, thinking that everything was at last resolved, only to find Valentino and Hoeksema with their heads in their hands in despair. Among all the merchandise, there was not a single signature red dress. In one final, last-minute panic, someone was dispatched from New York with three or four in their luggage—just in time for the opening.

THE SITE WAS ORIGINALLY A ROW OF FIVE BUILDINGS, AND THE DESIGNERS' TASK WAS TO OPEN UP STRATEGIC VISTAS AND RE-CREATE THE VALENTINO STYLE IN A RUSSIAN SETTING. MOST DRAMATICALLY, THE GOLD LEAF SCREEN AT THE FAR END OF THE CENTRAL SPINE OF THE STORE ACHIEVED THIS EFFECT.

(RIGHT) THE INCREDIBLE STANDARD OF THE FINISHES WAS DUE TO A COMBINATION OF ITALIAN CRAFTSMEN AND ONSITE RUSSIAN SKILLS. IN PARTICULAR, THE GOLD LEAF CEILING, WHICH WAS COMPLETED BY TWO MEN WORKING ROUND THE CLOCK FOR FOUR DAYS. THE ACCESSORIES AREA FORMED THE MOST RUSSIA-INFLUENCED SPACE WITH ITS BLACK MARBLE FLOOR AND DOMED ROOF.

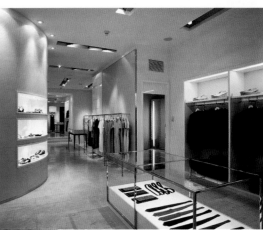

APART FROM KEY AREAS, THE REST OF THE INTERNAL SCHEME HAD A "COOL WESTERN SMARTNESS" THAT THE RUSSIAN AGENT THOUGHT "MIGHT BE A BIT BORING." THROUGHOUT THE SPACES, THE USE OF LIGHT AND THE REFINEMENT OF DETAIL "IS RICH IN ITS SIMPLICITY." THE LIMESTONE FOR THE FLOORING AND WALL PANELS, WHICH WAS EN ROUTE FROM SPAIN IN TWO TRUCKS, SOMEHOW "DISAPPEARED" IN POLAND. IN FACT, IT HAD GOT STUCK IN CUSTOMS ON ITS WAY INTO RUSSIA, WHEN THE WEIGHT OF THE TRUCKS DIDN'T TALLY WITH THE CUSTOMS FORMS. SOMEWHERE, SOME OF IT HAD "GONE MISSING." WHEN IT ARRIVED IT TOOK FIVE DAYS AND NIGHTS TO LAY. AT ITS HEIGHT, THERE WERE 50 WORKMEN ONSITE, WITH STOVE HEATERS TO FEND OFF THE FREEZING TEMPERATURES OUTSIDE.

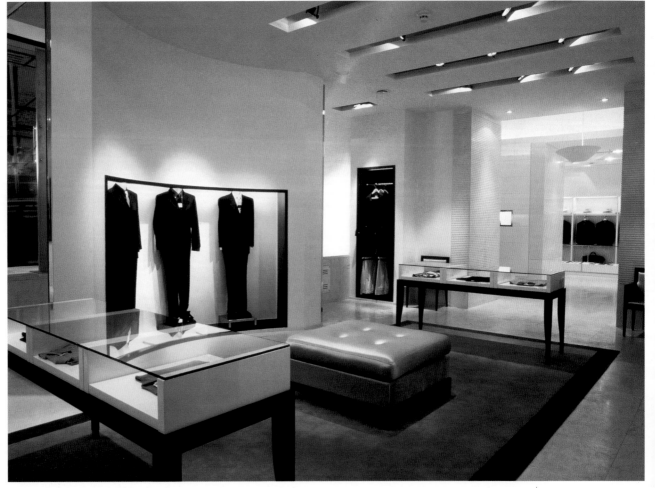

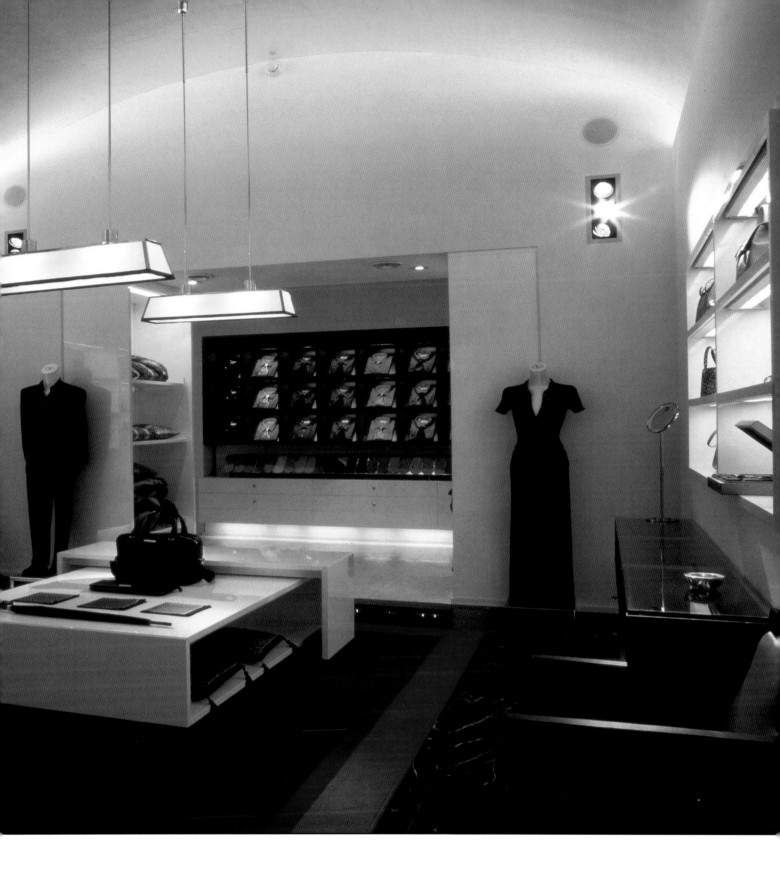

Space NK

Major retail chains are developing new brands and shopping concepts all the time, but every once in a while an individual comes along who believes so passionately in an idea, that their enthusiasm convinces everyone else, including customers. They almost will it to succeed, and it is their originality that often **keeps the high street alive**

When retailer Nicky Kinnaird—the NK of the title—first met Andrew Hodgkinson, she was still working for a property developer, selling space in some of London's prime retail locations. She wanted to branch out on her own, and she had an idea: a modern version of the traditional apothecary's shop. It was 1994, and she was in her late twenties. She needed to collaborate with a retail designer who, Hodgkinson recalls, "wouldn't pontificate or shout at her." Her idea was to stock different brands of cosmetics, culled from smaller, more individual and less widely available suppliers, whose products do not appear in the department stores, but whose quality or originality give them a loyal local following. In addition, she planned to include some fashion, luggage, accessories, and shoes.

During her travels, Kinnaird had gathered together a wide range of branded products. Next, she found a space, wedged into one corner of the basement of a newly converted warehouse shopping center in the highly fashionable Covent Garden area of central London. Over the following year or so the space grew, they put in a very dramatic glass staircase that people wrongly attributed to the French designer Philippe Starck because of the huge airplane propeller-type fan set into the wall above it—and the business took off. Next, she opened a space on the first floor that sold only the cosmetics. It was linked to the basement, but at last people

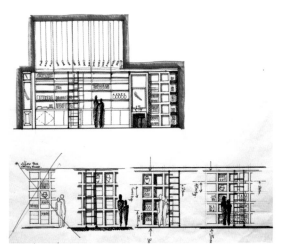

THE EVOLUTION OF THE FIRST SCHEME HINGED ON THE INTRODUCTION OF A MEN'S RANGE, FOR WHICH THE SLIM GLASS SHELVES WERE SUPPLEMENTED BY A MORE MODULAR SYSTEM OF CUBES. THE HIGH LEVELS WERE REACHED BY MOBILE LADDERS.

SKETCHES OF THE NEW FITTINGS SHOWED A DESIGNATED AREA FOR BEAUTY TREATMENTS. "GOING FROM THE MACRO TO THE MICRO," ANDREW HODGKINSON WORKED OUT THE DETAILED MODULES AND THEN PROJECTED THEM ACROSS THE WHOLE SCHEME. IN THE WINDOWS OF NEW STORES HE CREATED GLASS PANELS INCORPORATING THE LOGO AND FLEXIBLE SHELVES.

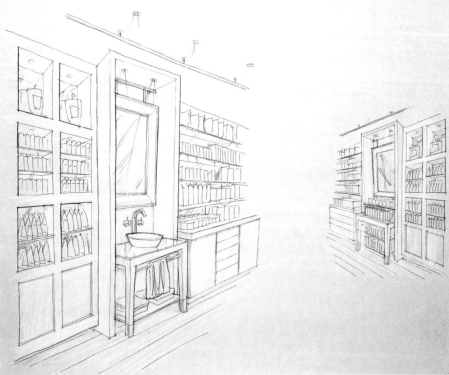

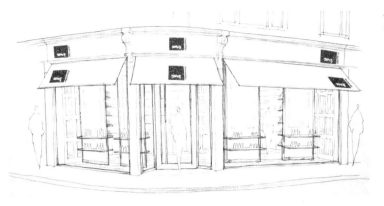

A "TYPICAL" EXTERIOR SHOWED HOW THE CLEAN, MINIMAL INTERIORS WERE REFLECTED ON THE FASCIA WITH A NEW GRAPHIC PROPOSAL. "IT HAD TO BE FASHIONABLE, CONTEMPORARY, ASPIRATIONAL, AND FRESH," SAYS HODGKINSON. "AND IT WOULD HAVE TO BE ACCEPTABLE TO LOCAL PLANNING AUTHORITIES."

could see it from the street. "Within six months she knew she had discovered a formula that was working," explains Hodgkinson. "It became a recognized 'hot spot'—a pleasant place to be in, a place people enjoyed." How much the design of the interior helped is not clear, but from the start the shop had a sleek, white originality that was not quite a pharmacy, not quite a boutique, and it gave it a certain cachet. The emphasis was much more on the cosmetics, and this was the aspect that Kinnaird decided to introduce into upmarket department stores—ironically, since it had been conceived as an alternative to the department store concept.

It was at this point that she asked Hodgkinson to take stock and create a system that would work in a variety of different locations, expanding it to include an area for men's products but, as Hodgkinson explains, "keeping the same linear qualities and contemporary language, and the same materials—wood and glass, clear and opaque." He responded with a prototype concept that was not site specific and that was developed over a period of five or six weeks and a number of relaxed, informal conversations with his client, during which she contributed ideas she had seen or thought of.

"I had a target shopfitting budget," he explains, "and my experience told me what I could and could not do. Designing a shop is like buying clothes—you have to be able to feel comfortable in them and they have to work." Once the core concept was in place, Hodgkinson, working with studio designers Tim Owen and Ben Stenholme, completed three stores in Brook Street, London, Bishopsgate, in the City of London, and another Space within the very first Covent Garden complex. The "language" was still white-on-white with stainless steel, but the men's area had a chunkier, pigeon-hole design and there were glass window display units. This gave the products space around each range or category, and the whole scheme became more structural, extending to 10 feet high in some cases.

A flood of press coverage followed. Nicky Kinnaird was now on the map as a serious beauty and cosmetic retailer, talked about internationally. Customers were happy, too, and were showing a positive response. Two more stores opened a year later, and then, almost in final acknowledgment that she had made it, the prestigious and highly admired Knightsbridge store, Harvey Nichols, asked her to open her

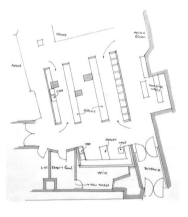
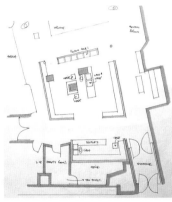
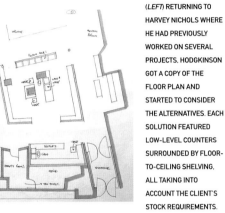

(LEFT) RETURNING TO HARVEY NICHOLS WHERE HE HAD PREVIOUSLY WORKED ON SEVERAL PROJECTS, HODGKINSON GOT A COPY OF THE FLOOR PLAN AND STARTED TO CONSIDER THE ALTERNATIVES. EACH SOLUTION FEATURED LOW-LEVEL COUNTERS SURROUNDED BY FLOOR-TO-CEILING SHELVING, ALL TAKING INTO ACCOUNT THE CLIENT'S STOCK REQUIREMENTS.

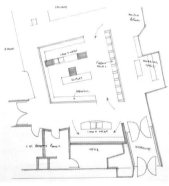
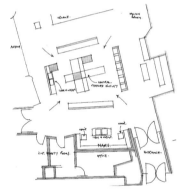

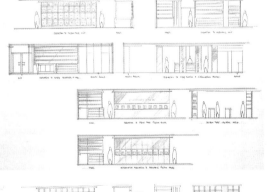
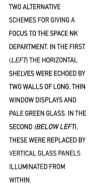

TWO ALTERNATIVE SCHEMES FOR GIVING A FOCUS TO THE SPACE NK DEPARTMENT. IN THE FIRST (LEFT) THE HORIZONTAL SHELVES WERE ECHOED BY TWO WALLS OF LONG, THIN WINDOW DISPLAYS AND PALE GREEN GLASS. IN THE SECOND (BELOW LEFT), THESE WERE REPLACED BY VERTICAL GLASS PANELS ILLUMINATED FROM WITHIN.

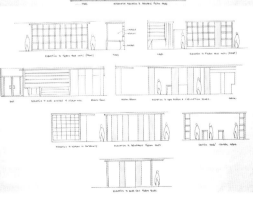

first shop-in-shop within its first-floor cosmetics department. "It was a breakthrough, both for her and her business," says Hodgkinson, who again worked on the fittings and the concept, this time with the addition of new graphics and identity by Michael Nash & Associates. But although he had worked in the store before and knew the people, there was a lot to do and very little time—eight weeks, in fact. This time there were no walls and no fascia, so the identity had to be put across in a small—700 square foot—space. It was a four-way collaboration, but Hodgkinson had to lead the way. He worked up the plans and sketched out his scheme, for the first time introducing a series of backlit glass panels that defined the space virtically and "did the job of a sign, but in a very different language," he says.

All the elements were an extension of the original schemes, but "the 18 lighting panels definitely gave it a 'kicker'. They replaced the usual back-lit beauty photographs and provided a cleaner, more sophisticated edge." There was considerable anxiety over their brightness: "Would they upset the adjacent retailers? Would Harvey Nichols like them? Would any of us like them?" wondered Hodgkinson. "We spent a lot of time discussing if we'd got the balance right between blocking things off and creating visibility—it was a risk." Kinnaird's company's reputation rested on it—but so did his. They even made up a test panel to show to Kinnaird, but it was too late—with time running out, they would just have to wait and see.

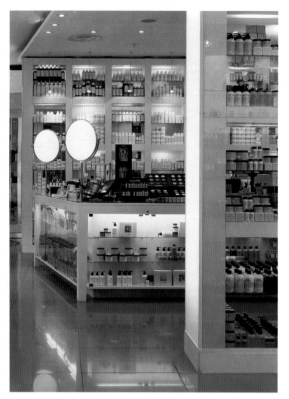

"SOME OF THE LANGUAGE OF THIS SCHEME CAN BE TRACED BACK TO THE FIRST SHOP IN COVENT GARDEN THREE YEARS BEFORE," EXPLAINS HODGKINSON. THE DESIGNERS WERE FORTUNATE THAT WHEN THEY STRIPPED AWAY THE TIMBER FLOOR, PALE GRAY MARBLE TILES WERE REVEALED, WHICH GAVE A VISUAL "FLOW IN" FROM THE REST OF THE STORE. THE NEW MICHAEL NASH GRAPHICS INCLUDED TICKETING AND CARRIER BAGS. THE GLASS PANELS PROVED TO BE A GREAT SUCCESS, AND THE DESIGNERS HAVE SINCE INTRODUCED COLORED GELS FOR SEASONAL CHANGES— GREEN AT CHRISTMAS, FOR EXAMPLE.

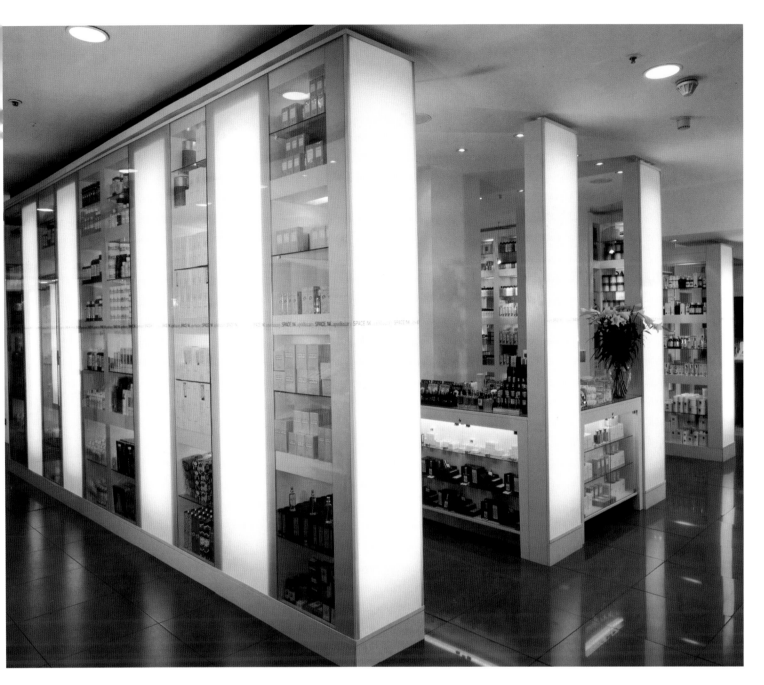

(*LEFT AND FAR LEFT*) TWO VISUALS OF THE SCHEME, CONVERTED TO A SHOP-IN-SHOP ARRANGEMENT. MANY OF THE ELEMENTS WERE ADAPTED FROM THE CURRENT STORES, BUT THE FREESTANDING SHELVES BECAME PERIMETER WALLS WITH EYE-LEVEL BRANDING THAT WRAPPED ALL AROUND THE DEPARTMENT.

Nitya Paris
Every store sets out to convey an identity, and retailers spend a lot of money trying to get it just right. But the designer often sets himself a difficult task, too, in attempting to evoke **qualities** in a store that **cannot be put down on paper,** working with space and volume, playing with light and creating pleasing forms, without competing with the product

John Herbert is a designer with 18 years' experience in the retail trade. His design company, which is based in a leafy suburb just north of London's Regent's Park, employs 19 designers and handles every type of retailing, from niche markets and department stores to airports and shopping centers. When he began to work with Nitya, a husband and wife fashion design team who wanted to open their first store in Paris, Herbert's first task was to understand the client's philosophy. He did this by synthesizing various ingredients into four "mood" boards, each of which had a different emphasis. Until then Janak and Peachoo Datwani had been designing and making clothes for 25-year-old women and selling them through the pret-a-porter market. Their beautifully cut, soft forms relied on patterns designed by former students of the Royal College of Art to create a feeling that was not Indian and not Oriental, but seemed to be influenced by both cultures.

Pinning down this mood and trying to convey it in an interior space was the designer's key objective. The Datwanis had found a small site for their first store, on a corner of rue Bonaparte in central Paris. It was an awkward L-shaped space, with no special architectural features, so deciding on the right personality became all important. Looking at the images now, it is hard to discern the differences in these four compositions but for the client it was precise and immediate. "They did not want the shop to pin them into any particular ethnic origin," explains Herbert. "From that point of view, they were quite an unusual client with a different attitude. Rather than being driven by a deadline, their main concern was to get it right. The work became increasingly pleasurable."

The first board had some Japanese images; the second was more West Coast American/contemporary; the third had rough mud wall and looked rather "New Mexican," with a

THE PARIS SITE BEFORE THE DESIGNERS MOVED IN SHOWS THE CHALLENGE THEY FACED, BUT THEY RESPONDED TO THE "ODDLY SHAPED SPACES THAT FRENCH BUILDINGS TEND TO HAVE; IN FRANCE WHERE THERE ARE RARELY HALLWAYS, YOU WALK FROM ONE ROOM TO ANOTHER." JOHN HERBERT EXPLAINS.

THE KEY TO UNDERSTANDING THE CLIENT'S BUSINESS AND "THE WOMAN WHO IS NITYA" WERE THESE THREE "MOOD" BOARDS. EACH BOARD CREATED A SLIGHTLY DIFFERENT ATMOSPHERE AND EMPHASIZED DIFFERENT MATERIALS. THE DESIGNERS ENCOURAGED THE CLIENT TO LOOK INTO EVERY DETAIL, AND FROM IT CAME THE DECISION NOT TO USE ANYTHING TOO EXPRESSIVE OR OF ONE PARTICULAR CULTURE.

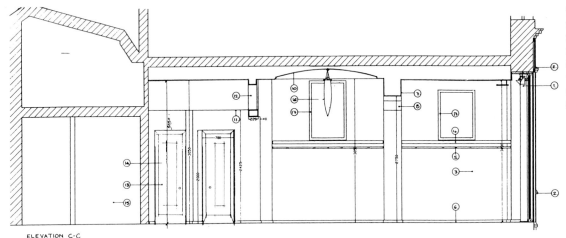

ELEVATION C-C

THIS CROSS SECTION OF THE STORE GOES FROM THE FRONT WINDOW, ON THE RIGHT TO THE SERIES OF NEWLY CREATED 'ROOMS', TO THE CHANGING ROOMS AT THE BACK (SEE PLAN).

cross-reference to old and new working together; and the fourth had architectural elements that might be Egyptian, Indian, or Moorish. Each composition had a Nitya logo, depicted in the style of the other elements. Although the reproductions included here look quite understated, Herbert notes: "It took quite a while to put them together. We had to try to tickle out the personality through all the elements, not just the graphics."

The client's reaction was positive. "They did not want a designer who would say, 'this is what you should do'," says Herbert. "We didn't want to overwhelm the space, and we thought people would enjoy a sense of quality and subtlety." This "sense of subtlety" drove a lot of what the designer did, but first they had to define the space. "How do we make it appear bigger but introduce a sense of mystery?" they asked. Inspired by a tiny Moorish plan on one of the compositions and a carved marble screen, they set about "creating smaller volumes that you pass through"—glimpses through windows, reflections in mirrors and "the space beyond".

There were some colonial elements, a Moorish window that was later changed—"Paris might have a problem with Moorish"—and the contrast of dark and light finishes. The walls were cream, and the furniture was specially designed and made in dark brown mahogany. On the floor one visual showed dark gray and white marble in a slightly rough but shiny texture. "Having kept the walls clean, it needed the richness and strength of a patterned floor to offset the pattern in the clothes," explains Herbert, "but being in a horizontal surface, we thought it would not be too intrusive."

Working with design colleague Mike Duncalf, Herbert debated long and hard about the moldings—what kind of devices appear not too derivative. "It's more a question of proportions—you have to exaggerate certain forms to get the proportions you want. You learn by experience," he says, "but we mocked up a lot of the details too." The product is not expensive, so one of the client's concerns was that it was not made to seem so. When it came to the design presentation of the new shop, the client said: "Come over to my side of the table and you can see it from my point of view —we can pull it apart together and then you won't be

RESPONDING TO A TINY ARCHITECTURAL PLAN ON ONE OF THE BOARDS, THE DESIGNERS USED THE SERIES OF ODD SHAPES IN THE BUILDING TO CREATE A SENSE OF MYSTERY, WHICH THEY RELATED TO THE FEMININE PERSONALITY. SMALL WINDOWS LIT FROM BEYOND, AND HIGH-LEVEL ARCHES WERE ONE RESPONSE.

ADDING RICHNESS THROUGH EVOCATIVE DETAIL WAS AN IMPORTANT WAY OF CONVEYING QUALITY AND COLONIAL HERITAGE IN SUCH A SMALL SPACE. AND THE DESIGNERS' SKETCHBOOK SHOWS DOZENS OF DETAILS FOR MOLDINGS THAT THEY SPENT HOURS DISCUSSING AND EVOLVING.

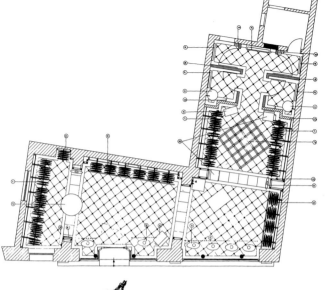

offended." The approach seemed to work. "It's a very personal, quite delicate relationship that we've had with them," reflects Herbert.

Turning to the exterior, the designers looked at the building as a whole for their lead and re-introduced stone columns and glazing panels that echoed the features and proportions of the floors above. "In its simplicity, it's quite modern," explains Herbert. Long drops of semi-transparent fabric made in India from banana leaves hang at the windows and give glimpses through to the store from outside without exposing too much. Peachoo Datwani added this and other elements to the scheme, including a large porcelain light shade she found in the Paris flea market.

The store has been so successful that it has given them a focus for their whole activity. "The space and logo became instantly their personality," reflects Herbert. "After they saw it, it just locked in and became them."

Working through the implementation with architect Jean Michel Vinay of L.A.U.R. in Paris, seems to have been uneventful and smooth. "The French craftsmen who did the plasterwork and floor were a joy to work with," says Herbert. The shop opened on January 21, 1997. Does it convey the culture of the company? "No one can quite put their finger on what the nationality is—it isn't quite what it seems."

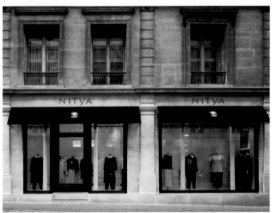

ONE DISAPPOINTMENT FOR THE DESIGNERS WAS THAT THE METAL CAPS THAT WERE SO MUCH A PART OF THE CARTOON MAGNET IMAGE, COULD NOT BE MADE IN TIME. NEVERTHELESS, ALL THE SHOES STAYED IN PLACE AND THE RED UNITS COULD ONLY BE REMOVED BY USING GREAT FORCE. BECAUSE OF THIS, ANY PRODUCT COULD BE DISPLAYED IN ANY POSITION THROUGHOUT THE STORE.

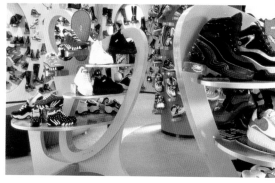

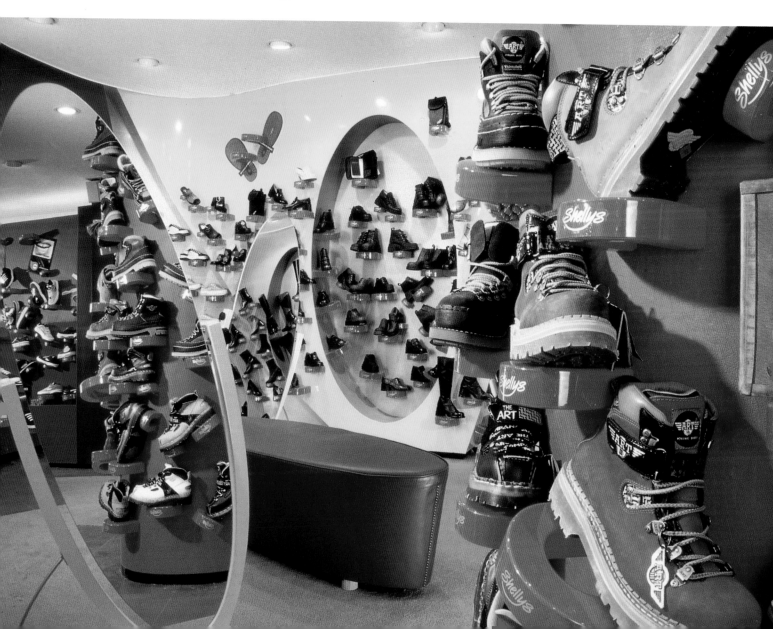

Harrods

Without doubt, this is one of the most famous department stores in the world, but rarely can any retail space have seemed as unpromising as their basement area: a subterranean labyrinth formerly given over to stock, service, and back-of-house administration, with low ceilings, enormous columns **and not a hint of daylight**

Andre Maeder, Harrods board director in charge of men's wear, leisurewear and sportswear, outlined the company's aims for a brand-new approximately $19.2 million men's wear department, and showed Ken Corsie the in-house work they had done so far—a very minimalist concept—asking for his comments. "Our approach," says Corsie, "is to start with the merchandise—take the quantitative information and translate it into a design that works for the product." Corsie took the existing elements back to Corsie Naysmith's London studio and went through Harrods' rationale with his co-director, Stuart Naysmith. They wanted to assess the existing work and take it forward. It was an enormous project, which would eventually take up 16,000 square feet of the basement of the 120-year-old store, but first, all the back-of-house facilities—stock rooms and plant rooms—had to be relocated in nearby buildings, which Harrods also owned. In fact, the in-house architects had already briefed builders to start work, so before long they would need some of the specifications for ceiling, wall, and floor finishes. In addition, because it was impossible to get an impression of the existing overall space, Corsie Naysmith found it difficult to assess what they could and could not do.

Realizing that there were no existing special features that they could incorporate into the scheme, they quickly started translating the merchandise matrix they had produced into a detailed layout, taking into account the client's product adjacency guide. In addition, a major part of the space was to be taken up by four large brand boutiques—Giorgio Armani,

A SERIES OF FOUR VISUALS (*RIGHT*) FROM THE FIRST PRESENTATION SHOWS HOW THE DESIGNERS STARTED TO DEAL WITH SOME OF THE INHERENT PROBLEMS OF A LARGE, LOW-CEILINGED BASEMENT SPACE. AT THE LEFT-HAND ENTRANCE THEY INTRODUCED GLASS-BLOCK, BACKLIT PANELS AND ROOF LIGHTS TO GIVE A DAYLIGHT EFFECT AND CONCEAL LARGE FIRE DOORS. AT THE OTHER ENTRANCE A FURTHER GLASS PARTITION WALL CONCEALED CHANGING ROOMS AND PROVIDED CONTINUITY. THE DESIGNERS DEMONSTRATED THE "LANDSCAPING" WITH A WALL BAY, THREE GONDOLAS, AND A TABLE DISPLAY, ALL AT DIFFERENT HEIGHTS. THE CENTRAL GALLERIED WALKWAY AFFORDED GLIMPSES INTO EACH DEPARTMENT.

FLOOR FINISHES SCHEMATIC

PLANNING

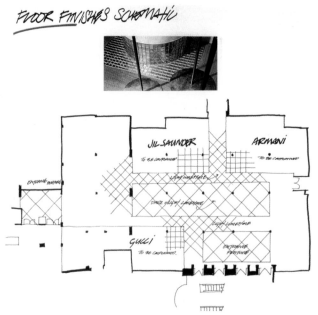

FLOOR LAYOUT PLAN

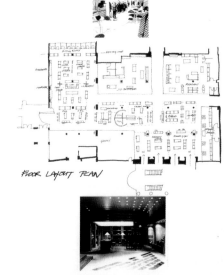

FROM THE FIRST PRESENTATION, THESE TWO FLOOR PLANS SERVED TO SKETCH IN SOME OF THE PRINCIPAL THINKING. THE FLOOR WAS USED TO DEFINE PRODUCT AREAS FROM WALKWAYS, WITH DARK AND LIGHT LIMESTONE USED IN TWO MODULES. AS A FIRST ATTEMPT AT THE PLANNING, THE JIL SANDER AND GIORGIO ARMANI BOUTIQUES WERE POSITIONED AT THE TOP. ONE ENTRANCE HAD A HUGE PIVOTING DOOR, AND WIDE AISLES WERE USED TO GIVE STRUCTURE TO THE FLOOR SPACE.

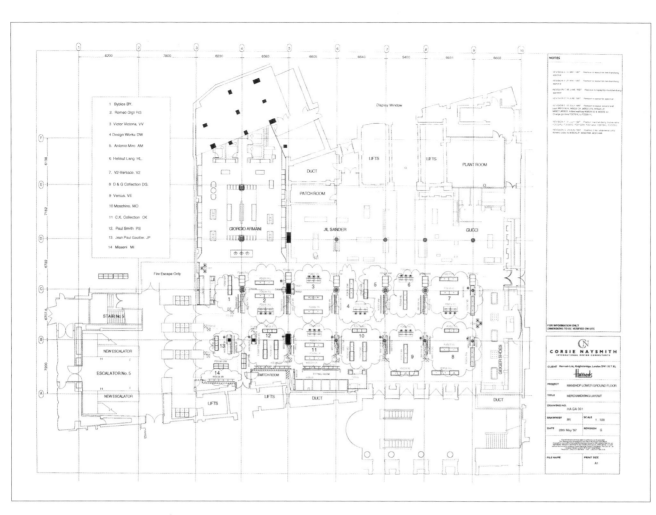

Jil Sander, Gucci, and Kurt Geiger shoes—which meant that the Corsie Naysmith designers would have to work closely with the designer from these design houses to ensure that a single, seamless retail space was created.

Developed through a series of detailed conversations with their client, the designers produced three alternative plans, each of which took into account the two entrances, the mandatory fire doors, and 3-foot wide concrete columns. "We wanted to get the problems out of the way at the very beginning," explains Corsie. In addition, they showed a number of ways of lighting the space so that the 8-foot ceiling height would seem higher and the space more welcoming. This was partly a technical exercise and partly an esthetic one, because the structural limitations of the site dictated where lighting troughs and raised ceilings could go. Corsie and his team conceived the scheme as one whole area, as opposed to a series of enclosed rooms.

During the next phase Corsie Naysmith applied their rather structured approach, finely tuned over a number of large retail projects in Europe, to the display and merchandising principles. "Going back to the product again," says Corsie, "our knowledge helped us, and it helped the client in the smooth running of the project and its implementation."

In stage two they showed table displays; hanging and folded clothes; front appraisal and side appraisal; wall displays; branding ideas; and special areas for visual merchandizing. At this point, they were working with, and helping to liaise between, the management, the in-house architects, the display staff, and the buying teams. Four or five visuals soon formalized the whole scheme and showed the space as a series of "walk through" views, so that Andre Maeder could get an overall picture. "We had taken what we saw in the beginning and converted it into an area capable of holding the whole volume of merchandise, while remaining true to the minimalist feel of the brief," explains Corsie, "and the client was delighted."

What happened next was something that the designers had developed to a high level of expertise—it was almost an obsession with them. First, a set of merchandising documentation that ran to 200 minutely detailed pages, all coded to the plan. Second, an equally bulky set of shop-fitting documents for the contractors to quote on and for the merchandise teams to use to allocate products. Every shelf and hanging area, and how many of each and in which sizes was itemized. Because the tight schedule permitted no time for setting up, this system allowed the merchandise team to prepare all the products offsite and just wheel them in at the last minute, all in the right order and right quantity.

Once the contractors had been chosen, Corsie Naysmith had a sample area set up in one of Harrods' nearby buildings. The 1,000 square foot space included flooring, ceiling, walls,

THIS PAGE OF IDEAS FOR
THE MID-FLOOR
GONDOLAS, WHICH CAME
FROM A LATER
PRESENTATION,
COLLECTED TOGETHER
ALL THEIR EARLIER
WORK IN A COORDINATED
SCHEME.

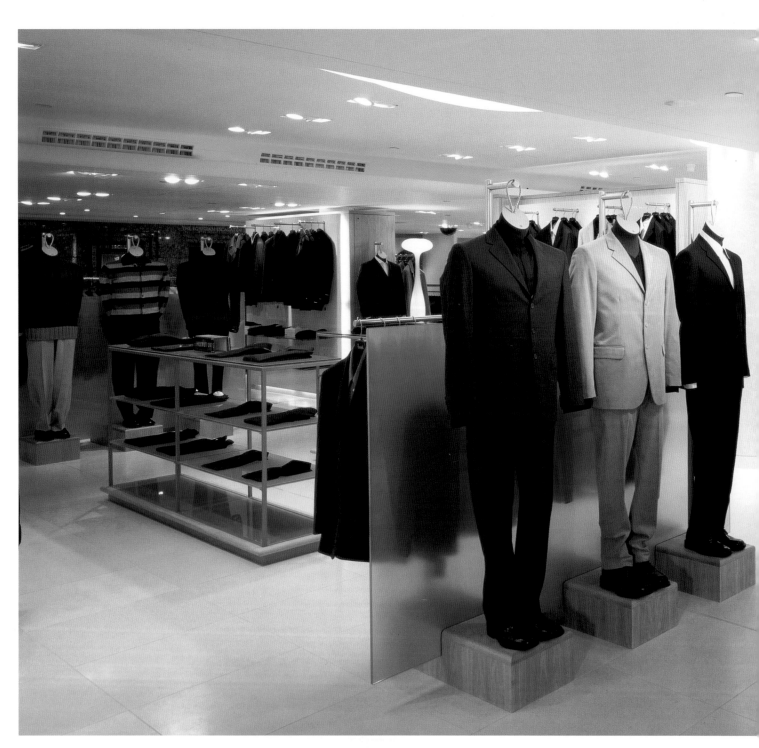

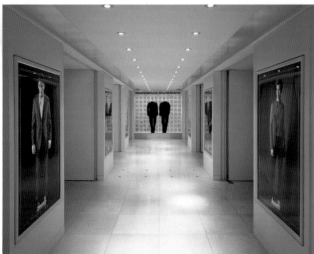

and, of course, shop fitting, and it was large enough to use for meetings with suppliers. Ken Corsie remembers that there was a lot of debate, but in the end everyone was behind the new scheme. Even the chairman came over, unannounced, for a quick look. There followed a few amendments and modifications, including changing the wooden shelves to glass.

From then on, the schedule was extremely tight. The opening had to hit the seasonal cycle and the contractors were all working 24-hour shifts, and both Corsie and Naysmith spent a lot of time onsite resolving problems as they arose. "It surprised me in a way," says Corsie, "just how smoothly the whole thing went."

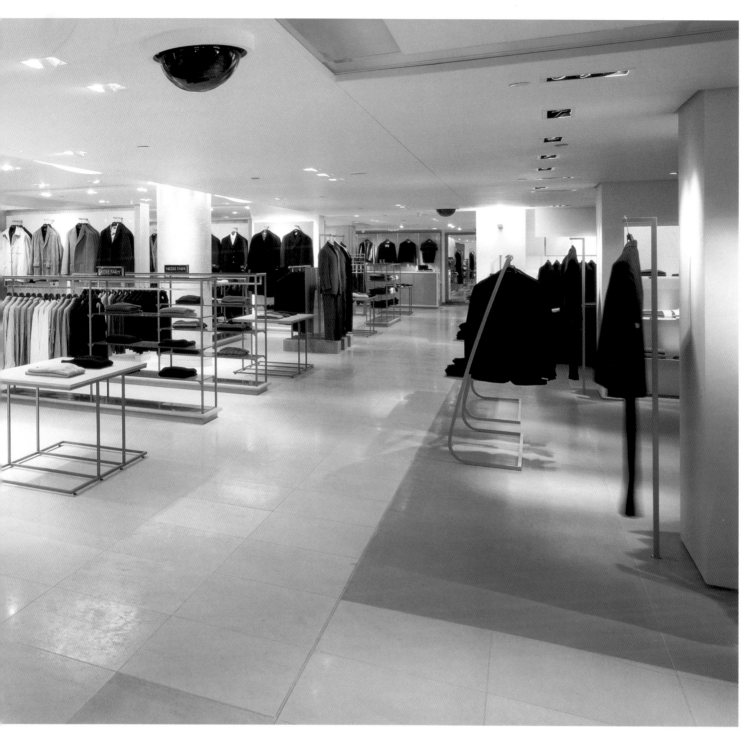

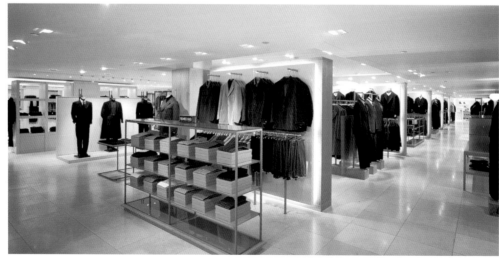

RATHER THAN A SERIES OF ENCLOSED ROOMS, CORSIE AND HIS TEAM CONCEIVED THE HARRODS MEN'S WEAR DEPARTMENT AS A WHOLE AREA, COMBINING STOCK HOLDING, DISPLAY, AND PROMOTIONAL OPPORTUNITIES, INCLUDING SIDE HANGING AND "FRONT APPRAISAL," ALL AT VARYING HEIGHTS.

The Conran Shop

Most designers have to work with the space they are given. In this case, providing they retained the original façade, the designers were able to start from a hole in the ground. Terence Conran, who is often drawn to buildings with a certain visual appeal, briefed his team: **"What I'd like is a sophisticated warehouse"**

Two strands of research marked the start of this project. First, a business plan: how many square feet of trading space would be needed to make the required return on capital? Second: an investigation into the history of the site, an old tire garage, which had previously been stables, where once had stood an eleventh-century manor house that was mentioned in Domesday Book.

The results of the first element, the business plan, dictated the need for a building with three floors and a warehouse/office in the basement. The second strand led, following consultation with the local planning authorities, to investigative drilling onsite to ascertain that there were no significant archeological remains. Set beside this was a further need to be sympathetic to the adjoining mews houses directly behind the site, both during the construction work and in terms of ongoing privacy and rights to light. The architectural team at CD Partnership, headed by Richard Doone and Simon Bowden, began to consider a strategy for the building. "We wanted to move away from flat white plasterboard ceilings and develop some kind of spatial rhythm and cohesion to pull it all together, linked to a practical requirement for buildability on a major urban site with a tight program."

Apart from the elegant brick and terracotta façade, the remainder of the rambling succession of buildings were to be removed, and when the designers discovered a series of barrel vaults on the first floor, their subliminal influence seemed to hold the key to the solution. It answered Conran's request, and it solved both a practical and an esthetic

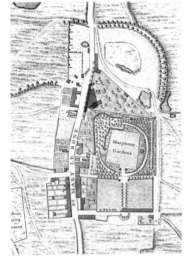

THE POSITION OF THE NEW SHOP WAS MARKED ON A COPY OF A MAP SHOWING THE AREA IN 1740. IT IS SITED IN WHAT WAS AN AREA OF PARKLAND OPPOSITE ST MARY LE BONE CHURCH. THE MANOR HOUSE WAS BUILT SHORTLY BEFORE 1791, AND THE MARYLEBONE GARDENS (*BELOW RIGHT*), WHICH OPENED IN 1650, BECAME A PLACE FOR PROMENADING, WITH AN "ORCHESTRA" BUILDING AND ASSEMBLY ROOMS FOR CONCERTS.

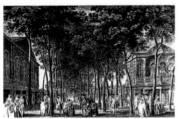

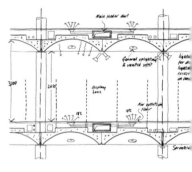

THIS EARLY SKETCH BY ARCHITECT SIMON BOWDEN EXPLAINED TO TERENCE CONRAN HIS CONCEPT FOR THE CONCRETE COFFERED CEILING PANELS. HEATING DUCTS RAN BENEATH THE FLOOR AND CONCRETE COLUMNS SUPPORTED THE ALTERNATE BAYS.

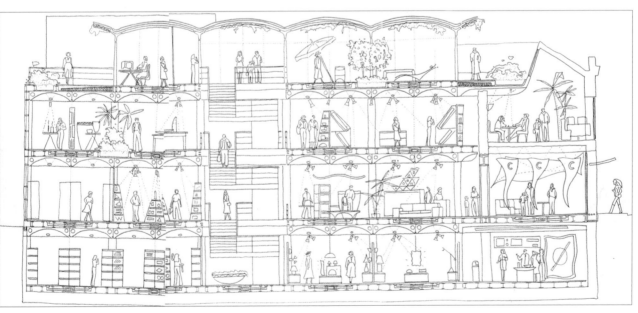

ONCE PLANNING PERMISSION HAD BEEN OBTAINED, BOWDEN DREW THIS CROSS-SECTION TO SHOW CONRAN HOW IT MIGHT LOOK. THE BASEMENT LATER BECAME STAFF OFFICES AND STOCK ROOMS. THE ORRERY RESTAURANT WAS POSITIONED ON THE RIGHT (SECOND FLOOR) AND, CRUCIALLY, THE ABUNDANT SPOTLIGHTS WERE REPLACED BY A MORE INTEGRATED SYSTEM.

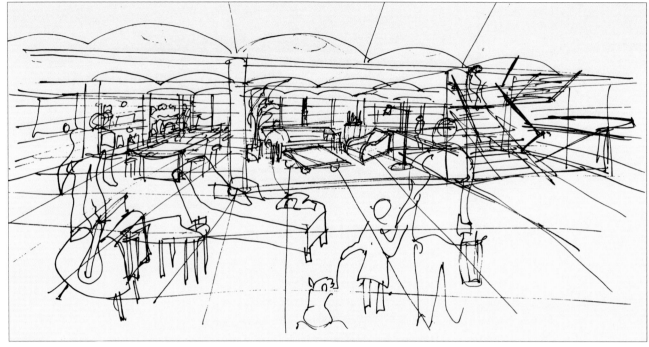

AN EARLY SKETCH OF THE
FIRST FLOOR SHOWS
HOW THE SPACE WAS
CONCEIVED AS A LARGE,
OPEN VISTA,
PUNCTUATED ONLY BY
OCCASIONAL CONCRETE
COLUMNS.

THREE EARLY DRAWINGS
OF THE SAME FIRST-
FLOOR VIEW. IN THE FIRST
(RIGHT) THE CEILING WAS
SHOWN AS FLAT AND THE
STAIRCASE UP AND DOWN
WAS IN THE SAME
DIRECTION. THE SECOND
OPTION (BELOW RIGHT)
SHOWS MULTIPLE
COFFERS JOINED BY A
FLAT BIT AND A TWO-
FLIGHT STAIR LAYOUT. THE
THIRD OPTION (BOTTOM
RIGHT) SHOWS THE
CEILING IN WIDER,
SIMPLER ARCHES, AND A
DOG-LEG STAIR.

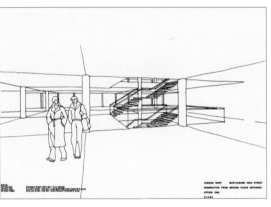

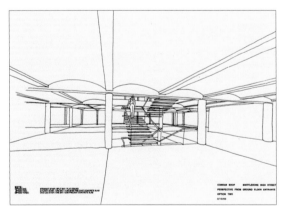

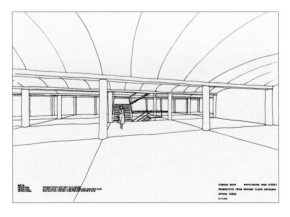

requirement. "I was having a love affair with good quality concrete," recalls Bowden, "and it offered us the opportunity to do something that is unusual in most retail spaces while at the same time providing real benefits in terms of usability and flexibility." More specifically, he conceived a system of pre-cast, arched concrete ceiling modules, 20 feet long by 8 feet wide. "The largest size you can get on a flat-back lorry, two at a time, without needing a police escort," Bowden says.

Uniquely, the interiors and the architecture of this building were bound together, the one influencing the other, in a way that was both good and bad. While the concrete modules gave the spaces a strong character, the precast lighting holes and the directions of the arches created problems when it came to planning the position of shelving and departments.

Tina Ellis, head of the company's interior design division, explains: "Since we had a distaste for track or surface mounted spotlights, we designed aerofoil lighting booms that were sculpted to fit within the ceiling arches, with lights recessed to illuminate the merchandise and displays, and uplights in the top that made the coffers glow." When it came to the floor, there was much more flexibility. "We had the huge luxury of a raised floor, so all the voice and data cabling was contained beneath 2 x 2-foot reconstituted stone floor tiles that could be subdivided into four smaller modules and lifted when necessary. There was a lot of intense discussion between our two departments," says Ellis. "The structure of the ceiling set up a very regular framework, so we had to plan the fixtures so they would work in the direction of the grid. In some areas we could maximize the lighting and in some areas we couldn't." In the center of each floor, an open-tread staircase circled around a lift and allowed light to filter down from a glass roof over the stair on the top floor. The planning of the departments evolved through a close relationship with Conran Shop buyers and management, all housed within the

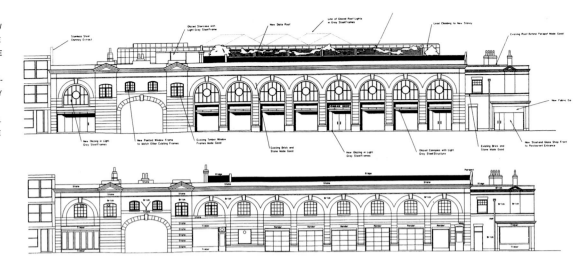

TWO ELEVATION DRAWINGS SHOW HOW THE ORIGINAL FAÇADE WAS IMPROVED BY THE ADDITION OF GLAZED INSERTS AND THE TOP-FLOOR CONSERVATORY SET BACK FROM THE FRONT BUILDING LINE. THE TINY CORNER SITE WAS RETAINED AS AN ESPRESSO BAR AND PROVISIONS SHOP

same Conran headquarters. Conran himself was heavily involved, both in the concept and the details. "A lot of people go to the Conran Shop to buy furniture, so we had to decide: do we put it furthest away, so they have to pass everything else, or on the first floor in the front?" confides Ellis. Conran felt sure that it should be in the front, spilling into the wide window bays. From that point, a certain logic dictated what went where. Beds go next to upholstered furniture and that leads into bedlinen and then bathroom accessories, and so on.

A different problem arose on the second floor. The buyers wanted a big lighting department in a prime area at the top of the stairs, but, as Ellis explains: "It didn't feel very comfortable. Lighting products don't lend themselves to being strung out along a 52-foot wall. They look better with some depth." Ellis's experience in detail design is considerable—she was designing some of the first Habitat stores for Conran back in 1973. "In the end, we moved lighting to an area toward the back, where it could be enclosed in a walled area." So what use could they make of the prime wall space as you come out of the elevator? "Something very prominent, that will hit you in the face as you arrive. Our suggestion was vases," admits Ellis. They are one of the most striking, individual aspects.

Taking the cabinetry in the first Conran Shop, Ellis designed and adapted new units. She had been given very precise floor area and linear dimensions for each department, but, with fewer walls available had to accommodate 14 percent more density than before. "It's very much an on-going process," says Ellis. "The standard shelving is constantly being reviewed and augmented, as the store acquires new merchandise, we are adapting and improving standard details."

Towards the end of the 14-month build and fit-out program, everything got very tight. With only three or four days to go, the builders were still saying everything would be finished, but, in the end, only 95 percent was ready and working. "It was," says Ellis, "a sort of controlled chaos, contractors were still painting walls while the display team were doing their finishing touches." Conran himself was there every day, too. "It gets the adrenaline going when everything is happening at the last minute like that."

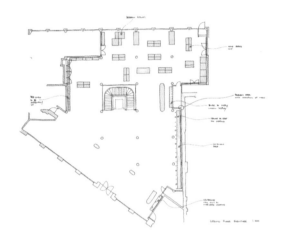

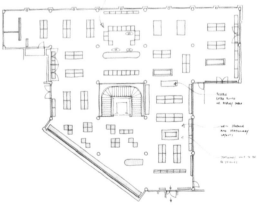

THE FIXED LIGHTING PRESENTED A "PLANNING CHALLENGE" TO THE DESIGNERS, IN BOTH COMMERCIAL AND VISUAL TERMS. CUTTING UP BITS OF PAPER TO REPRESENT SHELVING UNITS, ELLIS HAD TO POSITION THINGS WHERE SHE KNEW THEY COULD BE LIT WITHOUT ENDING UP WITH EVERYTHING RUNNING IN THE SAME DIRECTION "LIKE A SUPERMARKET." ON THE FIRST FLOOR, A LARGE CASH DESK WAS PLACED TO THE RIGHT OF THE STAIRCASE (NOW WITH ITS CENTRAL ELEVATOR), BUT MOST OF THE FLOOR WAS LEFT FOR FURNITURE DISPLAY.

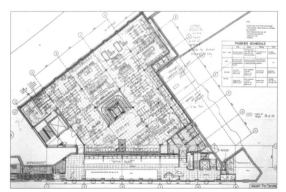

A "TENDER" DRAWING SHOWS THE LINE OF THE CEILING COFFERS, THE POSITION OF THE COLUMNS AND THE GRID OF FLOOR TILES. THE DEPARTMENTS ON THIS VERSION OF THE SECOND FLOOR HAVE BEEN MARKED IN RED, AND THE LIGHTING DEPARTMENT MOVED FROM THE AREA MARKED "DISPLAY" TO A TOP CORNER.

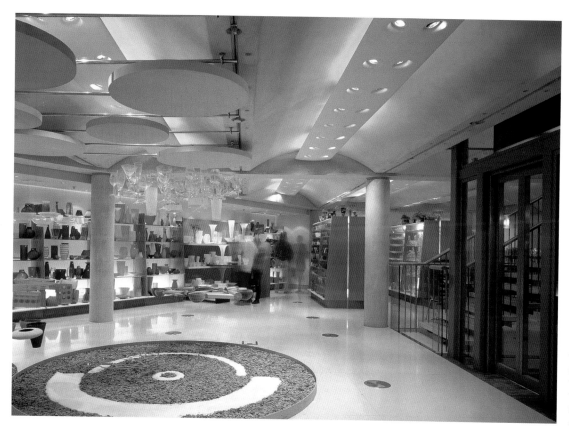

THE VASE DEPARTMENT
BECAME A UNIQUE AREA
IN THE STORE, WHERE
THE RUN OF WALL
SHELVING ALLOWED
PRODUCTS TO
BE DISPLAYED BY COLOR.

THE FINAL SHOP, AN $8
MILLION DEVELOPMENT,
OPENED ON OCTOBER 4,
1997 AFTER A 14-MONTH
START-TO-FINISH
PROGRAM. IT TOOK FIVE
WEEKS TO INSTALL THE
FIXTURES AND STOCK ALL
THE SHELVES WITH MORE
THAN 8,000 LINES,
INCLUDING A NEW
CONRAN COLLECTION.

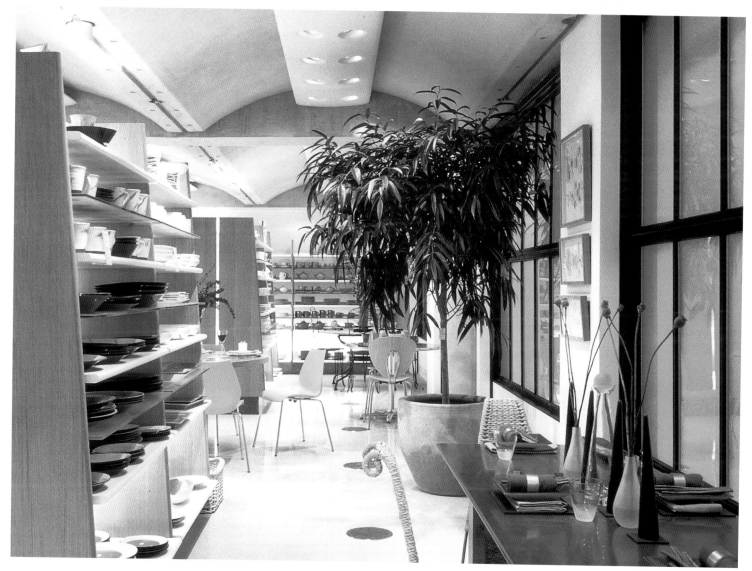

Selfridges

One of the "jewels" of the retailing world. This prestige department store in London, the largest building ever designed as a single shop opened on March 15, 1909. Coming back for a major refit 70 years later, the John Herbert Partnership set out to **explore and re-awaken some of its original characteristics:** height, light, and drama

As part of a major refurbishment program reputed to be costing approximately $128 million and lasting for four years, the second-floor men's wear area was to be completely gutted, reallocated around new escalators, and a central atrium cut through from the floor below. John Herbert and his team were the leading designers, and worked with other design consultancies and architects in order to redefine the store in a more contemporary environment, while paying homage to its architectural history. Herbert's involvement goes back to 1980 when the partnership designed a department for Olympus Sport on the fifth floor and, later, a young fashion department on the first floor.

Moving now to the second floor, JHP was asked to totally restructure the layout of the merchandise, and, in the eastern corner, to create an area for the young men's market with, as John Herbert describes it, "leading-edge street culture, fast-moving clothes for fast-movers."

Herbert recalls that there was no brief, just a series of discussions. He already knew what he had to do: "Make the building work for you, rather than against you." In particular there were wonderful tall windows along the front which he wanted to reinstate as much as possible. "We didn't get our way as much as we wanted because you lose potential wall space for merchandise," he recalls. "Daylight helps orientation," Herbert continues. "The modern person wants it." In addition, the designer planned to strip out the old, lower ceiling and take the space right up, "exposing the surfaces and maintaining the fabric of the building at a high

WORKING WITH JOHN HERBERT ON THE STORE WAS RAJ WILKINSON, WHOSE SKETCHBOOK CONTAINS SOME OF THE EARLIEST IDEAS— STRONG SHAPES TO DESIGNER DEPARTMENTS AND THE BOLD USE OF COLOR. FROM THE START HE INCLUDED A COFFEE BAR IN THE SCHEME, AND THE ILLUMINATED PANELS BESIDE THE DOORS TO EACH CHANGING ROOM WERE ALSO DRAWN OUT.

BEFORE AND AFTER PLANS OF THE 15,000 SQUARE FEET SECOND-FLOOR EASTERN CORNER SHOW HOW, COMPARED WITH THE CLUSTER OF OFFICES AND STOCK ROOMS, THE DESIGNERS PLANNED TO MAKE THE DRAMATIC CORNER WINDOWS (BOTTOM RIGHT) THE FOCUS OF THE SCHEME.

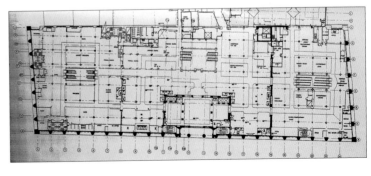

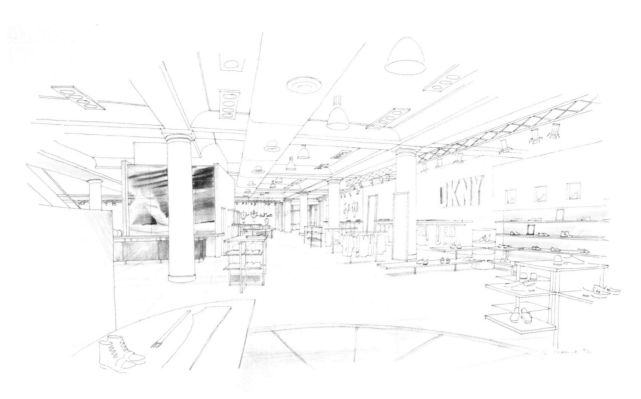

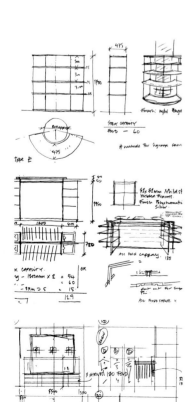

level." The store was one of the first steel-frame buildings to be erected in London, so Herbert knew that there would be interesting columns, but "there was no remarkable discoveries when we peeled it back."

The major part of the work, Herbert explains, were the adjacencies, putting the key brands like Jean Paul Gaultier, Helmut Lang, and Paul Smith in place, and creating interesting perspectives with a minimum of walls. "A structured-unstructured area that was stimulating—using stone, timber, metal, simple plasterwork, and plastics," says Herbert. All the design work was done in four months, but at this early planning stage they did not even know what the merchandise would be like or what the brands would be when the area reopened. One of the first ideas was to focus everything toward the corner, where floor-to-ceiling windows looked out over Oxford Street. "We wanted to use it for seating—an area to chill out, read newspapers, watch video screens—and get away from the relentless hard sell," explains Herbert. "It's one battle we lost."

The designers also put in a coffee bar at an early stage to add to the unique character, but they came up against resistance from the operational side—the cost of servicing it, the loss of retail space, and so on. "We saw it as a dynamic— you need things like this—and we felt strongly that you can't just say you've got more and more clothes," says Herbert. On the plans it came in and out of focus.

Meanwhile, there was more debate about materials and color. The store's Building Services Department was reluctant to have the ceiling exposed. "It is more expensive than putting in a new ceiling and covering it up," explains Herbert. "You need new ducting, new air-conditioning systems,

sprinklers, lighting—everything has to be coordinated to look good when you can see it." Although the budget for fitting out the space was approximately $2.16 million, it wasn't, Herbert recalls, "anywhere near enough."

When it came to the fittings, the designers wanted a flexible scheme that was based on two methods of presentation—shelving or hanging—and a style that was minimal and simple so that it would not compete with the stock, "which tends to be outrageous."

"Everything can be moved around," explains the designer. "All the perimeter fittings are the same steel and glass system. You can change the presentation format without any major physical problems. But sometimes flexibility is an excuse for not making up your mind, and you can waste a lot of money if it never gets utilized." At the same time, Herbert says, "if it is too flexible, the operators change it all around and the design can be lost." So the planning of the scheme and its use of the space were crucial. "The form is the drama." Additional drama was added by the discreet use of color. For the most part the entire space was kept neutral—ivory and off-white with parts of the floor in limestone and parts in dark walnut floorboards. In contrast, the fitting rooms were in pale blue laminate with vibrant, shocking pink doors that matched four plastic banners beside the coffee bar. In the original proposal there was also a series of large graphic panels on glass, but the client was worried that, although they were meant to be changeable, once they were up, they would never be changed. "The product is so engineered and hyped that, in a way, you can stay clear of it a bit, like an art gallery. In other retail formats we'd get more involved with the elaborate detail," says Herbert.

Following the design concept presentation and discussions with the operators, the details were modified and prototypes made before the job went out to tender. "Broadly, it went forward quite well," remembers Herbert. The contractors put up prototypes in the store, and some heights and proportions were changed—"more the details than the concept," he says. From then on, however, nothing went smoothly, and a lot of decisions were held up, and at the time of going to tender there was still no concessionaire. "We had to take a gamble on it and set the dimensions of the fittings."

The exposed ceiling continued to rankle. Not only was it proving more expensive but it was causing a lot more work in planning the services so they would look neat. It needed a decent trunking system for lighting and cable management. Fortunately, the designer room they had designed elsewhere in the store had gone from nothing, to an approximately $11.2 million business in five years. "That was the catalyst that inspired the client to trust us," explains Herbert. "Selfridges has got to accommodate the young if it is going to sell street fashion. Scale is what the store has in its favor—it can do big event that other high street outlets can't do." And when it works, as it had here, it attracts big sales, too.

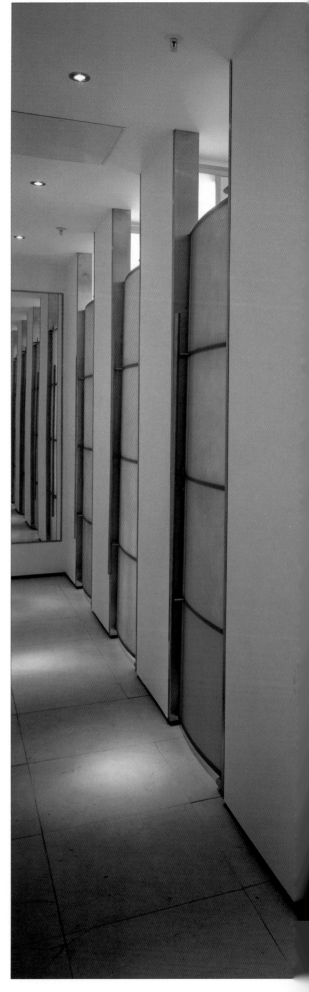

A NARROW ALCOVE LEADING TO THE PALE BLUE CHANGING ROOMS. WHERE THE DOORS. A STRUCTURE OF PLYWOOD AND PLASTIC HELD IN A TENSILE CURVE. ENCLOSED PINK FABRIC. WHICH COULD BE CHANGED LATER ON.

BECAUSE THE BULK OF THE INTERIOR IS WHITE, THE IMPACT WAS CREATED BY THE CLOTHES AND THE SERIES OF BOLD PLASTIC PANELS, SUSPENDED FROM FOUR CORNERS BY TENSION WIRES. EXTRA CHAIRS AND TABLES WERE ADDED IN FRONT OF THE COFFEE SHOP.

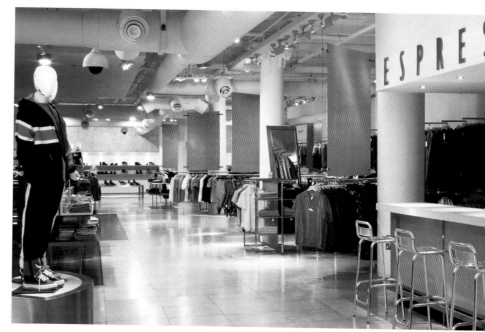

IN THIS VIEW THE AIR-CONDITIONING TRUNKING ECHOES THE STATUS OF THE ORIGINAL STEEL COLUMNS, AND THE CHANGE BETWEEN WOOD AND LIMESTONE FLOORING HIGHLIGHTS THE WALKWAYS.

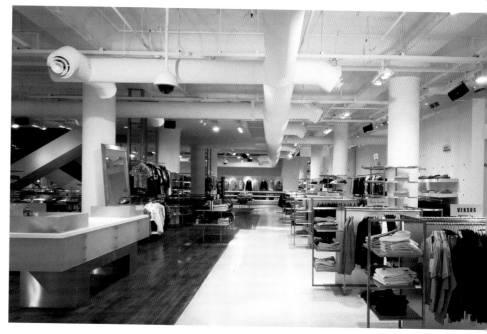

ALTHOUGH THE DRAMA OF THE CORNER WINDOWS WAS LOST TO COMMERCIAL PRESSURE, THE LIGHT IS STILL ALLOWED TO FILTER IN ABOVE THE PANELS.

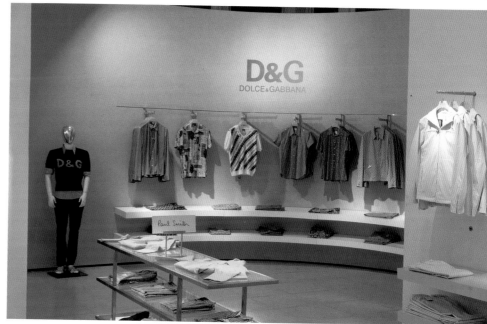

George's

In this unique partnership, both the client and the designer are storekeepers who travel the world, observing the retail scene and collecting ideas. When, after a five-year friendship, they worked together on this department store in Melbourne, Australia, they began not with a brief or with a list of proposed merchandise, but **with the quality of light**

ALL THE KEY ISSUES WERE SKETCHED ON THESE VERY EARLY FLOOR PLANS, INCLUDING VARIOUS ACCESS ROUTES, TRAFFIC FLOW, AND FOCAL POINTS ON THE FIRST FLOOR. A CAFÉ DRAWS PEOPLE IN AT ONE END AND FRESH FOOD DRAWS THEM AT THE OTHER END. THE VIEW THROUGH THE LONG, THIN SHOP IS VITAL FOR CUSTOMERS, AND ANY COMPARTMENTALIZATION WAS DEVISED TO FRAME, NOT BLOCK IT, A TECHNIQUE CONRAN HAS ALSO USED IN SEVERAL OF HIS RESTAURANTS.

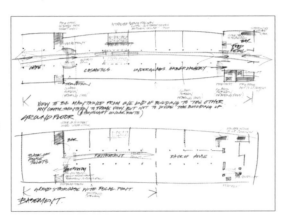

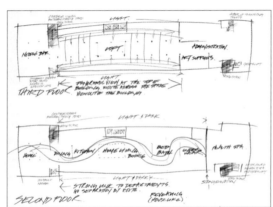

The building in question is George's, which had been converted from a warehouse to a department store in 1988, when, because of mining, Melbourne was the world's second wealthiest city. It evoked the best in fashionable shopping, with its elegant Victorian façade on Collins Street. Inside, hidden behind years of false partitions and lowered ceilings, the five-floor building was supported by cast iron columns with a factory-style glass roof. "It was the straightforward type of Victorian building that we love," explains Terence Conran, who recalls what a "terrible state" it was in when he first went to see it in March 1997.

Stephen Bennett is a co-founder of Country Road, the successful chain of fashion and houseware stores, which has been described as defining the beach-house chic and pragmatic urban aspirations of a whole stratum of Australian society. Bennett saw this George's as his "second career," notes Conran. As soon as the lease was signed, the builders started to strip out the building and to reveal for the first time what they were dealing with.

In the meantime, Bennett had been around the world, taking photographs of shops he liked, and he was full of ideas. Although he had no specific brief and there was no merchandise list at that stage, he had a vision of how much merchandise there would be and, crucially, a vision of an unstructured department store, not segmented in the way that most existing stores are organized, with rigid divisions between departments and permanent layouts.

He was also keen to include food in the offer, and during a key trip to London, Conran introduced Bennett to Martin Webb, then the chef at Quaglino's restaurant. Webb had previously spent time in Australia and was thinking about

IN ELEVATION, GEORGE'S BUILDING CAN BE SEEN WITH ITS SAW-TOOTH GLASS CEILING, ALLOWING NATURAL DAYLIGHT TO FLOOD RIGHT DOWN THE CENTER. ONLY THE RESTAURANT IN THE BASEMENT RELIED SOLELY ON ARTIFICIAL ILLUMINATION.

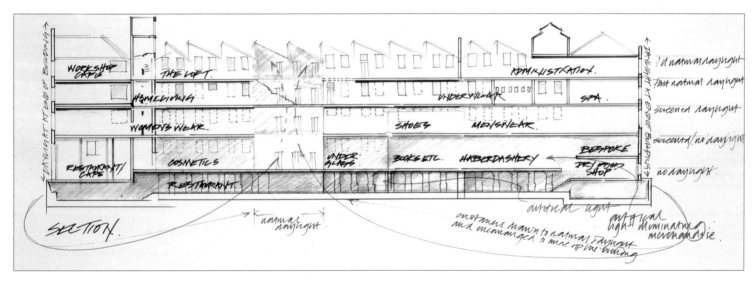

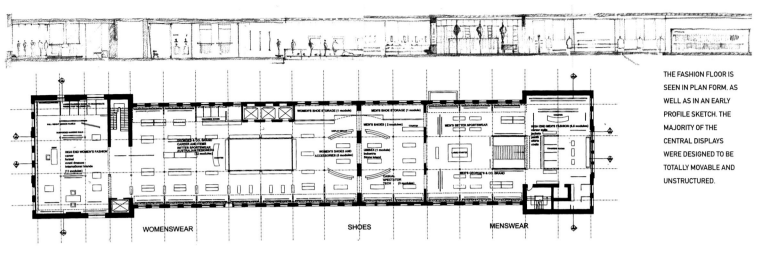

THE FASHION FLOOR IS SEEN IN PLAN FORM, AS WELL AS IN AN EARLY PROFILE SKETCH. THE MAJORITY OF THE CENTRAL DISPLAYS WERE DESIGNED TO BE TOTALLY MOVABLE AND UNSTRUCTURED.

THE GRAPHICS FOR THE STORE WERE DESIGNED BY CHARLIE THOMAS AT CD PARTNERSHIP. HIS INSPIRATION CAME FROM PHOTOGRAPHS FROM THE 1940S, INCLUDING A PHOTOGRAPH OF BENNETT'S MOTHER, WHO WAS A SOCIETY BEAUTY IN HER DAY.

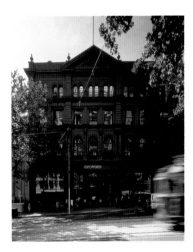

THE COLLINS STREET STORE EXTERIOR WAS PAINTED DARK GRAY, CONCEALING THE RESTORATION THAT WAS DONE ON ITS ORIGINAL DETAILS AND GIVING IT A MODERN AIR. INSIDE THE FRONT DOOR, (RIGHT) STAIRS LEAD UP TO THE COSMETICS DEPARTMENT OR DOWN TO THE BRASSERIE. THE HANDRAIL, PERHAPS AS A METAPHOR OF GEORGE'S REBIRTH, CHANGES MIDWAY, FROM WOOD TO STAINLESS STEEL.

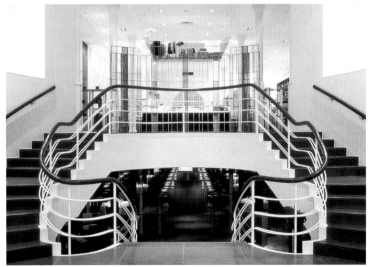

going back. The two men hit it off, and Webb became a key member of the team, contributing to the development of the restaurant layouts and helping to determine the type and style of cuisine for each of the restaurants and food retail areas. As executive chef he was to be responsible for the running of the three restaurants—the brasserie in the basement, the first floor café and the canteen in the loft.

CD Partnership were commissioned to provide the concept design for the store, which comprised four retail floors (also including a Conran shop on the third floor). This involved working closely with international architects Daryl Jackson PTY Ltd who were responsible for refurbishment and for implementation of all works onsite.

In the initial stage Bennett prepared a rough layout for the merchandise, and he and Jane Lawrence, senior designer at CDP, worked on floor plans. "Stephen had a good visual memory and could recall things in the context that he'd seen them," says Lawrence. The layouts produced took into account the desire to create an unstructured store. Particular attention was paid to the use of light which penetrated the building from each end, Collins Street, and Little Collins Street and from the newly created atrium. Bennett was also very keen on the floor to ceiling display, making high-level storage part of the shop's features.

On completion of the layouts, CDP produced more specific drawings which were sent to Australia and drawn up as working drawings by Daryl Jackson PTY Ltd. They also did precise drawings of any little areas they thought needed more explanation, and these went back and forth by courier. "Working so far away," Lawrence says, "could have been very different but, once we started working with the architects, things were fine."

Four months went by, and then in August 1997 Lawrence and Bridget Salter, architect and colleague from CD Partnership, went out to Australia to work onsite with the Melbourne architects. For five weeks they helped speed up the design process which involved the contribution of the entire team. "There were no design language barriers at all" Lawrence recalls. The dialogue continued once CDP were back

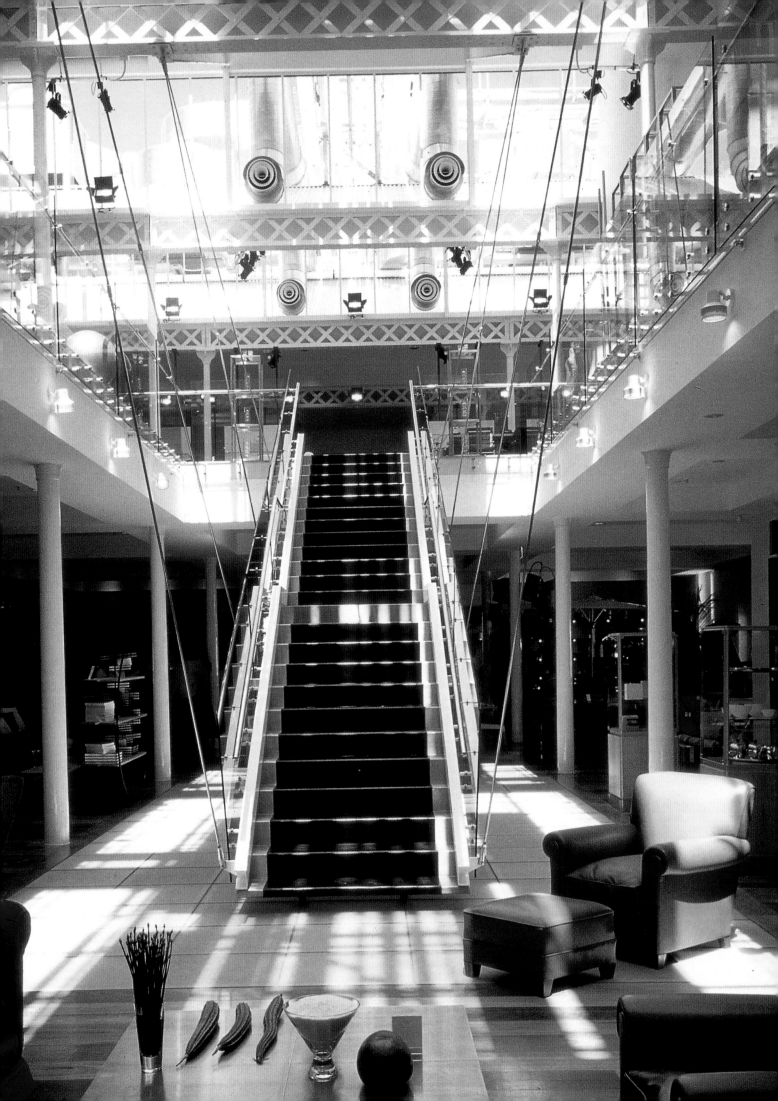

THE CONRAN SHOP FITTINGS WERE ADAPTED TO THE 10 FOOT CEILINGS, AND NEW DEPARTMENTS, INCLUDING AN INTERIOR DESIGN "MADE IN MELBOURNE" SERVICE WERE INTEGRATED.

in England, with faxes being sent back and forth and with Daryl Jackson doing an extremely good job onsite modifying the designs where site conditions or the client required it.

In the meantime, discussions had been going on between Bennett and Conran about the possibility of including Conran Shop merchandise in a "home-living" department on the third floor, and a deal was struck to make it into a self-contained Conran Shop, the first of its kind. This is when Tina Ellis, the CDP associate responsible for designing Conran Shops, was called in. Having just completed a new shop in London and being midway through the latest, largest development in New York for the six-strong chain, she could adapt the standard fixtures and fittings needed for the Conran Shop merchandise and make sure that they fitted in well with the rest of the scheme. In addition to producing all the detailed drawings for the shop fixturing, she was able to work with a local Australian company, S & B Shopfitters, to make sure that they were made to the correct standards and at the right cost. "There was tremendous empathy there," she recalls.

"We knew that in some cases the finishes we had specified could not be obtained because they were too expensive, and decisions were being made on the spot, all the time. I felt apprehensive, not knowing what it would look like," says Ellis who was sent to Australia to review the project.

The quality of the fitout proved to be very high, and cost about one third of what would normally be anticipated for a fitout of this scale. Conran has described the store as "modern and optimistic, with its roots in the Bauhaus philosophy in which form follow function follow fun—it has filled the gap between the fashion boutique and the out-of-town shopping mall." Above the door, the original George's motto has been reinstated: "What we do, we do well."

(ABOVE AND RIGHT) FOUR VIEWS OF THE SECOND FLOOR MEN'S AND WOMEN'S FASHION AREAS, WHICH WERE TARGETED AT "MODERN THINKING 35-YEAR-OLDS." THE WHOLE STORE WAS ABOUT LIFESTYLE," SAYS ELLIS, "IT'S CLEAN BUT NOT DICTATORIAL."

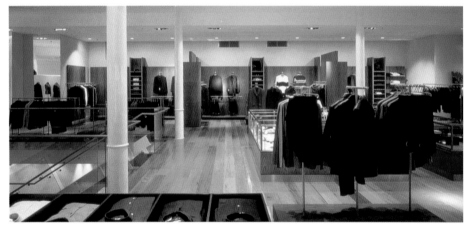

(LEFT) FROM THE THIRD-FLOOR CONRAN SHOP, WHICH SELLS HOMEWARES, CENTRAL STAIRS LEAD UP TO THE LOFT FLOOR AND THE CANTEEN, WHICH HAS VIEWS OVER THE CITY. "THE STORE COULD BE IN TOKYO OR PARIS OR ROME," SAYS CONRAN. "IT'S SHOWN THE RETAILING WORLD A NEW WAY OF DOING THINGS."

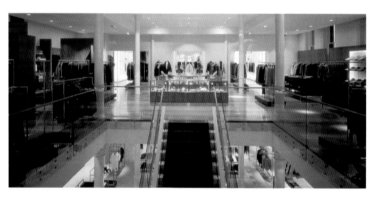

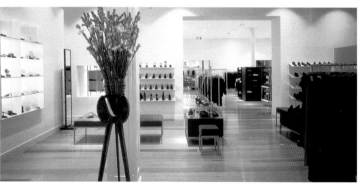

Virgin Vie

In order to develop a closer relationship with customers and encourage them to spend time in the environment, this shop was planned like a landscaped garden, with a winding pathway, a water feature and three key areas, called **attract, inspire,** and **capture**

The original idea to open this new chain of shops selling cosmetics—targeted at a gap in the market between Estée Lauder and Body Shop—came while Liz and Mark Warren were still working at Body Shop in 1995. The customers, they realized, devote a high spend on beauty products and would buy something more populist, more fun, but still good value. The cosmetics industry takes itself too seriously, they felt. "But how do we go about launching such a concept?" they wondered. The answer came with an introduction to Richard Branson, whose company, Virgin, was already investing in the fashion and cosmetics industry. Through its partnership with Rory McCarthy and Victory Corporation, an off-shoot of Virgin established to launch new ventures, they finally got the go-ahead. Although it took six months of discussions and perseverance, once they had finally signed an agreement, Branson was impatient to start. "He wanted it up and running as soon as possible," recalled Derrick Power, design director at Revolution, who first heard about the project when a co-director reported a conversation his cousin had had with friends outside church one Sunday morning. His friends, of course, were the Warrens. By this time, they had been joined by marketing director Roz Simmons and commercial director Axia Gaitskill (both ex-Body Shop). When they came to see Revolution in north London, they had formulated a brief. "A lot of clients won't commit to paper," says Power. "But they had done a fabulous job." Nevertheless, as the project progressed, Power came to realize how little they all knew about what needed to be done in order to launch a new chain of shops and a totally new range of cosmetics products.

In those early days, however, it was still all very secretive. The client saw several design consultants and made each of them sign a confidentiality agreement. "When we got the

PART OF THE PRESENTATION BY REVOLUTION INCLUDED A SERIES OF SIMPLE BLACK AND WHITE DIAGRAMS, WHICH EXPLAINED THEIR APPROACH TO THE FASCIA AND THE PLAN, IN PARTICULAR, FIXTURING VERSUS LANDSCAPING, AND DIVIDING THE SPACE INTO THREE ZONES *(BOTTOM RIGHT)* WERE INFLUENTIAL IN WHAT WAS TO COME.

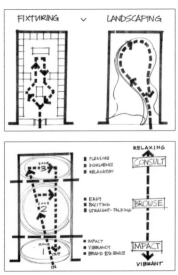

THE GARDEN PLAN THAT THE DESIGNERS USED TO EXPLAIN THEIR THINKING, WITH "ATTRACT" IN THE FRONT AND "CAPTURE," A CONSULTING AREA, AT THE BACK. NOT ONLY WAS THE ASYMMETRICAL LAYOUT IMPORTANT BUT THE CHANGE OF STYLE BETWEEN THE TWO SIDE WALLS WAS ALSO NOTED.

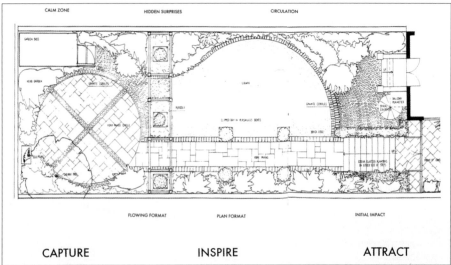

CAPTURE INSPIRE ATTRACT

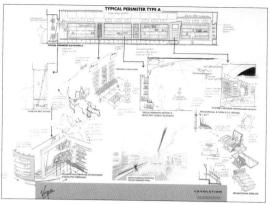

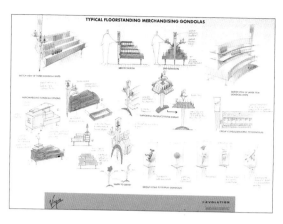

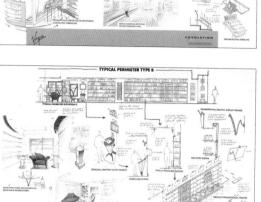

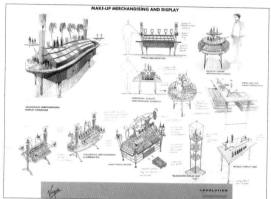

brief for what would be a paid pitch, they asked us to write back with our interpretation of it," says Power. "We treated it as if it were our own business. What would we want? We did a series of 'must haves' and 'nice to haves'," he explains. They also worked out what they would charge, and after three weeks they presented their scheme. It was June 1996.

Although Revolution had done a lot of retail work, it had never worked in cosmetics before. "But it was a problem-solving exercise. If you're any good as a designer, you should be able to come up with the correct solution, whatever it is. We don't have any particular house style. Each project is individual," says Power. "It's an existing industry. We saw an opportunity to popularize it, marry cosmetics to the Virgin brand. We spent an inordinate amount of time getting to grips with what the business was about, and we looked, too, at other Virgin activities. On the surface, they're about fun. They appeal to people who are free spirits, all genders, all lifestyles, and all ages." They also looked at other shop interiors—floors, ceilings, entrances, and so on—clarifying some parts of the brief and questioning others. "Expanding on evolution. We didn't want it to look out of date in three years," remembers Power. Humor, they thought, was an important element, too.

At Revolution's studios four designers worked on the proposals, including design director Steve Scott, and the work they produced covered almost every aspect of the store except the packaging, which was being done by Dieter Bakic Enterprises in Munich.

Looking at the plan—they had no specific site yet, so took a typical, 1,500 square foot space—they thought of ways to

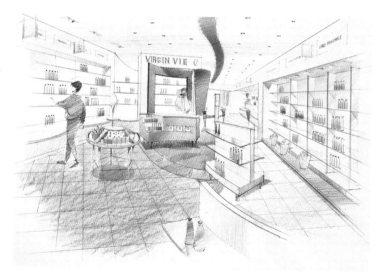

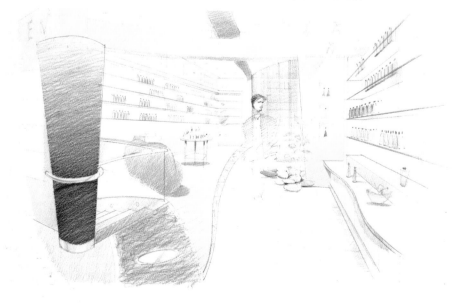

FOUR EXAMPLES FROM
THE DOZENS OF
DRAWINGS DONE TO
SHOW THEIR IDEAS FOR
PRODUCT PRESENTATION.
"HAVING TO PRODUCE
THIS LEVEL OF DETAIL
BEFORE WE'D SEEN THE
ACTUAL PRODUCTS WAS
VERY DEMANDING
TECHNICALLY," SAYS
DERRICK POWER. "THE
CLIENT KEPT ASKING
'HOW DO WE DISPLAY
THIS?' AND WE HAD TO
WORK FROM
ENGINEERING DRAWINGS.
WE LOOKED AT HOW
OTHER TYPES OF
PRODUCT ARE DISPLAYED
AND USED A CERTAIN
AMOUNT OF LATERAL
THINKING."

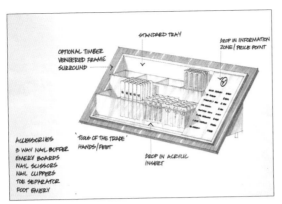

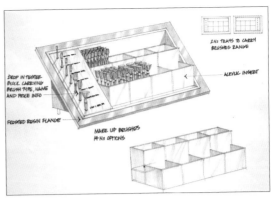

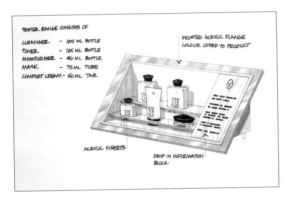

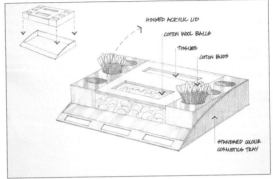

(RIGHT) A SPECIAL
CONSULTATION AREA AT
THE REAR USES TWO
CONSULTANTS' STATIONS
AND TWO PANELS
BETWEEN THE BACKLIT
WALL SHELVES.

create a sort of landscape, with areas of interest, and this is when they found the idea for the garden plan. Instead of designing fixtures, they thought of it as landscaping, introducing "movement" by changing heights, curving shelves and punctuating perimeter walls with areas of promotion. "We asked ourselves: What does the customer need, at what stage?" says Scott, who drew up the following hierarchy of importance with each piece of information given at the right time in the shopping process.

- store name
- the department
- product category
- product-specific information
- how do you pay for it?
- an opportunity for the customer to communicate back

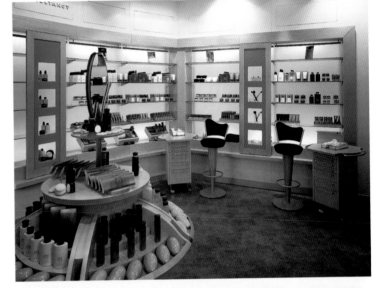

Also part of the new shop was the offer of a consultancy service, with experts on hand to give advice. Should it be on view, as in a department store, or, if it were to be shrouded in secrecy, how would people know it was there? How could they make it more comfortable and relaxed, the designers wondered. These issues were as important for the client as for the designers. "No one option was the answer," says Scott. "It was a discussion point for the client, but the design industry has a responsibility to think about operations, too."

(BELOW RIGHT) TO
STIMULATE THE
CUSTOMER, EVERYTHING
WAS DESIGNED TO BE
FLEXIBLE, FROM THE
UNSTRUCTURED
SHELVES TO THE
CENTRAL ISLAND UNITS,
TO THE LIGHTING, WHICH
COULD BE FILTERED INTO
DIFFERENT COLORS.

When it came to the name of the shop, Revolution's report included 32 ideas. "We all had a go," says Power. "We tried to capture the Virgin spirit with design ideas of how it might look." From that point of view, the client later asked them to look at all the other store graphics as well. To cap the first presentation, the designers had also produced a "fly through" on video—a computer-generated interior visual encapsulating all their ideas, which the viewer was able to

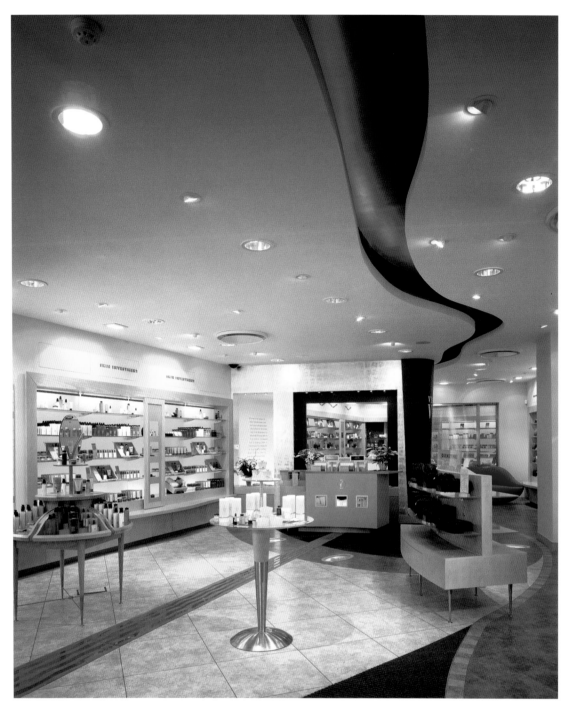

THIS PHOTOGRAPH OF
THE FRONT AREA OF THE
OXFORD STREET SHOP
SHOWS THE SAME
CUTAWAY CEILING DETAIL
AS IN THE VISUAL—BUT A
"RIVER" OF FLOWING
WATER, STARTING FROM
THE FRONT WINDOW
"WATERFALL DISPLAY"—
WAS ADDED BELOW
ETCHED GLASS IN THE
FLOOR.

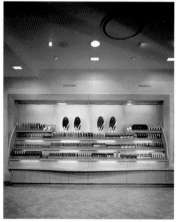

"fly through", almost as if it were real. "It's not that expensive, and even if we didn't get the job, we decided it would be good for business," explains Power. At the end of the two-hour presentation, they got a round of applause, followed next day by a phone call to say they had got the job.

Over the next 16 months the project grew to mammoth proportions as more work came to light and more things needed to be considered. There were design development meetings every two weeks, but for 13 of these months there was no actual site for the first shop. Not until three months before the opening, was the site for the flagship store found on London's Oxford Street, which in itself posed fresh problems, because unlike the central-door schemes, this building had two doors, a huge front window, and a lot less wall space inside than the design scheme suggested. "Everything else went pretty smoothly," says Power, "but the

one thing the client didn't like was the legs on the units, which we spent a lot of time discussing."

Revolution produced a set of more than 50 drawings, which were sent out to tender to nine contractors, and a prototype section of a shop was built, to look at shelving details and to test lighting filters. Meantime, the designers had become involved in product presentation and display. "We established a more extensive partnership than with any other client or job," says Scott.

In addition to London, other stores opened in Bromley, Kent; Meadowhall; Lakeside, Thurrock (almost exactly like the video); Brighton, East Sussex; Norwich, Norfolk; and Bristol, Avon; and there was an on-going agreement to develop the next 70 across the U.K. Curiously, no one seems to know where the final name came from. The client was reportedly "knocked out" with the results.

THE V FROM THE VIE
LOGO WAS ADOPTED AS
AN ELEMENT WITHIN THE
STORE AND THE
SIMPLICITY OF THE
PRODUCT DISPLAY
CONCEALED MONTHS OF
CAREFUL DESIGN AND
PLANNING. "LOTS OF
DEVICES TO MANAGE THE
PRODUCT ON THE SHELF
AS WELL AS THE
RESTOCKING BOXES—
THEY SHOULD LOOK
GOOD, TOO." EXPLAINS
DERRICK POWER.

Moschino
What would he do if he were here now? It's quite difficult to design a new retail concept and six brands, which have all the elements of anti-design that Moschino made his trademark, **when he is no longer there to see the designs.** It was a design conundrum. It seemed at first that the designers had to go back in time and find the most obvious visual clues to his way of thinking. **Only then could they start to build a new identity for the future**

The team at Moschino, headed by managing director Marco Gobbetti, was very supportive. Like a family, it knew what was right but could not articulate it. Moschino had some stores and sourced shops-in-shops, and the team brought photographs to show the designers. The very strong character came partly from the shop interiors and partly from the clothes, which had found their own place among the other fashion brands. In the Los Angeles store a theater designer had used one-off bits of furniture and created a crazy, "Alice in Wonderland" effect that was more to do with anti-design. But it was a non-repeatable solution, and in a way it detracted from the clothes rather than contributing to them.

"We spent a lot of time wondering what we were going to do," remembers Peter Kent. "How could we make it natural for us?" In the end they watched all the videos of Moschino's fashion shows and focused on a book, produced in 1993. "We went through it hundreds of times," Kent explains. "We had to try and distill the essence of Moschino and do things the way he would have done. We were going to have to break all the design codes we had been brought up with. It was very difficult," continues Kent, "trying to discern all the positive elements and those that we could take forward. We wanted some chaos but with control—it had got to be manageable. In the end, we had only a week to pull it all together."

The first presentation was huge. The designers wanted to include things to which the Moschino team could react. In the book were certain elements that emerged as themes. His great imagery: the heart, one of the world's greatest symbols, was sacrosanct and must be used quite strongly, they felt. Cartoon images—humor and wit—are synonymous with Moschino. Black and white stripes and checks kept coming up, as did black and white wording on everything from *haute couture* to T-shirts. There was a lot of surreal imagery in the book and juxtaposition of unexpected styles—baroque and hard-edged, for instance. Also there were certain constants

FROM A BOOK OF 10 YEARS OF MOSCHINO'S WORK, THE DESIGNERS ISOLATED CERTAIN IMAGES THAT THEY THOUGHT WERE SIGNIFICANT, INCLUDING CLOUDS IN VARIOUS SURREAL JUXTAPOSITIONS.

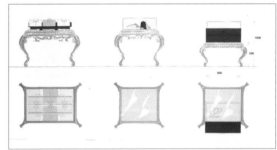

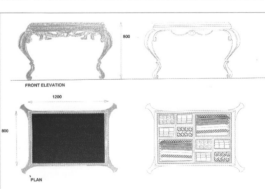

USING THE GILDED BAROQUE TABLE THEY HAD SEEN IN THE MOSCHINO SHOP IN LOS ANGELES, THE DESIGNERS EXTENDED THE IDEA AS FAR AS THEY COULD, CREATING A WHOLE RANGE OF FURNITURE, INCLUDING SHOWCASES AND DISPLAY CABINETS, WHICH WERE CHANGED LATER FROM SILVER TO GOLD.

JUXTAPOSITION WAS AN IMPORTANT THEME— MODERN AND BAROQUE, SOFT AND HARD, METAL OVER SILK, DARK AND LIGHT

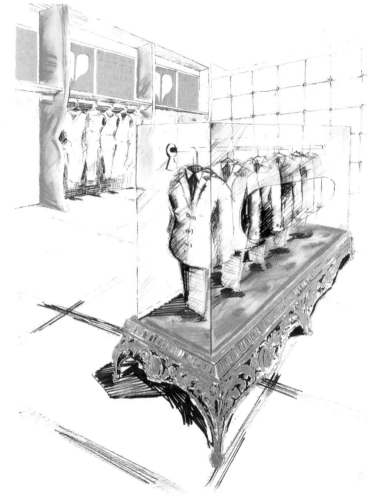

RIGHT AND BELOW FOR THE PERIMETER WALLS THE DESIGNERS NEEDED A SYSTEM OF INTERCHANGEABLE PANELS AND FLEXIBLE SHELVING, AND THEY CHOSE CLOUD PANELS, QUILTED SQUARES, AND FELT CURTAIN PANELS TO DIVIDE THE CLOTHES.

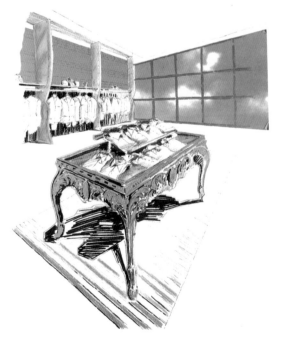

to which Moschino kept returning: gold stars, black, and white stripes and bright red. "I was trying to find things that I could relate to," confesses Kent. Obviously a special piece of furniture was going to be important, but it had to be adaptable to all the things it needed to do. At one point they considered chairs, too—perhaps a different style for each of the six brands, which were: couture, the women's mainline collection; mass diffusion, the big seller, "cheap and chic;" Moschino jeans, a younger, cheaper line; Moschino Borse, bag and accessories; Moschino Uomo, men's ranges; and kids, for children between four and 14.

To begin the presentation they defined the brief, to create a store combining the essence of Moschino with the spirit of the future. A surreal juxtaposition of the baroque and the new. A store that:

- is unique and distinctive
- pays homage to the clothes
- is powerful at its simplest
- has a strong street presence
- is easy to shop in
- is easy to maintain
- is a natural evolution

Having worked through the first stage, Kent and his team now felt confident enough to show some solutions, even as part of that first presentation. At the end, the client went through the boards and said what they did not like and what they did, which was quite a lot. They picked out the heart, of course, the sample board that showed black and white stripes, and the one using black, white, red, and gold. They also loved the designers' ideas for a set of baroque tables, although they wanted them in gold, not silver, which Kent had thought might make them more "now." "Why should we?" they asked.

Kent was relieved but not totally relaxed. There were a lot of ideas on the table, but he did not feel that it had all come together yet. Then, even before they had had a proper de-briefing, the chance came up to do the first new shop—an accessories department on the ground floor of the new Harvey Nichols store in Leeds. But it had to be ready in three months. "If we don't get the final solution now," Kent realized, "it's all over."

This was all it needed. "Like a lightning flash, I just knew what I was going to do," says Kent. Helped by Louise Hosker, he got the plans and pulled it all together. He remembers that the presentation of the final scheme was sent by courier to Gobbetti, who was on holiday in Jamaica. "It was very

Moschino, but cleaned up, and he loved it," recalls Kent. They had the link—accessories—between couture and cheap and chic, so they had to work out how to do the sub-brands.

While the Leeds department was going ahead, the designers started to focus on the rest, which was easier now that the central idea had been established. Time was running out. Other franchisees were already desperate for one of the new shops. Elements from the first presentation were salvaged and additional elements, such as black and white cowhide and heart-shaped central hanging units, were added. Stripes played an important role in linking all the brands. "A department store might have one of each department on each floor," explains Kent. "So each one had to be different but related."

Threaded through the schemes were a lot of quirky elements—"bringing entertainment to the shopping experience"—like cabinet handles in Uomo in the shape of black lacquered pipes, and a jewelry or scarf display bust made in the shape of two heel-to-heel women's shoes. There were minor changes, but the client seemed pleased. "Gobbetti can be very restrained, but I could tell we had hit the mark," says Kent.

They put all the elements into a manual and the first sites were in Rome, Tokyo, and Osaka, with 20 or 30 shops-in-shops around the world to follow. There was no time for prototypes. They did the first six or seven (all the furniture was made in the U.K.), monitoring the pieces as they were shipped out and changing certain small details

"There was one disaster," admits Kent. The rugs, lavish, thick-pile productions that were used to demarcate the space in instances where the floor could not be changed, got dirty in a few days—the stripes smudged together and people complained. They have now been replaced with less graphic designs that have more solid color and less white. Along the way, the design team, with design associate Rachel Toomey, have had to monitor the whole production process and implement both quality and cost control measures. For stand-alone shops they can still introduce new elements, and they are, says Kent, "developing new ways to display things all the time". If Moschino is turning in his grave, it is probably to get a better look.

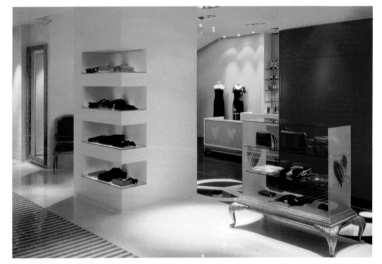

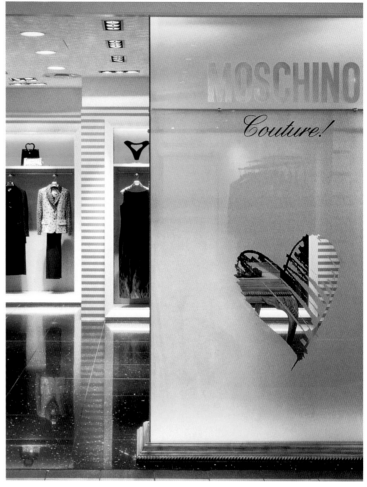

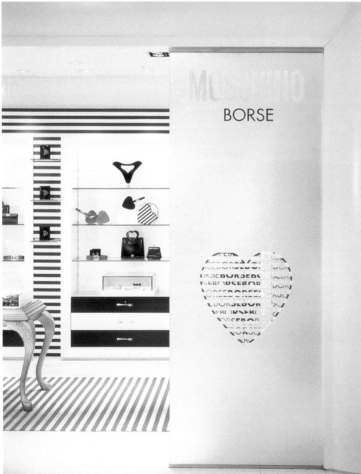

The Sweet Factory

"Long, long ago, when planet Earth was young, the robot sweet traders of Orion were victorious in the Taste Wars, vanquishing both the Veg Raiders and the Gray Empire. Their Sweetships and Sweet Factories had become a familiar sight across the Cosmos—and out to the Far Edges. Every ship, from humble probe to mighty sweet freighter, carried the message:

Eat sweets, be happy

So begins the Sweet Factory story if you click onto it on the Internet. The design story also begins long ago, but not so long ago that Paul Mullins, the youthful designer responsible, cannot remember it. It was 1986. Mullins was working on retail design projects at Michael Peters & Partners (MPP) in London, and a small jewelry store that he had just completed (the first of a chain of 10) was seen by Swedish entrepreneur David Pagrotski. Britain was in the middle of a retail boom, and Pagrotski, realizing that there was money to be made, had the idea of creating a "fantastic sweetshop" and immediately called up MPP. "That's how we made contact," explains Mullins. The mood at the time was about "green" issues ("things that were good for you, for the environment"), and this concept didn't really fit in with that. Pagrotski had thought up an "indulgent fantasy" about a Sweet Factory, with an endless supply of very enticing sweets—"every kid's dream," says Mullins. Nevertheless Pagrotski presented his idea with great enthusiasm. "Everyone has ideas," says Mullins, "but with Pagrotski, you knew he'd make it happen. He certainly convinced us." It was all about indulgence, rather against the prevailing health trend, but Pagrotski thought that a little indulgence would be good for people. The first site was in Kingston, Surrey, and it was an immediate success. Pagrotski sourced the sweets from "all over the world", and soon the Sweet Factory had 15 branches, all designed by MPP. But Pagrotski traveled a lot, and he needed someone to run the company and to look after all the day-to-day details. "Pagrotski has a 20-minute attention span—he's enthusiastic and then he's off onto something else," says Mullins. That is why Chris Adams came onto the scene, and while the shops in Britain started to feel the effects of the recession, Pagrotski was off to the U.S.A.,

(LEFT AND FAR LEFT) MULLINS WAS INSPIRED BY 1950S' FILMS, TV PROGRAMS AND SF NOVELS. FINDING THE GENRE A RICH RESOURCE. HE COMBINED *THUNDERBIRDS* STILLS WITH *SPACE INVADERS* GRAPHICS TO VISUALIZE HIS IDEAS.

TWO PAGES FROM THE WEB SITE TELL THE STORY OF THE ROBOT SWEET TRADERS OF ORION, CONSIDERED IDEAL FOR THE SAFE TRANSPORTING OF SWEETS. THE VARIOUS GRAPHIC ELEMENTS OF THE SCHEME SHOW THE TIN MAN LOGO AND MULLINS'S VERSION OF LEONARDO'S ADAM DRAWING.

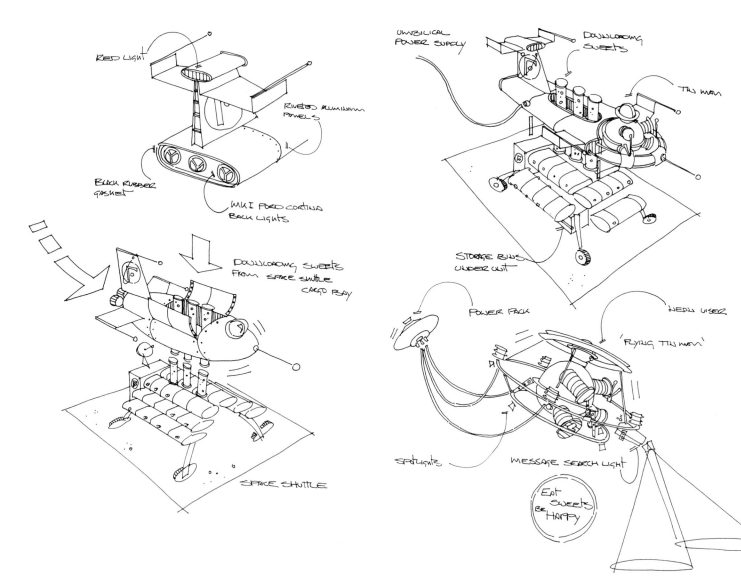

RED LIGHT

RIVETED ALUMINIUM PANELS

BLACK RUBBER GASKET

MK I FORD CORTINA BACK LIGHTS

DOWNLOADING SWEETS FROM SPACE SHUTTLE CARGO BAY

SPACE SHUTTLE

UMBILICAL POWER SUPPLY

DOWNLOADING SWEETS

TIN MAN

STORAGE BINS UNDER UNIT

POWER PACK

MENU USER

'FLYING TIN MAN'

SPOTLIGHTS

MESSAGE SEARCH LIGHT

Eat Sweets Be Happy

Japan, Portugal, and South America, making new contacts and setting up franchise operations. Soon there were 350 Sweet Factories, the biggest single brand of pick-and-mix retailer in the world. Mullins left MPP in 1987.

He now runs a small studio in central London. "The sweet shop work went on for 10 years," recalls Mullins. "I built up a package of certain standard details, but I didn't design every single shop, and, over the years, standards began to slip, details changed." Adams thought that some of the design integrity had been lost because of the rate of growth and the nature of the installations and, with the retail environment in the U.K. becoming more optimistic, it was time to look at the next generation of Sweet Factories.

Mullins analyzed what was good about the original concept and thought of ways to re-energize it. That is when he thought of the idea of creating a bit of a legend—a myth on which to hang the whole scheme. And what better place than a web site? The original idea had been a slightly futuristic factory set in an ambiguous time, run by robots. In a series of client meetings, Mullins started sketching. He analyzed the essence of what had made it successful before and added to it. In particular, he developed three levels of installation,

"THE MODULE WAS DESIGNED LIKE AN AUTOMOBILE, WITH A WORLD WAR TWO AIRCRAFT STRUCTURE BOLTED ON AND MADE IN ANODIZED ALUMINUM AND SILVER-FINISHED MILLED STEEL," SAYS THE DESIGNER. TWO GENERATIONS OF SPACECRAFT CAN BE SEEN IN THIS SERIES OF PROFILE WORKING DRAWINGS. (ABOVE) INCLUDING THE SMALL SATELITE UNIT AND THE SPACE SHUTTLE WITH THE TIN MAN IN THE DRIVING SEAT. (LEFT AND ABOVE RIGHT) APART FROM AN ELECTRICITY CABLE, THE UNITS WERE COMPLETELY INDEPENDENT AND TRANSPORTABLE, WITH BACKUP STOCK KEPT UNDERNEATH OR NEARBY.

from a 48-bin mobile unit that functioned as a small free-standing unit in railroad stations or shopping malls, to a slightly larger mobile unit, to a small shop. "At its most basic," says Mullins, "it was an ergonomic retailing concept that presented loose sweets in an easily accessible and visually dynamic tiered display." Essentially, it was "help yourself" with a sales assistant to take the money.

But the design of the units told another story. Inspired by 1950s' magazines and TV programs such as *Thunderbirds*, the smallest module represents an early reconnaissance spacecraft hovering above the tubes of sweets, checking for stock levels and sending messages back to the space shuttle for replenishments. The larger craft, when it arrives (as a larger module) to deliver extra product through clear plastic tubes from its midships, has a round tin robot in front and a tail

section inspired by the rear lights of a 1960s' Mark 1 Cortina.

"We tried to keep it simple," says Mullins. "In the past we had a moving tin man, and it kept breaking down." In the meantime, an old Sweet Factory shop in London's Victoria Station came up for rent renewal. Mullins designed all the details and worked with tool-maker Mike Tonkin, who had been involved with the Sweet Factory since the beginning, to build the prototypes.

"We might have made it much more theatrical," says Mullins, "with a lot more features, but its impossible in a public space." At the moment, he is developing a small satellite unit. "That's the advantage of having the story," he explains. "You can go back to it and find lots of other opportunities. "As Captain Pickmix of Heavy Sweet Freighter Gobstopper 10 says: "The sweets are safe with us."

(RIGHT) ONE OF THE MOST COMPLEX DESIGN PROBLEMS WAS THE NIGHTIME SECURITY. "IT'S LIKE HAVING TO WRAP A BIG STEEL BATTLESHIP." MULLINS SAYS OF THE MESH SCREEN IN THE STORAGE DRAWERS BELOW.

MULLINS, WHO WAS KEEN TO KEEP A TIGHTER REIN ON ALL THE GRAPHICS, DESIGNED A PROGRAM OF PROMOTION ITEMS, INCLUDING POSTERS, BADGES, PRICE TICKETING AND CARRIER BAGS, CLEARLY INSPIRED BY *SPACE INVADERS*.

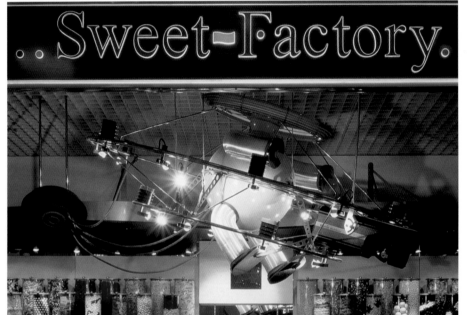

THE RECONNAISSANCE VEHICLE, SEEN THROUGH THE WINDOW OF THE FIRST SHOP IN THE NEW REFURBISHMENT PROGRAM. THE. TIN MAN IS IN COMMAND. SURROUNDED BY 10 SPOTLIGHTS AND WITH A "GOBO PROJECTOR," WHICH SHOOTS "EAT SWEETS, BE HAPPY" IN A MOVING PATTERN ON THE FLOOR IN FRONT OF IT.

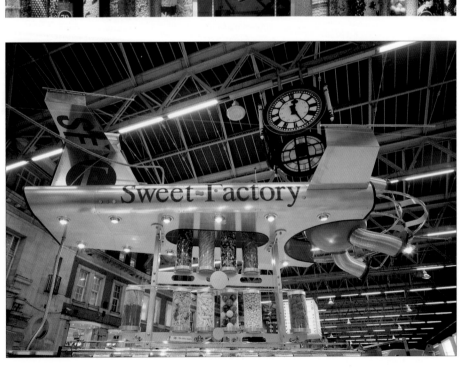

(LEFT AND RIGHT) THE FIRST INSTALLATION THAT FEATURED THE SPACE SHUTTLE WAS IN THE CONCOURSE OF THE RAILROAD STATION AT WATERLOO.

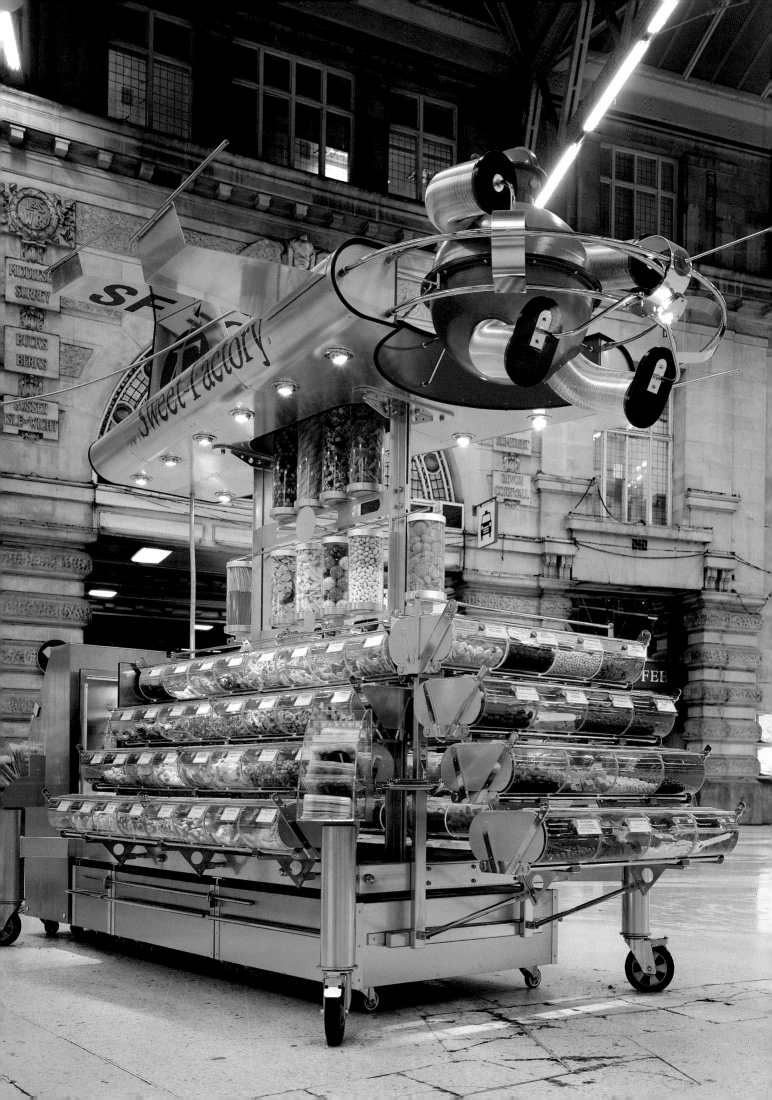

Ray-Ban

The store was intended as a statement at the Atlanta Olympics, to assist in presenting the personality of the Ray-Ban brand and act as a stage from which to orchestrate PR activity. The method the designers initially used to respond to the brief—by creating a "visual stratum"— had an impact not only on the flagship store but also on every aspect of Ray-Ban's sunglasses' global marketing strategy

A SNAPSHOT OF THE NEW ATLANTA SHOP, WITH ITS HIGH CEILING AND GENEROUS WINDOWS, BEFORE WORK BEGAN.

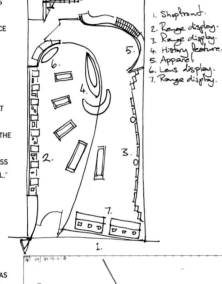

ONE OF THE EARLIEST SKETCH PLANS SHOWS HOW MUCH OF THE THINKING WAS IN PLACE FROM DAY ONE. CUSTOMERS WERE CHANNELLED VIA THE LEFT-HAND RANGE DISPLAY TO THE LENS DISPLAY, AN AREA THAT EVENTUALLY DEMONSTRATED HOW THE PRODUCT WAS MADE, FROM A "LUMP OF GLASS AND A SHEET OF METAL," TO THE APPAREL COLLECTION AT THE REAR.

ONE OF THE EARLY IDEAS THAT PRECEDED THE FIN CONSTRUCTION WAS A TWO-SIDED DISPLAY PANEL, SUSPENDED SEVERAL INCHES ABOVE THE FLOOR.

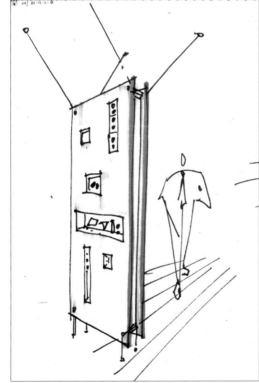

In the beginning, the brief given to the designers at Checkland Kindleysides (CK) in Leicester, was for the creation of the first U.K. store. The executives of Ray-Ban had already seen and admired CK's work, and Adam Devey Smith, sales and marketing director at CK, attended an initial exploratory meeting with the U.K. senior management, discussing the history of Ray-Ban, a brand of Bausch & Lomb.

Visualizing a brand is a technique that CK began in the 1980s with its retail work for Levi's, creating a montage of images (strata) that assist in visualizing the core values, the personality of the brand. When Bausch & Lomb's global image director heard about the CK retail work and brand identity presentation for his company, he called Devey Smith to ask "Talk me through this approach." Bausch & Lomb had been working on the store to coincide with the Olympic Games in Atlanta to capitalize on the company's sponsorship; "What kind of timescale could you build my new store in?" they asked. When Devey Smith said it would take between six and eight months, he simply said "We can't postpone the Olympic Games. You'll need to work to half that time-scale."

Over the following weeks the designers worked with the Bausch & Lomb archive team searching for movie stills,

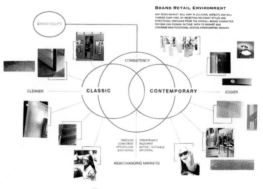

TWO SIMPLE CHARTS, ONE (*LEFT*) FROM AN EARLY STAGE OF THE WORK, WHICH BALANCES RATIONAL/PHYSICAL ELEMENTS AGAINST THE EMOTIONAL ATTRIBUTES OF RAY-BAN, COMPARED TO ANOTHER (*BELOW LEFT*), WHICH SHOWS HOW THE CLASSIC AND THE CONTEMPORARY ASPECTS OF THE BRAND EQUITY WERE REFLECTED IN THE MATERIALS THAT MADE UP THE STORE'S INTERIOR.

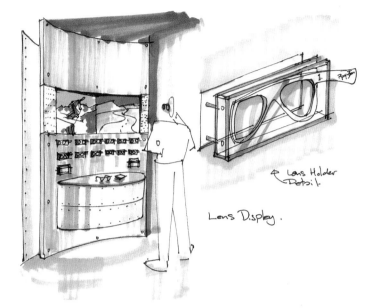

Lens Holder Detail

Lens Display.

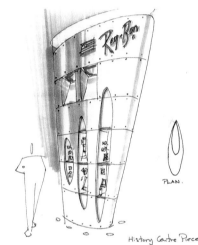

PLAN.

History Centre Piece.

archive documents, evocative music, and contemporary expressions of the Ray-Ban brand.

"These guys really get it," the global image director said, referring to their understanding of the Ray-Ban brand, and they promptly appointed CK and flew the team to Atlanta to look at a number of sites. Devey Smith and the CK creative director Richard Whitmore saw various high street locations but few with architectural presence that would contribute to the brand image. With so little time to go before the start of the Games, property was at a premium, but Bausch & Lomb, realizing the importance of the project, eventually signed up a prime site—an historical building in a large mall, with a 25-foot-high ceiling, that opened onto a big square. Over the next four days they assessed the space potential, took snaps, and started discussing "the physical things we'd need to do," explains Devey Smith.

Back in London, senior designer Marc Epicheff was added to the team, and over the next week their brainstorming sessions turned up "some really ground breaking ideas." Working with the associate marketing manager at Ray-Ban, they researched Ray-Ban sunglasses' history, gaining insight into its two German founders, Henry Lomb and John Henry Bausch, and in particular, the company's commission by the U.S. Army Air Corps in the 1920s to develop a glass that could overcome the brutal glare encountered by pilots. The first Ray-Ban sunglasses, known as Aviator style, were introduced to the public in 1937. Throughout the decades the famous eyeware have become "compulsory" wear for music and movie stars from Marilyn Monroe to James Dean, John Travolta to Tom Cruise. In 1955 the company even received an Oscar for its services in lens-making, to the motion picture industry.

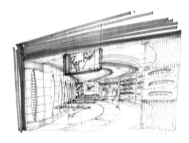

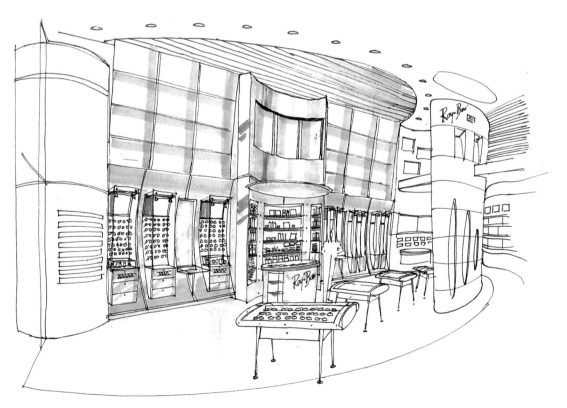

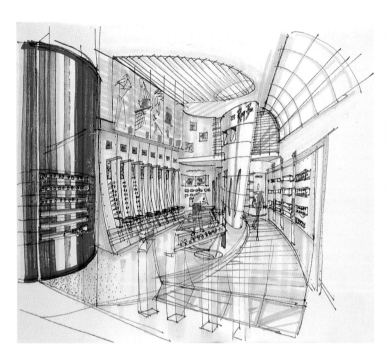

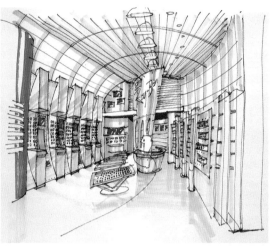

IN STAGE THREE, THE LEFT-HAND WALL, IN A COMBINATION OF MAPLE, ALUMINUM AND FROSTED GLASS, HAD BECOME CURVED LIKE AN AIRCRAFT FUSELAGE, BUT THE DESIGNERS WERE STILL NOT HAPPY WITH THE RIGHT-HAND WALL, WHICH THEY THOUGHT NEEDED TO BE "MORE FUN AND EXCITING."

THIS ALTERNATIVE STAGE THREE SKETCH SHOWS THE IMPACT OF THE RED "STATEMENT"—SIX BANDS OF PRODUCT FROM DIFFERENT DECADES, WHICH SUMMARIZED WHAT RAY-BAN STANDS FOR. INSIDE THE STORE, LIFESTYLE PHOTOGRAPHS HAD BEEN ADDED AT A HIGH LEVEL.

ONCE THEY HAD "CRACKED" THE RIGHT-HAND WALL, THE DESIGNERS QUICKLY ADAPTED THEIR WORKING MODEL TO SHOW THE FLOOR-TO-CEILING CONCRETE WALLS AND THE TWO TRY-ON BOOTHS.

"It's not often that you get an opportunity to work on something like that; it's a designer's dream," says Devey Smith. "We had a very open brief." Unlike any other store, they did not start with a floor plan, but thought instead of ways to pick up on those moments in time: "What medium could we use to communicate those 60 years of Ray-Ban's history? Our excitement about the brand became very infectious," recalls Devey Smith. The overall image needed to be modern and light, they thought, and gradually individual elements started to emerge:

Ray-Ban sunglasses, they realized, were about the balance of classic and contemporary messages, of a hard urban environment and the natural outdoors, about seeing and being seen. Quality and clarity of vision, and of course, because they were mostly worn outdoors and seemed to embody the outdoor life, the store, too, ought to be lit with a feeling of sunlight.

For the first presentation, as well as the visual stratum there were "sketches only," and a floor plan "in the loosest sense of the word." The space had been zoned into individual sections. Although they liked the approach, the client found it difficult to visualize the completed store. In fact, what they saw was part of a much bigger strategy. CK was not just designing a shop but focusing a brand—creating a platform through which the brand could be communicated—and it had far-reaching implications. "That's when the whole team got

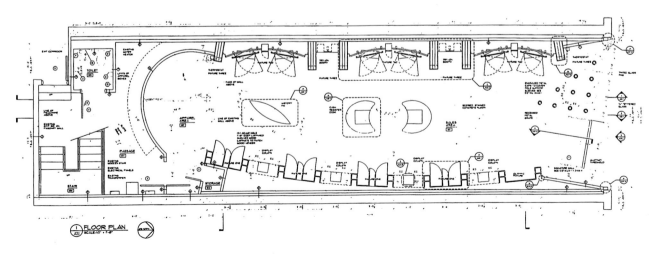

THE FINAL PLAN OF THE ATLANTA STORE, WITH THE SERIES OF MULTI-LAYER SWIVEL SHOWCASES ON THE RIGHT-HAND WALL, THE CURVED APPAREL AREA AT THE REAR AND THE TWO CENTRAL CASH DESKS, ADDED FOR THE DURATION OF THE GAMES, TO DEAL WITH EXTRA TRAFFIC.

really excited," recalls Devey Smith. It became a massive opportunity for communicating the image, not just a marketing slogan. It went deep into the culture of their business and went on to influence everything from point-of-sale to advertising to packaging.

As the store design and global brand strategy became integrated, the client agreed to move to the next stage. "Keep going," enthused their global image director. "Let's see a model." Working up the details, the designers found that the left-hand side of the store evolved swiftly. They started with a red wall that acted as the Ray-Ban landmark on the high street— six decades of product in six bands of display —this was followed by bays of current product, divided into classic, sport, and contemporary ranges, and featuring magazine covers of movie stars and Olympic athletes wearing the goods.

The next presentation, a few days later, took place as a video conference. The sketches were projected directly onto the client's screen in Rochester, New York. "We invested in video conferencing equipment to ensure the client had regular creative input while still enabling us to achieve the demanding schedule." In the center of the space, the designers had created an enormous aluminum fin, "a statement that echoed the elliptical forms of aviation," which, hinting on the company's aviation history became instantly recognized as a modern design piece that could be the brand signature across many media.

Although the designers had shown some ideas for the right-hand side of the space, they felt it needed to be much more fun and exciting, with, as Richard Whitmore explains, "a lot more interaction to portray the urban attitudes of the

THE VISUAL STRATA, PIVOTAL IN GETTING THE COMMISSION, SHOWED MULTI-LAYERED IMAGES FROM THE COMPANY'S HISTORY RELATED TO BUILDING MATERIALS THAT EVOKE EACH PERIOD.

DEMONSTRATING HOW THE ELEMENTS AND STRATEGY OF THE FLAGSHIP STORE WAS APPLIED TO THE COMPANY'S WORLDWIDE IMAGE. THESE EXAMPLES OF POINT-OF-SALE DISPLAY UNITS WERE ALL DESIGNED BY CK IN AN ON-GOING PROGRAM OF PROMOTIONS AND SHOP-IN-SHOP OPENINGS.

brand." In another late-night session, they watched Oscar Award ceremony clips and music videos, showing movie stars and musicians wearing Ray-Ban sunglasses and considered the effect that putting on a pair of sunglasses can have. "People act differently. It changes the way they behave. The mask theory," says Devey Smith. "Its part of what consumers like—it becomes a facade. You like being looked at, but you like being able to hide, too. Could there be an area in the store with four video screens behind a mirror, and when a customer tries on the product, there's film of paparazzi snapping them? Perhaps it would be too invasive," he explains. "Perhaps the film could be of famous people in Ray-Ban sunglasses, then one screen is replaced by the customer's own image. They could see how they look in

THE RIGHT-HAND WALL, AS IT WAS FINALLY REALIZED. THE GLASSES ALL HAD TO BE SHOWN AGAINST A BACKGROUND OF PETRACH, A WHITE, TEXTURED STONE MATERIAL THAT "LEAST INTERFERED WITH THE PRODUCT," EXPLAINS THE DESIGNERS.

(RIGHT) SEEN FROM OUTSIDE THE FRONT DOOR (NOTE THE DOOR HANDLES), THE 1350 SQUARE FOOT SPACE HAD A BRIGHTLY LIT, CONTEMPORARY FEEL, WITH A POLISHED CONCRETE FLOOR, PRECISION CONCRETE COLUMNS AND BACK-LIT PANELS OF MAPLE WOOD, A BALANCE BETWEEN NATURAL MATERIALS AND THE MANMADE QUALITY OF THE PRODUCT.

SNAPPED ONSITE, THIS VIEW SHOWS THE CONCRETE FINS IN PLACE, THE CURVED FIBERGLASS CEILING AND THE NUMBER OF FLUORESCENT TUBES REQUIRED TO CREATE THE DAYLIGHT EFFECT.

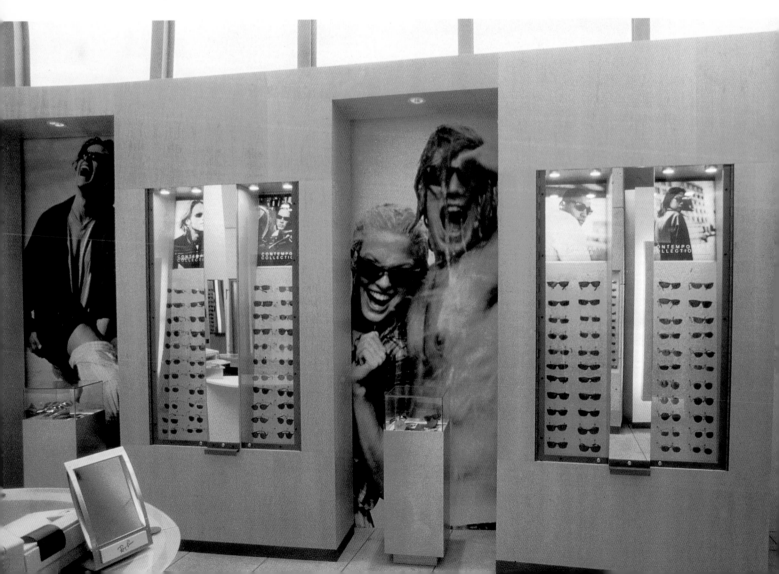

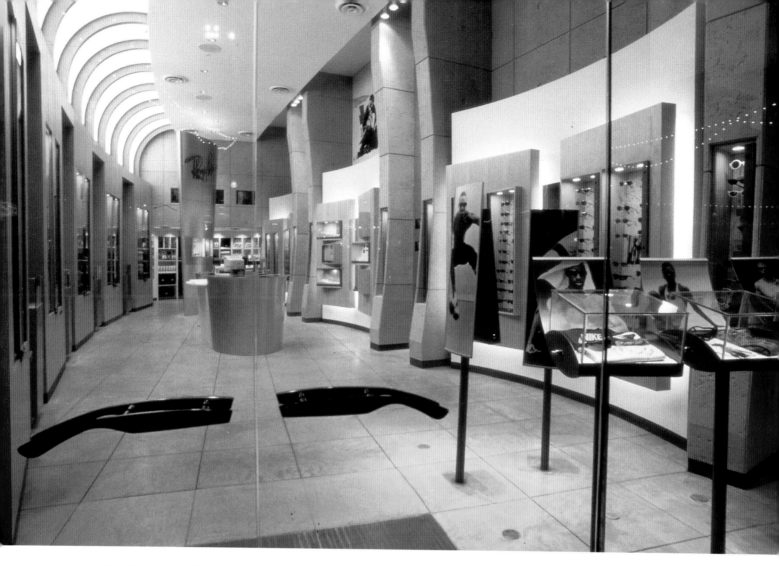

Ray-Ban sunglasses." Eventually, the concept evolved to four images of the customer, perhaps wearing four different models, perhaps with a whole group of friends? The pictures, they thought could be printed out on a card for customers to take away. The idea became known as "try-on booths," and the global marketing image team at Bausch & Lomb loved it. In the end, there were two booths divided by displays of contemporary ranges and large photographic blow-ups.

By this time, Steve Rivera had been appointed as Ray-Ban's flagship Store Manager, so when it came to all the details—levels of service, selling techniques, volume of product—CK worked with him to produce all the detailed drawings. "It was a period of intensive dialogue between designers, client and our architects in Atlanta," recalls Devey Smith.

Atlanta architects Randall Paulson were chosen to handle all the local planning aspects, and, CK chose Exhibit Group in Atlanta, who had just built an exhibition stand for Nike in four days and were used to working to short deadlines.

"We were still designing details only a month before opening," confides Devey Smith. The store opened only three days behind the initial schedule, but well before the deadline and the start of the PR events surrounding the Olympics, with a big party, full of celebrities and sports stars. "It was a typical Hollywood-style party, with everyone wearing Ray-Ban sunglasses, of course."

A CUSTOMER'S IMAGE IS FROZEN ON FOUR TV SCREENS BY A CAMERA HIDDEN BEHIND THE MIRROR AND ACTIVATED BY SENSORS AND A CONTROL PANEL

Calvin Klein

Following the opening of the highly influential, much photographed flagship store on Madison Avenue and an equally stylish one in Tokyo, Calvin Klein turned his attention to a building in Seoul, South Korea. "Eventually," says John Pawson, the architect Klein commissioned, "he wants me to design his stores in every fashion capital where there is **no other store designed by me**"

But at that time, the capital of South Korea was the center of Klein's interest, and his chief ex-officer C.E.O, Gabriella Forte, sent Pawson the details. "Every site and every city has different requirements and limitations", explains Pawson, but in this case the building presented few problems. Pawson flew over to look at it, came back, spent the weekend working on ideas and flew to New York, where he showed them to Forte. "They tend to work like that," says Pawson. "They take quite a while—and sometimes leave no time for the architect." Nevertheless, with two long flights and two stores already under his belt, Pawson was well equipped to have a go.

Based on the plans and a briefing letter he had been given, Pawson sketched out "a layout showing where things would go. Some fashion companies can be badly run," says Pawson, "but Calvin Klein has a good working formula, and Gabriella Forte is an expert retailer—ex-Armani. There are certain things she knows that we need to learn, and, of course, Calvin wants 'his look' incorporated too."

Pawson remembers that there were two problems to solve: where to put the staircase and how to deal with the façade. The building had offices on the top floor that needed separate stairs and an elevator, and ultimately their own entrance. At first, he thought he should keep the 15 windows on the upper levels to let in natural light, but the client said

TAKING AS AN EXAMPLE, THE FIRST FLOOR MEN'S ACCESSORIES AREA THE PLAN WENT THROUGH EIGHT GENERATIONS, AS MORE COMMENTS CAME IN FROM THE CLIENT. SOMETIMES THERE WERE MAJOR CHANGES—MOVE THE ELEVATOR, MAKE THE CORRIDOR TIGHTER, ADD EXTRA STEPS—AND SOMETIMES THEY WERE MINOR—A NEW SHOES AREA, A TIE TABLE, A TURN IN THE STAIRS AT THE REAR.

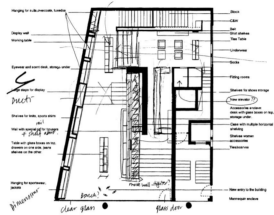

FOCUSING ON THE SAME SPACE, THE NOTE ON THIS COMPUTER VISUAL SPEAKS FOR ITSELF. THE DESIGNER'S RESPONSE IS NOT RECORDED, BUT THE COUNTER REMAINED WHERE IT WAS.

THE WOMEN'S WEAR AREA ON THE SECOND FLOOR, SEEN IN A SERIES OF COMPUTER AXONOMETRIC VISUALS THAT INCLUDED MANY OF THE DESIGN ELEMENTS INTRODUCED IN THE NEW YORK STORE, WHICH WAS COMPLETED YEARS EARLIER. SEVERAL ELEMENTS, SUCH AS THE CHROME AND LEATHER CHAIRS DESIGNED BY LE CORBUSIER, WERE INCLUDED, MORE BECAUSE THE DIMENSIONS WERE ALREADY ON THE COMPUTER THAN BECAUSE THEY WERE PART OF THE SPECIFICATION.

(RIGHT) THE FAÇADE OF THE NEW SHOP WAS RECLAD IN LIMESTONE, A SCHEME THAT PAWSON HAD FIRST PROPOSED FOR AN UNBUILT INSURANCE COMPANY HEAD OFFICE IN OSTEND, BELGIUM.

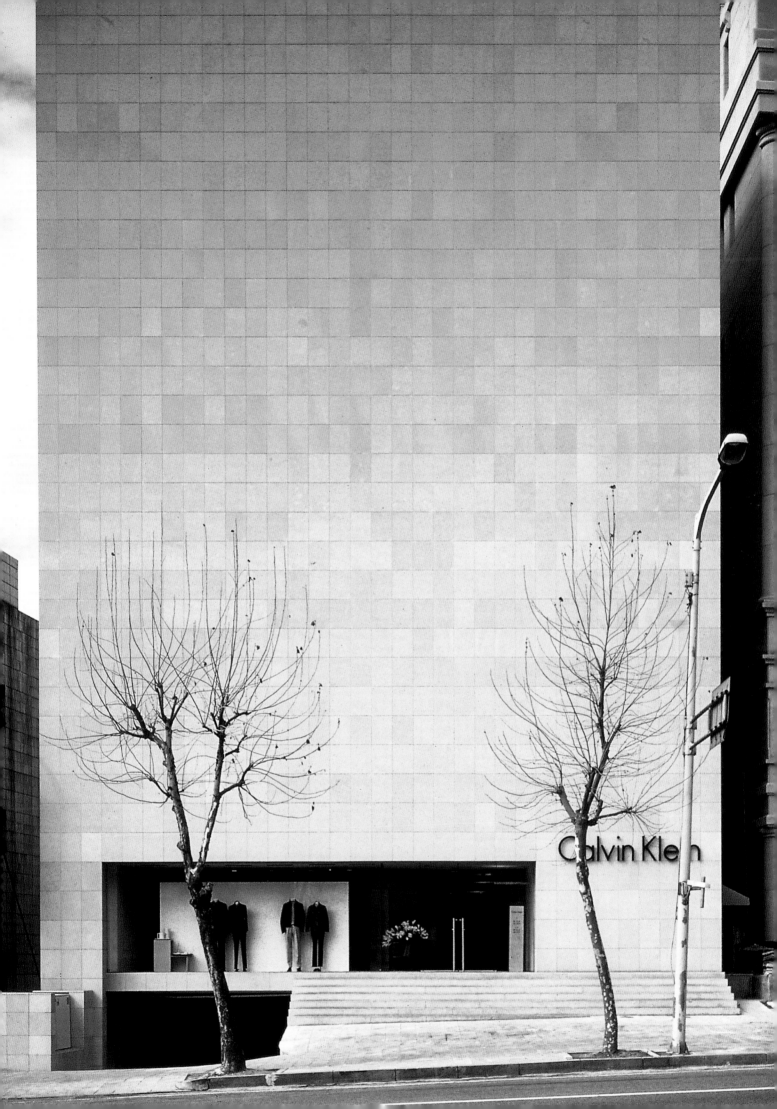

(fortunately): "We don't need it." This left the architect with two external elements: steps up to the front door and a shop window, but, like in Los Angeles, most people in Seoul travel by car, so the shop would be a "destination" and did not need to attract customers with its windows alone. "What is the minimal intervention required in this building?" Pawson asked himself. The plan came back from his client in New York with notes and comments all over it. Pawson was trying to formulate a strategy for the layout based on the client's guidelines. "I normally try to avoid a change of levels on a shop floor but in this case I had no choice," he says. "Usually there are too many different things in one space. My ideal is a bath in a bathroom, not a bidet, basin and all. Here, they had all sorts of different requirements, and they wanted customers to pass through the space. Once they arrive, they're not going to not go upstairs," he reasoned, so women were made to pass through the men's area and to cross the second floor from back to front to get to additional stairs to the third floor, home department.

The client wasn't so sure. Forte seemed to analyze every detail. "It was a lot different from the New York store, where Klein dealt with everything as if it were his home." When it came to the interiors, Pawson and his architect Enzostefano Manola incorporated most of the Calvin Klein flagship components, including floating glass shelves, sand-blasted stainless steel and the simple wooden benches by the American Donald Judd. They used a Spanish limestone floor found at a Korean supplier, but otherwise there was no local

inspiration. "They wanted the Calvin Klein look," remembers Pawson. "I don't subscribe to magazines or copy things I see elsewhere, and I never thought my work would be copied," he continues. "If you don't understand what was behind it in the first place, it doesn't work. You can't put something seamless together with bits of other people's designs."

Eventually, the client sent them the product breakdown, but as details kept changing, so, too, did the plan, which ran to eight variations, each one quite complicated to do, particularly some of the axonometric computer views. One example comes from notes relating to the left-hand wall of the men's accessories area on the first floor:

· The rear of the left wall should accommodate men's suits, overcoats, and tuxedos
· The front of the left wall should accommodate men's sportswear and jackets
· The stairs could be reworked to provide a tiered display space, while still providing adequate passage

During the nine-month programme, Enzostefano Manola went to Seoul every month to work with the Korean architects who were handling the job, and deal with any on-site problems. It opened on time and on budget. "I didn't go to the party," says Pawson, but Calvin Klein and Christy Turlington opened it, and there was a lot of publicity."

THE FILLED-IN DISPLAY TABLE IN EBONIZED WOOD WAS ONE OF A SERIES OF FURNITURE PIECES MADE LOCALLY TO PAWSON'S DESIGN.

ALTHOUGH THE ARCHITECT HAD TO ADD A HANDRAIL, THE STAIR DESIGN HAD ALL THE SIMPLICITY AND IMPACT OF JOHN PAWSON'S OTHER RETAIL WORK.

THE FIRST-FLOOR
WOMEN'S WEAR AREA
WAS DEFINED BY THE
CENTRAL WALL UNIT,
WHICH CONCEALED
LIGHTING THAT WASHED
THE CEILING. "BASED ON
THE CLIENT'S NOTES, WE
DID A CAREFUL ANALYSIS
OF WHERE EVERYTHING
WENT," SAYS PAWSON.

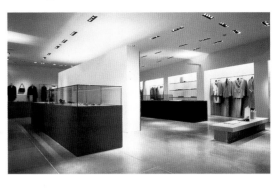

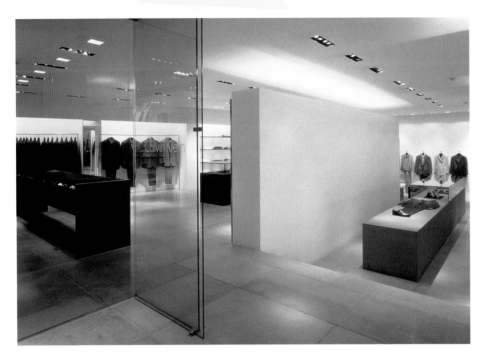

VIEWED FROM THE
FRONT DOOR, THE
GLASS-WALLED
ENTRANCE LOBBY DOES
NOT BLOCK THE VIEW OR
THE DAYLIGHT, AND THE
CHANGE OF LEVELS
FALLS TOWARD THE
FRONT ON THE RIGHT
AND TOWARD THE REAR
ON THE LEFT. "ONE OF
THE MAIN THINGS I CAN
DO IS CREATE A FEELING
OF SPACE AND MAKE
PLACES SEEM BIGGER,"
SAYS PAWSON.

ANOTHER VIEW OF THE
WOMEN'S FLOOR SEEN
HERE AT NIGHT. THE BACK
WALL OF FROSTED GLASS
ALLOWED IN DAYLIGHT,
WHICH THE OMISSION OF
FRONT WINDOWS
PREVENTED. THE BLACK
OBLONG IS A DONALD
JUDD BENCH, EXTENDED
TO BECOME A
MERCHANDISE DISPLAY
PLINTH.

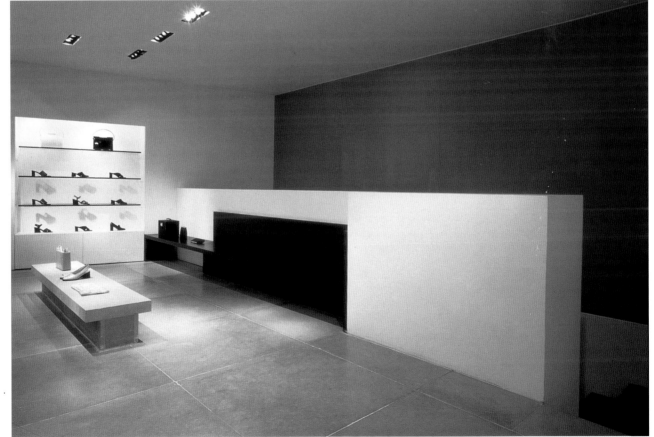

Bobo
When the owner of these stores, a widely traveled Belgian fashion retailer named Jan van Leemputten, briefed his "design" partners at Creneau, he came with pictures of things he had seen: but

what he showed them were things to avoid, rather than ideas to copy

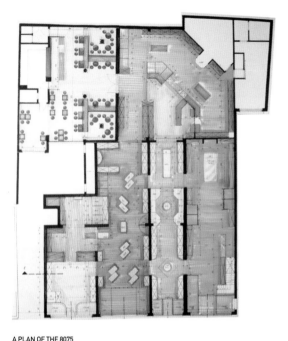

A PLAN OF THE 8075 SQUARE FOOT SPACE HELPS TO EXPLAIN THE INTERLINKED COMPLEX THAT IS BOBO. AT THE FAR LEFT IS THE MEN'S STORE, SHOWING THE ANTIQUE FLOORBOARDS IN THE REAR. NEXT IS THE CASUAL FASHION STORE. NOTICE HOW THE MEN'S CHANGING ROOMS STEAL SPACE FROM THE ADJACENT STORE AND USE THE SPUR WALL FROM THE PREVIOUS BUILDING. LIKE THE FILLING IN A SANDWICH, THE THINNEST STORE IS "NEW ENGLAND" WHICH HAS A MORE EXTENSIVE USE OF THE WALL SPACE AND ONLY THREE SMALL ISLAND UNITS. ON THE FAR RIGHT IS THE VOGUE STORE, WITH FOUR DEDICATED CHANGING CUBICLES ALONG THE TOP ARE THE BRASSERIE AND THE CASUAL STORE.

Jan van Leemputten already had a men's wear shop called Bobo, stocking jeans and casual clothes, in the Belgian town of Tremelo, and he also owned the six adjacent buildings. When he first talked to interior designer Michelle Janssen, who, with her husband Will Erens, runs a design company called Creneau in nearby Hasselt, his idea was to knock all the buildings down and start again with a new building. The snag was that he hoped to continue trading on the existing site, which would eventually be incorporated into the new structure. But it was an architect's nightmare, and, in the end it proved too expensive and technically almost impossible. Jan van Leemputten's dream was completely shattered.

The alternative was to keep the four façades and convert the other premises, which were cafés, into new stores, with apartments above, that could be rented out. Jan van Leemputten, whose nickname is Bobo, thought about it for a few weeks and, after a few sleepless nights, decided to go ahead. It was the summer of 1994. Janssen recalls that the demolition work started almost immediately, and so did the planning. "The existing buildings had a lot of character, and because they were in a little village, I wanted to do something personal." She had "no rigid budget," but van Leemputten, whom she and Erens had known since the days

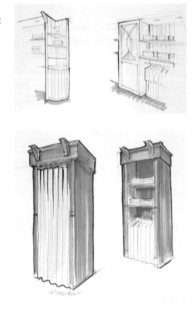

THE UNITS IN EACH STORE WERE DESIGNED TO PROJECT INDIVIDUAL MOODS. IN THE VOGUE STORE *(ABOVE)*, CABINETS HAD HEAVY DETAILS, WHILE IN THE BASIC SHOP *(TOP)*, A LIGHTER FEEL PERVADED.

(ABOVE AND LEFT) THE CLIENT, NICOLE AND JAN VAN LEEMPUTTEN, SAID THEY DID NOT WANT ANY COPIES OF OTHER STORES EXCEPT IN THEIR CASUAL STORE AND THE BRASSERIE. THOUGH THE ELEMENTS SEEM FAMILIAR, THE FINAL INTERIORS WERE A PATCHWORK OF OLD AND NEW ELEMENTS, ARTFULLY TREATED TO BLEND TOGETHER.

TWO SKETCHES OF THE INTERIOR FITTINGS EMPHASIZE THE DIFFERENCE IN MATERIALS. IN THE FIRST (RIGHT) A SECTION OF THE VOGUE STORE SHOWS A RICH MERBAU WOOD FLOORING COMBINED WITH A CASH DESK THAT FEATURES AN ORIGINAL MOROCCAN DOOR SET INTO ZINC PANELING. A MORE CONTEMPORARY MOOD IN THE CASUAL STORE (RIGHT) WAS CREATED BY A RIBBED METAL CEILING, STONE "SPUR" WALLS AND "LOFT-STYLE" BEAMS AND COLUMNS.

(LEFT AND BELOW) AT THE REAR OF THE SHOPS, THE JEANS DEPARTMENT ALSO FEATURED A UNIQUE FLEA MARKET FIND—A WOODEN CASH DESK CUBICLE, WHICH INSPIRED THE DESIGNERS TO ADD AN ALTERATIONS FACILITY.

CRENEAU'S WAREHOUSE OF ANTIQUES, JUNK, AND ARCHITECTURAL ELEMENTS HAS BECOME PART OF THEIR REPUTATION, AND IT MADE A SIGNIFICANT CONTRIBUTION TO THE ATMOSPHERE OF THIS COMPLEX.

when he had had a model agency in the late 1980s and for whose shops they had organized fashion shows, knew that they had the best prices and wanted to work with them and a series of contractors rather than employ an architect.

Meanwhile, Janssen says that she had been "fantasizing" about the project, and it had become "very clear what we were going to do." The client wanted a series of small stores—one for men, one for women's casual clothes, one "New England" basic women's fashions, one (called Vogue) selling more expensive designer outfits for women aged about forty, and one selling jeans (all to be called Bobo). Janssen spent a lot of time considering what kind of atmosphere would be right for each space and each brand. Although he wanted the stores to look fashionable, van Leemputten stipulated that they should not be permanent concepts, but at the same time they should last for between five and ten years and not be out of date almost immediately.

"He didn't want things that would go out of style," says Janssen. "Bobo wanted to be able to move stock around very quickly when new deliveries came in." However, he gave the designers a clear indication of how many yards each brand needed and what type of systems—hanging rails, mid-floor fixtures (island units), spare systems parts (accessories), display tables, and so on—should be used in each case. The sort of information that "now we often have to work out for our clients," admits Janssen. "I started sketching immediately." She had only 10 days in which to prepare the first stage ideas. "He was very pleased," she says, "and clearly identified any changes he wanted immediately. I worked almost exclusively on this job," says Janssen, who, two days later, had developed further sketched concepts and initial plans.

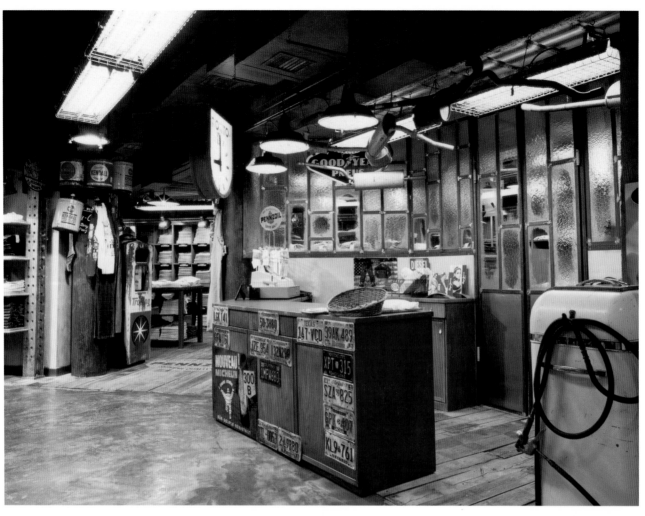

(RIGHT AND BELOW RIGHT) TWO VIEWS OF THE CASUAL STORE, ONE SHOWING THE FRONT DOOR AND A VIEW INTO THE STORE, AND THE OTHER WITH A RECYCLED FLOOR AND CURVED METALLIC CEILING, SHOWING THE LOFT STYLE DETAILS APPLIED TO PERIMETER WALLS AND SALES TABLES.

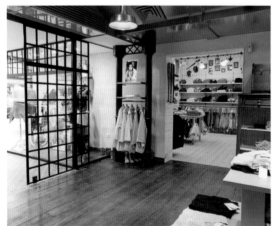

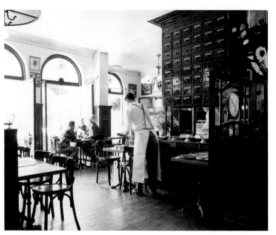

LIKE OTHER PARTS OF THE COMPLEX THE BRASSERIE WAS A COLLAGE OF OLD AND NEW ELEMENTS AND QUICKLY BECAME A DESTINATION IN ITS OWN RIGHT, PARTICULARLY FOR SUNDAY LUNCH.

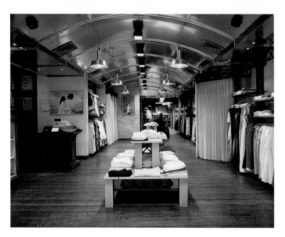

Because Tremelo alone was not large enough to sustain such sophisticated shops, their success depended on attracting customers from nearby areas and encouraging women to bring their husbands so that they might stay longer. Creneau had the idea of including a small brasserie in the complex, even though van Leemputten had never run a restaurant before. The designers' trump card was provided by Erens, who, since the days when he ran a brocanterie store in Hasselt, had kept a warehouse stuffed full of bits from old buildings and flea market finds. "We took Bobo to see it," remembers Janssen, "as we do with all our clients—it's what we've become known for." Jan van Leemputten was

delighted by the Aladdin's Cave, much of which became integrated into the moodboards that the designer produced and made a unique contribution to the look of the stores.

"We designed the 'New England' first," says Janssen, "and when we got to the casual store, the ideas looked too similar. After a lot of discussion, we threw the casual shop ideas away and started again in order to keep them all different."

The secret of the look of each store is the feeling of *déjà vu* they create, and although part of this comes from the integration of original elements, much of it is new, made to look old by the use of special paint techniques. Creneau employed a local carpenter, electrician, and building contractor, who have continued to work for them and who, over the years, have become "like family," says Janssen. For the shop fittings, Janssen did not design a new hanging system, so she approached a large Dutch shop-fitting specialist and, with their technical support, managed to integrate standard elements into Creneau's own detailing, adding new shelves to standard modum uprights.

"If it looked 'new' we made it look old," confesses Janssen, who managed to integrate 19th century timber floorboards—"from an antique dealer, very expensive"—into the men's shop. Although each façade was treated differently, the fascias link together, as do the spaces inside.

When it came to the brasserie, which was called Miel van Kest (a combination of van Leemputten's father's and grandfather's first names), the designer wanted to create something that was uniquely of the town. To involve the townsfolk, van Leemputten placed an advertisement in the local paper asking for old photographs of readers' ancestors. These, in return for an enlarged print, were framed and used to decorate the walls. As a frieze, the names of all the families were spelled out in large letters and painted in "Van Dyck Brown" above the dado rail. On the first Sunday of every month, the brasserie is open for brunch, with seats and tables spilling out into the small terrace at the rear, while a local orchestra provides the entertainment.

Looking back, Janssen admits that they had quite a big budget. "Bobo never made a point about the costs, and he often contributed things he had found himself, like the dog painting by Thierry Poncelet that hangs in the men's shop. He was prepared to spend money on all the details. " When it came to his own office, van Leemputten wanted a place where sales reps could sit and wait, and he also wanted a kitchenette and space for the staff to change their clothes.

To make sure that nothing went wrong, Janssen was on site every day. The project, from the first meeting to the opening, took 18 months, with the actual building taking seven months. "Belgium is a very small country," says Janssen. "Everyone knew about the shops, and people who saw them were immediately convinced that they should become our clients. It's the high quality of the finishes and the details— that's what people notice and remember."

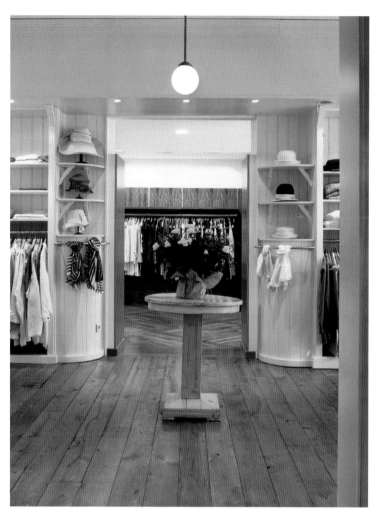

A VIEW OF THE WOMEN'S WEAR BASICS SHOP, LOOKING TOWARDS THE MORE LUXURIOUSLY FITTED VOGUE SHOP WHERE THE CASH DESK AND CHANGING ROOMS INCORPORATED AUTHENTIC MOROCCAN ANTIQUES. 'WE DID ALL THE LIGHTING PLANS OURSELVES' SAYS THE DESIGNER, 'BUT OUR SUPPLIERS WORKED OUT THE TECHNICAL SPECIFICATIONS FOR COLOR BALANCE OF LIGHT.

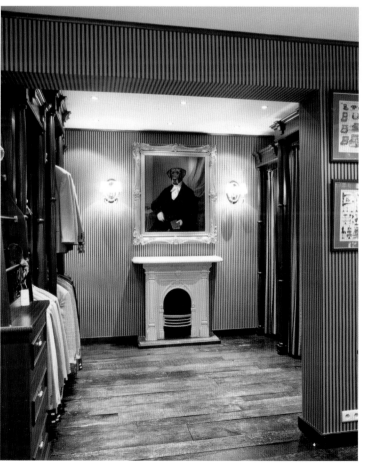

THE MEN'S SHOP WITH THE THIERRY PONCELET PAINTING, ANTIQUE FLOORBOARDS, AND RICHLY DETAILED MAHOGANY FIXTURES.

W. & L.T. Having designed restaurants, bars, tableware and furniture, this was Marc Newson's fourth retail venture, and the inspiration for this project came from his need for control. He says his greatest satisfaction comes when he can create spaces where there is a total fusion of architecture and interior design, **and his ultimate goal** would be to **design a space station**

Coincidentally, W. & L.T. was intended to be a new universe in itself. "Consumers who wear W. & L.T. do so," says the briefing document, "to be different. However, they also wear it for the sense of community it engenders; they wear it to demonstrate that they are an important part of the W. & L.T. universe."

This new fashion line was the brainchild of Walter van Beirendonck, "one of the world's leading designers and avant-garde personalities." He is also one of the "Antwerp Six" (fashion designers) and "a man," continues the document, "of great vision and daring, of great contradictions, equally moved by life's softer moments and its harshest realities."

Backed by the Mustang Jeans Group, which is based in Germany, the Beirendonck Collection was launched in 1994 and sold initially in department stores, but the "bright, strong identity" clothes—W. & L.T. stands for wild and lethal trash—needed an equally bold, aggressive, and uncompromising retail environment. Beirendonck had seen and liked Newson's work and started sending faxes to his Paris office (he has now moved his operation to London). Newson, who was busy on other work, didn't know who it was and ignored the faxes. When they eventually met, the designer, inspired

(BELOW) THE TABLE OR DESK, MADE OF POLYETHYLENE, WAS INTENDED TO SIT ON THE FLOOR OR BE RAISED ON SMALL METAL LEGS, AND IT WAS OFFERED IN SIX COLORS—WHITE, BLACK, BLUE, GREEN, RED, AND YELLOW—TO MATCH THE CHAIRS.

LOOKING A BIT LIKE RAILROAD CARRIAGES, THE FIVE-UNIT W. & L.T. BOX (SHOWN OPEN AND CLOSED), WAS VISUALIZED ON COMPUTER FOR THE FIRST PRESENTATION. THE LOGO WAS STAMPED ONTO THE SIDES, AND METAL HANDLES, INITIALLY SHOWN AS SQUARE, WERE INSET INTO EACH SIDE. EACH UNIT MEASURED 76 X 76 X 25 INCHES.

by the collection, saw "the opportunity for the perfect marriage of clothes and design," explains Newson's press officer, James Hulme.

Even before he started to sketch ideas, Newson proposed the use of an emergent, under-utilized plastic molding technique called roto-molding, about which he had been enthusiastic for its potential to rotation-mold large forms—it is used in the making of recycling bins from polypropylene. While Newson was sketching out his ideas, he started a collaboration with fellow designer and architect Benjamin de Haan, a New Yorker working in Paris. De Haan brought to the partnership a knowledge of CAD systems and computer technology that Newson immediately saw as a quicker way to render his often "supersonic organic" forms, and he realized how easily he could visualize his W. & L.T. ideas, although he stresses that it augmented his creativity rather than affected the solution.

Newson's concept was like a kit system, a series of large, almost identical components that, as well as serving to hold the clothes, created their own environment—both self-contained and accessible. The large "boxes" sat side by side, kept in place by a tracking system of two rails that held them in a row, while allowing them to be opened, closed, or re-

ALSO ROTATION-MOLDED IN POLYETHYLENE. THE CHAIR WAS DESIGNED TO CO-ORDINATE WITH THE REST OF THE SCHEME AND WAS MARC NEWSON'S FIRST CHAIR TO BE DESIGNED EXPRESSLY FOR MASS INDUSTRIAL MANUFACTURE.

14/01/97

SAME DESIGN, EXCEPT THAT
THE 6 "BLOCK" WILL BE IN DEEP

REVERSE

THE NOSE-CONE
COMPONENT, SHOWN IN
ONE OF THE
SPECIFICATION
DRAWINGS SENT BY THE
MANUFACTURER FOR THE
DESIGNER'S COMMENTS.

spaced. There were three types of box: a six-portal unit, a hanging version with two rails, and a stacking unit with a logo panel, later abandoned. The units at each end of the run could be closed on one side by a "nose cone" and the retailer could order as many modules as he wished—"no more than six in a row or no fewer than three," explains Hulme. Added to this, Newson also designed a table, a chair and a tiled floor system on which the track could run—each unit had wheels.

To demonstrate the possibilities, Newson sketched a series of floor plans and proposed a range of bold colors—red, green, black, and white. Beirendonck liked it immediately. "He saw it through the eyes of an esthete," says Hulme, and although the board made minor changes later, such as the use of an existing tracking system rather than a new one, the basic idea went ahead.

Beirendonck wanted to launch the W. & L.T. scheme with seven pilot sites in seven months' time, but first a prototype had to be made. Working with a French manufacturer Metroplast, molds were produced directly from the three-dimensional AutoCAD data. Although the first run was done in a variety of colors, two complete units were made in green and red and set up in the W. & L.T. press office in Paris. It won universal approval; all the brand managers came to see it, and Beirendonck was "ecstatic." "The manufacturers were seminal in developing the system," says Hulme, who also recalls that "very little fault-finding occurred."

Three months later, the first shops were installed in France, Germany, and Japan, and there have been more since. Newson's office now handles all the planning. Receiving the delineation of each franchisee's space—the number of units will already have been decided—they plan the layout and coordinates the ordering. Meanwhile, Newson continued to develop the components, adding a cash desk facility to the table. "They can be spat out and recycled," says the designer. "They're disposable, like the clothes—ideas born in an instant and ejected."

IN PLAN, THE
COMPONENTS FOR A
SHOP-IN-SHOP AREA,
HERE SHOWN AS A
(430 SQUARE FEET)
COULD BE POSITIONED
IN A VARIETY OF LAYOUTS
IN THE UNIQUE INTER-
LOCKING FLOOR TILES.

Can rotate 360°

CAN GO UP
OR DOWN
LIKE SIMPLE
SINGLE RUNG.

AN EARLY COMPUTER
VISUAL, BEFORE ALL THE
DETAILS WERE RESOLVED,
SHOWS A ROTATING SHELF
THAT COULD ALSO BE
RAISED OR LOWERED.
ALTHOUGH DETAILS STILL
HAD TO BE FINALIZED, THE
SCHEME LOOKED
REMARKABLY LIKE THE
FINAL ITEM. *(RIGHT)*

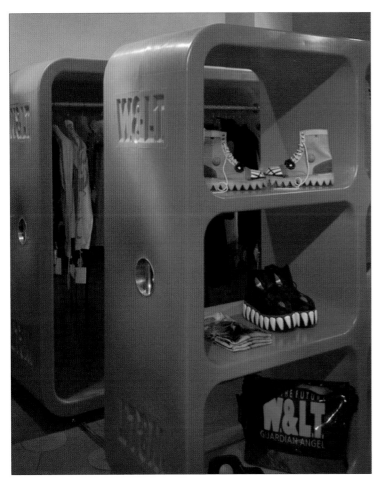

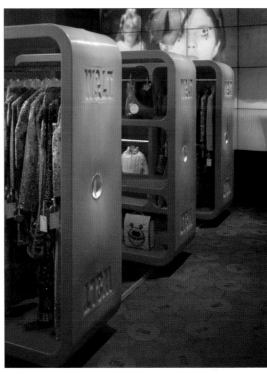

THE FIRST INSTALLATION OF THE PROTOTYPES IN PARIS SHOW THE IMPACT MADE BY THE BOLD SIMPLICITY OF THE LARGE MOLDED COMPONENTS. BY USING THE ROTO-MOLDING TECHNIQUE, NEWSON WAS ABLE TO CREATE ELEMENTS NOT PREVIOUSLY POSSIBLE IN PLASTIC AND AT A GREATLY REDUCED PRICE. ON LATER MODELS, THE ROLLERS WERE CHANGED IN SIZE, AND THE TRACK SET INTO THE TILED FLOORING AS ORIGINALLY INTENDED.

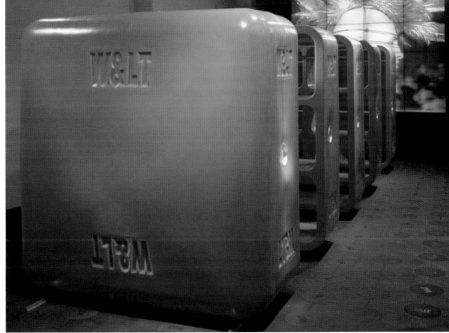

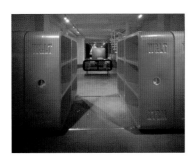

Gaff

There are many ingredients in a new retail concept. The product is obviously important, but so is the environment, and, in this case, the environment included elements intended to make the young fashion-conscious customers feel, literally, at home. That's why the designers **didn't want it to look too new**

For the design team at Fitch, understanding street fashion and knowing the club scene were not essential although they were certainly an advantage. The clients—Nick Starsmore, Paddy Campbell, and Wayne Binney—were all in their late 20s and had a combination of skills. Nick had been a market trader, selling on the streets, while Wayne had been a fashion buyer, and Paddy was an expert in business management. The three men gained control of the ailing Bankrupt Clothing Co. in 1997 after a management buy-out, turning it into a profit making venture with 10 outlets across Britain.

Introducing major brands to Bankrupt was essential, but the brands were not prepared to be associated with bankruptcy, and the partners needed a new retail branding proposition that would attract the brands and the customers who were buying them. They talked to a number of the major design companies in London and decided that Fitch could provide the solution.

Steve Haggarty, the project director at Fitch prepared a proposal and some initial image generation based on Bankrupt's proposed budgets, and explained their way of working. Their unique four-dimensional process divided the program into distinct stages:

- Discovery—getting to know the company, their current customers, their current market position, strengths and weaknesses, and understanding the issues that will motivate a purchase.
- Definition—defining the project and the potential directions in which it could go, holding brainstorming sessions with the client in which they conceive indirect and direct competitor scenarios to identify changes and define tangible directions.
- Design—from the design orientation boards to sketch ideas, circulation plans, interior visuals, and graphic iconography.
- Delivery—all aspects of implementation.

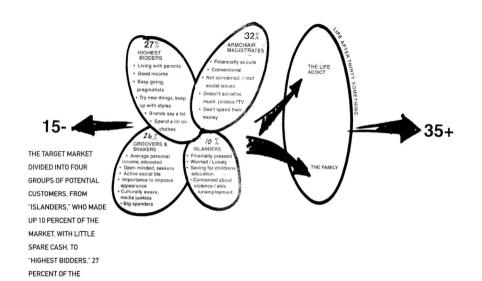

THE TARGET MARKET DIVIDED INTO FOUR GROUPS OF POTENTIAL CUSTOMERS, FROM "ISLANDERS," WHO MADE UP 10 PERCENT OF THE MARKET, WITH LITTLE SPARE CASH, TO "HIGHEST BIDDERS," 27 PERCENT OF THE MARKET, TO WHOM "BRANDS SAY A LOT." "WHAT'S MISSING FROM THIS?" FITCH ASKED THE CLIENT.

PART OF STAGE ONE, "DISCOVERY," WAS THIS SERIES OF MOODBOARDS OF POTENTIAL CUSTOMERS, TAKING AN IMAGINARY EXAMPLE OF EACH CUSTOMER ILLUSTRATING WHAT IT MEANT IN SHOPPING TERMS.

CONCEPT INSPIRATION AND DESIGN DIRECTION TOOK THE FORM OF A SERIES OF COLLAGE MOODBOARDS THAT FOCUSED ON ELEMENTS OF SPACE, TEXTURE, LIGHT, DISPLAY, AND GRAPHIC LIFESTYLE IN AN EARLY EFFORT TO VISUALIZE THE NEW CONCEPT. IN ONE, (RIGHT) ALL THE ELEMENTS OF THE LOFT LIFESTYLE, CAPTURED AN IMPORTANT MOOD.

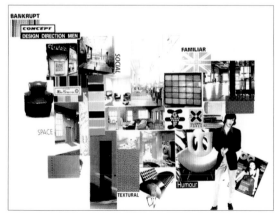
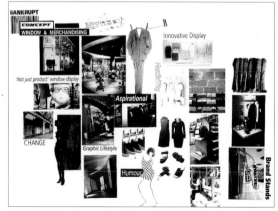

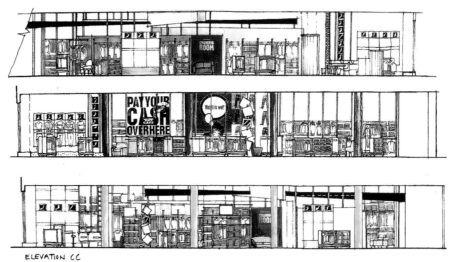

ELEVATION CC

THREE SECTIONS
THROUGH THE PLAN
SHOWED THE CLIENT THE
FIRST ASPECT OF SHOP
FITTING, HIGH-LEVEL
DISPLAY AND OVERSIZE
GRAPHICS.

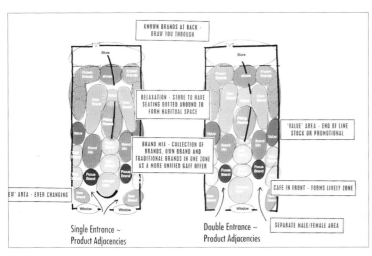

Single Entrance ~
Product Adjacencies

Double Entrance ~
Product Adjacencies

THESE TWO DRAWINGS
ILLUSTRATE THE
PLANNING STAGES. IN THE
FIRST (LEFT), WHICH WAS
BASED ON A 300- TO 500-
SQUARE FOOT SPACE,
BRAND POSITIONING AND
ADJACENCIES WERE
APPLIED TO A SINGLE AND
DOUBLE ENTRANCE UNIT.
IN THE SECOND (BELOW
LEFT), ALTHOUGH STILL
NOT SITE SPECIFIC, SOME
FUNDAMENTAL IDEAS HAD
EMERGED. ON THE RIGHT,
THE FLOOR FROM THE
STREET OUTSIDE WAS
SHOWN TO FLOW INTO THE
SHOP, WHERE A COFFEE
BAR WAS PLACED WITHIN
TWO BRACKET-SHAPED
SCREENS. THE REST OF
THE SPACE WAS DIVIDED,
ALTHOUGH NOT
SEGREGATED, INTO MEN'S
AND WOMEN'S, WITH
CHANGING ROOMS IN THE
CENTER.

Haggarty and his team started by going to visit several existing Bankrupt Clothing stores, talking to staff, observing customers and looking for leads. He remembers that the "overall image was fairly poor and lacking innovation." They also looked, with Bankrupt's guidance, at the new stores' generic competition and possible new customers. Nick Starsmore and the group's store managers were also well informed about where their customers shopped.

At Fitch, the designers had access to Yankelevitch youth segmentation research material that told them about the basic target market segmentation. Next they held think-tank sessions, both internally, among their own design and marketing staff, and with their client, and they gradually put together a series of visual summaries of potential customer groups. During these sessions they also created "indirect competitor scenarios." Haggarty recalls, "We asked ourselves what would various well-known brands—Adidas, Levis, Virgin, Spice Girls, and a teen magazine—do if they opened such a store. The client was quite outspoken and very vocal. Each idea was recorded on a flip chart for inclusion in the Discovery and Definition findings document which would in turn provide the team with the new brand strategy, expression, values, and essence. "It was quite exhausting," says Sue Daun, senior designer on the project.

Two or three weeks later, Fitch's team presented initial ideas to the client in the form of concept moodboards. "There was no design yet," says Daun. It was all about styles and imagery, providing the right touchstones for the drawing stage. Out of this and the document emerged the idea to provide somewhere very relaxed, where existing features of the building—perhaps an old warehouse or a town hall— would provide an eccentric mix of old and new. It had to have the language of these young customers.

The designers also realized that their ideas would have to be tailored to each specific site, but at this stage they were working on a generic "300- to 500-square foot space, an ideal plan, and a visual list. "We were looking for a unique concept and putting the right skin around it," says Haggarty.

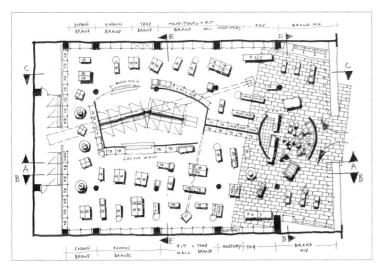

(LEFT) A SKETCH OF A
TYPICAL EXTERIOR
EMPLOYED SIMPLE
GRAPHICS, A PIVOTING
DOOR AND ROTATING
WINDOW FINS, WHICH
COMBINED PRODUCT AND
GRAPHICS. "SHOP
WINDOWS WITH
CLOTHING WOULD NOT BE
GAFF," SAYS HAGGARTY.

FIVE PRESENTATION
BOARDS, PRODUCED AS
PART OF THE CONCEPT
STAGE, START TO
ILLUSTRATE THE
SOCIABILITY OF THE SHOP.
THE COFFEE BAR (RIGHT)
USED A MIXTURE OF
FURNITURE STYLES, AND
INDUSTRIAL-LOOKING
LIGHT FITTINGS
CONTINUED INTO THE
"BRAND MIX" AREA.
(BELOW RIGHT) SET
BESIDE A COMFORTABLE
SOFA AND POOL TABLE.
THE "DENIM FIT" WALL
ANSWERED THE
QUESTION "WOT FIT IS
WOT?" WITH A VISUAL SIZE
CHART AND BOLD
GRAPHICS, WHICH MADE
IT ALMOST UNCHANGED
INTO THE FINAL
SCHEME—ALTHOUGH
NEW PICTURES WERE
TAKEN. THE FURNITURE
FOR THE PAYMENT AREA
AND LOW, MID-FLOOR
GONDOLAS WERE ON
WHEELS AND THE CASH
DESK, ALTHOUGH STILL AT
STAGE ONE, WAS QUITE
METICULOUSLY PLANNED.

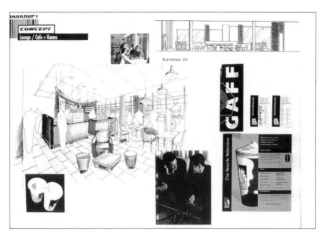

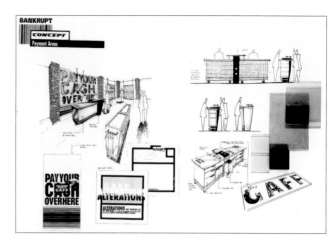

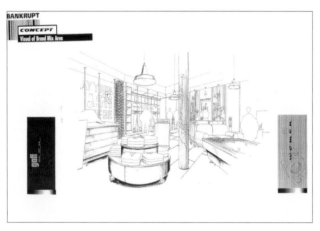

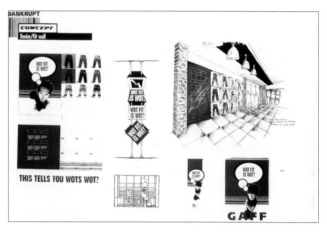

The designers' ideas were formulated into a report, which the client took away, to work on product allocation. Wayne Binney also took the report and went to talk to suppliers. His managers had already contributed, and some of them had participated in the initial think-tank consultations.

Thinking of a new name also led to further brainstorming sessions. The name had to be accessible to a wide customer base and fit with the new proposition. "It took a long time," says Haggarty, who admits to liking the name Union, one of over 50 they had generated. In the end, the client thought of Gaff ("your gaff, my gaff"), defined in the dictionary as a name for a public place of amusement.

Alastair Liddell, who was in charge of the graphics aspect of the project, knew from his experience of the youth market and the club scene, that one of the key components of the interiors of the shops was going to be the graphic language. He put together a combination of "club scene" typography and pictures of "ordinary-looking people," which "hit the right mark" with the client, recalls Liddell. At this stage, four designers were working on a full-time basis on the commission, using Gaff as the preferred name.

The second stage presentation pulled together all the elements they had developed, including several ideas that came out of the "competitor scenarios," such as a coffee bar, a pool table, (later changed to table football), and an in-house disc jockey. In particular, in order to create "a place to hang out, to feel at home, and meet your friends," they wanted to provide ingredients associated with the way their

(BELOW) NUTS AND
BOLTS SYMBOLIZED
MEN'S AND WOMEN'S
CLOTHES IN THE
GRAPHICS PROPOSALS.
"THERE ARE ONLY ONE OR
TWO OTHER PEOPLE IN
THE OFFICE WHO COULD
HAVE DONE THIS TYPE OF
JOB," LIDDELL SAYS.

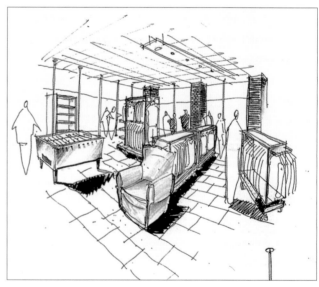

(RIGHT) ALTHOUGH THE FIRST
SHOP IN CARDIFF WAS NOT
CONSIDERED AN IDEAL SITE,
THIS PHOTOGRAPH SHOWS A
DRAMATICALLY HIGH CEILING
WITH METAL STAIRS TO AN
UPPER FLOOR. "AN
ENVIRONMENT THAT IS
INSPIRATIONAL BOTH IN THE
CLOTHES YOU WEAR AND THE
WAY YOU SPEND YOUR TIME," IS
HOW THE DESIGNERS DEFINE
THE CONCEPT, INSPIRED BY
URBAN LOFT LIVING, TO CREATE
"AN ATMOSPHERE OF COMFORT,
ACCESSIBILITY, SOCIABILITY,
AND ENTERTAINMENT."

"A UNIQUE STYLE OF TALKING," WAS HOW GRAPHIC DESIGNER ALISTAIR LIDDELL DESCRIBED HIS "BLOCKY," CLUB SCENE STYLE GRAPHICS FOR THE NEW SHOPS. ONE BOARD OF IDENTITY OPTIONS SHOWED THAT THE MAIN GAFF LOGO COULD BE SUPPORTED BY A VARIETY OF SECONDARY TYPE STYLES ON POINT-OF-SALE AND OWN-BRAND PACKAGING.

USING A CERTAIN AMOUNT OF HUMOR, THE GRAPHICS FOR THE FINAL SHOP WERE INTENDED TO BE BIG AND BOLD. TO MAINTAIN FLEXIBILITY, A STICKER WAS APPLIED BY HAND TO PLAIN CARRIER BAGS AND COULD BE CHANGED FOR SALES OR CHRISTMAS TIME. FOR THE PHOTOGRAPHY, LIDDELL CHOSE "EVERYDAY PEOPLE."

young male and female customers might like to live, rather than just creating a shop. It needed to be a place they would like as their home, a place to feel comfortable and hang out. The analogy of loft living came to be used as a focus. "Not too finished looking," explains Haggarty. "Rough plaster, plywood, aluminum, concrete bases to the columns, stone floors, reclaimed timber and used bricks—no frills."

By this time—the end of the main concept presentation— the designers were given the first site,—a less than ideal building with no usable shop window, in Cardiff. Developing the concept, the design team applied the scheme to the new shop and sent out drawings to tender. Although there was less floor space and a smaller clothes collection, "none of the ideas were cut," says Haggarty.

With the contract for the building signed up (Aztec Shopfitting Ltd), there was suddenly no time for mockups or prototype units. Daun produced detailed drawings of all the fittings and ideal bays for hanging and folded merchandise (II types in all), which she gave to Wayne Binney, who prepared planograms, positioning each unit within the space, based on Fitch's initial layout.

Since this first shop there has been talk of two more, in more ideal buildings. "The client is out looking for new sites all the time," says Haggarty. "Eventually they would like to have about ten."

Frontier

The best description of this store can be found in the marketing document, which outlined the idea behind the innovative new product range: "Sports shoes and clothing that reach for the skies, the water, the land, the edge." But if Cobra had wanted its merchandise to be presented in "an innovative, yet retail-friendly way, to a savvy customer," it can hardly have anticipated **talking shelves**

Cobra is a chain of 68 sports and footwear stores in the UK. In the early 1990s it expanded the product range to include sports fashion items: "Frontier clothing and accessories." But fashion, by its very nature, constantly changes, and, if it was going to stand on its own as a new store chain, Frontier had to shed the "North American log cabin" image that had become associated with sportswear chains and aim for a more distinctive appearance. As the brief put it: "Cobra Frontier should be a revolution in sports fashion stores, rather than simply an evolution. The expectation will be for more 'edgy' product, more niche brands, and more statement."

In spring 1997, when the team at Conran Design Group (which describes itself as "Europe's longest established design company") got the go-ahead to prepare design ideas based on a new site in London's Carnaby Street, the first task was to familiarize itself with the products and use the product strategy to extract a design brief. Rachel Hird, working with Conran managing director David Worthington and graphic designer Alan Watt, recalls there were few examples of stores that had departed from the generic language prevalent in the sports store sector.

Faced with a schedule of four weeks before the first presentation and a very tight budget, they had a

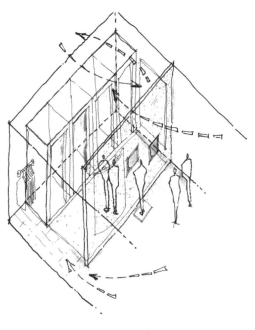

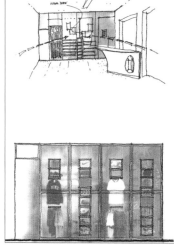

IDEAS FROM THE FIRST PRESENTATION WERE USED TO EXPLORE POSSIBILITIES AND "TRY TO LOOSEN THEM UP," EXPLAINS RACHEL HIRD. IN THIS INSTANCE, A LAYERED WALL OF SEMI-TRANSPARENT GLASS CONTAINED MERCHANDISE AS WELL AS PROMOTION DISPLAY, TO "PLAY DOWN" THE CHANGING ROOMS AND DRAW CUSTOMERS TO THE FAR END OF THE SHOP.

TWO EARLY SKETCHES FOR THE DOORS TO THE CHANGING ROOMS—ONE WITH A LITERAL INTERPRETATION OF AIR, ONE OF THE KEY WORDS IN THE BRIEF.

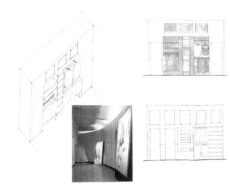

FURTHER DEVELOPED, THE REAR WALL CONCEPT IN THIS EXAMPLE INCLUDED FRONT AND SIDE HANGING, AS WELL AS "SOME FORM OF LIGHT WALL" AND A CUBE SYSTEM FOR SMALLER PRODUCTS.

IN THIS SCHEMATIC LAYOUT, THE CUSTOMER WAS SWEPT IN PAST THE MERCHANDISE TO A "WOW" AT THE BACK. IN BETWEEN THE CIRCLES ALONG EACH WALL WERE SMALLER DOTTED CIRCLES, INDICATING WHERE THE GRAPHIC "ELEMENTS OF WIT AND HUMOR" WOULD EXIST.

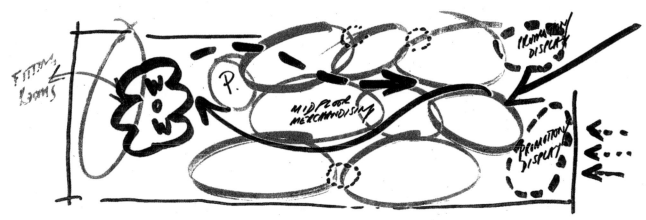

AN EARLY SKETCH OF A
WALL ELEVATION
SHOWED THE PRODUCT
SPLIT. EACH SECTION WAS
ALLOWED A GAP
BETWEEN, WITH LESS
CLUTTER ALSO ACHIEVED
BY SHOWING ONLY ONE
(NOT FOUR) OF EACH
PRODUCT, AND SHOES ON
INDIVIDUAL SHELVES. AN
ELEMENT OF FUN IS
CAPTURED IN THE BENDY
LIGHTS AT THE TOP AND
THE FLOOR TEXTURES.

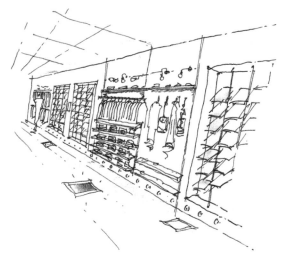

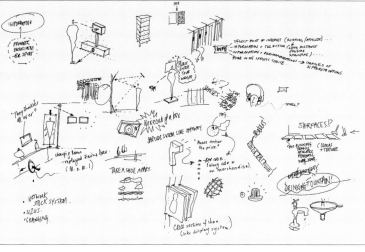

ONE CHALLENGING
ASPECT OF STORE DESIGN
WAS, SAY THE
DESIGNERS, MID-FLOOR
MERCHANDISING. THE
PLAN OF THE CARNABY
STREET STORE SHOWS
HOW SUCCESSFUL THEY
WERE IN CHANNELING
CUSTOMERS IN A ZIGZAG
FASHION SO THAT THEIR
ATTENTION IS DRAWN TO
THE WALLS. (BELOW AND
BELOW RIGHT) SOME OF
THE IDEAS FOR THE UNITS
INCLUDED AN ARCHED
RAIL WITH SHELVES ON
ONE SIDE AND HANGING
GARMENTS ON THE
OTHER, A BEAM THAT
PIVOTS FROM A CENTRAL
SHELF SYSTEM, AND AN
OVAL COMBINATION OF
ADJUSTABLE RAILS AND
GLASS SHELVES. THE
OVAL SHAPE REDUCES
VISUAL BULK, AND
ALLOWS CUSTOMERS TO
FLOW AROUND IT.

(ABOVE) THE DESIGNERS
WERE LOOKING FOR
INTERACTIVE IDEAS TO
MAKE THE CUSTOMER
ENGAGE WITH THE STORE.
THESE TWO PAGES OF
SKETCHES WERE THE
SOURCE OF THE OVAL
ISLAND UNITS. A
CUTAWAY SHOE DISPLAY,
A CAMERA WHICH SHOWS
WHAT EACH TRAINER
WILL LOOK LIKE AT
GROUND LEVEL AND A TV
MONITOR BY THE
CHANGING ROOMS THAT
REPLAYS THE CUSTOMER
AS THEY VIEW THEIR
GARMENTS.

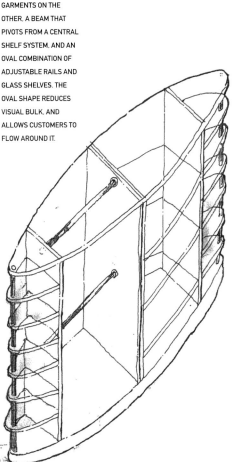

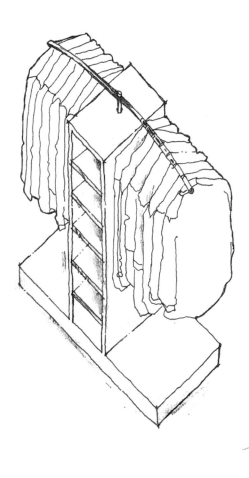

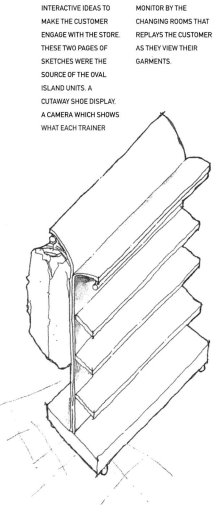

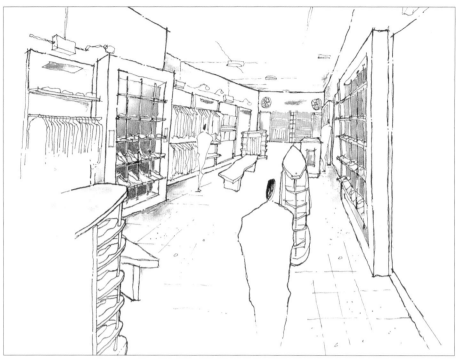

brainstorming session and felt that the elements included in the brief—sky, water, and land—held the answer, or at least the beginning of the solution, to the new concept. In order to ensure a flexible roll-out scheme and keep costs down, a standard merchandising system would have to be used. Developing "the elements" into an innovative shop-fit would occur in what was identified as two key areas. The first was the rear elevation. It was suggested that big industrial fans could create movement (and air) while water would be provided in the form of a drinking fountain. The wall itself could be illuminated with blue light creating a strong visual draw for the customer in what is typically a long, narrow store. The second key element was a section of wall allocated specifically to merchandising footwear. Each shoe would be provided with an individual floating glass shelf, giving the product the opportunity to "self promote." Behind the shelves backlit panels echoed the sky, water, land theme.

The walls and floor should, they thought, be kept neutral—"calm and cooling"—allowing the texture and color to come from the product, maneuvering away from the "clutter" of many sportswear retailers. Conran Design Group encouraged Cobra toward a policy of displaying only one version of each product. "Previously they were placing four versions of the same shoe, in different sizes, on the same shelf, which was using up the space. Achieving a more streamlined store didn't mean less product, it meant a process of rationalization," explains Hird. "Possibly the cleanest store for the muddiest of customers."

At this stage, the merchandise distribution—60 percent shoes to 40 percent clothes—was indicated on the plan in conceptual terms only—in some cases moving footwear onto the floor area and clothing onto the walls, grouping products by look rather than by brand.

Although the scheme was intended to look simple, the first presentation was extremely complex. Twenty-four A2-size boards were crammed with ideas in an attempt to consider every opportunity as well as to demonstrate the designers' grasp of the potential. Above all, Conran Design Group wanted a sense of fun to be evident in the scheme. The presentation included a host of graphic ideas that spoke directly to the target customer in a witty, amusing way.

Tucked in among a whole lot of wild notions was a simple sketch of an "interactive shelf," which used a light-sensitive microchip to play a brief product message about each shoe when the customer lifted it from the shelf. Some retailers would be happy to settle on this alone as their "big idea," but interestingly, to the client's credit, quite a lot of this style of wit made it through to the final scheme.

Cobra had initially had reservations as to the benefits of using a design company, but Sharon Tomkinson, marketing director at Cobra, was convinced it was what the company needed. "Cobra wanted to know exactly what the shop would look like before giving the go-head," recalls Hird. They were apprehensive that too much space might be devoted to the design and not enough to the merchandise. They wanted to see what every element would look like and, most importantly, they wanted to be sure that they could get it all for the budget.

"Intuitively, I think Sharon felt she'd got something different," explains Hird. "She acknowledged that we'd proved ourselves. We had listened to them and read between the lines, and they said we'd hit the mark spot on."

At this stage, however, there was still a lot of work to be done and many practical considerations to resolve. In

SORRY, THERES NO MORE SHOP

GET NAKED IN THE CUPBOARD

OPEN
SHUT

HEY NO NUDEY EXCEPT IN HERE

sportswear makes you glamorous and exciting probably

particular, Hird had to ensure the required stock could be accommodated. A lot of time was spent on the mid-floor gondolas. "Every designer's nightmare," reflects Hird, referring to the difficulty of creating a system that could hold clothing, footwear and accessories, be totally adaptable and, at the same time, look lightweight, airy, and stylish. Most radical of all was the suggestion that they should remove all product display from the front window and use strong graphic messages on the glass instead.

Two weeks later, in a second presentation, all the elements were resolved. The walls had a mixture of fixed footwear bays and a flexible ferrule system of plugs for shelves and hanging arms and the plan showed the streamlined oval gondolas. Color had been introduced to the scheme, and the backlit glass back wall had solid shelves with plug-in frames,

THE EXTERIOR OF THE NEW STORE IN CARNABY STREET SHOWS HOW ALL THE ELEMENTS HAD BEEN SIMPLIFIED BY BEING PAINTED PALE CREAM, THE TWO DOORS BALANCED SYMMETRICALLY, AND THE FOCUS PLACED ON THE FRONT-LIT NAME.

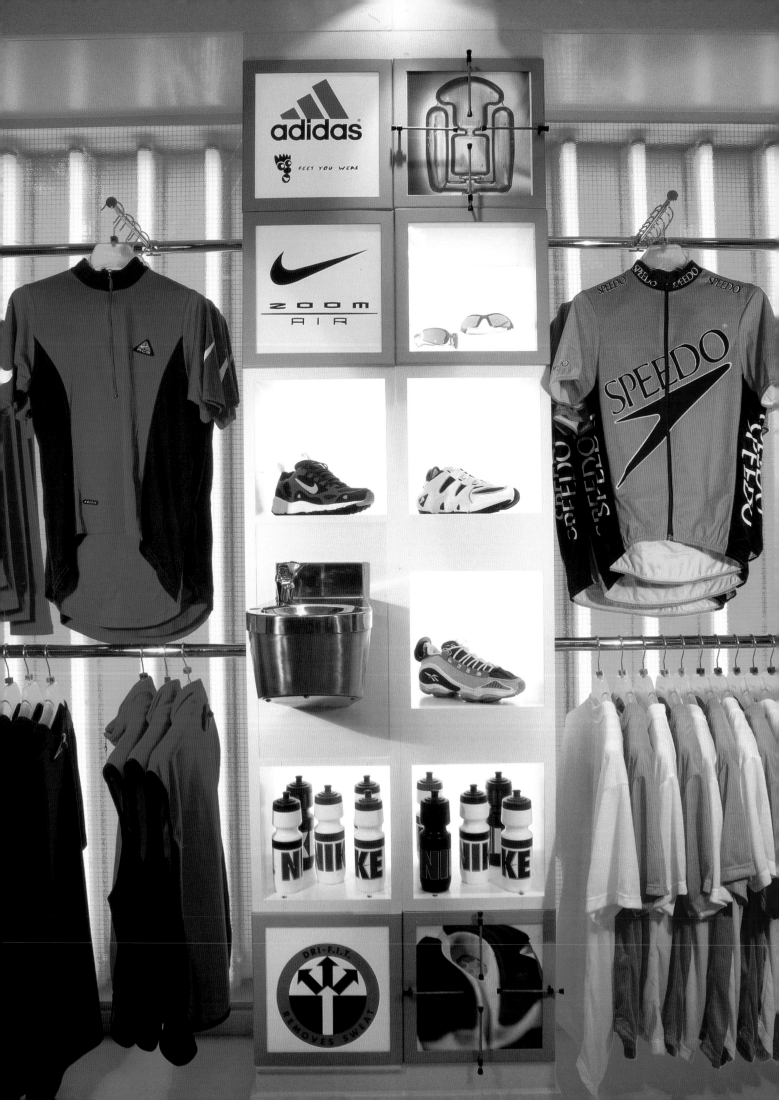

(LEFT) THE FAR END WALL, WITH ITS VARIOUS INGREDIENTS, HARDLY CHANGED FROM THE FIRST PRESENTATION. THE SHELVES HOLDING THE THREE TRAINERS ARE THE ONES THAT HAVE A VOICE MESSAGE.

ANOTHER DEPARTURE WAS THE ALTERNATIVE SOLUTION TO THE USUAL PRODUCT MESSAGES AND CHANGING-ROOM SIGNS.

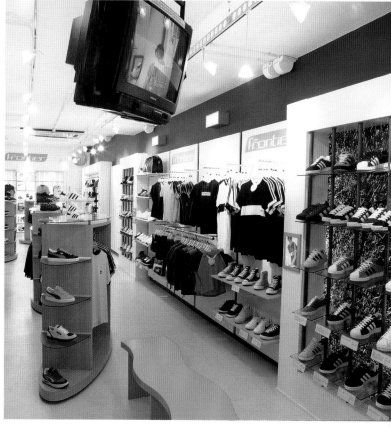

cube displays, backlit graphics, shoe clamps, interactive shelves, giant industrial fans, and a drinking fountain.

In the meantime, a new logo for Frontier, developed by graphic designer Alan Watt at Conran, had been applied to "dozens" of visuals of the fascia, which also showed the new, simplified shopfront, and enough graphic ideas for the windows to last the client months.

(BELOW) SOME OF THE SHELVES WERE 1/4-INCH GEORGIAN WIRED GLASS. AND THE BACKLIT IMAGES HAD A SUBTLE COBRA FOOTPRINT ON VARIOUS "EARTH" SURFACES.

Moreover, the scheme had now been applied to what would be the flagship store in Carnaby Street. "At this point we knew what the store was going to look like," explains Hird, "and the client happily went along with us." Mark Blackburn, managing director at Cobra, approved of the new logo and graphic messages on the glass. "From then on, everyone started to relax," remembers Hird. "We got down to the nitty-gritty."

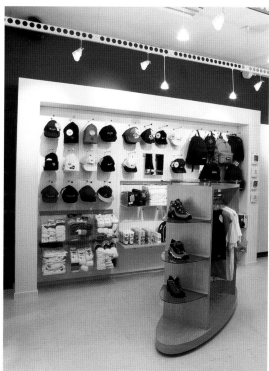

(ABOVE) A VIEW OF THE CARNABY STREET FRONTIER STORE SHOWS HOW THE PRODUCTS ALONG THE WALLS ALTERNATE BETWEEN FOOTWEAR AND FASHION. THE SHOES WERE DISPLAYED FRONT—RATHER THAN SIDE-ON, AND THE ORANGE SEAT ECHOED THE NEW LOGO.

(LEFT) THE NEWLY-SIMPLIFIED METHOD OF PRESENTING ACCESSORIES WAS FRAMED BY A SIMPLE PALE CREAM BORDER AGAINST THE BLUE WALL AND REPRESENTED A RADICAL DEPARTURE FOR THIS TYPE OF STORE.

Anthropologie

Each shop is site-specific and various factors influence the designers at Pompei AD in New York: the geographical location, the local culture, the national sensibility, how the creative team feels at the time, and what kind of esthetic they find provocative. This, they say, is the antithesis of "those cookie-cutter solutions"

But this project, for a subsidiary of Urban Outfitters Inc. in Philadelphia, started with the customer. Not the dry analysis of a research report, but with an intuitive feel for a quite specific segment of the American market: late 20 to early 50 year-olds, either married or about to be married, creating a home, about to have children, moving away from the dense urban areas where they were educated; professional couples, both working, looking for shops or products with some kind of variety, authenticity, choice; people who were likely to appreciate an environmental antidote to the electronic, information-oriented life they led at work. "The profile was quite loose," says Ron Pompei, "put together from our observations. These people have a more visceral, tactile sensibility, grounded in physical experience. They want adventure without peril."

This was not the beginning of work for Anthropologie, which had opened its first store in an historic 1930s Packard dealership building in Wayne, Philadelphia, in November 1992, and since then there had been 10 others. Before that, they had also worked for the parent company, Urban Outfitters, since 1983, but Pompei stresses that the work is collaborative. Anthropologie was set up to sell an original mix of men's and women's apparel and accessories, furniture, home furnishings, and gifts. The company, which is headed by Glen Senk, is "very patient," says Pompei. "They're not interested in the standard roll-out program. They identify the market, a community where the customer lives, and Wade McDevot scouts for buildings that have some character and some history. We do what we call 'selective' demolition—

THE VERY FIRST STAGE IN REALIZING THE NEW SHOP WAS TO LOOK AT PICTURES FROM MAGAZINES OR COPIED FROM BOOKS, COLLECTED BY BOTH DESIGNERS AND CLIENT. THE TEXTURED RUSTIC WALLS, DISTRESSED ARCHITECTURAL ELEMENTS, AND AUTHENTIC, UNDECORATED SURFACES ARE OFTEN USED TO EVOKE A SENSE OF THE PAST AND OF FARAWAY PLACES, AND HAVE NOW BECOME A HIGHLY SOPHISTICATED INTERIOR DESIGN DIRECTION.

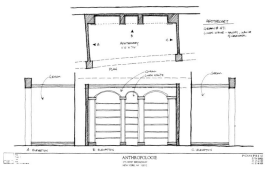

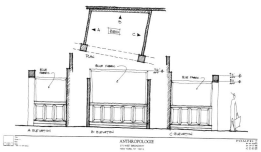

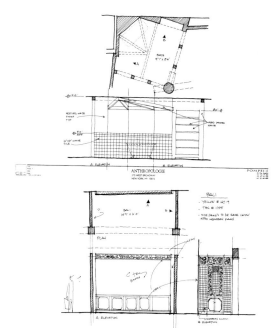

THIS SAMPLE BOARD NOT ONLY CONTAINS ALL THE SURFACES AND MATERIALS USED IN THE SCHEME, FROM "ORIENTAL" BAMBOOS TO "ITALIAN" FRESCO TO "NEW YORK" TIN PLATE, BUT IT COMBINES THEM ALL IN A CONTROLLED COLOR PALETTE.

LIKE CONTRASTING PAGES TORN FROM MAGAZINES, A FRENCH GARDEN WALL WITH AN INSET SHELF STANDS BESIDE A ZEN GARDEN, BOTH LOVINGLY RE-CREATED BY ARTISANS TO FORM A BACKDROP FOR GARDEN PRODUCTS.

carving away at the building to a certain stage to expose the structural elements and bring out the character." In the case of the Manhattan site, in the fashionable SoHo area, they tore up various layers of flooring to find the original tobacco factory warehouse floor and revealed the original tin ceiling that dated from 1875.

"But," continues Pompei, "several things were happening simultaneously. As designers, we were trying to understand the building, the proportions, and the volume—the light and the materials. At the same time, we're constantly collecting images—so is the client—and we put them all on the table, and, as a group—client and designer—we see what we like. We also consider materials—lead, steel, plaster, wood— which must be things that go with the history of the building. We make an acknowledgment of that history and choose materials that feel as if they have always been there." At the same time, the product evolves over time, too. Anthropologie's team, led by Kristin Norris and Greg Lehmkuhl, put together merchandise direction boards, and the designers try to understand and respond to them, too. It needs a lot of intuition.

This all evolves over a number of meetings as discussions become more focused. "But," says Pompei, "it stays in flux—a cross between sculpture and architecture." A plan starts to emerge too, to keep everyone aware of the physical limita- tions. "Initially around the perimeters, we put in the standard elements that have worked for us. These allow us to shape the space and imply a pathway, like walking through an old city or town. You're not sure what you'll find, there's a sense of anticipation, but it's clear how you can move through it. When it comes to the fittings, there are three levels of things happening. First, the store fixtures—pieces we have made up (all different) to look like they were once part of something else; as if they were left behind, as if they've had a previous

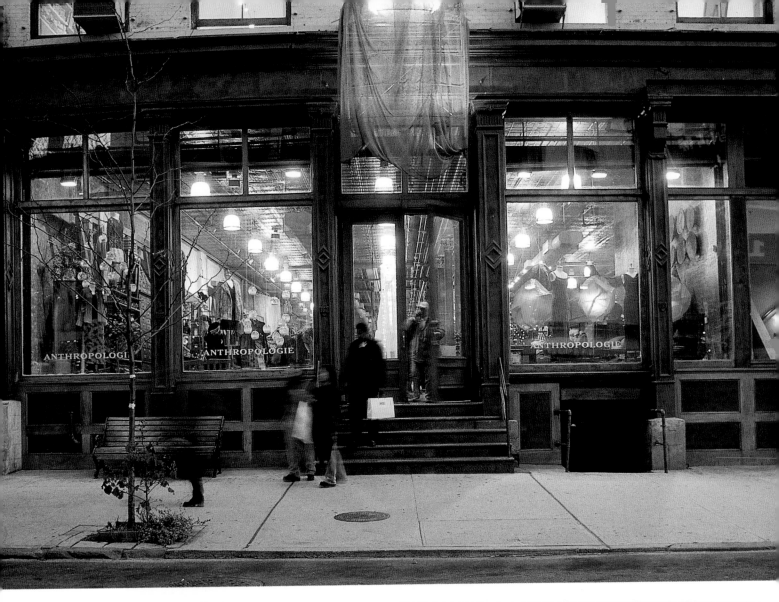

THE EXTERIOR OF THE
STORE ON NEW YORK'S
WEST BROADWAY KEEPS
THE VERNACULAR OF
THE WAREHOUSE
BUILDING BUT
INTRODUCES LARGE
WINDOWS AND MUTED
COLORS. INSTEAD OF A
FASCIA SIGN, CHAIN MAIL
HAS BEEN DRAPED
ABOVE THE FRONT
DOOR—"LIKE AN ICON,"
EXPLAIN THE
DESIGNERS.

THE FIRST AREA ON THE
RIGHT-HAND FRONT SIDE
IS USUALLY THE GARDEN
AREA. ALTHOUGH HERE
MOST OF THE PRODUCT
HAS BEEN GIVEN A
CHRISTMAS SLANT. THE
BOAT, AN AUTHENTIC
CRAFT FROM IRELAND,
DOUBLES AS A CUSHION
DISPLAY.

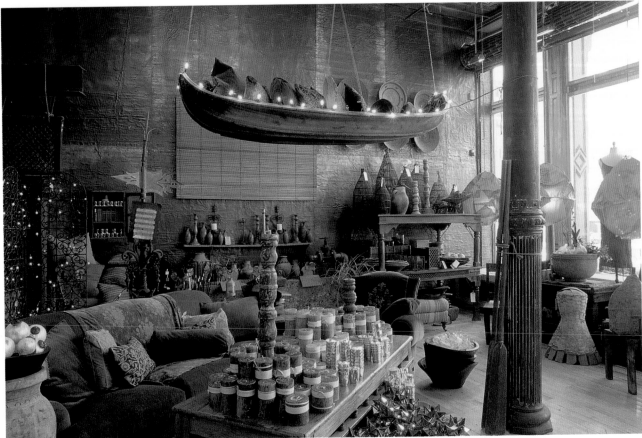

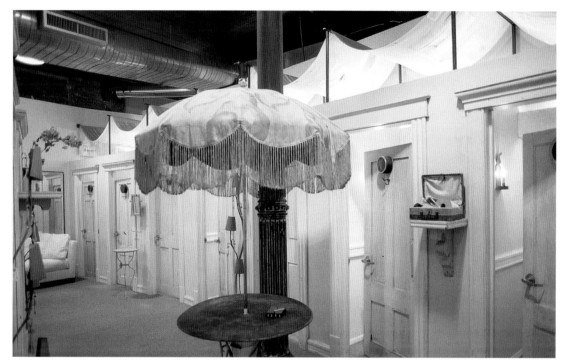

life. Then, there's the actual found pieces. Keith Johnson goes around the world looking for boats, benches, and bird cages. These are then modified to take merchandise, on shelves, on rails, on hooks. Finally, there are the pieces that form part of the look of the store but are actually for sale. There's a deliberately blurred line that goes from merchandise, to artifacts, to furniture, to fittings, to architecture," says Pompei.

Although it's usually different in each store, one wall is devoted to an arcade of room-size vignettes. These tend to evolve—one can be stripped out and replaced by another as the moods change and new product ranges arrive. They can range from a Mediterranean garden to a northern European dining room, to an Asian bedroom.

"Over the months, the design plan goes through various alterations, and we do many perspectives and elevations. It never stops." They also change things onsite—a wall that seemed fine on paper will be plastered in the wrong color or textured to a different scale. Sometimes domestic proportions

need to be adjusted to work in a large space. "Sometimes we do a bit of a mockup on site," says Pompei. "A fragment of the wall, a section of a cupboard made in cardboard. We were working to a very short timescale, it was all built in eight weeks. The creativity is great, and we have a lot of fun. It's very close to our own sensibility. I studied sculpture and Dick Hayne (the founder and chief executive officer) studied anthropology, so the approach is cultural."

During the construction process, there were two groups working onsite—the contractors, who were doing all the major construction work, and the artisans, who were doing all the plastering, woodwork, and more theatrical effects. The same people move from one site to the next. When it opened, Ron Pompei's partner, Allison Fonte, handled all the publicity, and a series of small community events, which are part of the ongoing activities in each store. "People come in just to spend time," says Pompei. "It's a retail space becoming more like a public space—a place where people can simply be."

Etam

Everything about this project was big: the scope of the work, which was two concepts in one; the onus on the design team to produce something effective with such a tight timetable; **and the big idea,** an entrance that 20/20 Design Ltd called **Fashion Boulevard**

Etam is part of the Oceana Trust, an international retailing consortium with six brands and more than a thousand outlets. It was December 1996 when Etam asked 20/20 to present its credentials and respond to a brief for the redesign of 223 Etam women's stores in the U.K. This was geared to Etam finding the right design partners, thinks Bernard Dooling, creative director of the London retail and marketing consultants.

The managing director of Etam, Nick Hollingworth, who is, by all accounts, a strong individual, liked 20/20 and the retail work it had already done, and he asked Dooling and project director Paul Bretherton to look at the shops and prepare a response. Dooling recalls: "Etam was looking to be challenged. The stores needed to make a quantum leap in retail terms, and I told Hollingworth at the outset that we would only present a piece of thinking (no design work). We had to find ways to communicate to him and build a robust relationship that would withstand the demands the later steps of the program would present. So we sat down as a team and said: "How can we tackle this?"

There were really two businesses: Etam, fashion for women aged between 25 and 45, and Tammy, clothing for girls aged from eight to 13 (this also included EJC, an area for girls aged two to six), all within one retail space. Research had shown that "no one disliked the shops, but no one said anything good about them." Dooling continues: "It was a bland brand—a thousand square feet of suet! I asked my 13-year-old daughter, Katie, what she thought of the Tammy departments, and she got groups of her friends to come and talk to us. We talked about this Tammy 'girl' and what

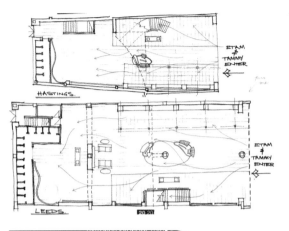

THESE TWO SCHEMATIC PLANS COMPARE PRODUCT LAYOUTS AND TRAFFIC FLOW IN THE LEEDS AND HASTINGS STORES.

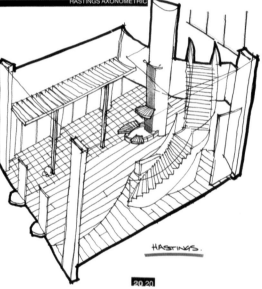

AS CAN BE SEEN IN THIS AXONOMETRIC VIEW, THE HASTINGS SITE HAD A CURVED STAIRCASE, WHICH MEANT THAT THE FASHION BOULEVARD WAS FORCED MORE TOWARD THE FRONT.

DURING THEIR RESEARCH TRIP TO THE U.S.A. THE TEAM SAW HOW ARCHITECTURAL ELEMENTS COULD DEFINE MERCHANDISE RANGES, AND THEY APPLIED IT IN THIS SERIES OF SKETCHES.

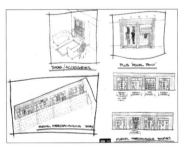

THE GRAPHICS HIERARCHY, ON WHICH COLOR THEMES WERE SUPPORTED BY LARGE BANNERS, AND THE "REAL WOMEN" THEME IN THE WINDOW WAS DEVELOPED ON POSTERS AND POINT-OF-SALE TICKETS IN THE FASHION BOULEVARD (*FAR RIGHT*).

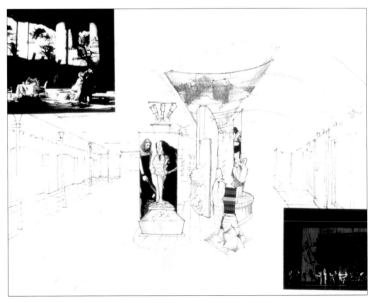

THE FASHION BOULEVARD KIT-OF-PARTS INCLUDED AN ARTICULATED CEILING AND FLOOR, SPECIAL LIGHTING, AND PROJECTION FACILITIES THAT MIGHT, AT ONE STAGE, HAVE INCLUDED SHOTS OF CUSTOMERS IN ETAM CLOTHES.

happened in her life. It helped to convince the clients that we knew as much about these kids as they did." In its report, 20/20 listed the aims of the new retail concept:

- to create theater and atmosphere
- to provide a cohesive and easily understandable mini-department store by (a) enhancing departments and (b) sub-brand definition
- to bring landscape and variety to merchandising
- to be aspirational but not intimidating
- to be welcoming and inclusive
- to achieve longevity and an ability to evolve naturally
- to be fashion friendly while offering value for money with mid-market appeal
- to use lighting and effects in a dramatic way

Of the core offer, the big idea was explained as "participative" retailing:

- What are the looks that her girlfriends are wearing?
- Show her on slide/video—make the product come alive (Etam is an experience, not just another "nice" shop)
- Put the looks and stories together for her
- She responds to fashion suggestions
- Give her choice and alternatives in both smart and casual looks (respond to her fantasies, Etam is not predictable)
- Build her confidence and suggest the cross-over looks—smart with casual

(ABOVE) AN EARLY SKETCH OF THE LEEDS SHOP FRONT WITH THE ENTRANCE AS "WIDE OPEN AS POSSIBLE", FLOOR-TO-CEILING GLAZING AND A DISPLAY DIVIDED BETWEEN TAMMY (ABOVE AND RIGHT) AND ETAM (ON THE LEFT). THE ETAM IDENTITY HAD ALREADY BEEN NEWLY DESIGNED BY THE PARTNERS.

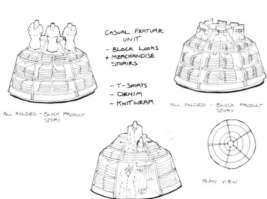

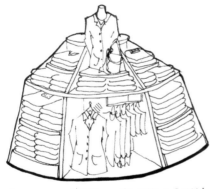

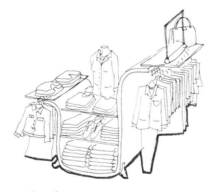

(LEFT AND ABOVE LEFT) "ONCE WE'D SHOWN THE CLIENT THAT WE UNDERSTOOD THEIR PRODUCT AND KNEW HOW TO MERCHANDISE IT," EXPLAINS BRETHERTON. "IT GAVE US A VERY STRONG GROUNDING FOR ALL OUR DISCUSSIONS."

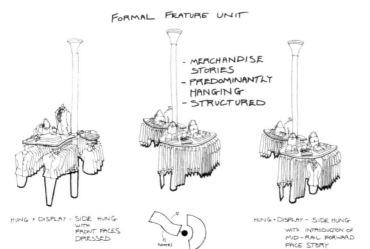

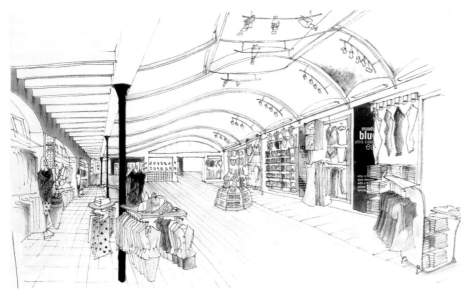

- She aspires to the looks in magazines—Etam shows her how to put those stories together but at Etam prices
- Etam sets the benchmark with its customer service proposition
- An instore fashion and skin-tone analyst visits your store one day each week
- She now buys into Etam completely—it has responded to her as a real "mate" would

Tammy, on the other hand, was conceived as "the living magazine," and when a girl walks into Tammy, it is like opening up her copy of her favorite magazine:

- The entrance has a distinct tone of voice that is all about Tammy and definitely not about Etam
- This is where "girls love to show girls of the same age the things they never show an adult"
- Tammy is the magazine cover

"It's an energetic and considered piece of work," said Nick Hollingworth at the end of the presentation, and 48 hours later, Stanley Lewis, chairman of Oceana, telephoned to say "we think you're the people we'd like to work with."

The first step was a fact-finding, four-day trip to the U.S.A. where, with the help of 20/20's Radar research division, the team—two designers and two Etam executives—visited relevant retail outlets in New York and Atlanta, took "discreet" photographs and shared their thoughts. "In particular, it reinforced certain issues we were able to refer to later," says Dooling. "The impact of large spaces, using physical merchandise breaks, high-quality materials, and architectural elements. They're not afraid to use bold statements and a lot of special-effect lighting in the United States, and their graphics were much more emotional."

Over the next few weeks, ideas started to emerge and were shown, bit by bit, to the client in three presentations. Amanda Beck and Sarah Page (both interior designers), also worked on the schemes. "I asked Amanda to approach the

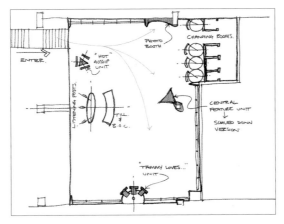

A VIEW OF THE LAYOUT OF THE HASTINGS STORE WITH SOME OF THE MID-FLOOR GONDOLAS. SPECIAL LIGHTING CONSULTANTS *INTO LIGHTING* WORKED ON THE OVERALL SHOP AND *DANCE LINES* PROVIDED THE LIGHTING AND VIDEO EXPERTISE THAT ANIMATED THE FASHION BOULEVARD FEATURE ON A 20-MINUTE CYCLE.

TWO PLANS OF THE TAMMY DEPARTMENT AT THE LEEDS STORE SHOW THE "PACE POINTS," THE "BABE ALERT" CENTRAL FEATURE, AND THE PRODUCT ADJACENCIES.

FROM THE TOP OF THE STAIRS IN THE HASTINGS STORE, WHICH WAS THE SECOND TO OPEN, THE TAMMY DEPARTMENT LOOKED FULL OF "CONTROLLED ANARCHY." "IF WE COULD SEE INSIDE THESE GIRLS' BEDROOMS," SAYS DOOLING, WHO HAS A YOUNG DAUGHTER, "WE'D SEE THE WORLD OF TAMMY."

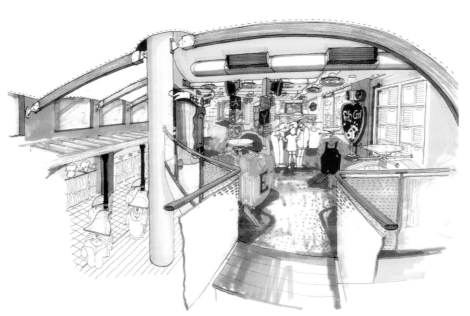

FROM THE FIRST PRESENTATION, A DRAWING BY KEVIN RETTIE OF ONE OF THE MIXED MERCHANDISE UNITS.

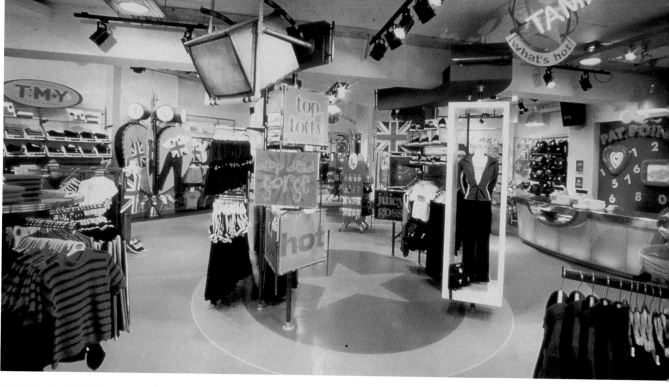

TWO VIEWS OF THE TAMMY CENTRAL FEATURE, WHERE ALL THE NEWEST FASHIONS SHARED SPACE WITH A HEIGHT CHART, AND A SERIES OF REVOLVING CUBES THAT DISPLAY PRODUCTS AND TEENAGE GIRL TALK.

ALL OF THE POINT-OF-SALE GRAPHICS WERE DESIGNED IN THE STYLE OF CLUB FLIERS AND VIDEO GRAPHICS, COMMUNICATING IN A VISUAL AND VERBAL WAY, WHAT AN EIGHT-YEAR-OLD GIRL UNDERSTANDS.

interior of Tammy as a 3D piece of graphics," explains Bretherton. "She brought real dynamics into the Tammy scheme and her massive visuals were almost bursting off the page. The hardest thing to tackle," he continues, "was Etam. Most of our effort went into trying to break it open—to create the 'Etam Experience,' which led us to Fashion Boulevard." He had told Etam, "This is going to make you different."

On the plans of the first three stores—at Milton Keynes, Hastings, and Leeds—the designers sited an area in the center at the front, a structure that would display the current fashion stories in both formal and casual wear, and create a regularly changing fashion billboard. "A visual summary of the big looks," says Dooling. Now that the client had signed up for three new sites, the designers had three very different architectural scenarios to deal with, but they divided the spaces in similar ways, positioning shoes and accessories together with lingerie in a more intimate area at the rear, opposite "Plus," a range for larger women, and under a lower ceiling. There were other bold architectural elements in the scheme, including a change of floor finishing between formal and casual merchandise, and, one half of the space had a curved, ribbed ceiling constructed of canvas and timber, which was backlit with changing colors and fashion statements.

Later in the presentation, boards showed "attitude to merchandising," with ideas that detailed focal points and formal merchandising "stories" as defined wall bays divided by architectural recesses, and an area for shoes was flanked by a low seating area. The Etam graphic language took examples of current advertisements—two girls together—and extended them to say "We're your mates," using fashion-friendly images and real-looking women giving fashion advice, just as fashion magazine articles do. More specific promotions were highlighted by long banners that gave "Etam's choice and interpretation of seasonal fashion

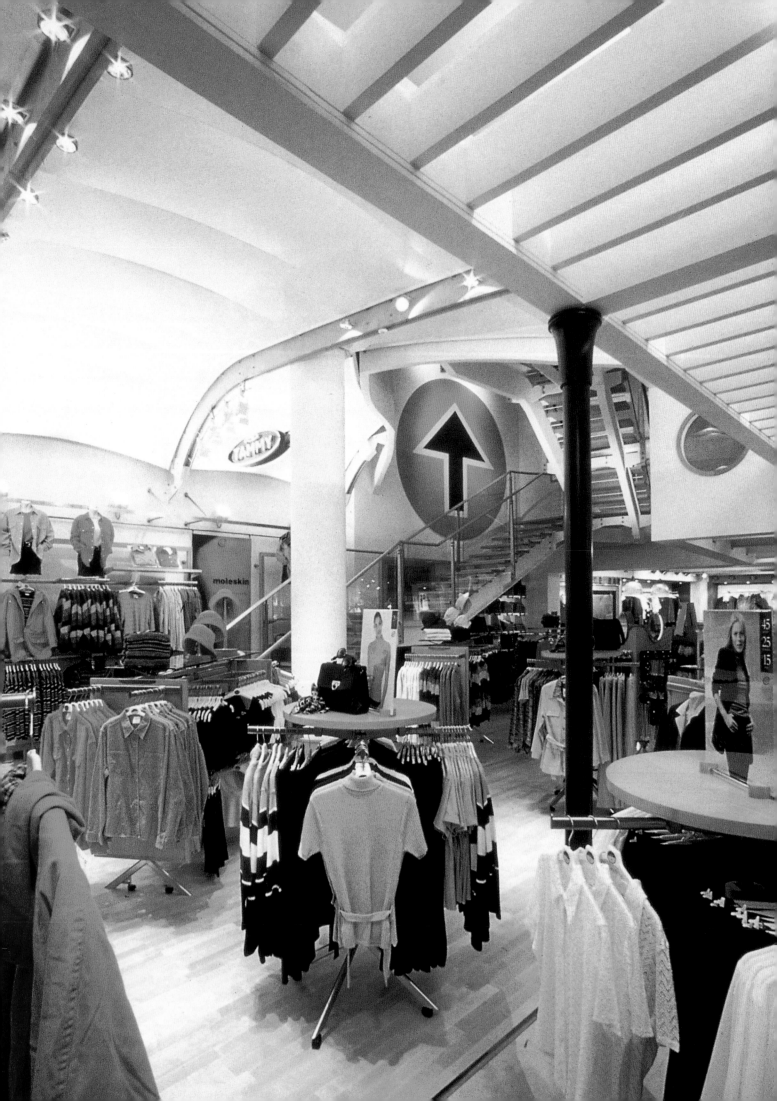

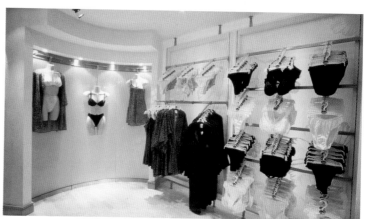

themes, with friendly and contemporary text." But the greatest amount of detailed work was spent in determining how the product could best be merchandised, defining best practice, and creating a system of suitable units.

At one meeting, as the designers fed back to the client's product team their own product audit in visual terms, the client was amazed. "They had never seen it laid out like that, and I'm sure they had never conveyed it through to the customer in the shop," says Sarah Page, who drew up every item in every color and style to see what it represented. Eight boards in the presentation explained the variety of units, from the basic mid-floor gondola with three add-on panels, to curving "casual feature units, formal feature units" and lively "head," "body", and "toe" furniture creations.

Stairs led up to the discrete Tammy department where, as they had promised, things were quite different. It wasn't a case of attaching graphics to a system of fixtures; the graphics led the scheme, with their own physical character-istics. Amanda Beck conceived the whole shop to be about interaction, with lots of things that the kids could do, from moveable cubes of product to photo booths, so girls could photograph each other in the latest gear. She wanted to divide the product by "pace points," "shopping by sound bites," as she put it, "with some juicy bits alongside the practical clothing items." She took her cue for the graphics from the club scene cards—stars, arrows, hearts, lips, and flowers, all in bright colors. In her scrapbook, Beck collected and sketched "hundreds" of ideas. Blow-up frames to the mirrors in the changing rooms, heart-shaped flip boards, peg boards, floor graphics, music listening points, and closed-circuit TV, and, working with the rest of the team, she translated them into shop fittings and an interiors scheme. It was the first store she had worked on, so she had no preconceived ideas of what ought to be done. "The whole project was a team effort. We all sat at one big table, and it was a constant process of brainstorming. If someone asks you why you've done it, you're forced to explain and justify it," says Kevin Rettie, another of the interior designers on the project. The whole team worked 12 hours a day throughout the 21-week schedule. After the opening of the first shop in Leeds, managing director Nick Hollingworth said: "We had no right to expect it to be that good."

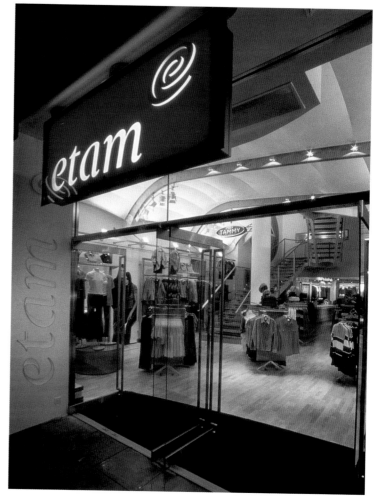

Vobis is a new format computer megastore in Portugal aimed at easing the access of non-technically minded consumers to information technology, while at the same time satisfying the needs of specialist consumers. The designers' brief put it more succinctly: "breaking the complexity compromise"

This was the sixth project that Davies Baron had done for Sonai distribution in Portugal. Steve St Clair was the design director responsible for coordinating all the projects, working with Nuno Azevedo in the retail specialist depart-ment at Sonai. Summing up the brief, St Clair wrote back:

"The store layout will be based around two distinct areas, namely Home World, aimed at children and parents using computers at home, and SoHo World, aimed at Small Office/Home Office consumers using computers for business. Overall, the store will offer the widest range of hardware and software in the market at competitive prices, with emphasis on excellent service both during and after the sale. The main focus will be on the use of PCs, which will be organized by brand or performance and which will be connected for consumers to test."

The project also required a complete retail identity, including a new name and instore signage. Working with St Clair were Jason Pollard, Terry Driver, and director of graphics, Darren Scott. Before any of the design work began, however, they took the client on a reconnaissance trip to the United States to look at specific areas of retailing in Illinois and Wisconsin, notably computers, sportswear, and home accessories. "Things were much more advanced there," says St Clair. "Forty percent of American households have a PC. In Portugal it's less than five percent." There was a fundamental difference in the way target customers had to be approached, and they didn't see anything that seemed to offer a perfect solution for Europe.

Back in the studio, the designers set to work looking for a way of making the store look friendly, dividing the 16,000

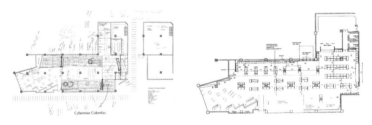

(*ABOVE*) THIS SERIES OF PLANS, BASED ON A TYPICAL 10,225 SQUARE FOOT SPACE, SHOWS HOW THE PLANNING PROCESS WORKED, FROM THE FIRST PRODUCT LAYOUT, TO THE FINAL AXONOMETRIC LAYOUT IN THE FIRST PRESENTATION, WHICH SHOWED THE CHANGE IN FLOOR FINISHES AND HANGING SIGNS.

(*ABOVE RIGHT AND FAR RIGHT*) TWO PLANS COMPARE THE FINAL SITE—FROM THE ENTRANCE ON THE RIGHT, PAST THE TOP-TEN PROMOTION, THE SERVICE DESK, AND KIDS' AREA, TO THE USE OF THE AWKWARD DOG-LEG AT THE BACK. COMPARE IT WITH THE FINAL MERCHANDIZING PLAN, THE RESULTS OF GREATER PRODUCT DENSITY, AND THE USE OF STANDARD SHOP-FITTING UNITS DICTATED BY THE CHANGE IN BRIEF AND TIMETABLE.

(*ABOVE AND LEFT*) TWO WALL ELEVATIONS FROM THE FIRST PRESENTATION SHOW THE LOWERED DOMESTIC PROPORTIONS OF THE HOME SECTION AND A SECTION OF THE BACK WALL WITH STAGGERED PRODUCT DISPLAY AND A PROPOSAL FOR A "BARN-TYPE" CEILING FEATURE TO ARTICULATE THE 18-FOOT CEILING VOID.

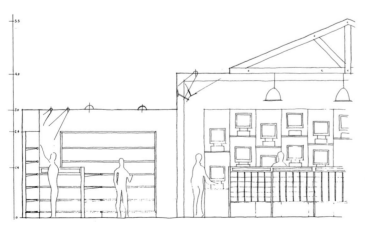

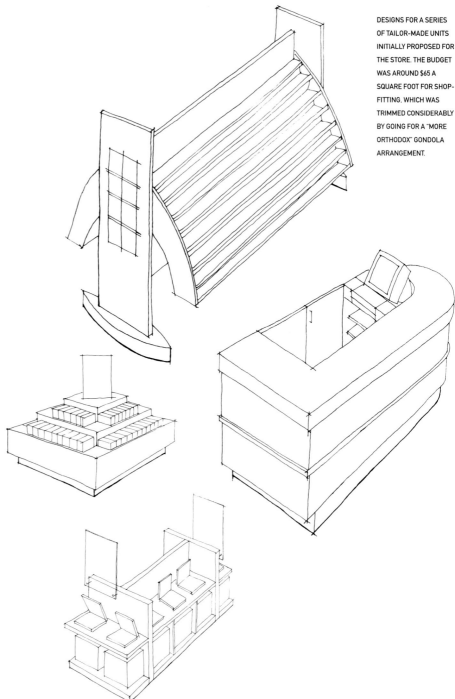

square foot space into Home World and So Ho, and evolving a
floor plan. "We tried to make the space more intimate, more of
a commodity-based environment," says St Clair, "with
different perceived spaces to soothe the customer."

Through a number of brainstorming meetings between the
interiors, graphics, and business development teams, and with
David Davies, they tried to "kick start" the project. It soon
became apparent that they could utilize the perimeters—with
a lowered ceiling—for Home and SOHO in a more controlled
environment of their own, with the rest of the product in the
center, perhaps with a change of floor finishes. To help de-
mystify the product, they avoided confusing narrative on signs
and used very large photographic panels of friendly-looking,
happy users, a technique they had already used with some
success for the Royal Bank of Scotland (see page 58).

"We tried to think pretty freely," explains St Clair, "and not
just stick products on shelves." Through their research they
already had plenty of good display ideas, and knew how the
key decision makers thought and what type of materials
customers were receptive to. They started to design the units
as well as to prepare plans, often on the same drawing. They
also added an internal cafe, a top-ten products feature, and a
special area for children. Using a "small footprint" (small units)
and a flexible merchandise system that would give presence to
the offer, they contrasted "nicely detailed fixtures" against
piles of boxes on plinths for promotional offers, "one step
above a palette," explains the designer.

The presentation three weeks later also included a list of
possible names, just to get a reaction. "After that, everything
went on hold," says St Clair, "and we sat around for three
months while the client, who was talking to various European
retail groups, looked for someone with which to do a joint
venture." Eventually they found Vobis, a German company,
with stores throughout the Benelux countries.

This arrangement meant a new name, a fresh injection of
expertise, a second client, and an expanded range of products.

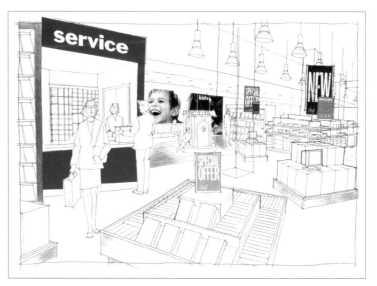

USING THE INITIALLY PROPOSED "CHIP" LOGO. THESE THREE PANELS DEMONSTRATED THE USE OF COLOR AND SIMPLE TYPOGRAPHY IN THE NEW DAVIS BARON SCHEME.

FOUR EXAMPLES OF THE PROCESS OF DEMYSTIFYING THE PRODUCT WITH THE HELP OF PROMINENT PHOTOGRAPHIC PANELS. WHICH WERE LATER ADAPTED TO BE USED ON COLUMNS AS CHANGEABLE BANNERS IN THE FINAL APPLICATION.

"Vobis wanted more promotion of the big brands, more hardware on display, and a combining of interactive areas in the Home and SoHo areas," recalls St Clair. "Not an insurmountable problem, just a switch of emphasis." More of a problem was still to come, when the client decided on the first site, a 9,000 square foot space in a large new retail development currently under construction (coincidentally by Vobis) outside Lisbon. The proportions were narrower, with a narrower entrance—26 feet—and an L-shaped aspect, which meant rethinking the repair and service areas. In addition, they now had 12 weeks until opening day.

A revised presentation was made to Sonae and Vobis. St Clair and his colleagues spent two days in Spain at a shop-fitting company, looking at standard fixtures and off-the-shelf systems and deciding what could be adapted, with some specially formulated elements that the team designed on the spot. "They made up some prototypes, but there was no time to do a huge amount," says St Clair. They came back and, with the clock ticking, did a set of profile drawings. Sonai's own project management team took over all the contract negotiations and even had the instore photographs taken. "We were still in creative control and did most of the artwork, but the ticketing, although based on our guidelines, wasn't quite right," admits Darren Scott.

"The last few days were complete lunacy," recalls St Clair. But the store opened on time, along with 300 other retail outlets within the Centro Colombo. The roads were not finished, and the whole center was struggling to meet its deadline. "Light fittings were being stolen off the wall by other retailers. Thank goodness we weren't the project managers." After the opening, sales were above target, and the client was considering rolling the concept out in Germany, The Netherlands, and France, as well as Portugal, with more stores over the following five years.

(ABOVE) THE FRONT OF
THE NEW STORE,
CONCEIVED AS A SCHEME
THAT MIGHT BE APPLIED
BOTH TO 8,000 AND 16,000
SQUARE FOOT SITES,
USED A LOGO ADAPTED
FROM THE CLIENT'S
EXISTING GRAPHICS.
INSIDE, THE USE OF
COLOR AND
PHOTOGRAPHY GAVE THE
FRESHNESS AND "GOOD
VALUE" MESSAGES.

(LEFT) LOWERED
CEILINGS MADE THE
SIDES FEEL MORE
DOMESTIC AND
SPECIFICALLY ADAPTED
UNITS HAD NONE OF THE
BRASHNESS OF NORMAL
DO-IT-YOURSELF TYPE
OUTLETS. THE GRAPHICS
WERE "EMOTIONAL" AND
NOT PRODUCT-BASED.

Pepe Jeans London Ltd
Even when the ideas are approved early on, there are many stages of development to produce a world class store that satisfies the client's brief, the budget, and the environment. This story, perhaps more than any other of those described in this book, illustrates **how many changes a scheme can go through** before the merchandise arrives.

The $1.6 million construction project creating a flagship store for Pepe Jeans in London's Covent Garden was a remarkable achievement due to the speed with which the construction phase was completed to achieve trading before Christmas 1997. Despite the complications added to the project intensity, including the local authority granting planning permission only one week prior to the opening, the store is a good example of the retailer having a strong brand that required a unique and dramatic store.

Creneau—the word is French for "niche in the market"—is an established European design company with a 40-strong team, which is based in Hasselt, Belgium, with offices in London and Barcelona. The company, run by chairman of European operations, Will Erens, started to work for Pepe Jeans in 1994 doing exhibition design and developing their merchandizing system. Since then they have designed the Pepe Jean's European HQ in Amsterdam, offices and showrooms in Brussels, Madrid, Barcelona, and Dusseldorf, stores in Antwerp, Rotterdam, Slovenia, Paris, Barcelona, Madrid, and Cologne as well as developing and installing the merchandise system for rollout throughout Europe.

So when Fred Gehring, chief executive of Pepe, approached Creneau's Will Erens during the fall of 1995 to discuss the creation of a flagship store in London, Erens was in an ideal position to understand the brand and the marketing philosophy. Pepe had found a site on a prominent corner of Neal Street in London's fashionable Covent Garden. A prime retail space, which had been an old paper warehouse and art gallery, Pepe needed an initial scheme for presentation to the Board, the landlord and most importantly, the local authorities. "The brief contained the basic details, recalls Creneau's project coordinator James Cameron, "but left plenty of scope for the evolution of ideas."

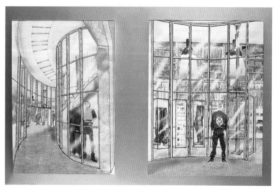

(ABOVE RIGHT AND RIGHT) ONE OF THE EARLY PRESENTATIONS FOR THE FLAGSHIP PEPE STORE WAS A SERIES OF DRAWINGS. ONE OF THE MOST IMPORTANT OF THESE COMBINED ALL THE LIKELY INGREDIENTS—THE MULTI-LEVEL JEANS WALL THAT SPANNED THREE LEVELS, THE EXPOSED COLUMNS AND THE CENTRAL ESCALATOR.

THREE VIEWS OF THE EXTERIOR, INCLUDING THE FINAL CONCEPT. IN THE FIRST TWO, DRAMA WAS ADDED TO THE FRONT CORNER BY OPENING UP ALL THREE FLOORS AND GIVING ADDITIONAL ACCESS THROUGH A SIDE DOOR. IN THE FINAL SCHEME THE DESIGNERS RESORTED TO HIGH-LEVEL BANNERS.

THE PROGRAM OF
DEVELOPMENTS CAN BE
FOLLOWED IN THIS
SERIES OF FLOOR PLANS.
IN THE FIRST *(RIGHT)*, THE
CENTRAL ESCALATOR
TAKES CUSTOMERS TO
THE CAFÉ AND
ADDITIONAL STAIRS ON
THE RIGHT LEAD TO AN
UPPER FLOOR, WITH A
"TRANSPARENT METAL
FLOOR" AND A WALK-
THROUGH GLASS DISPLAY
CABINET CONTAINING
STAIRCASES.

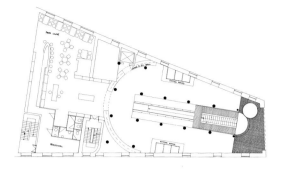

THE SECOND *(RIGHT)*
SHOWS THE FLOOR CUT
OUT IN A LOZENGE SHAPE
AND TWO CIRCULAR
STAIRS LEADING FROM
THE MEZZANINE TO THE
UPPER FLOOR.

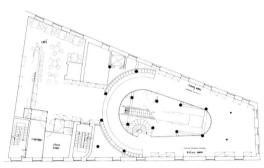

NEXT *(RIGHT)*, THE
ESCALATOR HAS BEEN
REPLACED BY TWO
STAIRS ON EACH SIDE OF
THE BUILDING AND A
LARGE AREA OF GLAZING
IN THE FRONT, RIGHT-
HAND CORNER.
THE CAFÉ HAS BEEN
REDUCED IN SIZE AND A
SMALLER STAIR JOINS
EACH FLOOR.

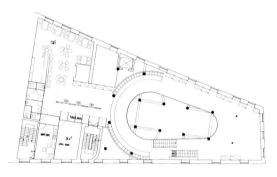

LATER, THE CAFÉ IS
SHOWN *(RIGHT)* IN THE
FRONT CORNER; THE
ESCALATOR AND STAIR
ARE BACK IN PLACE,
SUPPLEMENTED BY A
SPIRAL STAIR UP FROM
THE ENTRANCE ARCADE.

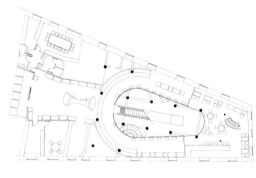

IN THE FINAL PLAN
(RIGHT) THERE WAS NO
ESCALATOR, NO
ELEVATOR, NO ARCADE,
NO CAFÉ AND NO
TEARDROP CUT OUT AT
FIRST FLOOR LEVEL.

At this stage the brand was number four in the U.K. jeans market and this was to be Pepe's global flagship.

The creative work was done by Erens and his team of 10 multinational creatives in Creneau's Belgian head office, with the design implementation being carried out by the London team. "Usually, this type of project will involve the full spectrum of architects, designers, and the inhouse prototyping team," says Cameron. Working from the existing plans of the building and following a study of the site and its environment, Creneau produced layouts, a series of sketch views and a sample board that showed how the historical aspect of the building could be respected. By stripping the concrete floors, removing the concrete cladding from the iron columns, and cutting away the second floor they designed a grand mezzanine and a soaring 28 feet high space. The aim was to create a "raw," yet elegant space, fitting for Pepe's product.

Because of the importance of the store (it was to be their first global flagship and a big investment), Pepe decided to throw the net wider and asked five U.K. design companies to pitch for the job. Each company was given the same brief for first stage concept ideas.

Basing its thinking on their first presentation Creneau added more details and refined their proposal. The scheme was evolving, there were modifications to the exterior and the directive came that the two side entrances could not be used. Creneau moved the café proposed for the second floor rear, to the front of the same level and introduced a small indoor arcade inside the front door as after-hours access to the café stairs.

"We had created a computer model using 'Star' with rendering using 'Stratavision' and looked at the space from 20 viewpoints," recalls Cameron, "there was also a beautiful scale model and a three-dimensional sample case."

Creneau, having used the RIBA to source architects with the right experience, approached Alan Power to join the team in joint partnership. The project was to require an experienced project coordination team. It was anticipated that there would be complications with managing the fast track construction project combined with the structural alterations that were proposed in the scheme, especially the removal of the majority of the central structural elements across the first floor retail space.

Creneau were still competing against one other design company. After the presentation Pepe said: "Sit tight and we'll let you know." Pepe were debating costings and although Creneau and Alan Power had generated a cost plan and program, the client asked for further cost savings. There followed a series of changes and recostings, and two months later, to their relief, Creneau was finally awarded the job. When Pepe gave instruction that the project was to finally go ahead, there was minimal lead-in time so a detailed procurement process was required to meet the critical dates.

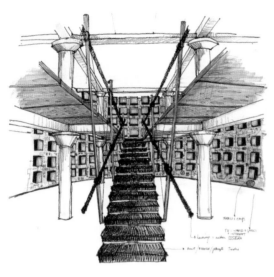

ALTHOUGH THE JEANS'
WALL STAYED MUCH THE
SAME, LIKE AN IMMENSE
DENIM LIBRARY
ACCESSED BY ROLLING
LADDERS, THE MEANS OF
ACCESS CHANGED WITH
THE BUDGET. IN AN
EARLY DRAWING *(RIGHT)*,
OPEN-TREAD STAIRS
TAKE CUSTOMERS
THROUGH A SMALL CUT-
AWAY TO THE SECOND
FLOOR.

THIS WIDE VIEW *(BELOW
RIGHT)* ALLOWED HARDLY
ANY FLOOR SPACE AT THE
UPPER LEVELS, AND THE
STAIRS FOLLOW THE
CURVING WALLS.

LATER *(BELOW)*, BOTH
THE FLOORS WERE CUT
AWAY, THE STEEL
COLUMNS WERE
REVEALED.

A 'GLASS' ELEVATOR
(BOTTOM) WAS
VISUALIZED IN THIS
SCHEME, WHICH ALONG
WITH ALL THE OTHERS,
HAD TO BE RECOSTED
AND REPRESENTED.

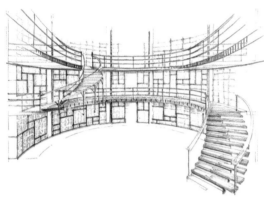

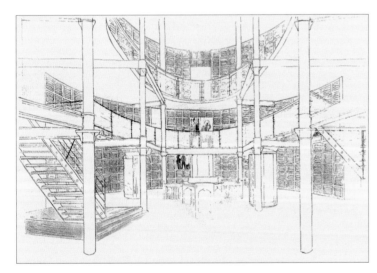

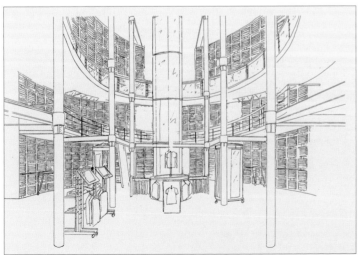

Vincent Wang was appointed as Client Agent, his role was to oversee this process, particularly the contracts that would enable the design team to make changes as the project proceeded without incurring contractual penalties. The capacity to develop ideas and prototype them in the space was an important part of the design evolution and management of the project.

The client wanted to progress planning approvals with the local authority; since this was an historic building in a conservation area that would also necessitate consultation with the Covent Garden Community Association and The Bloomsbury Committee. A protracted and hard fought battle followed, due to the strong views being held regarding the alterations to the exterior. Pepe were keen on the site for its prime location and the historic qualities of the building were an ideal backdrop for their product, but there still remained an inherent contradiction between the requirements of modern retailing and the desire of local amenity groups who wanted the appearance of the building to remain unchanged. "To obtain the planning consent, a compromise was reached , thereby allowing the store to commence trading, but the debate continues as to whether the exterior was effectively resolved and Pepe are reviewing their design requirements of the exterior," says Cameron.

The design development team had transferred to London, and working closely with Alan Power Architects the team produced over 100 drawings for issue to the contractors. The timetable was brought forward by Pepe to a challenging 11-week site program. Creneau's European merchandise system was supplemented by new mid-floor display units, tables, and mirrors. "It was the same principle, but looked at every item, and in all cases adapted the appearance —cleaner details and a nickel-plated finish suited the U.K. market better," explains Cameron. As is often the case, initial prototypes were made in Creneau's own warehouse, where their teams prototype fixturing and try special new finishes and effects, produce special display items and revive old furniture for the group's more eclectic projects. The designers made a mockup in their warehouse of the jeans wall and key materials to be used on the project to see how they looked and assess the scale.

Onsite, Alan Power was busy coordinating the first wave of demolition works. Dozens of skip-loads of rubble were being removed, and the contractors had to comply with severe noise restrictions. "The restaurant below was remarkably patient and understanding," says Cameron. To further aggravate matters during the 11-week contract, the builders were to receive a staggering 150 parking tickets as they tried to get to the site access in the maze of narrow streets around Covent Garden.

It was of great benefit to Pepe that they could use the space itself to help establish the brand as the U.K.'s leading youth jeanswear retailer. The store opened for trading on the November 27, 1997 with a big press party

THE FINAL SCHEME
RETAINED ALL THE
ELEMENTS FROM THE
INITIAL CONCEPT. THE
BACKLIT WALL OF 7,000
PAIRS OF JEANS, AN
INNOVATION INSPIRED BY
THE TAPERED PROFILE OF
THE BUILDING, REMAINED
THE DOMINANT FEATURE,
HELPED PERHAPS BY THE
FACT THAT NO ESCALATOR
INTERRUPTED THE VIEW.
THE ORIGINAL CONCRETE
FLOOR WAS "GROUND
BACK" AND RESEALED,
AND ALL THE STEELWORK
WAS GRIT BLASTED TO
THE FOUNDRY FINISH
AND COATED WITH
INTUMESCENT PAINT.
"THE BUILDING CAME
ALIVE," SAYS CAMERON,
"WITH THE TRIPLE-
HEIGHT VOLUME."

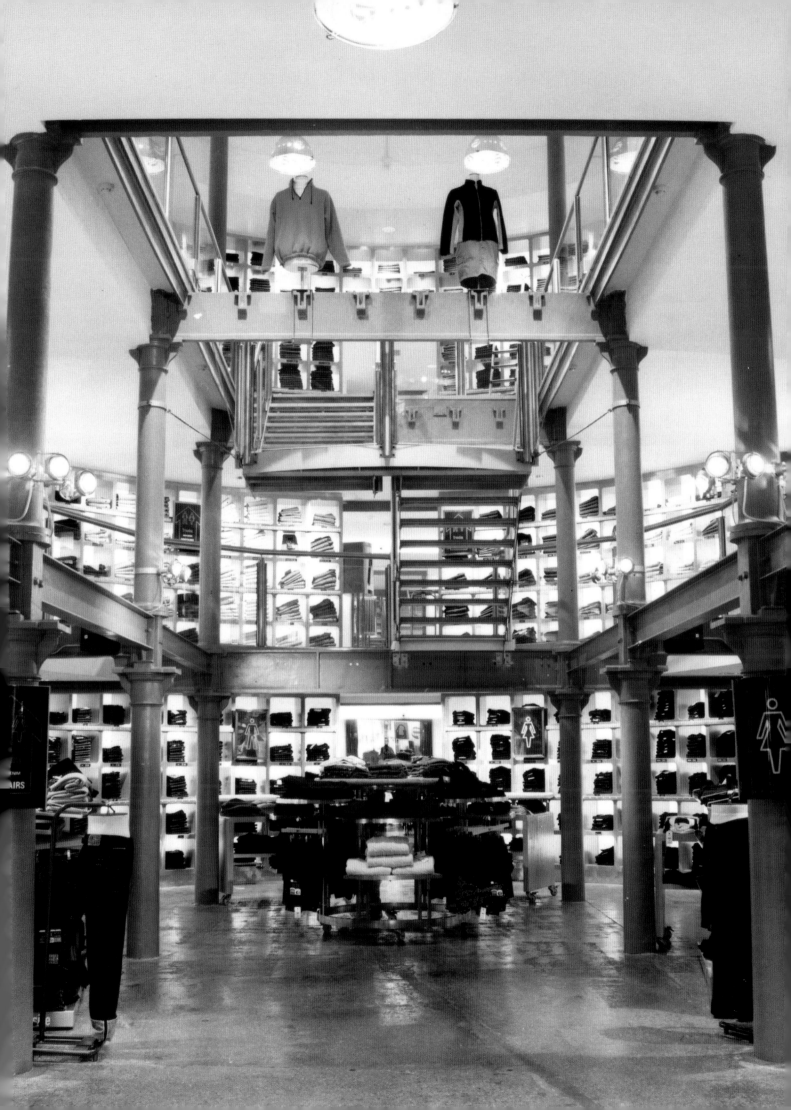

Discovery
The vast undertaking of the Discovery Channel's Destination store in Washington D.C. was more like **movie making than retail design.** In the beginning, everything happened in reverse—the company had a building before they had a retail concept, and they had a brand essence

before they had a product Greg Moyer, Project Executive in charge of development and President and Chief of Editorial and Creative Officer at Discovery Communications Inc. explains "Our first venture into the cable network retail was in 1995, when we acquired two retail chains, the Nature Company, with 124 stores, and Discovery, an 11-store chain. We were learning then, so we did little or no remodeling. They were successful retail ventures, but they didn't speak of the Discovery channel's unique intellectual capital. We'd always assumed that we'd convert them later. In our region there are three types of retail outlet. The first, the "big box," is a vast warehouse with a huge inventory but no sense of entertainment and no educational value. Then there's the museum, with products related to exhibits. Finally, there are the traditional retailers, with a wide variety of branded and unbranded products. We wanted to synthesize aspects of all three and create a store to cover the whole Discovery Channel "story," dividing it into templates that could be expanded into any realm we wanted and then produce products to fit the stories."

In December 1996, a huge, new, three-storey building attached to the MCI sports arena in downtown Washington, D.C., became available and Discovery, seeing it as an ideal place for a flagship store, negotiated a lease.

Ron Pompei, founding partner and head of design at

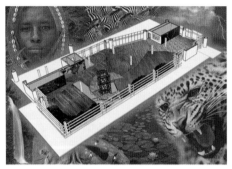

THE PROJECT INVOLVED NUMEROUS SKETCHES AND SAMPLE BOARDS. IN ADDITION TO COMPUTER VISUALS. THIS SERIES OF FLOOR PLANS. HOWEVER. USING ONE CENTRAL STAIRCASE. WAS THE FIRST TO CLEARLY SHOW THE USE OF DIFFERENT AUTHENTIC MATERIALS TIED INTO EACH REALM.

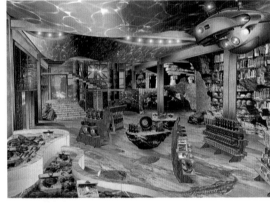

"ONE OF OUR GREATEST CHALLENGES WAS TO FIGURE OUT HOW THE SPACE WOULD UNFOLD AND REMAIN INTERESTING AND PROVOCATIVE ENOUGH OVER FOUR FLOORS," SAYS THE DESIGNER. RON POMPEI. THESE VISUALS WERE USED BY TO HELP EXPLAIN THE CONCEPT TO THE BOARD.

AT THIS STAGE IT WAS JUST A RECTANGULAR BOX, WITH 10,000 SQUARE FEET ON EACH FLOOR. THE DESIGNERS STARTED TO SCULPT THE SPACES USING AUTHENTIC MATERIALS.

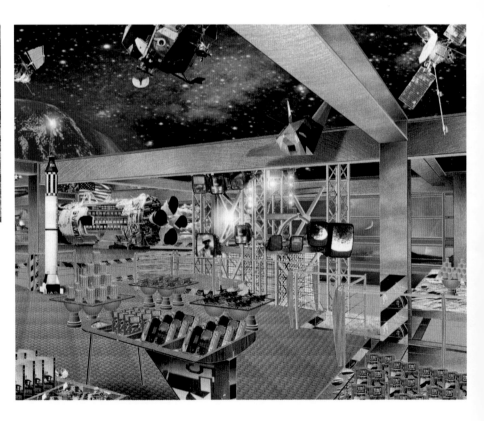

THIS SERIES OF DRAWINGS TRACES THE DEVELOPMENT OF IDEAS FOR SHOP FITTING SCHEMES IN THE FLIGHT AREA. FOLLOWING THEIR REMIT, ALL THE UNITS USED AUTHENTIC MATERIALS AND, IN MANY CASES, ACTUAL OBJECTS, INCLUDING (*RIGHT AND FAR RIGHT*) MODIFIED WINGS AND AIRPLANE CARCASSES, AND LOOMING OVERHEAD, THE FORWARD FUSELAGE OF A SECOND WORLD WAR B-25 BOMBER, THROUGH WHICH CUSTOMERS COULD WALK. IN THE FINAL INSTALLATION, THE DISSECTING STEEL BRACE WAS NOT REQUIRED.

SCOVERY FLAGSHIP AT MCI CENTER

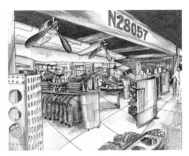

(*RIGHT*) DRAMATIC VIEWS WERE CREATED BY CUTTING A THREE-LEVEL ATRIUM OUT OF THE BUILDING. "YOU COULD SEE YOU HAD A GREAT JOURNEY TO GO ON," SAYS POMPEI, WHO INTRODUCED BRIDGES AND GANTRIES, WHICH HE CALLED "PATHWAYS OF DISCOVERY."

(*FAR RIGHT*) "THE SAME PEOPLE, DIFFERENT TOOLS," ADMITS POMPEI OF THE TEAM RESPONSIBLE FOR THESE EARLY PENCIL AND INK DRAWINGS OF MERCHANDISE FIXTURES.

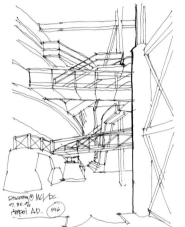

(*RIGHT*) A FLOOR PLAN BEGINS TO SHOW THE COMPLEXITY OF THE PLANNING. "WE TRIED TO CREATE A STUDIED BUT SIMPLE BALANCE, USING PRODUCTS INTEGRATED WITH THE DISPLAYS," SAYS POMPEI.

(*RIGHT*) ON THE GROUND FLOOR THE PALEO WORLD HIGHLIGHTS INCLUDED A 42-FOOT *TYRANNOSAURUS REX.*

Pompei A.D. in New York (see page 138) was Creative Director on the project. He continues, "with so many disciplines to consider, we approached the project as a collaborative effort, assembling a team of 25 people and holding a series of regular conceptual conversations over a period of three months." The "charettes," as he calls them, contained architects, retail designers, industrial designers, set designers, writers and film directors from the film industry, conceptual consultants, video, audio, and lighting technicians and, of course, merchandise buyers, many newly employed by Discovery for the task.

"Every two or three weeks we all got together and 'blue skied'" he says. "The designers sketched, the writers wrote. These brainstorming sessions were a hybrid experience. We win when we are generous with our knowledge. We all realized, early on, that the difference between Discovery and any other store—or a museum for that matter—is that the Discovery Channel is "content rich." There is a vast amount of quality content, and it's increasing all the time." They wanted to interpret artfully the "world to be explored," creating an environment that was a series of journeys into different realms. With authentic materials and objects, they aimed to "position Discovery as the retailer of knowledge and access" and to spearhead a new movement into retailing as an educational experience in addition to being a marketing venue for the brand.

At the end of three months they had established a core creative group, which included Moyer, Pompei, John Katz (concept consultant), Tim Newman (video and audio producer) and John Farnum, (co-creative director). "The building was not well designed for this purpose," says Pompei, whose team started to visualize the key structural idea of dividing the floors into geological and evolutionary strata, starting on the ground floor with Paleo World (prehistoric) and moving to Ocean Planet on the mezzanine level, Wild Discovery (adventure, art and cultural

ON THE GROUND FLOOR (*RIGHT*) A COMPASS SHOWING TRUE NORTH WAS SET INTO THE FLOOR SURROUNDED BY A 260° SCREEN VIDEO PANORAMA. ON THE THIRD FLOOR (*TOP FAR RIGHT*) THIS SCHEME WAS REPLACED BY THE HUBBLE TELESCOPE EXHIBIT, AND BY RAGING PLANET, AN INSTALLATION FOR IDENTIFYING IMMINENT HURRICANES, TORNADOES AND TROPICAL STORMS. OCEAN PLANET ON THE MEZZANINE (*FAR RIGHT*) WAS DESIGNED TO SUGGEST THE INSIDE OF A SHIP.

PLANNING RESTRICTIONS ON THE EXTERIOR PREVENTED THE DESIGNERS FROM CREATING THE GLOBE FEATURE SEEN IN THIS INITIAL SKETCH (*ABOVE*). ONLY THREE BANNERS WERE SUSPENDED ABOVE THE CANOPY, BUT IMAGES WERE PROJECTED IN EACH WINDOW AS THIS COMPUTER VISUAL PROPOSED (*LEFT*).

exploration) on the second, and Aviation, Space, and Science on the third floor. The fourth floor, designed by Genster Associates, was devoted to a Discovery Channel 80-seat theater, which opened with a specially made high-definition cine-tour of Washington, D.C.

Early ideas for personalizing each floor, "like walking into an explorer's factory or Leonardo's atelier," were discarded. "We decided that nothing should be ersatz or fake," says Farnum. The breakthrough came when they considered opening up the whole building by cutting a canyon from top to bottom and creating what Pompei calls a "cosmology continuum." The idea was, as customers moved through the building, they experienced a change in time and terra. From any one location in the store, the "canyon" allowed customers to view a gradation from the prehistoric age through to the space age and materials and merchandise evocative of each environment.

By the end of May 1997 the complete design document was ready for presentation and board approval. Work started on site in August. In all, there were 500 discrete design projects to get the store open, from shooting 35mm film to creating gift certificate cards. The appropriate consultants were brought in at every phase, including, of course, the channel's own program makers, science and design experts. "That's where the *Tyrannosaurus rex* came from," says Pompei. "We had been discussing getting some really amazing fossils, not thinking large scale at all; then Discovery Channel contacted a supplier for the Nature Company, which could provide a cast of the world's largest *Tyrannosaurus rex*." Moyer says, his own team at Discovery contributed with enormous enthusiasm whenever they could. "They were very hungry for this challenge and really stepped up to the line."

TWO-THIRDS OF THE TIME
WAS SPENT ON
DEVELOPING INTERACTIVE
ATTRACTIONS AND
FIXTURES, AND SOURCING
APPROPRIATE MATERIALS,
SAY THE DESIGNERS, WHO
ALSO POINT OUT THAT
"IT'S A LIVING STORE, AS
WELL AS A FULLY
FLEXIBLE RETAIL SPACE."
POMPEI SAYS THAT
"WHATEVER HELD
MERCHANDISE HAD TO BE
PART OF THE STORY. WE
DREW INSPIRATION FROM
PEOPLE WHO WORK IN
THESE REALMS—
DOCTORS, SCIENTISTS,
ARTISTS, COLLECTORS. AT
THE SAME TIME WE DIDN'T
WANT TO MAKE IT TOO
DISNEYESQUE. WE'RE NOT
TRYING TO FOOL ANYONE
INTO THINKING THEY ARE
"UNDERGROUND OR ON
THE MOON." WE WANTED
TO KEEP THE STRUCTURE
OF THE BUILDING VERY
EVIDENT."

No less important than the design was the merchandise being sourced and developed for the store. Pompei admits, "at one stage I was quite worried that it wouldn't live up to the interior, but then I realized the incredible resources the client could bring to bear. For example, the kind of equipment and clothing used by explorers and scientists in the field—that's what they could sell."

"It's a call to action for the customer," says Pompei, "and this environment is as real a point of access as you could imagine." With 15 interactive stations throughout the space, "the flagship is designed to get people closer to our brand—to let them reach out and touch it," Moyer explains. "It brings our programming to life and gives us a medium to tell stories about objects that the public can actually see, hear and feel. The Washington D.C. store is an incubator and a laboratory," he says. Moyer's priority now is to convert the other 124 stores, between 2,000 square feet and 7,000 square feet, to Discovery Channel stores, a process that should be completed in about two years, and Moyer does not rule out foreign locations. With broadcast operations in 142 countries around the world, "we think there is definitely an opportunity to start "globalizing" our retail experience. This flagship store has succeeded in extending the Discovery Branch, but it's only the opening salvo!"

(OVERLEAF) "WE HAD TO
TRY TO CREATE INTIMATE
AREAS AS WELL AS LEAVE
SPACE FOR LARGE
NUMBERS OF PEOPLE,"
EXPLAINS POMPEI OF THE
SPORTS ARENA ADJACENT
TO THE STORE. THIS
GROUND-FLOOR VIEW
SHOWS THE CANYON, THE
EXPRESS ELEVATOR TO
THE THIRD FLOOR AND A
LESS AMBITIOUS MIX OF
MATERIALS THAN THE
EARLY COMPUTER
VISUALS HAD PROPOSED.

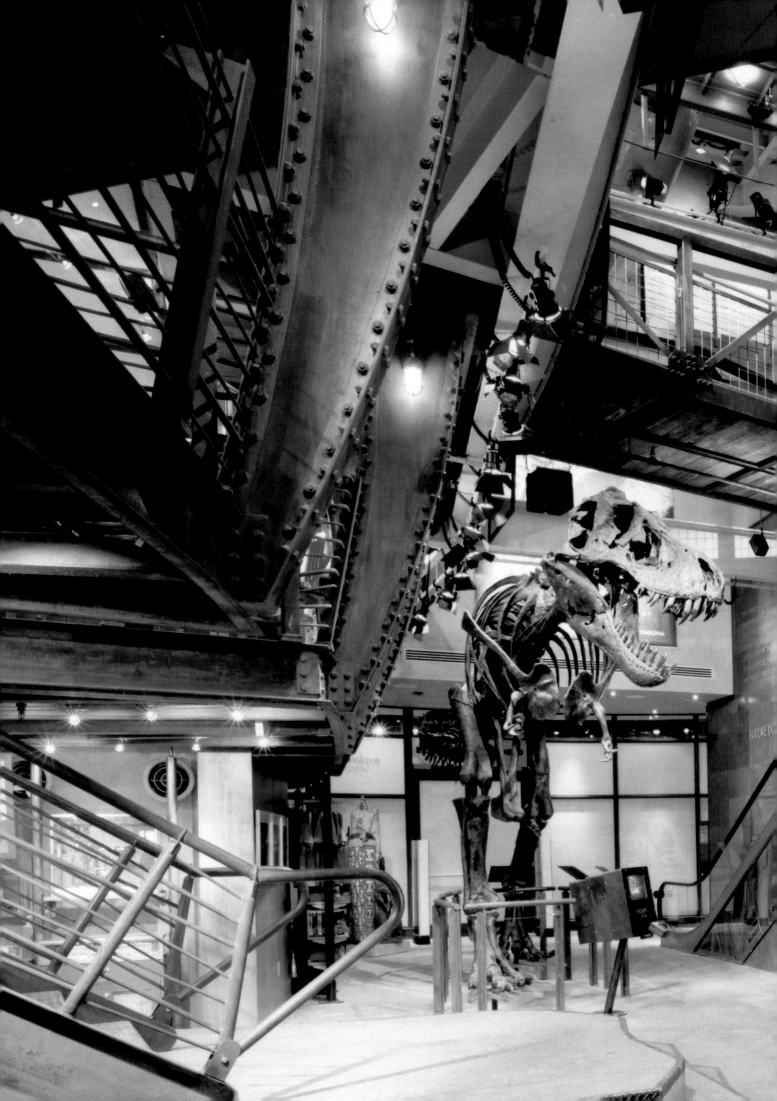

Do not follow where the path may lead.
Go instead where there is no path.
And leave a trail.

Anonymous

Iper

Within the chain of 14 out-of-town hypermarkets, the clothing section had been stagnating and Ronny Helvey, retail consultant and project director at Landor in London, identified that the visual merchandizing and range selection needed to be formalized and more customer focused. On his first visit Helvey **demonstrated what he had in mind by moving around some of the store merchandise**

For over 18 months, Landor has been working with Finiper, a north Italian based retail group comprising hypermarkets, garden centers, furniture stores, and pizzerias. After successfully reworking the furniture division, Inca, by developing and implementing a new name, identity, and interior concept, Landor set in place a branding and design strategy that was to became the springboard for all future Finiper design. The strategy proposed a consistent, coherent, and individual communication platform to visually link the Finiper divisions and create the opportunity for the launch of the Finiper Group loyalty card "Vantaggi." Landor worked closely with the founder, chairman of the Finiper group, Signor Brunelli.

To grow the business within the hypermarket, the non-food areas were ripe for development. Clothing, as the poor relation, had the greatest potential for growth, explained Helvey, whose background is in fashion retailing with the Burton Group in the U.K. He conducted a detailed visual audit to identify the issues within the clothing sector at the nominated prototype store in Varese, where the new concept to exploit the potential of clothing was to be trialed. On reviewing the audit material, "Signor Brunelli had the imagination to see what needed to be done and the courage of his convictions to say 'do it'," Helvey said.

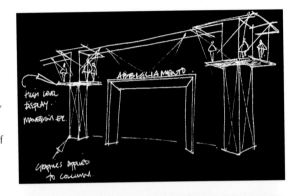

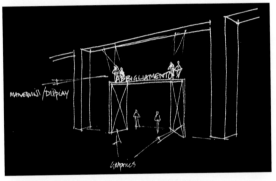

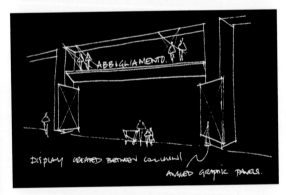

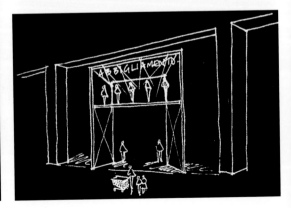

FOUR EARLY SKETCHES PRODUCED BY LANDOR TO EXPLAIN THE IMPORTANCE OF CREATING A "SHOP FRONT" INTO THE CLOTHING WING OF THE STORE. EVEN THOUGH CUSTOMERS COULD ENTER FROM OTHER DIRECTIONS, IT WAS IMPORTANT TO CREATE A FOCAL POINT THAT WOULD DRAW THEIR ATTENTION. THE CONCEPT (RIGHT) WAS ALSO APPLIED TO OTHER NON-FOOD DEPARTMENTS.

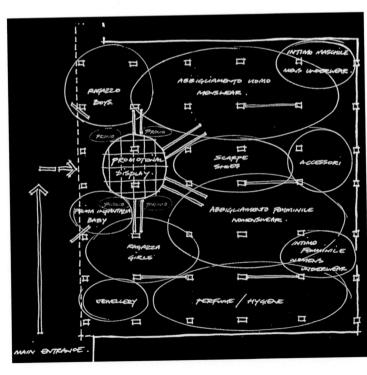

WORKING WITHIN THE STRICT GRID OF COLUMNS, RONNY HELVEY AND HIS TEAM PRODUCED SEVERAL MERCHANDISE PLANS, EACH ONE FOCUSING ON THE PROMOTIONAL DISPLAY "BEACON" AND POSITIONING PRODUCTS THAT RELATED TO ONE ANOTHER, EVEN IF IT MEANT BRINGING IN NON-CLOTHING ITEMS, SUCH AS PERFUMERY AND PERSONAL HYGIENE PRODUCTS, WHICH HAD HITHERTO BEEN POSITIONED ELSEWHERE IN THE HYPERMARKET.

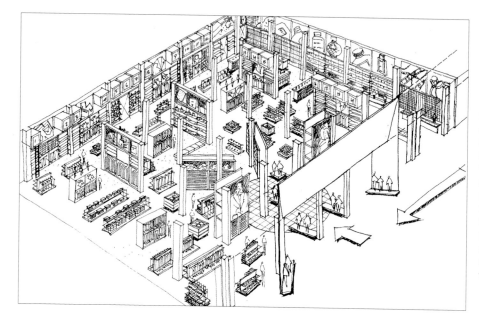

THIS EARLY SKETCH (LEFT) SHOWS ALL THE ELEMENTS IN PLACE, INCLUDING THE SHOP FRONT, THE PROMOTION "BEACON", THE EXTENSIVE USE OF LARGE PHOTOGRAPHS AND THE EXTRA STOCK STORAGE BINS INTENDED TO REPLACE THE EXISTING CARDBOARD BOXES THEY FOUND WHEN THEY FIRST SURVEYED THE STORE. A FURTHER DRAWING (BELOW FAR LEFT) SHOWS THE SIMPLICITY OF THE NEW WALL PROFILE.

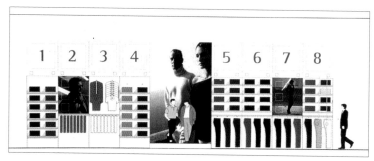

Over the next four weeks, Helvey made several visits to the store to explore all the issues relating to customer profile and the wish list, from an operational viewpoint, "I don't speak fluent Italian and they don't speak English, but fortunately both teams had French in common so discussion of all the issues relevant to the project was possible. "

The process, says Helvey, "basically became a productive informal discussion. It was clear they were satisfied someone was taking away some of their worry. They were able to react quickly to my ideas, and through these they were able to stand back and view the position from the customers' viewpoint, as opposed to an operational perspective."

To complete the analysis before design work began, Helvey organized a study tour with the key store players, as well as the head of central buying, to visit the best retail practices in the U.K. and France. "It became easier for me to understand what would work in the Italian market and for them to imagine what I was suggesting they implement in their new store."

The next step was to draw up the time schedule and begin the complex task of designing the new store. We proceeded after having formalized the customer lifestyle profile which assisted us in preparing the design brief. "It was paramount that the clothing sector remained appropriate to a hyper-market environment." explained Helvey. "We wanted to create a refined warehouse feel to take advantage of the large, high space (19,377-feet square) where the volumes demanded by its various departments—mens/womens/kids as well as accessories/personal care, etc—could be delivered within a hypermarket environment."

THREE EXAMPLES OF IDEAS THAT HELVEY PRO-DUCED TO DEMONSTRATE HIS MERCHANDIZING PHILOSOPHY, USING "BEFORE" PHOTOGRAPHS AND SIMPLE DIAGRAMS TO EXPLAIN EACH SOLUTION.

Landor's final design brief had to:

• clarify the offer and focus the choice
• ensure accessibility of product/service
• shorten the distance between customer and product
• create an environment relating to quality and position of offer

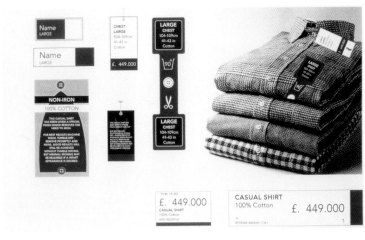

THREE PAGES FROM A 23-PAGE REPORT THAT DEALT WITH THE SIGNAGE AND INFORMATION HIERARCHY. GREEN WAS ADOPTED AS THE CLOTHING DEPARTMENT COLOR, WITH RED AND YELLOW FOR PROMOTIONS AND SALE GRAPHICS. NO BUDGET WAS AVAILABLE FOR SPECIAL PHOTOGRAPHY, SO STOCK PHOTOGRAPHS HAD TO BE FOUND TO MATCH THE MIDDLE-MARKET CUSTOMER.

- define a strong and unique personality with a specific tone of voice
- create an identity reflecting the offer, values, and experience of Iper—identified as "fresh," "friendly," "genuine," "intuitive," and "poineering."
- define a clear brand positioning to facilitate future brand communication messages.

The design concept was based on "beacons," as the clothing area needed to draw people to the area from the food end of the hypermarket and lead customers to the department within the clothing world. "The store design and layout was seen as a means to shift clothing purchases from one of impulse buy, while shopping at Iper for food, to one of Iper as a destination for clothes shopping for the family," explained Helvey.

The design concept was fully developed by designers Martin Williams and Katherine Bond to cover all aspects from shop fixturing, lighting and textures, to color-coded sizing labels for hangers and instore fashion graphics.

Landor's implementation director, Steve Slemmings, oversaw hundreds of technical drawings before the job could go to tender, while Helvey worked on all the department layouts, product by product, to maximize customer circulation and multiple purchase opportunities.

For commercial reasons the store did not close during the implementation, which took three long weeks working through the night to enable new sections to be open by morning. Helvey was assisted by Jania Rackham and Sara Melochy, both visual merchandizing specialists. The store opened on March 23, 1998, seven months after the first audit visit to Varese. Signor Brunelli, on seeing the new store, was delighted.

The months after the launch saw Helvey working with the store team on visual merchandizing and store issues to adapt the new concept to trading activity and new stock deliveries. Finiper have reported that the contribution of sales generated from Iper's clothing world is steadily increasing and that sales are well up on the previous year.

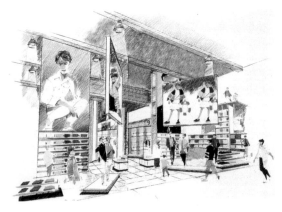

(LEFT) A PRESENTATION VISUAL OF THE "SHOP FRONT" IDEA, WITH ITS EXTENSIVE AND DRAMATIC USE OF HIGH LEVEL PHOTOGRAPHY, WITH A PHOTOGRAPH (BELOW) OF THE IMPLEMENTED SCHEME, SIMPLER YET NO LESS DRAMATIC.

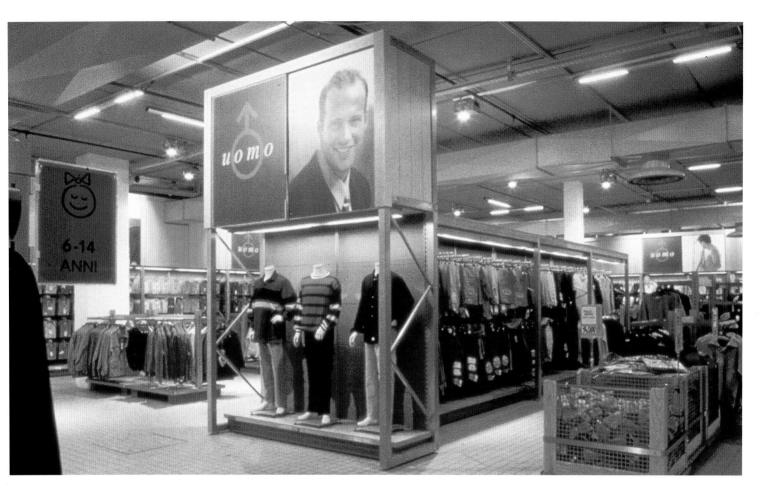

THREE VIEWS OF THE
FINISHED DEPARTMENT
AT VARESE. "30,000
PEOPLE GO THROUGH
THAT STORE ON A
SATURDAY,
PREDOMINANTLY WOMEN
AND YOUNG FAMILIES,"
SAYS HELVEY. "WE HAD TO
DO SOMETHING THAT
RELATED TO THEM—THAT
WAS MY BIGGEST
CONCERN." FIVE PERCENT
OF THE SALES IN THE
STORE WAS FROM
CLOTHING—FOLLOWING
THE REFIT, THAT FIGURE
DOUBLED IN TWO
MONTHS.

Ingredients
A second-time Fitch client, Dutchman, Pieter Totte was about to embark on his first solo retail venture, an opportunity in which **his nose for a winning formula** was combined with

his love of the aroma and taste of freshly baked bread

Totte, a consultant on the buying and selling of businesses, had been working with Don Miller, a large manufacturer with a chain of bakery shops when, in the early 1990s, he had worked with Fitch on a concept for a more contemporary version of the traditional British bakery. In the end, Don Miller did not develop the project to the extent that Totte would have liked, but Totte loved working in the bakery industry, and seven years later he still thought there was a ground-breaking opportunity to be realized. People, he thought, were demanding fresh, natural, good quality, convenient food products, and supermarkets, who had seized the opportunity, had merely provided a synthetic experience for the customer by "piping in" the aroma of baked bread to simulate freshness in the bread aisle. For the most part products were premixed, and packed with preservatives.

Carol Dean, project manager and graphic designer at Fitch in London, recalls her first meeting with Totte was a 10-minute conversation. "It was quite casual. He's a very relaxed guy, and there was no formal brief, or predetermined budget—just the germ of an idea." she explains. Fitch, with its formal design process, it is strategic planning program and its 130-strong staff, were flexible enough to be able to respond to his informal approach and contagious conviction. His idea, Dean continues, was to launch a chain of bakery shops which combined the traditional qualities of baking with a more contemporary approach, which exposed the baking process, so that customers could see the quality, witness the freshness of the product, and learn about bread baking through demonstrations. As well as selling baked foods, customers could buy premixed ingredients, ready to bake at home, plus, perhaps, other associated products.

Dean developed a detailed strategy with Neil Whitehead at Fitch, who had worked as senior consultant on the client's previous job. She began to collect ideas and images in an attempt to visualize what the concept could look like and to give the shop a personality. The process, though tentative,

AS A WAY OF CLARIFYING THE BRIEF, DESIGNER CAROL DEAN, AT FITCH, PUT TOGETHER THESE THREE COLLAGES. CALLING THE NEW SHOP "THE BREAD FACTORY," SHE SKETCHED IN THE CORNERSTONES OF THE OFFER, THE CORE PRINCIPLES, AND THE BRAND PERSONALITY.

INGREDIENTS:

in·gre′di·ent (in-grē′dē-ənt) *n.* an essential part of a compound or mixture; constituent; element.

ALTHOUGH THERE WAS A PAGE OF IDEAS FOR NAMES, INCLUDING "TAKE-TO-BAKE" AND "THE FLOUR FACTORY", DEAN HAD INCLUDED IN THIS FIRST LINE-UP A PHOTOCOPY OF THE INGREDIENTS LIST FROM THE BACK OF A CRISP PACKET. SHE EXPANDED IT INTO A DICTIONARY DEFINITION AND SHOWED HOW IT MIGHT LOOK IF IT WERE APPLIED TO PACKAGING.

FASCIA/STOREFRONT GRAPHICS

PROPOSED
PROJECTED SIGN

FASCIA

ENTRANCE
BRAND WALL

ENTRANCE
BRAND PANEL (BACK)

ENTRANCE
CAFE WINDOW

ENTRANCE
CAFE WINDOW side

(ABOVE) FROM STAGE TWO, THIS SERIES OF STORE FRONT GRAPHICS SHOWS HOW THE SCHEME DEVELOPED. TOTTE THOUGHT THAT THE IDEA OF "USING INGREDIENTS AND EXPLAINING WHAT THE SHOP WAS ALL ABOUT WAS REALLY IMPORTANT," SAYS DEAN, WHO HAD BULK-HEADS BUILT INTO THE FINAL SCHEME (BELOW) SO THAT COLOR AND A HIGH-LEVEL GRAPHIC LANGUAGE COULD BE APPLIED.

was embryonic in that it established many of the key elements that were to remain unchanged, right through to the final scheme, including her idea for a name for the shops. "I threw out a suggestion that felt friendly and engaging," she explains.

After two weeks she presented to Totte in a 45-minute meeting, a series of A1 size orientation boards, which outlined cornerstones of the offer as well as adding considerable detail to his original thoughts. On the first orientation board she detailed ideas to include breads of the world, a variety of savory baked goods and confections, dry ingredients for baking and cooking, condiments, and take-out items such as sandwiches. Among the collage of pictures and graphics on the second board was the name "ingredients," written as if in a dictionary, the tiny drawing of a flour scoop that went on to be a major element of the shop

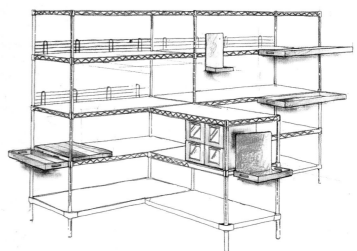

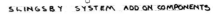

SLINGSBY SYSTEM ADD ON COMPONENTS

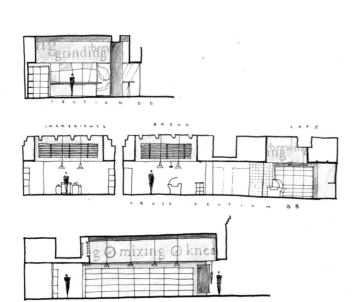

SECTION DD

INGREDIENTS BREAD CAFE

CROSS SECTION BB

SECTION 1:100 AA

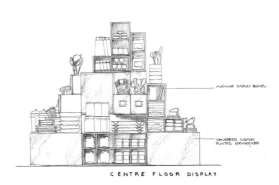

MODULAR DISPLAY BOXES

VENEERED DISPLAY PLINTHS 600 x 600 x 300

CENTRE FLOOR DISPLAY

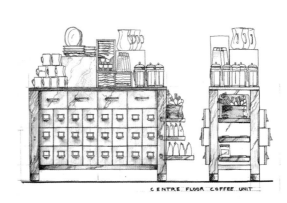

CENTRE FLOOR COFFEE UNIT

WHILE THE CLIENT WAS OUT LOOKING FOR THE FIRST STORE, NICK BUTCHER WAS DESIGNING THE OVERALL INTERIOR AND FIXTURES AND FITTINGS. STRIVING FOR A COMBINATION OF TRADITIONAL AND MODERN, HE DESIGNED NEW UNITS AND ADAPTED STANDARD SHELVING SYSTEMS. APPLYING A "BEST-PRACTICE" ANALYSIS ON THE BASIS OF ITEMS ALREADY IN THE MARKETPLACE.

THE FIRST SHOP IN
NORWICH USED THE
NAME EXACTLY AS IT HAD
BEEN TAKEN FROM THE
FRAGMENT OF
REFERENCE, AS WELL AS
THE QUAINT FLOUR
SCOOP SITTING IN FRONT
OF A MISSION STATEMENT
PANEL JUST BEYOND THE
THRESHOLD.

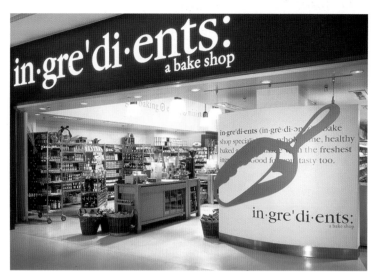

CAROL DEAN WENT ON TO
APPLY THE NEW IDENTITY
TO A HOST OF
PROMOTIONAL AND
PACKAGING IDEAS, ALL
OF WHICH HAVE SINCE
BEEN IMPLEMENTED,
INCLUDING PACKAGING
FOR COFFEE, A CAFÉ
MENU, AND COMPANY
STATIONERY.

graphics, and an idea for a mission statement which set the
tone of voice for the brand. Elsewhere there was a long list of
other words grouped below headings—a place, a person,
health, sensory, baking process—which began to build the
personality of the brand. An important aspect of the retail
proposition was the use of kitchen-style fixtures and finishes,
which would be familiar to customers through kitchen shops
and contemporary restaurants who now expose the kitchen
and the chefs as part of the food offer. It was, says the
designer, "a reflection of the introduction of entertainment
and theater which is emerging in retailing."

Although there was no interior designer working on the
project at this stage, Dean sketched a view of an interior and
a plan of the food layout, including an area for coffee. "I
wanted to give an impression for Pieter to respond to," she
explains. "Do more work," was his approving endorsement,
as he went off to look for a site. It was time to call in her
colleague, Nick Butcher, who, as an interior designer at Fitch,
had worked on various restaurants, including L'Odeon in
London's Regent Street. While they were working on the
interior design language, their client found a space in New
Castle Mall in Norwich, a prestigious development with a
"great catchment, 30–40 miles in every direction," says
Butcher. He was clear about the quality he wanted—a feeling
of open space and an abundance of product on a very simple
merchandise system. "The product had to be king," he recalls.
The site, a 20-foot high combination of two units, divided
naturally into a shop and a baking area, and in a hand-drawn
plan, Butcher put a small café in a space left on the far right.
The scheme lent itself to high-level graphics, and, of course,
Dean's scoop featured large on the shop front. As an addition
to the presentation, Dean also showed ideas for graphics on
coffee cups, napkins, and various packaging ideas. "The more
ideas you show Pieter, the more tends to happen." she says.
This presentation, too, was "amazingly painless." With no
time to lose, the design team immediately went into concept
development, producing profile drawings of all the units,
which they gave to the contractor ECSEC, who did all the
working drawings for them to approve. "It was a good
partnership," says Butcher, "and a fast track to an end."

The client also approved every drawing. By now he had a
husband-and-wife team as chef and manager on board to
approve the floor plan. "It costs what it costs," said Totte,
who wanted to get the first shop right and, if it proved too
expensive, to introduce fine-tuning on subsequent sites. "We
have enough experience to know what things cost," says
Butcher "and to keep an eye on things." In all, there were
nearly 40 drawings—everything from a standard shelf system
with add-on elements, to complete new fixtures.

"I went on one site visit," recalls Dean, "but after that, the
client became our site foreman. It's very rare for it to happen
in this way. Working totally intuitively, he started with a
vision—and that's what got built."

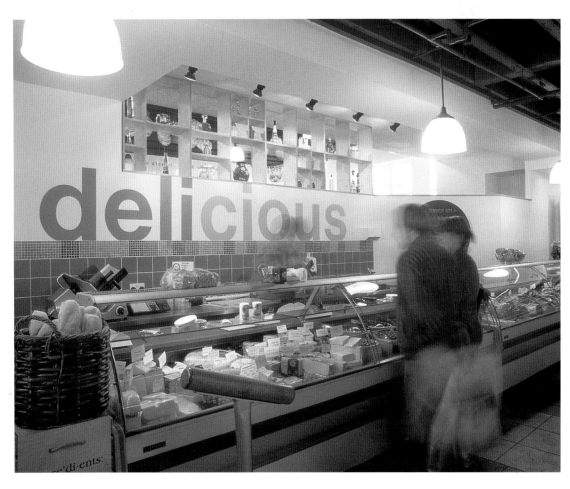

IN NOTTINGHAM, THE
THIRD STORE TO OPEN
12 MONTHS LATER, A
DELICATESSEN COUNTER
WAS INTRODUCED,
STRETCHING ALONG ONE
WALL. THE FLOOR WAS
LINOLEUM AND THE
CEILING WAS LEFT WITH
EXPOSED DUCTWORK.

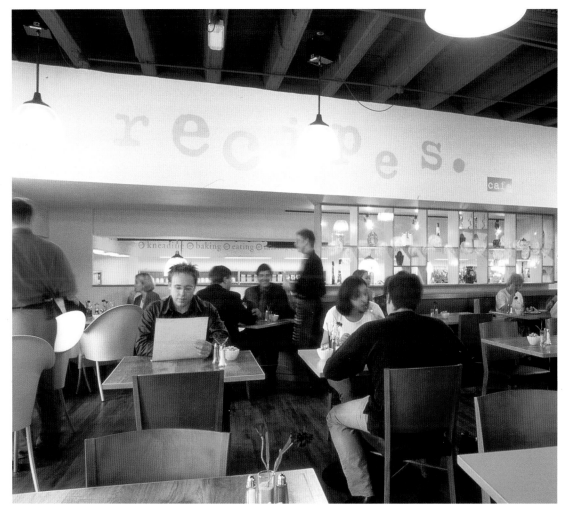

ON THE RIGHT-HAND
SIDE, THE CAFÉ HAD ALSO
INCREASED IN SIZE.

Seen

When freelance London-based architect Kulbir Chadha went to collect color prints of a recent retail project from her local Kodak processor, she can hardly have expected to pick up one of her most **creatively challenging design jobs** as well. But Chadha, who does a lot of small retail work, got talking to the two partners, Dilip Patel and Jay Patel, who ran the photo shop and who had, naturally, seen **the photographs of her other work**

The two Patels (no relation) had already got several Kodak Express mini-labs, two in the West End of London, which operated under the name Photoplace, and they were planning to open their next shop in a prestigious site in Regent Street. Wanting to create something different from most Kodak franchise outlets, they had used as their inspiration a concrete and metal interior in a futuristic movie they had seen. This is why Chadha's work appealed to them when they saw it. They thought that she would be capable of producing something totally different. Normally such outlets are a pretty standard shop-fit solution. Kodak leases to the franchisee the processing equipment and provides the signage and, of course, the processing materials. On this occasion, the Patels had formed a good relationship with Kodak and had found a tiny, half-unit to rent.

Not certain if they were serious or not, Chadha took them to see her most recent job, a shoe shop in the King's Road (see page 180). She had trouble with the size (or lack of it) of the space they had got and the size of the processing equipment they had ordered. "I did a little diagram plan in front of them. Dilip saw what I was trying to do immediately and asked me to go ahead," says Chadha.

"The onus is always on the architect to get all the imformation," says Chadha, and she finally had to demand that she be given the dimensions of the various pieces of equipment. Since they took up so much space, everything else had to be geared around them. In addition, there had to be a service space and provision for plumbing. Chadha solved the plan by sitting down with her clients and with a drawing of the shop, cutting out bits of black paper that represented the equipment and moving it around in front of them. "It was a very volumetric scheme," she says, and it involved an underlit counter with bar stools and a light box and a staircase up to a mezzanine level with extra work space.

PARTNERS JAY AND DILIP PATEL WERE WELL-KNOWN KODAK EXPRESS MINI-OPERATORS WITH A LIKING FOR THE LATEST NORITSU DIGITAL COLOR PRINTING EQUIPMENT. BUT THE SIZE AND TECHNICAL SPECIFICATIONS OF THIS EXPENSIVE TECHNOLOGY POSED A PROBLEM FOR THE ARCHITECT, WHO USED THIS SERIES OF COLOR PLANS TO FIND THE BEST USE OF THE SPACE. THE MAIN DIFFERENCE BETWEEN THESE THREE, SHE SAYS, "IS THE SPACE BETWEEN THE MACHINERY AND THE CASH DESK. THE DISTANCE BEHIND THE DESK AND IN VERSION TWO (*CENTER*) THE ADDITION OF A LASER COPIER".

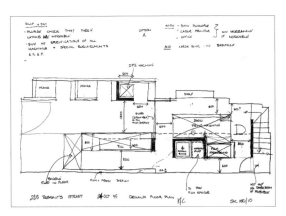

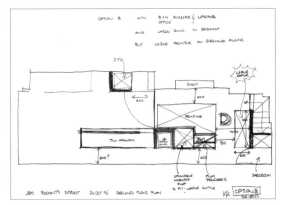

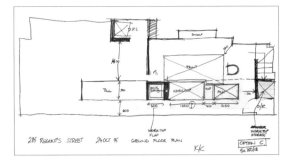

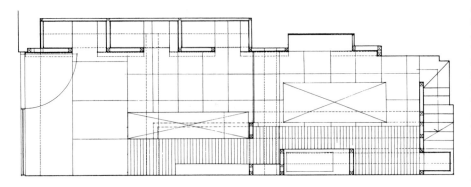

A PRESENTATION DRAWING OF THE ARCHITECT'S SOLUTION TO THE TINY SPACE. A STUD WALL AT THE BACK HID STAIRS TO A MEZZANINE LEVEL WHERE A GALVANIZED STEEL GRATING FORMED THE BALUSTRADE AND A GLASS WORK TOP PROJECTED OVER THE MACHINERY BELOW. ALL THE METAL WORK WAS DONE ONSITE BY ANDREAS ALEMAN.

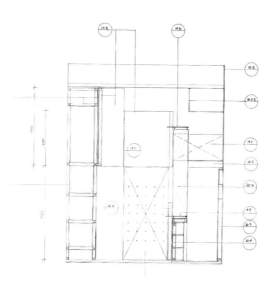

KULBIR CHADHA'S PASSION FOR SIMPLE GEOMETRY IS SEEN IN THIS PROFILE DRAWING OF THE TINY TWO-LEVEL SHOP. THE DRILLED GLASS PANEL DOUBLED AS DISPLAY AND ENTRANCE TO THE REAR OF THE SPACE WHERE ALL THE COLOR PRINTERS WERE KEPT. "THE DIMENSIONS WERE ALL CRITICAL," SAYS THE ARCHITECT.

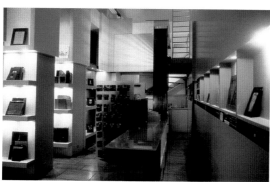

PHOTOGRAPHS OF THE FINAL SHOP, WHICH WAS THE WORK OF INDEPENDENTLY COMMISSIONED CRAFTSMEN, WHO BUILT EVERYTHING ONSITE. "THE SCHEME COST THE SAME AS ANY OTHER STANDARD KODAK EXPRESS MINI-LAB FIT OUT," SAYS THE ARCHITECT, WHO ALSO DID ALL THE GRAPHICS.

"It was very tight to fit it all in, but everything in the end just works."

At this point her client had two options—hire a contractor to handle the whole fit-out or subcontract the building work individually to different specialists, who might take longer but who would almost certainly be cheaper. The Patels chose the latter route. "They found all the people and I sourced all the materials," Chadha recalls. But that meant she had to produce very exact drawings for the Spanish blacksmith who was doing the metalwork. "He wasn't used to doing shop fitting to scale," she says. Nor was the client, who pushed ahead with the structural aspects, like the mezzanine floor, while the building application was being processed.

Before the metalwork came the plasterer, who did all the wet plaster work on the walls and ceiling, followed by the slabs of concrete for the floor. Then last came the two carpenters to make on site all the MDF (medium density fiberboard) panels, shelves and left-hand wall unit. "In all, the work took six weeks onsite, with Christmas in the middle," says Chadha.

"The tender price had been approximately $80,000. Doing the works in this way they cut the cost by half. Sometimes this is a better way to do it—my clients just loved the whole process of it, but I wouldn't recommend it to everyone."

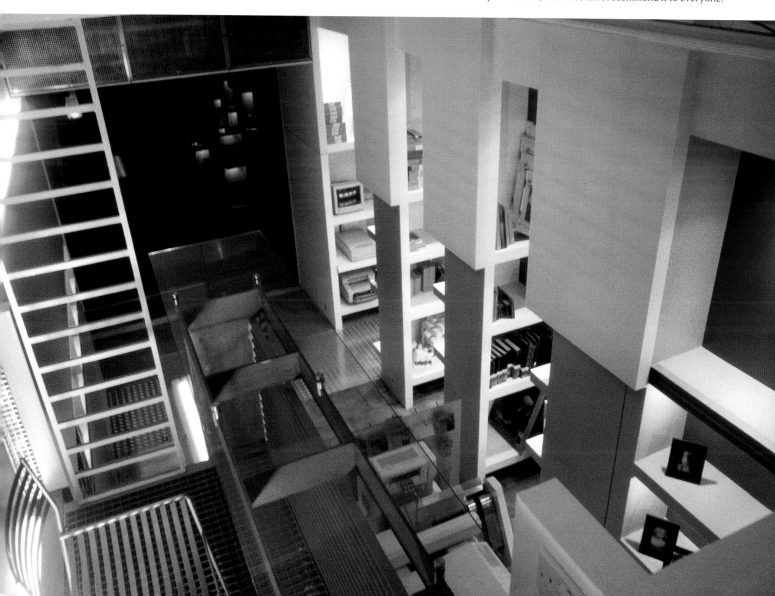

Costume National

When it came to his first New York store, the Italian fashion designer Ennio Capasa had to have "emotion." He wanted something unique, **something that embodied the quality of his monochromatic clothes,** even when there were no clothes in it. But this task was neither difficult or new, for he had designed his first store when he

was just 16 years old Over the last three years, Capasa has been heralded as "the number one designer for Hollywood hipsters" and acknowledged as such by being the first of a younger generation (he was then aged 36) to be invited to design the featured collection at Pitti Immagine Uomo, a men's wear trade show held each year in Florence, Italy. In 1993 his first men's wear collection had followed his women's collections and it proved to be an instant success. By 1997 he had stores in Milan, Rome, and Tokyo. Working with his brother Carl, and architect Cosimo Antonaci, he had evolved a formula of combining cubes and light boxes in simple white spaces.

"The architecture is simple. A box built out of other boxes, a machine of freedom, a compendium of different elements, which allow each person and piece to create its own authenticity. Elements can be taken away, added, joined together, and adapted to the space and the location. It's about light," says Capasa. "Like everyone, I feel good when I have nice light."

Capasa studied fine art in Italy, and he particularly enjoyed stage design. "The control of light is better in the theater than in retail," he observes. His parents owned a clothes shop in southern Italy, and when he was in his teens his mother asked him to design a shoe shop. As a hobby, he also worked on her three subsequent fashion stores as well as on ideas for his parents' two houses, one in Milan and one on the coast. After that, friends asked him to design their houses, but he found he could not work with their demands, doing things to order. "This business is not for me," he realized, and that is when fashion design beckoned. In 1983, at the age of 23, he spent his apprenticeship in Tokyo, working for Yohji Yamamoto.

THREE DRAWINGS SHOW THE DESIGNS OF THE DOORS. THE FRONT PIVOT DOOR, IN BRUSHED STAINLESS STEEL AND ETCHED GLASS (LEFT), HAD THE SAME 8-INCH SQUARE DOOR HANDLE (ABOVE LEFT) AS THE THREE FITTING ROOM VERSIONS (ABOVE) THAT WERE INFILLED WITH "STAR LIGHT FROSTED GLASS" (THIS PARTICULAR GLASS HAS NO GREEN TINT AND IS PERFECTLY WHITE).

THE OPALINE PLEXIGLAS CEILING-MOUNTED REAR LAMP COVERS INCLUDED A PROVISION FOR HOLDING THEM IN PLACE WITH HIDDEN METAL FIXINGS. ONE DRAWING ASKS FOR RECOMMENDATIONS FOR "OPTIMAL BALANCE BETWEEN THE EVEN DIFFUSION OF LIGHT AND SHARPNESS OF CORNERS AND VISIBILITY OF SEAMS."

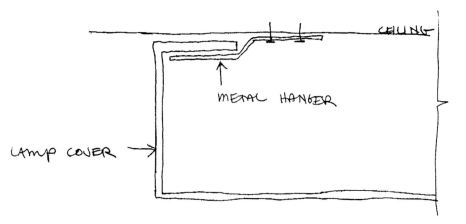

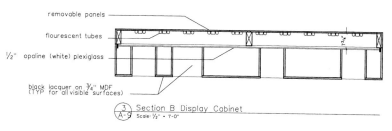

removable panels
flourescent tubes
1/2" opaline (white) plexiglass
black lacquer on 3/4" MDF
(TYP for all visible surfaces)

③ Section B Display Cabinet
A-9 Scale: 1/2" = 1'-0"

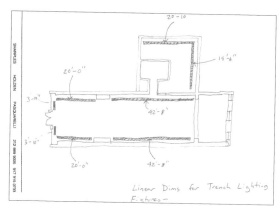

(RIGHT) STILL RELATING TO LIGHTING, THIS SKETCH INDICATES THE LINEAR DIMENSIONS FOR THE TRENCH LIGHTING FIXTURES AROUND THE PERIMETER.

Linear Dims for Trench Lighting Fixtures

AT THE FAR END OF THE STORE A WALL OF HAPHAZARDLY SIZED AND SPACED DISPLAY NICHES WAS MADE IN BLACK-LACQUERED 5/8-INCH MDF, BACKLIT BY 20 FLUORESCENT TUBES, CONCEALED BEHIND A LAYER OF 1/2-INCH OPALINE PLEXIGLAS.

(BOTTOM) AN ELEVATION PLAN OF THE LEFT-HAND WALL SHOWS THE POSITION OF ALL THE RAILS, SHELVING AND CEILING LIGHT BOXES, AS WELL AS A ROLL-DOWN SECURITY GATE, WHICH IS HIDDEN IN THE CEILING INSIDE THE FRONT DOOR.

(BELOW) FLOOR PLAN OF THE STORE AT 108 WOOSTER STREET IN NEW YORK, INDICATING THE SINGLE STEEL CLOTHES RAIL ALONG EACH SIDE WALL. THE

THREE CENTRAL PLEXIGLAS LIGHT TABLES AND THE SERIES OF PROJECTING PLEXIGLAS SHELVES, BOTH HALF-WAY DOWN AND AT THE REAR OF

THE STORE. BEHIND THE SCENES ARE STORAGE ROOMS, WASH ROOMS, AND CUSTOMER-FITTING AREAS, AS WELL AS A SMALL KITCHEN.

"I'd always wanted to have a store in New York, and for months we looked at different locations, including some on Madison Avenue. But I wanted to be down in Soho," says Capasa. Even before they found the space, Capasa was thinking of ideas for the interior. "I wanted to give my best, to do something really strong, with a sense of costume and of attitude; something that hadn't been done before. As soon as we found the site it helped me a lot, knowing it was a long, narrow space." Alan Firestone is a New York project manager, who was hired to negotiate the lease and coordinate the project onsite. This meant commissioning a New York architectural practice to translate into U.S. terminology all the design details as Cosimo Antonaci produced them and to hire all the contractors.

"The store that he found was at 108 Wooster Street, a long, vertical box—30 x 100 feet—with no obstructions, no cast iron columns. It had beautiful windows that had never been changed. In fact, the space used to be a plant store and hadn't been touched for 40 years," recalls Capasa. Negotiating the lease and getting planning permission took about five months. Not only were there New York building codes to deal with, but it was a landmark building owned by a cooperative, so even when the city authorities were satisfied with the details, the members of the cooperative had their own demands.

A New York survey architect was hired to define the parameters of the space. He sent a dimensional drawing to Capasa and Antonaci in Italy on a CAD disk. By this stage, they had decided to use all the standard elements—but in black. They used the square units and cube lights in a similar scale to their earlier stores, but because of the smaller space, they reduced the proportions. "We used light in the opposite way. It was important to be able to see the clothes, but only when you got up close. From a distance it could be like night time. I wanted the walls and the floor to disappear so that everything is floating. The commercial people thought I was crazy. No one believed it would work," recalls Capasa.

When he returned to New York he explained his plan to Firestone and the chosen architects, a keen young team called S.H.o.P. (Sharples Holden and Pasquarelli). In particular, Capasa wanted glossy black walls and a black floor that looked as it if was wet. Once they had got the demolition permit, the contractors moved in to take out the false walls

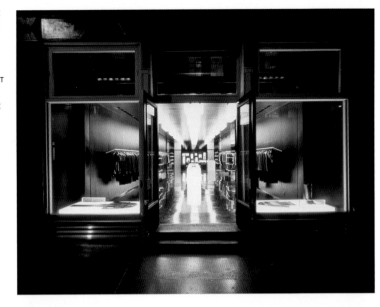

(FAR RIGHT) THIS SIMPLE DETAIL SHOWS HOW THE GLOWING FOOTWEAR SHELVES WERE LIT.

(RIGHT) FROM THE STREET THE COSTUME NATIONAL SHOP SEEMS TO RADIATE LIGHT, IN SPITE OF ITS ALL-BLACK INTERIOR.

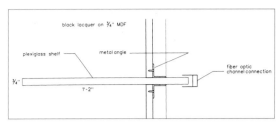

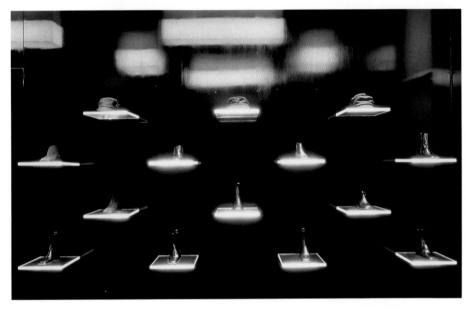

(ABOVE) TOWARD THE REAR OF THE STORE THE PLEXIGLAS SHELVES PROJECT FROM THE LACQUERED WALLS. AND LIGHT FROM WITHIN EACH SHELF ILLUMINATES THE PRODUCTS.

(RIGHT) THE ILLUMINATED FITTING ROOM DOORS.

(OPPOSITE) FROM INSIDE THE FRONT DOOR THE GLOSSY BLACK SPACE IS DEFINED BY ITS LIGHTING. ON THE CEILING A SERIES OF SQUARE AND RECTANGULAR LIGHT BOXES WAS SUPPLEMENTED BY TWO TROUGHS THAT CONTAINED HALOGEN BULBS (PRODUCED BY SYLVANIA). "WE HAD A LIGHTING DESIGNER AND AN ILLUMINATION EXPERT," EXPLAINS FIRESTONE. THEY EXPERIMENTED AS THEY WENT ALONG, ALLOWING SOME ADDITIONAL JUNCTIONS IN CASE EXTRA SPOTLIGHTS WERE NEEDED. BUT THEY WEREN'T."

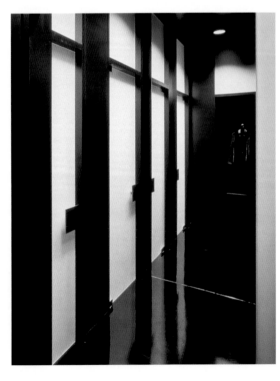

and floors and strip the building back to the basic box. "We made a number of discoveries, including pipes in the walls that couldn't be moved," recalls Firestone. "So we had to bring in both sides by 18 inches to conceal them and keep everything symmetrical." New plans were drawn up and sent back to Antonaci in Italy so that the scheme could be adapted.

In the meantime at S.H.o.P., one team set about sourcing materials and finishes; one team worked on converting the Italian drawings so that they were technically correct for U.S. permits; and one team dealt with all the legal aspects of the project. When the revised drawings arrived from Italy, they included all the lighting details and a selection of samples of the materials they had been using, including Plexiglas (for the shelves), frosted glass (for fitting room doors), and formica (for the furniture).

Inspired by Capasa's vision, of an equivalent to the "wet" floor effect already utilized in the Milan and Tokyo stores we found a material called "clear glass." On contacting the manufacturer we found that they also produced a nontoxic, nonporous epoxy flooring that was available in clear or black versions for use mainly in kitchens, cafeterias, and operation rooms, where its bactericidal properties were important.

One aspect of the project caused certain obstacles. When the ceiling lights were vacuum formed in Plexiglas, they turned out to have rounded corners instead of crisp, neat ones. Even mitered corners were unacceptable, and several tests were done before they achieved a perfect shadowless box. Although the architects knew what fittings they wanted, a lighting designer was brought in to work out the voltage and wattage, and tests were set up instore to check the number of fittings, the spread of light, and the type of bulb.

"The schedule was quite tight," recalls Capasa. "We wanted to open in August 1997, but what with permits and the paperwork, we couldn't. We were three weeks late. But when I saw it, it seemed exactly right, and I still wouldn't do it differently. A kind of elegance came out of it. For the next store in Osaka (August 1998) I have an evolution in mind, in the same way that I work with my clothes. Others can change from one collection to the next, but I can't. Stores and clothes have a lot of things in common: they give definition to a space. One happens to be built around a body, and when you dress a body it has a temperature, an emotion, a sentiment. When you dress a space, the relationship is very different. It doesn't have a heart you have to add the heart— but it's still about how you define the space. One is inside and one is outside. You use the same values."

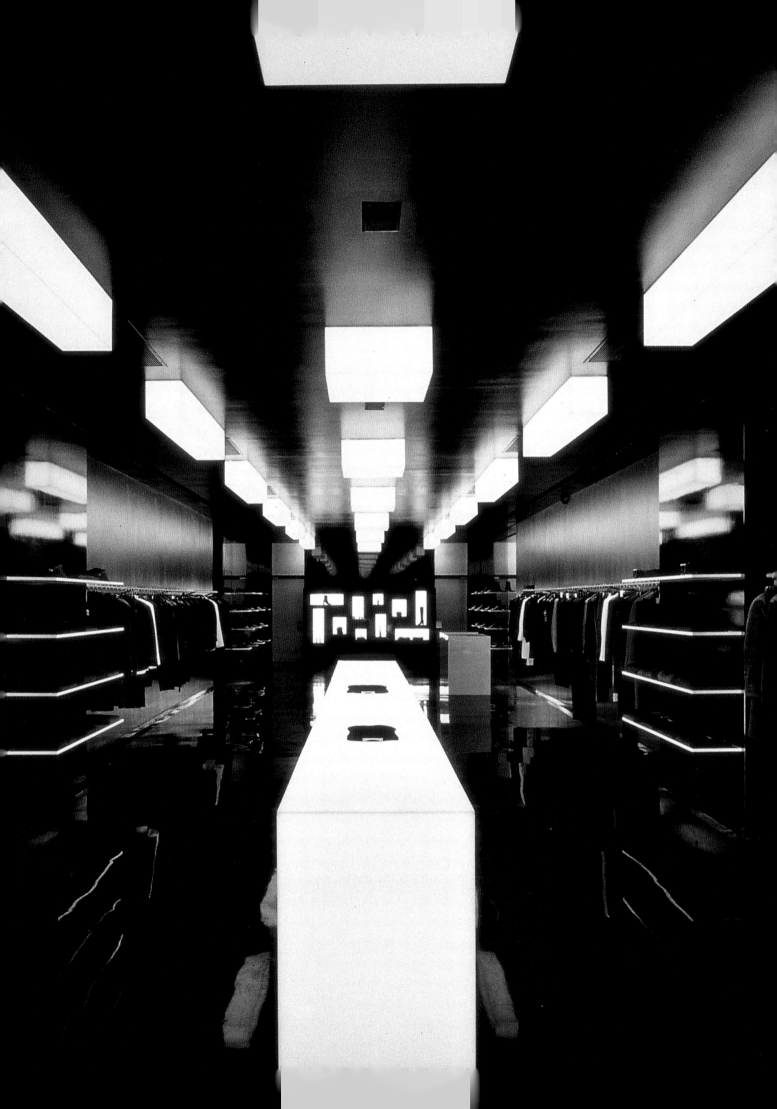

Colette

Like its name, Colette is a very simple store, says Sarah, one of its three creators.

"Everyone was saying nothing's happening here in Paris, so we decided to do something. Even so, when it opened, it generated so much excitement that we were very surprised. **We didn't expect so many people would come"**

Perhaps it's the mix of products, which range from fashion to art, to gifts, to food; perhaps it's the refreshingly relaxed attitude to retailing shown by the owners. "It all started when we found this beautiful space, in a three-levels building in the center of Paris, near the Place Vendôme, which had been empty for a long time and had, apart from its restored façade, just been demolished and rebuilt," says Sarah. Colette, Sarah, and Milan joined for this concept. "We set out to find a name that would work in English and Japanese as well as in French, and in the end we used my mother's name. It is so simple, and we liked the old-fashioned and essentially French sound, which was in contrast to the very modern store." They all knew Arnaud Montigny, a young French architect, who had worked for Colette several times, most recently on her apartment. "This was his first retail project. The building was in good condition, but needed new ceilings and a new staircase, and we wanted something very light and very simple."

When Montigny first saw the building, it was, he recalls, a skeleton, with concrete floors and a spiral staircase in one corner. Having designed and redesigned Colette's showroom many times over the previous 10 years, he knew her taste and her clothes, and they had visited a lot of stores both together and separately. "We were on the same wavelength," he says. "Colette told me what she would like to have in the store, but she didn't know where or how. At this stage, she just said: 'It's

TO THE NEWLY REFURBISHED BUILDING ON THE CORNER OF RUE SAINT HONORÉ AND RUE DE 29 JUILLET IN PARIS. THE ARCHITECT ADDED SMALL FABRIC WINDOW SHADES AND REMOVED THE GLAZING BARS IN ALL THE WINDOWS. THE STORE'S NAME APPEARED ON THE BOTTOM OF EACH WINDOW.

EARLY SKETCHES BY MONTIGNY OF THE SECOND FLOOR SPACE SHOW AN IDEA FOR THE COLUMNS WITH CHUNKY BEAMS SUPPORTING A LOWERED CEILING *(RIGHT)* AND ONE OF SEVERAL SCHEMES HE CONSIDERED FOR A SHOWCASE TO DISPLAY PRECIOUS PRODUCTS AT THE TOP OF THE STAIRS *(FAR RIGHT).*

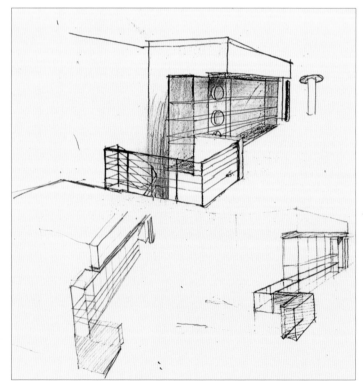

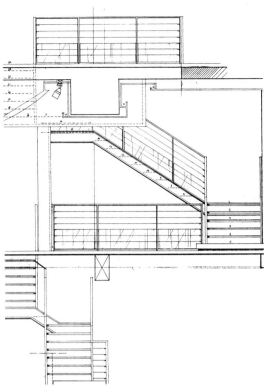

BY FAR THE GREATEST NUMBER OF SKETCHES IN THE ARCHITECT'S FILE CONCERN THE DESIGN OF THE NEW STAIRCASE. IN THIS SERIES, THE TEAM ADDED A LARGE FOOT PLATE AT THE BOTTOM OF THE STAIRS *(LEFT)*, CONSIDERED THE DIRECTION OF THE HANDRAIL *(BELOW LEFT)*, THE TURN OF THE TREADS AND VARIOUS OTHER OPTIONS, INCLUDING *(RIGHT)* THE POSITION OF GIRDERS TO SUPPORT ONE OF THE LANDINGS.

ALTHOUGH MOST OF THE SHOPFITTING UNITS SEEM TO BE SIMPLE BOXES, PLINTHS, AND SHOWCASES, THE ARCHITECT'S SKETCHBOOK REVEALS DOZENS OF TINY IDEAS THAT WERE DEVELOPED IN DISCUSSION WITH HIS CLIENTS.

your project—you design it for me.' I knew she didn't want it to be like anything she had seen before," he adds, "and neither did I. But I took it further and added some overscaled elements—large openings, big doors, monumental staircases—which I had to work hard to convince her about." Once the plans were approved, Montigny carried out a site survey and asked a team of engineers to do a feasibility study.

"When I first saw the building," he says, "I thought it was just one floor, not three. I didn't have a vision of the scheme. It's just based on the beautiful space." One of the most important ideas was to have an opening around the large central staircase so it is possible to see up and down to the other levels. "I knew it would cost a lot, but I told them that it wouldn't work without it," says Montigny, whose initial budget was for "the envelope." "I could have spent twice as much, but they trusted me to do it in their best interests."

Fellow architect Cyril Issaverdens, who collaborated with Montigny on the scheme, recalls: "We didn't want to make it a loft space. It had to have more presence." Both architects agreed that one of the most important elements was the ceilings, which were lowered to conceal the services or highlight the merchandise fittings. All the walls, apart from one corner that was left in its raw, unfinished state, were painted white or gray, and the shopfitting pieces covered in gray laminate. "I wanted the fittings to be as flexible as possible so that they could be regrouped or even cut down and re-built," says Montigny. "Apart, that is, from the glass units for the beauty area on the first floor."

The 7535 square foot space was divided into three floors: the basement, which they allocated for an all-day restaurant; the first floor, which was devoted primarily to beauty products, design items, electronic accessories, and trainers;

SEVERAL SKETCHES
SHOW THE DEVELOPMENT
OF THE CASH DESK AS A
SERIES OF LAMINATED
BOXES AND PLINTHS.

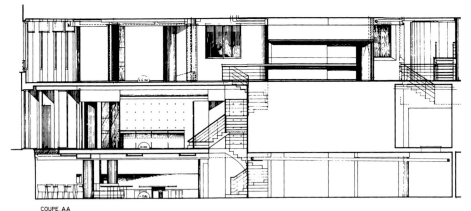

COUPE AA

THE FINAL SCHEME OF THE STORE IS SEEN IN THESE TWO CROSS-SECTION DRAWINGS, IN WHICH THE NEW CENTRAL STAIRCASE LEADS DOWN TO THE RESTAURANT AND UP TO THE SECOND FLOOR AND MEZZANINE. ON THE FIRST FLOOR *(LEFT)* "VERY UGLY" BEAMS IN THE CEILING WERE CONCEALED BY CURVED BAFFLES.

(BELOW LEFT) DOWN IN THE RESTAURANT CEMENT-FINISH AND STRUCTURAL-STYLE MOLDINGS WERE USED TO ACCENTUATE THE "MORE MODERN" BLACK AND GRAY SCHEME.

and the second floor, where they put men's and women's clothing from well-known designers as well as up-and-coming talent. On the mezzanine there was space for temporary exhibitions from artists and photographers, plus books, music, and magazines. As if to emphasize the mix, they added a subtitle to the name 'Styledesignartfood.' "A lot of shops now tend to look the same. We didn't want it to look tired in two years' time. It's o.k. for fashion to be 'of its time' but not architecture."

On the second floor they wanted the clothes to be shown on mannequins or folded on tables. "No hangers," says Sarah, who admits that they had to add a few later for coats and "special clothes." "We wanted them to look like art objects. People have to pick them up and try them on and not be afraid to touch anything. Not everything is expensive." The presentation of it is very important to us because we want to give the best look to each product."

"The job was full of compromises and challenges," she continues. "We had to destroy the stairs completely and put in new ones. I was afraid that the industrial style stairs Arnaud suggested would look too cold, but usually they seem to be working very well," she admits.

They were working to a 10-month schedule, and Montigny and Issaverdens were doing all the detailing. "People said it was impossible and that it would take two years; it was very fast, and we had Christmas in the middle."

"Although the initial concept was accepted right away," adds Montigny, "one thing that was in dispute was the order in which we did things. I insisted that we do all the technical

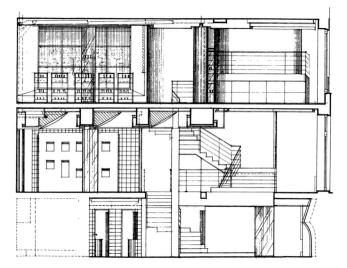

(RIGHT) THIS VIEW OF THE FIRST FLOOR SEEMS DOMINATED BY THE GRAY UNITS THAT WERE DESIGNED FOR MAXIMUM FLEXIBILITY AND BUILT IN FRANCE . THE FLOOR WAS COVERED IN A GRAY-BROWN STONE CALLED CASCAIS, NAMED AFTER ITS SOURCE IN PORTUGAL.

and logistical things first—the services and structural aspects—whereas they wanted to do the esthetic part."

The planning authorities also presented additional problems when they insisted that the retailers added an elevator. "We couldn't open without it," says Sarah, who admits that it turned out to be a good idea. "But it was very expensive and very difficult to know where to put it.

"We didn't know if the shop was going to work or not, and we'd probably do things differently now—an extra cash desk, for instance. We've already put new shelves in the épicerie part of the restaurant and changed the legs on little tables we use for shoes, which were not stable."

With only 4 1/2 months onsite, including the time for completing all the building and finishing work, the shop opened on schedule on the first day of spring in 1997.

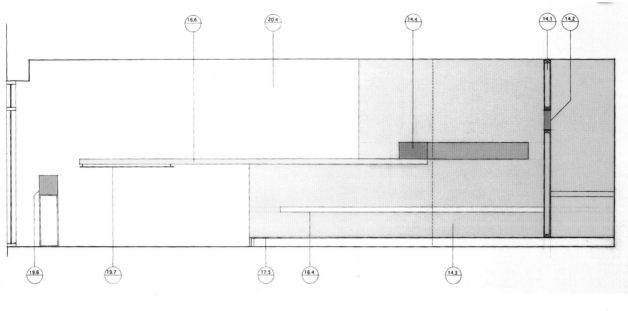

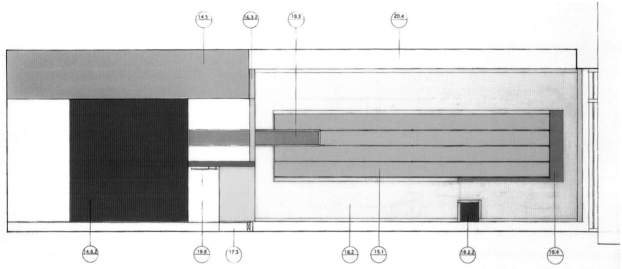

THESE TWO WALL PROFILES FORMED PART OF KULBIR CHADHA'S CLIENT PRESENTATION, AND THEY HELP EXPLAIN AN APPROACH TO THE FITTING OUT OF THE SHOP, WHICH SHE DESCRIBES AS "ARCHITECTONIC." THE HORIZONTAL PLANES COME OUT TO GREET YOU AND PULL YOU INTO THE SHOP. IT WAS INTENDED THAT SHOES WOULD BE DISPLAYED ON THE RIGHT-HAND SIDE ONLY (*BELOW LEFT*), WITH JACKETS AND HANDBAGS ON THE LEFT.

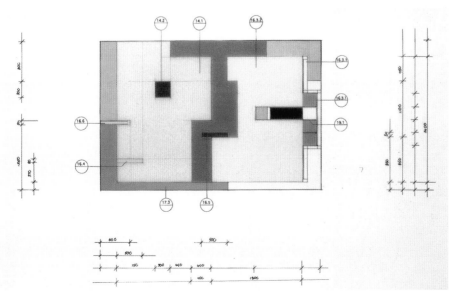

"I USED COLORS ON THE PLANS TO SHOW HOW THE SPACES RELATED TO EACH OTHER. SOMETIMES THEY WERE PAINTED THAT COLOR, SOMETIMES NOT," SAYS CHADHA, WHO CONFESSES THAT SHE FOUND A WHOLE LOT OF COLORED FILM IN THE STREET ONE DAY AND "STUCK IT ON THE DRAWINGS TO GIVE APPEAL". IT CERTAINLY MAKES THE COMPLEX SERIES OF LAYERS EASIER TO UNDERSTAND.

THE FLOOR PLAN OF THE
LITTLE SHOP SHOWS HOW
THE ARCHITECT DIVIDED
THE FLOOR INTO TWO
LEVELS AND CONCEALED,
WITH A SERIES OF WALL
PANELS AND SCREENS,
CHANGES IN THE WALL
LINES AND STAIRS TO THE
BASEMENT STOCKROOM.

qualities I can bring out. What I can retain and what should be removed. How are the horizontal and vertical planes going to go, and what's the big idea—is it solid or a thin film applied to the walls? I look at the functional ideas and the architectural ideas in tandem. Architect-designed shops are different," says Chadha, "because they are a more integrated solution."

Although she did "loads of sketches" of other ideas, she says, "I spend a lot of time with the client at the briefing stage and often start sketching in front of them, while looking at the site. Options are good, but if you can determine what a client wants it's easier." She finds that this helps them form their own opinion too. "I go on and refine it according to my own vision after that. Some clients do not follow the sketches, and find them confusing so I try not to saturate them. We go to the site and I explain in broad terms. I mark out the plan on the floor with masking tape. Clients really appreciate that. Most clients just trust me—it's very flattering—but that's why the shops I've done have been very successful because of their full hearted backing."

Her solution for Lello Bacio involved layering the walls with a combination of maple and MDF. "creating distractions away from existing features that were not attractive," explains the architect. To this end she found a joiner who had done a similar fit-out for a friend of hers. "I did plans and six cross-section elevations, and I worked out the main footage of the display areas. Everything was fine," she says. The joiner built everything on the premises. "It took a long time, four weeks, but because he was a craftsman he did a better job in the end." Chadha is very particular about who is doing the work, and because she lived nearby, she was able to pop in as often as needed. "Quality can vary a lot, depending on how much a contractor understands and supports what you are trying to achieve."

Although the shop was not large, Chadha managed to create the illusion of space with the use of mirrors, planes, and color. One wall could be repainted each season. "With a small budget I try to work with standard size sheets of MDF or plywood. The shop was opened with hardly any changes, although a window display was added some time later.

THE FINAL SHOP AT 311
KING'S ROAD WAS, SAYS
CHADHA, "DESIGNED FOR
THE SCALE OF THE
PRODUCTS, WITH
SHELVES THE SIZE OF A
SHOE AND NICHES
CREATED TO FRAME JUST
ONE. THE ELEMENTS
THEMSELVES ARE VERY
SIMPLE, SO THAT
PRODUCT COMES TO THE
FRONT." ONE WALL WAS
MADE IN MAPLE AND THE
OTHER IN M.D.F. PAINTED
IN TWO TONES OF A
"LUMINOUS LIGHT GRAY".

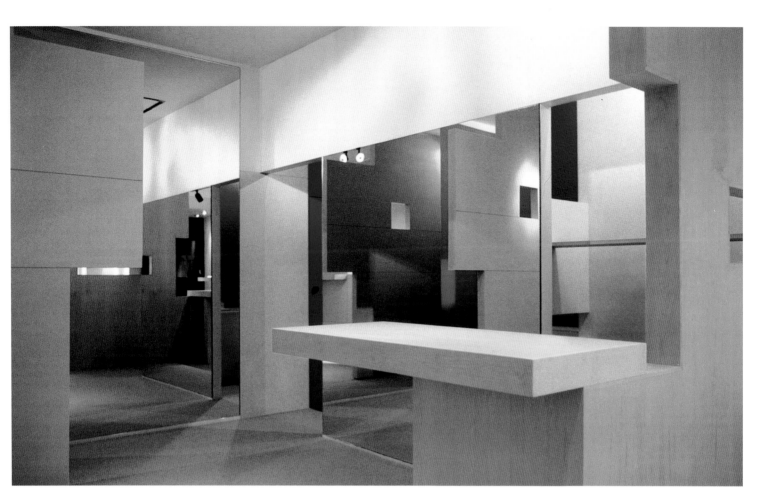

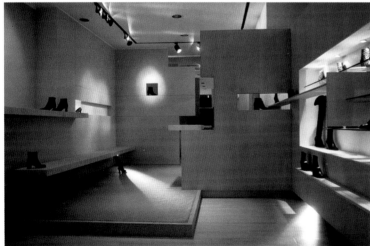

ELSEWHERE THERE WERE THREE MIRRORS—ONE FACING THE CUSTOMER, ONE AT FLOOR LEVEL AND ONE AT THE REAR—FOR VISUAL EFFECT. "YOU LOOK THROUGH THE GAPS. THE RED WAS INTENDED TO BE REPAINTED EACH SEASON, AND THE BLUE, WITH ITS ASSOCIATION WITH SKY, HAS A WAY OF EXTENDING THE SPACE," EXPLAINS THE ARCHITECT.

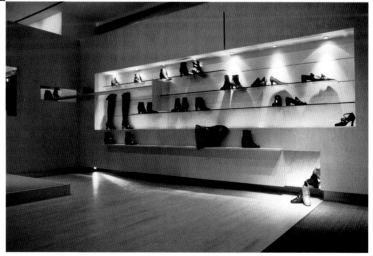

Cucinaria
This unusual Hamburg kitchen shop was conceived and created by its owner, Rolf Jehring, who was inspired by the building, a derelict, turn-of-the-century spice mill. "It's been a problem all my life, telling someone what I want. Most of my ideas I have to realize myself," he says. In this case, referring to the interior, he adds: **"The main thing I did was to do nothing"**

ONCE AN OLD SPICE MILL ADJACENT TO THE HAMBURG SLAUGHTERHOUSE, THE BUILDING WAS DERELICT WHEN ROLF JEHRING FIRST SAW IT.

ALTHOUGH THE BUILDING WAS RELATIVELY CLEAN AND BRIGHT, THIS PHOTOGRAPH, TAKEN TWO YEARS BEFORE ITS TRANSFORMATION, GIVES LITTLE HINT OF THE DRAMATIC RETAILING SPACE IT WAS TO BECOME.

(*BELOW*)THE PLAN OF THE 5,920 SQUARE FEET SPACE SHOWS HOW THE CHECKERBOARD PATTERN OF ASPHALT TILES CHANGED DIRECTION WITHIN THE CENTRAL RECTANGLE OF THE EXISTING COLUMNS.

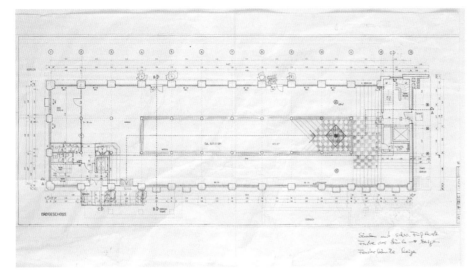

Jehring has been in the kitchen business for 20 years, but it was not his first career. His father had a furniture shop in Bonn, and Rolf joined it when he was 19 years old, and in 1976 his father bought him his own shop in Trier. He married a woman from the Netherlands, and after five years they realized that they could no longer live in Trier. "It was too small for us and the business, and there was no future there," he explains. So they moved back to Hamburg, where Jehring got a job as general manager of a new and fashionable store called Magazin. Created by Willand Hachfeld, it sold furniture and living accessories to architects, designers, and design-oriented people at reasonable prices. It was an enormous success. "In the first year we took one million Deutschmarks, and by the time I left, five years later, sales had risen to 12 million DM," says Jehring. During that time, they opened a second branch in Hamburg and branches in Frankfurt and Berlin. "The only problem was that, because of a lack of organizational structure and computer backup, it wasn't possible to continue to expand at the same rate."

Starting out afresh, Jehring and a partner bought a wholesale company called Duerkop, which sold classic, well designed products for the home. After six years his partner found that growth was too slow. "My partner wanted to expand the business in the low value market, but there was too much competition. Everyone was selling this type of product and profit margins were too low. In my opinion, it was the wrong way to go," explains Jehring.

So in 1996 he sold his shares to his partner and decided to start again. "I didn't know what I wanted to do. I spent a year as a freelance product scout for various china and houseware companies, visiting about 40 trade fairs a year, from China to San Francisco. My contract stipulated that I couldn't start up another company in competition with my previous partner, and anyway, the market was too small for another wholesale company in the same niche. I wanted to use my product knowledge, and I'd seen various stores like Dean and DeLuca, Crate and Barrel, and the Pottery Barn and there was no one in Germany who had a large and competitive cookshop."

The idea had been taking shape in his mind for three months, when a series of serendipitous events occurred. "I was working with a company that made the machines for spraying enamels. Because they needed to vary the area that was lacquered, they had produced a flexible system of components, which included perforated metal legs and adjustable shelves. When I saw it, I realized it would make an

ALTHOUGH NEITHER AN ARCHITECT NOR AN INTERIOR DESIGNER, JEHRING SKETCHED OUT HOW HE IMAGINED THE METAL FRAME UNITS MIGHT LOOK AS A KITCHEN WORK CENTER.

(LEFT) JEHRING'S FIRST INTUITION WAS TO PLACE A ROW OF SEVEN TABLES DOWN THE CENTER OF THE SPACE. IN THE FINAL SCHEME, HOWEVER, THESE WERE REPLACED BY ONE LONG TABLE, CREATING A DRAMATIC EFFECT THAT REQUIRED BOTH CUSTOMERS AND STAFF TO WALK ALL THE WAY TO THE END BEFORE THEY COULD CROSS TO THE OTHER SIDE OF THE SHOP.

ideal shelving system. They only built the system for themselves, but I asked them to make enough for a shop."

When it came to the building, Jehring had in mind a factory he had seen when he worked for the Magazin company. He looked around Hamburg and discovered a building in a very run-down area of the city. Since the adoption of new regulations imposed by the European Union, the complex had lain empty for five years, and the entire surrounding area had become home to squatters and vagrants. "It needed someone with a lot of imagination but that's what I had. As soon as I saw it, I knew what it could be," explains Jehring. "I'm a gambler. I wasn't in a hurry. If it wasn't successful right away, I didn't mind. I knew it was a risk. My friends all told me I was mad, but it's not the first time they've said that."

Jehring's concept for the shop was to sell everything to do with the kitchen, in the widest possible range—apple-peelers from 9.50 DM to 285 DM—and to work on the same basis with equipment ranging from espresso machines and knives to cooking pots. "It was a very big undertaking," he says. "I wanted to do it in my own way and not copy someone else." The building he chose was an old spice mill, which was adjacent to the former slaughterhouse. "It was damp and dirty, and the upper floor had been burned out two years before. A bank had begun to develop the area, when no one else had the vision or the confidence to invest, so when I took the first floor and basement, it was the impetus other shops needed to follow."

Jehring gave instructions to the developers about how he wanted the shell of the building to look, and they did the work. The floor was laid with asphalt tiles from DASAG in Germany. The standard module, 10 x 10 inches was too small, so Jehring had the two-tone checkerboard of beige and dark gray squares laid in units of four at a time. The steel cladding that had been added around the columns to protect them from production-line trucks was removed, and the windows were replaced in the same style as existing ones by wooden framed copies painted to look like gray metal.

"At that stage it was just me and a secretary. We went in every day to keep an eye on things and help out. Basically, I just took everything out," says Jehring. "We sealed all the rust and then painted it all with six coats of white paint. It looked

(ABOVE AND LEFT) JEHRING ASKED GRAPHIC DESIGNER STEPHAN GARBE TO PRODUCE A SERIES OF LOGOTYPE IDEAS FOR THE SHOP—AT THIS STAGE CALLED CULINARIA—BEFORE FINALLY DECIDING ON AN ADAPTATION OF CUCINA (KITCHEN) AND CULINARIA (COOKART).

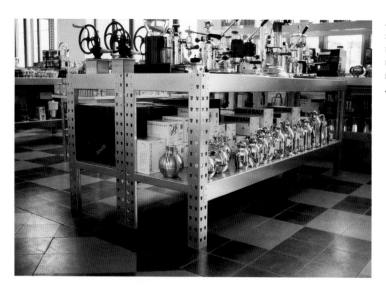

A METAL SHELVING SYSTEM PROVIDED THE RETAILER WITH THE INSPIRATION TO GO INTO BUSINESS ON HIS OWN ACCOUNT.

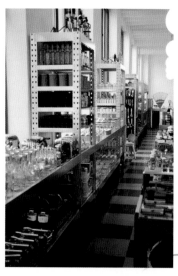

A SERIES OF TALLER UNITS WAS PLACED BETWEEN THE HUGE WINDOWS ON EACH SIDE OF THE SHOP, WHILE AT THE FAR END *(RIGHT)* A WORKING KITCHEN CONTAINED UNITS THAT WERE ALSO FOR SALE.

THE ONCE-HIDDEN RIBS IN THE CEILING WERE EXPOSED, AND A LIGHTING SYSTEM—"A VERY SIMPLE FIXTURE THAT IS MADE FOR CHURCHES AND GIVES A GOOD LIGHT," SAYS JEHRING—WAS SUSPENDED IN THREE ROWS FROM A 2-INCH-WIDE GALVANIZED STEEL TUBE.

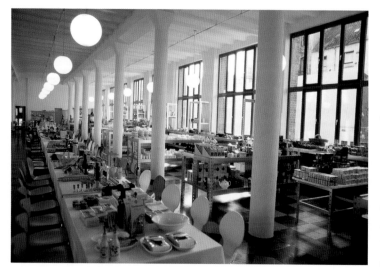

very beautiful. I would have liked to have left it empty for ever."

He did a few sketches for the layout of the merchandise units and realized that the space needed something big in the center. At first he made a diamond shape out of seven tables, but when he looked at the actual site again, he changed it to one long table right down the middle. "Everything in the kitchen centers around the table," explains Jehring. The floor pattern had given the space a 20 x 20-inch grid, which he needed to follow with the merchandise units. He designed shelves that were 24 inches deep (the same depth as kitchen units), and the rest followed without making a mock-up first. "All I had was one sample leg and one shelf," says Jehring. "I had a bit of a feeling that the size would be right." The height of the units varied, with lower units of 30 inches high, in the center, and taller ones against the walls between the windows. He left four aisles, one along each outside wall and one each side of the long table. "I didn't use any rules of standard retailing. I let people go round the whole shop, because they can't cross the table from one side to the other." It's a disadvantage from the staff's point of view. Jehring says that he has to walk the 65 feet stretch 20 or 30 times a day.

When it opened on September 13, 1997, Jehring's two daughters came in to help out. "One of the most difficult things I found was to get good staff who know about the products and the materials and how they are used. It's the worst problem—even if we have 4 million people out of work, it will still be a problem," confesses Jehring, who holds cooking lessons for 10 customers in the store every second Saturday. Thinking about the reasons for the store's success, Jehring admits that people say they have never seen anything like it. "Perhaps it's the combination of the space, the wide product range, the personal selection of international merchandise and the good prices," he says. "I didn't realize that there would be so much attention from the world press and from the public. People have been coming from Holland and all over Germany. I've even started a website. Thiery Mugler wants to launch a new perfume here, and someone asked if they could have a huge dinner party at the big table."

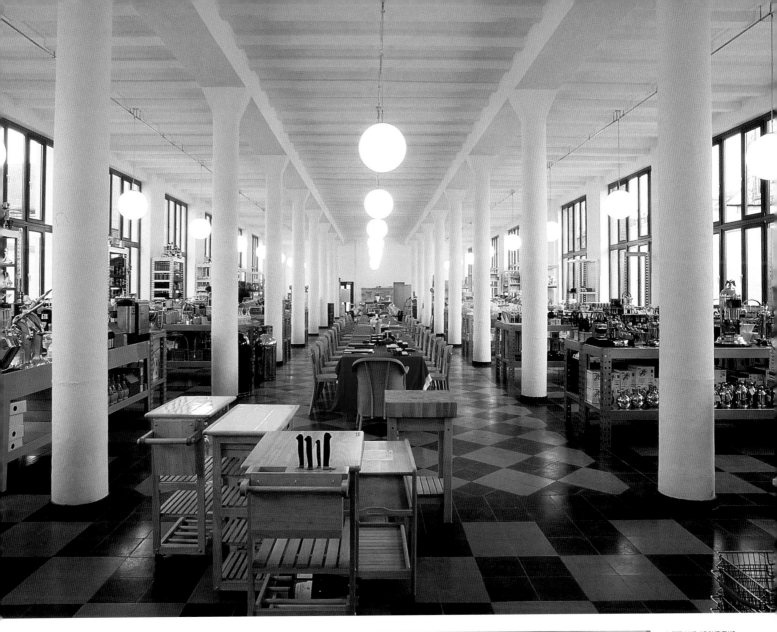

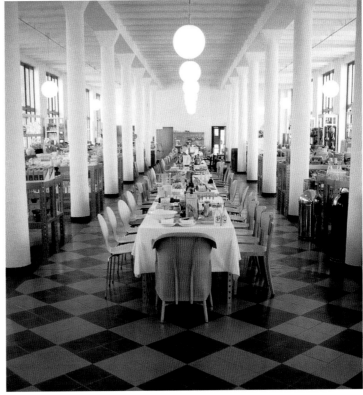

(LEFT AND ABOVE) TWO VIEWS OF THE 100-FOOT LONG TABLE, WHICH WAS MADE UP IN 10-FOOT SECTIONS. THE DISPLAY CHANGES IN COLOR AND THEME EVERY THREE WEEKS.

Vasari

The creators of this store used a **spatially powerful** architecture to help make the retailer's variety of merchandise more visible and comprehensible. "By sending a succinct visual message to the customer, the single, streamlined space maximizes product display and guides the occupant's eye and body without visual or physical interruption"

Mark Macy, a partner in the San Francisco-based firm Jensen & Macy, continues: "It achieves, from both the inside and the outside, a high degree of visibility and transparency along with a simplicity that is neither reductive nor alienating." Jensen & Macy began working with Vasari, a Las Vegas-based retailer, in 1991 and had designed four other menswear stores for the owner, Ardavan Najmabadi when he once again approached them for something entirely different . "As recently as the last decade, it was common for every store to have its own individual look, its own identity," says the other partner, Mark Jensen. "Currently, there seems to be a tendency toward a pared-down generic minimalism. Our client wanted something that was simple, clean, and functional but also unique and inviting; a look that did not ape the well-known brands. It was imperative that it serve as an analog to his long-standing approach to business."

EARLY IDEAS FOR THE CEILING OF THE MALL SITE STORE INCLUDED 13 EQUALLY SPACED DISCS (*LEFT*). IN FACT, MOST OF THE DESIGNERS' DRAWINGS CONCERN THE SOLUTION FOR THE CEILING, WHICH ON SOME DRAWINGS (*ABOVE*) WERE CHARACTERIZED AS A SERIES OF PROJECTING DISCS AND ON OTHERS AS A RECESSED DOME, COMBINED WITH TROUGHS BESIDE EACH WALL TO CONCEAL LIGHTS THAT WOULD "WASH" THE WALLS.

IN THIS DEVELOPED DRAWING (*BELOW*), DONE TWO MONTHS LATER, THE CEILING COFFERS CAN BE SEEN TO CORRESPOND TO THE FURNITURE LAYOUT BELOW, WITH CIRCLES ON THE WALL REPRESENTING THE WALL PUCKS.

Their design process normally includes three important meetings and, based on a largely verbal brief, the architects produced a variety of conceptual sketches for the long, thin space. "We decided to look at ways to emphasize the space with a variable of configurations of modular display using repetitive elements. The formal problem of modular or serial composition is not the accentuation of the center but how to finish the extremes." Additonally they paid close attention to the ceiling. "We spend a lot of time on ceilings in general," explains Macy. "It's a very important element and potentially powerful aspect of a store that designers often ignore." The view as a customer goes into a store and all the clutter that

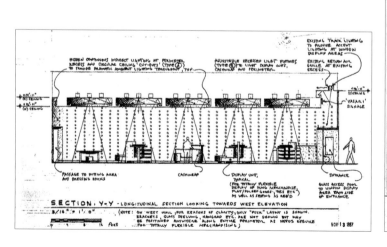

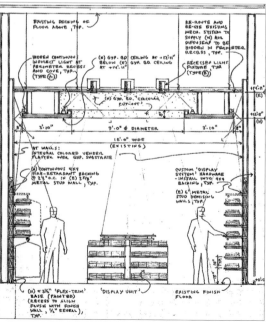

IN GREATER DETAIL, THE CEILING (ALTHOUGH NOT THE FINAL PROFILE) CAN BE SEEN TO HAVE BEEN LOWERED TO ACCOMMODATE ALL THE SERVICES. IT IS A SIMPLE CONSTRUCTION OF RELATIVELY INEXPENSIVE GYPSUM BOARD, ANIMATED BY THE USE OF CONCEALED LIGHTING.

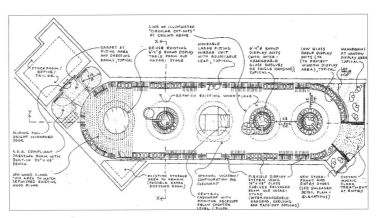

THE FLOOR AND CEILING PLAN SHOWN AS EARLY SKETCHES. TWO CHANGING ROOMS WERE SET OFF AT AN ANGLE AT THE BACK OF THE STORE AND THE WALLS HELD A COMBINATION OF COMPLETELY INTERCHANGEABLE SHELVES. HANG-RAILS AND FACE-OUT BRACKETS.

A COMPUTER RENDERING OF ONE OF THE "SPATIAL CASTINGS". THIS ONE FROM ABOVE. "IT'S AS IF YOU TOOK A PLASTER CAST OF THE SPACES INSIDE THE STORE," EXPLAINS MACY.

THE DISPLAY UNITS WERE A SERIES OF CIRCLE-BASED, MULTI-LEVEL FIXTURES EVENTUALLY MADE OF MEDIUM DENSITY FIBERBOARD, AN AMALGAM MATERIAL THAT THE ARCHITECTS REFER TO AS A KIND OF "TOFU", IDEAL FOR CABINET-MAKING BECAUSE OF ITS STABLE AND MONOLITHIC NATURE.

typically occurs up there—light fixtures, heating, air conditioning, smoke alarms, fire sprinklers, strobe, and music systems—typically gets overlooked. "Normally a designer will try to organize it all, but we wanted to go further, we wanted to conceal it," says Jensen. It became a critical part of the store and provided a strong theme that they then reflected in both the placement and geometrical display units below. "We showed the client several alternatives. He's a pretty visual person and was able to get a good understanding of our ideas," recalls Macy. "We ultimately went ahead with a seamless, streamlined approach. It projected a crispness while avoiding a hard-edged look and it aided movement; promoting a graceful and easy flow through the space. The idea of an environment rendered in one predominant material appealed to them, and although they costed making the entire store out of an

integrally-colored veneer plaster, they decided that the overall effect was not dependent on the use of an expensive or precious finish. "Eventually, we used painted gypsum board," says Jensen. It is an inexpensive and entirely common material that challenged us to make it extraordinary through thoughtful detailing; keeping the focus on the overall spatial effect."

The merchandise system combines maximum simplicity and maximum flexibility. It consists of a series of aluminum "pucks" that stud the walls at regular horizontal and vertical intervals. These pucks accept a variety of shelf, hang-rail and face-out brackets and allow for an infinite variety of display configurations. "Compared with Vasari's previous store, the design of this new one provided an equivalent amount of flexible display space within 23 percent less rentable floor area," adds Macy.

A COMPUTER DRAWING OF THE STORE. "ACHIEVING THE REQUIRED AMOUNT OF FLEXIBILITY WHILE PRESERVING ORDER AND CLARITY" SAYS THE ARCHITECT. IN THIS CASE, ANYTHING CAN GO ANYWHERE AND THE OVERALL EFFECT IS MAINTAINED."

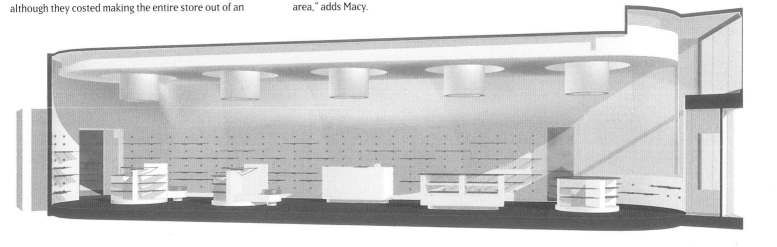

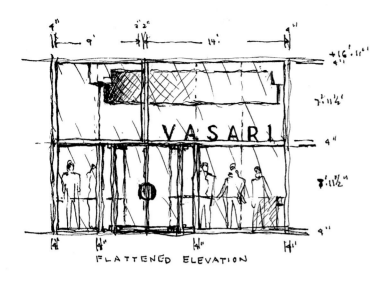

FLATTENED ELEVATION

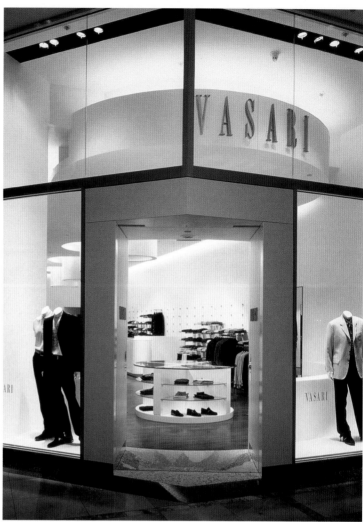

THE WHOLE STORE CAN BE SEEN FROM THE FRONT DOOR, SAY JENSEN & MACY, WHO MOVED THE ENTRANCE SO THAT CUSTOMERS ENTERED FROM THE CORNER AND THE LAYOUT WAS SEEN FROM ONE SIDE. THE PROJECTING DISC HOVERING ABOVE THE ENTRANCE ECHOED THE CIRCULARITY OF THE REST OF THE SCHEME, AND THE ONLY DISPLAY MANNEQUINS WERE THOSE IN THE WINDOWS.

(*RIGHT*) SOME OF THE FIVE CEILING FUNNELS THAT, ACCORDING TO THE ARCHITECTS, "CREATE A RHYTHMIC AND UNIFYING EFFECT THAT MEDIATES BETWEEN THE IMPRESSIVE SCALE OF THE ROOM AND THE MORE INTIMATE ONE OF THE CUSTOMER AND THE MERCHANDISE".

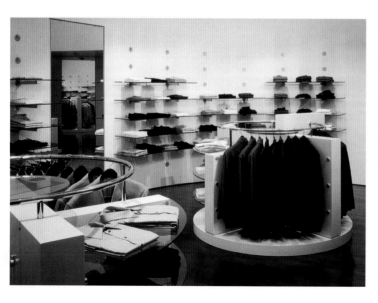

TOWARD THE BACK, THE WALL CURVES BEFORE IT REACHES THE ENTRANCE TO THE CHANGING ROOMS. THE FLOOR WAS STAINED OAK AND THE CENTRAL DISPLAY UNITS WERE FINISHED IN A WHITE OPAQUE "CONVERSION VARNISH" (SIMILAR TO CAR FINISH), WHICH HAD THE REQUIRED DENSITY AND HARDNESS.

Another unique aspect of the design process is the series of spatial castings the architects created on the computer. "It's a kind of internal research for us," says Macy. "We think of space as a substantial entity as opposed to merely a void. The nature of space is something we discuss a lot."

It took about eight weeks for the team to get to final working drawings. "There were a lot of nuances to work out," says Macy, who works to three phases — design, working drawings, and then construction administration. "We used the same contractors, Oliver & Company, that we have worked with on other projects. It was on schedule and on budget, and apart from some small modifications, there were no real changes. At the end of the day," says Jensen, "a store can only be as good as its merchandise and its staff —and in this instance these are both excellent."

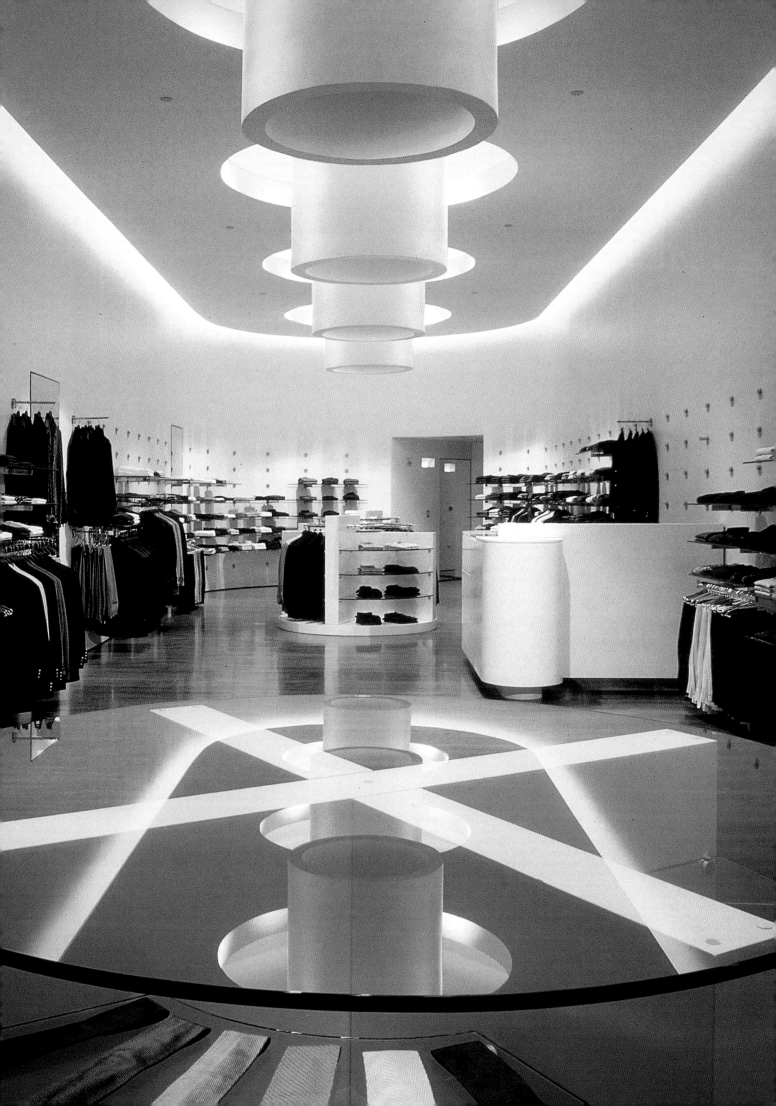

Wild at Heart
Entering across a stepped aluminum bridge, customers pass through an egg-shaped lens cut into a glass veil, which is set against the historic Georgian façade, and provides the passage into an all-white space. The soft fluid surfaces and cascading display terraces reflect the organic forms of petals and stems, and perhaps **define a new way to sell flowers**

So runs the description by Future Systems, a small but provocative architecture design practice, headed by Jan Kaplicky and Amanda Levete, that has designed this new flower shop in London's Notting Hill Gate. Its name Wild at Heart could also describe the owners, Nikki Tibbles and Oliver Backhouse, whose first outlet was based nearby in Piers Gough's award-winning building known as the Turquoise Triangle. It was their brief to create something completely different which drove this scheme.

Tibbles is a creative personality, she already had an idea of the way that she was going to present the flowers—in a couture-type environment, refined, simple and innocent, but also relaxed, somewhere she could sit with customers who wanted to place special orders for wedding functions.

Her first shop, which was only a few hundred yards away, was almost entirely outdoors and street-focused, so now she needed somewhere for her growing workforce, and where deliveries could be made, stock stored, and bouquets made up under cover.

Future Systems went to look at the building Wild at Heart had found near Portobello market. Once a run-down antique shop, the interior was small and in a very poor state. They encouraged Wild at Heart to use the basement for stock and as a workshop, rather than having two floors for display.

The architects started by developing initial concepts, and sketching various solutions. Flowers are organic structures whose forms change as they grow and as such it was

ONE OF THE FIRST SKETCHES BY FUTURE SYSTEMS SEEMS TO HAVE ALL THE ELEMENTS IN PLACE. BY OPENING UP THE WHOLE FRONT FAÇADE, THEY WERE ABLE TO ALLOW LIGHT TO PENETRATE RIGHT TO THE BACK OF THE STORE.

THE INITIAL IDEA WAS TO CREATE A SINGLE SHELF FOR THE FLOWERS BUT THIS DEVELOPED INTO A SERIES OF CASCADING TERRACES WHICH WRAPPED AROUND THE ENTIRE ROOM.

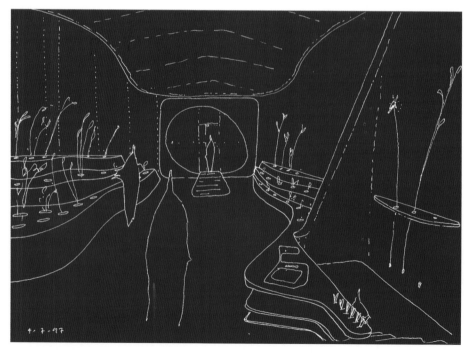

THIS VIEW WAS DRAWN IN ORDER TO ILLUSTRATE THE GENTLY CURVING TERRACES FROM A PERSPECTIVE AT THE BACK OF THE GROUND FLOOR LOOKING OUTWARD. THE SHELF CURVES OUT ON THE RIGHT TO INCLUDE A SMALL SEATING AREA FOR CLIENTS WHICH WAS LATER MOVED TOWARD THE FRONT.

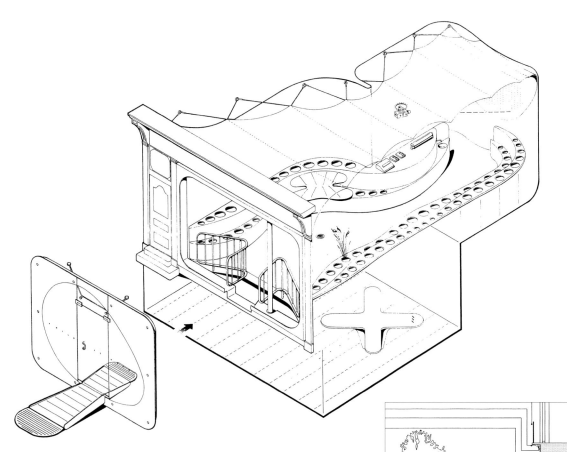

IN THIS EXPLODED
ISOMETRIC DRAWING, THE
FRONT LAYER HAD BEEN
REMOVED TO SHOW HOW
IT FITTED INTO THE REST
OF THE SCHEME. THE
FLOWER BUCKETS AND
CASH DESK WERE
INDICATED AND IN THE
BASEMENT THERE WAS A
LARGE CRUCIFORM TABLE
ON WHICH STAFF CREATE
BOUQUETS AND SPECIAL
COMMISSIONS.

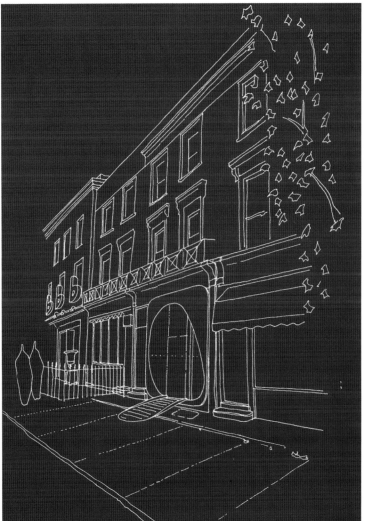

A VERY EARLY DRAWING
OF THE EXTERIOR
SHOWED HOW THE EGG-
SHAPED FASCIA
CONTRASTED WITH THE
REST OF THE TERRACE
AND HOW THE ALUMINUM
RAMP PROJECTED ONTO
THE SIDEWALK AND
EMBRACED A SERIES OF
LEVELS, PREVIOUSLY
DEFINED BY THREE
STEEP STEPS.

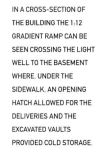

IN A CROSS-SECTION OF
THE BUILDING THE 1:12
GRADIENT RAMP CAN BE
SEEN CROSSING THE LIGHT
WELL TO THE BASEMENT
WHERE, UNDER THE
SIDEWALK, AN OPENING
HATCH ALLOWED FOR THE
DELIVERIES AND THE
EXCAVATED VAULTS
PROVIDED COLD STORAGE.

A PLAN OF THE CEILING,
WITH THE FABRIC HELD
IN PLACE BY STAINLESS
STEEL CABLES AND
TURN BUCKLES
CONNECTED TO ANCHOR
BOLTS IN THE WALLS.

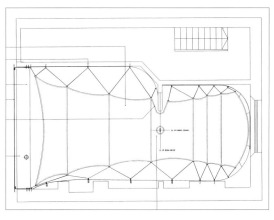

WILD AT HEART 193

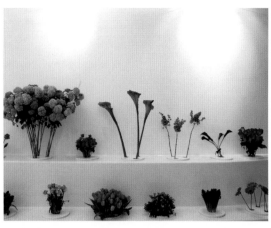

THE FRONT WINDOW WAS MADE FROM TWO LAYERS OF 5/8 INCH TOUGHENED GLASS, SPRAYED WHITE ON THE BACK, WHICH, IN DAYLIGHT, LOOKED PALE GREEN BECAUSE OF THE COLOR OF THE MATERIAL. AT ONE STAGE THE ARCHITECTS PROMOTED A STRONGER COLOR. BUT EVENTUALLY AGREED WITH TIBBLES THAT THE SHAPE WAS STRONG ENOUGH IN ITS OWN RIGHT.

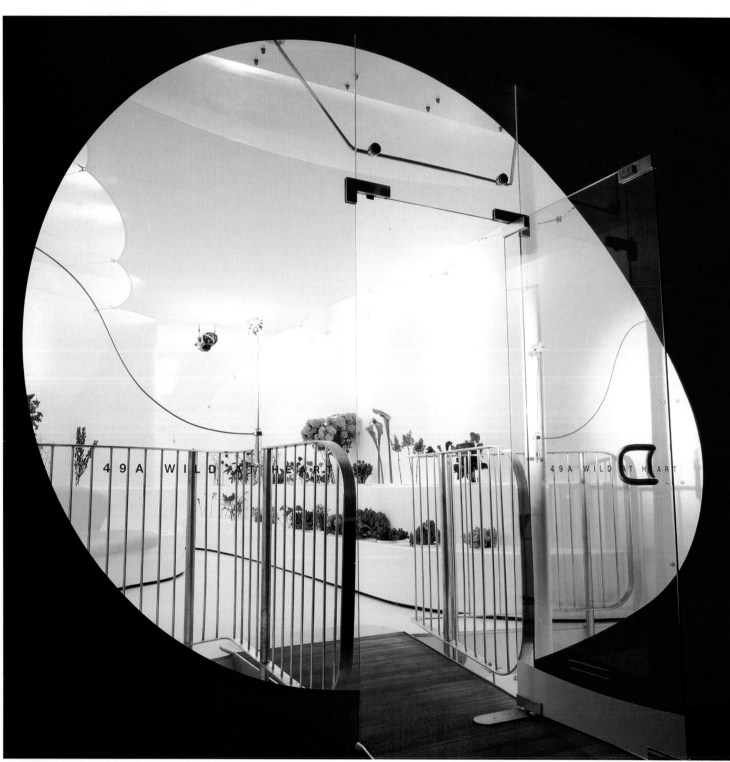

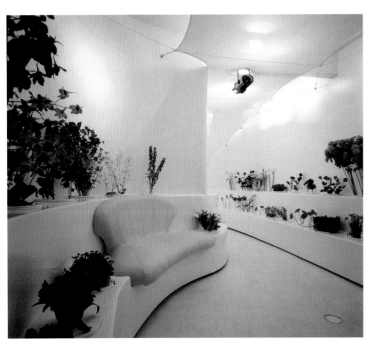

(*LEFT AND FAR LEFT*) ALL THE FLOWER BUCKETS HAD INFILLS OF WHITE PERSPEX TO ACCOMMODATE MORE OR FEWER BLOOMS, WHILE CONCEALING THE STEMS. THE YELLOW CUSHION, THE ONLY IMPOSED COLOR, MARKED THE SEATING AREA.

established at a very early stage that they would aim to create fluidity in both the plan and in section. Their emphasis was on the flowers, not the finishes.

Wild at Heart had said that in contrast with the vivid, plentiful displays at the Turquoise Triangle, the new shop would have fewer flowers and fewer varieties. At one point they considered displaying a single color as a way of exploring a more cohesive interior. The architects had two meetings with their client to present and discuss their ideas, which were largely described in sketch form. For the second meeting Future Systems used a simple model to help demonstrate the organization of the space and the relationship of the terraces and curved walls within the volume.

The street level was devoted to the flower display "terraces," including a small seating area denoted by a bright color. Part of the floor had been cut away to allow daylight into the workshop below and to give those working in the basement a feeling of being part of the same space. "It also creates a drama and a feeling of a much greater volume," says Future Systems. However the most radical part was the treatment of the exterior, which created an exciting entrance into the flower shop, allowing customers to move through a double height space into a sculpted light-filled room.

The stretched fabric canopy concealing the ceiling space came about as a result of two requests; to give a softness to the interior developing from the contours of the walls; and to recess the lighting and conceal the light fittings. It gently curves downward at the rear to enable a series of projected X-ray images of flowers.

Future Systems admit that a brief such as this one from Wild at Heart, who from the outset were focused on creating something so completely different, is a rare opportunity. When the shop opened on Valentine's Day with only red roses on display, the impact was immediate.

THE IDEA OF PROJECTING A PHOTOGRAPH OF A "FLOWER OF THE DAY" LED THE ARCHITECTS TO ADD TWO STAINLESS STEEL RODS, EACH PROJECTING INTO THE STORE BESIDE THE ENTRANCE AND EACH HOLDING A FRESH BLOOM IN A GLASS PHIAL.

Aveda

This unusual solution developed from the decision to leave the majority of the space as found and to create the store and café interior from a combination of **poured concrete** elements and **roughly finished teak** furniture

Jamie Fobert, the young architect who designed this store, had previously worked with George Hammer, director of AVD Cosmetics, the U.K. distributor of the unique Minneapolis concept that is now owned by Estée Lauder. Fobert had acted as planning advisor on two instore projects in the Harvey Nichols stores in Leeds and London.

Hammer was planning to open a flagship store that would, in shop-fitting terms, be a departure from Aveda's 16 existing instore outlets and that would set a precedent for the store-in-store schemes to come. With this shift of image in mind Hammer organized for a team of designers to visit New York. The team also included Hammer's inhouse graphic and display designers and the instore designers.

Besides visiting the existing Aveda Institute retail units, the team also explored New York's latest stores and debated the use of materials, lighting, and space in the current environment. Aveda were very conscious of using environmentally friendly materials. Their philosophy concentrates around natural, pure plant-based products. The task for the designer was how to extend this philosophy into the built environment. The New York trip and a subsequent visit to Paris provided a common reference for the rest of the design process and the seeds of the conceptual design.

Hammer had acquired an old post office in London's currently fashionable Marylebone High Street. It was a light and spacious corner site that was more than sufficient to allow Hammer to develop his own vision of an Aveda Institute for London. "George had been refurbishing different buildings around London for many years and had developed a good working relationship with various builders and contractors," explains Fobert, "he was not interested in pursuing a traditional building contract but preferred to negotiate individually with his own contractors."

ONE OF JAMIE FOBERT'S VERY FIRST IDEAS. WHICH HE SKETCHED. WAS TO USE POURED CONCRETE TO CREATE FURNITURE. THE CASH DESK. A SERIES OF SOLID PLANES AND PLATFORMS. WAS WRAPPED AROUND ONE WALL AND INCORPORATED ONE OF THE STRUCTURAL STEEL COLUMNS.

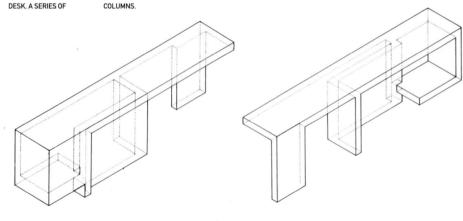

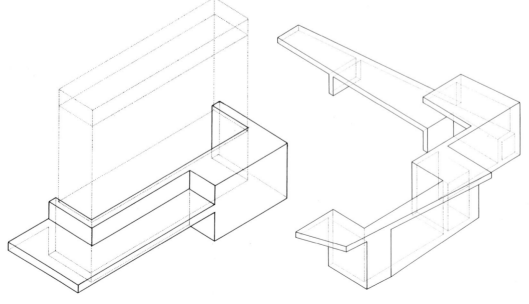

THESE FOUR DRAWINGS SHOW THE CONCRETE PIECES AS THEY WERE BUILT ONSITE, ALTHOUGH WHEN FOBERT SHOWED THE CONTRACTORS THE DRAWINGS THEY FOUND THEM IMPOSSIBLE TO UNDERSTAND. HE COULD PROCEED WITH THE TIMBER SHUTTERING ONLY ONCE HE HAD CREATED SMALL-SCALE MODELS. THE FINAL DESIGN FOR THE FISH TANK UNIT CAN ALSO BE SEEN (FAR LEFT).

THE IDEA TO USE
CONCRETE ALSO APPLIED
TO A BASE UNIT NEAR THE
DOOR, WHERE THE CLIENT
WANTED TO INCLUDE A
LARGE FISH TANK. ONE
OF THE HALLMARKS OF
AVEDA CONCESSIONS.

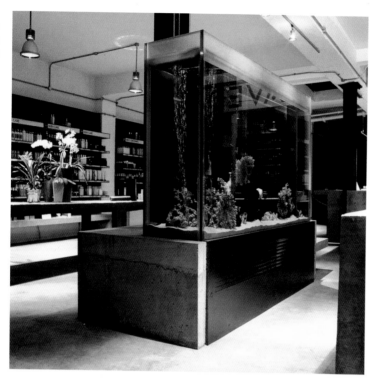

TAKEN ONSITE, TWO
PHOTOGRAPHS RECORD
THE POURED CONCRETE
PROCESS AND CLEARLY
SHOW (FAR LEFT) THE
TIMBER SHUTTERS OF
THE CASH DESK. "SOME
PIECES COULD BE
POURED IN ONE GO,
OTHERS HAD TWO OR
THREE STAGES. THE
SECOND PHOTOGRAPH
(LEFT) SHOWS PART OF
THE UNFINISHED DESK
ONCE THE TIMBER
SHUTTERING WAS
REMOVED.

This unorthodox method allowed the project to develop in a continuous process of design. A basic strategy and spacial arrangement was decided prior to demolition and as the space was opened up each new element was designed based on the evolving brief and found situation.

In Paris, Hammer and Fobert had been impressed with a store called Colette (see page 176), and it was there that they first debated the possibility of leaving the shell of the space in a raw, unfinished state. Instead of relining the room in plaster to create a pure modern space, this strategy allowed the space to take on a rough urban feel in which the new elements of design could stand in contrast. "It was a conscious move against the sterile environment of the white box. It established the tough urban mood of the store in which we developed the furniture pieces" says Fobert. The "found object" strategy was also considerably less costly and allowed funds to be concentrated on the design elements.

Once back in the London, Fobert considered ways to display the product. "It's a problem to isolate or elevate the product as you would in a fashion store, when it is a thousand small brown plastic bottles." The solution was to concentrate the products along the long wall in bays. The shelving units were designed in conjunction with John St John, a designer based in Leicester, who had worked with Hammer on the store-in-store units.

One of the most interesting aspects of the work for the architects was the construction of many of the furniture pieces in concrete. "We were interested in exploring the plastic nature of concrete as a liquid and its ability, through its internal reinforcement, to take on complex forms. A reinforced concrete cantilever can virtually hang in space, unlike any other material. The process of construction formwork (the timber molds) into which the liquid concrete is poured also allows you to see the object in reverse before you pour the concrete and this gave the client the opportunity to make some last minute alterations."

THE PLANNING OF THE
SPACE BEGAN WITH
THESE TWO INITIAL
SKETCHES. IN THE FIRST
(RIGHT) FOBERT KEPT THE
ENTRANCE IN THE
CORNER WHERE IT HAD
BEEN AS A POST OFFICE,
BUT IT MADE PLANNING
THE SPACE MORE
DIFFICULT GETTING A
CLEAR ACCESS THROUGH
THE TWO DISTINCT
PRODUCT AREAS.
ANOTHER ARROW
INDICATES HIS IDEA TO
MOVE THE DOOR TO THE
SIDE WHERE. IN THE
SECOND PLAN (FAR
RIGHT), HE STARTED TO
REALLOCATE THE SPACE.

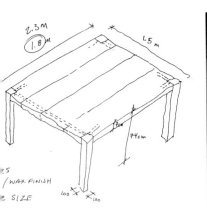

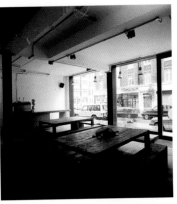

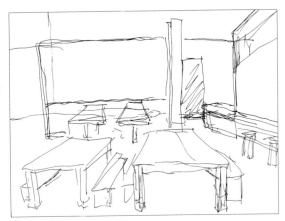

Fobert felt the other furniture pieces should be in a natural material to complement the hard interior but he was concerned not to lose the solidity of the work. "In London most timber you see in stores is constructed in MDF with a timber veneer. I was keen to find a source for solid timber which would be both economically reasonable and ecologically sound. In Paris we found a company called Hati that imports teak furniture made in a cooperative, from reclaimed timber" says Fobert, who on the spot with Hammer sketched and ordered the tables and benches. "While the concrete could be poured in angles and cantilevers, the timber pieces, made up of single 12-foot planks, 4 inches thick, needed to be as simple as possible, so that you could enjoy the extraordinary beauty of the wood".

These three elements: the "found" interior, the poured concrete elements, and the teak tables make up the major components of the store. The steel shelves, a free-standing fish tank, and the deep steel-framed shopfront formed a secondary layer.

The design of the store evolved as the interior partitions and shop front were demolished. The client began to formulate his vision of combining Aveda with a organic café in the rear shop and to include a flower concession in the front. This meant altering the design to accommodate these new functions. Suddenly, Fobert had not one client to satisfy but three. "I had to balance what they wanted with both George's budget and the overall image of the space." he says. "He was creating a community of different products, each reinforcing the other."

Fobert was assisted throughout the project by architect and colleague Thomas Spranger, taking it in turns to visit the site every morning to oversee and resolve any problems. "We were experimenting with lots of things we had not done before. Particularly with the poured concrete, a constant presence onsite was critical." With so many distinct trades each working independently, the site Foreman, Dave Jenkins, became a joint project manager with George Hammer.

In the end for Fobert "This method of construction allowed a flexibility in design which would be unattainable in a standard contract or with a less visionary client."

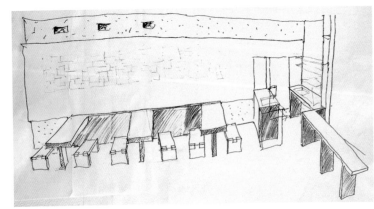

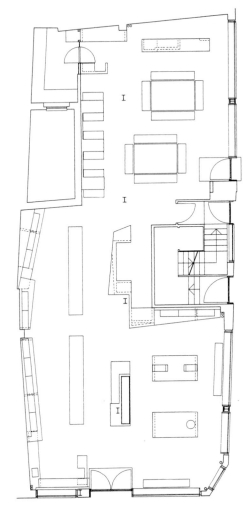

TWO MASSIVE TABLES WERE ORDERED FOR THE CAFÉ WHERE, AS THIS EARLY SKETCH (TOP) SHOWS, THE ARCHITECT PLANNED TO SEAT CUSTOMERS TOGETHER ON THE TEAK BENCHES OR ALONG A COUNTER ON THE RIGHT THAT WAS LATER REPLACED BY A SERVING UNIT (ABOVE). THE LEGS ON THE TABLES ALONG THE WALL WERE ALSO LATER REMOVED. (FAR RIGHT)

THE FINAL PLAN (LEFT) SHOWS HOW BOTH STORES WERE KNOCKED TOGETHER TO PROVIDE THE LOVE CAFÉ AT THE REAR WITH ITS OWN ENTRANCE. INSIDE THE FRONT DOOR WAS THE SMALL FLOWER STORE CONCESSION (ON THE LEFT) AND STRAIGHT IN FRONT, THE UBIQUITOUS FISH TANK. "I WANTED TO LEAVE IT OUT," SAYS FOBERT, "BUT THE STAFF ALL PROTESTED." CENTRAL TO THE SPACE IS THE WRAPAROUND CONCRETE CASH DESK.

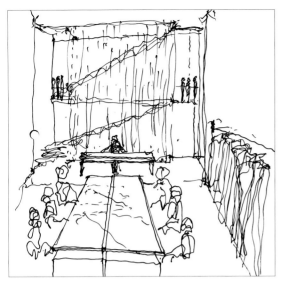

(LEFT) AN IDEA FOR DISPLAYING THE CLOTHES ON MANNEQUINS THAT WERE SITTING AT A LONG DINING TABLE IN THE WAY THAT CUSTOMERS MIGHT SIT IF THEY WERE GOING OUT TO DINNER. IN THE REAR, THE STAIRS CAN BE SEEN BEHIND THE WALL OF GAUZE FABRIC.

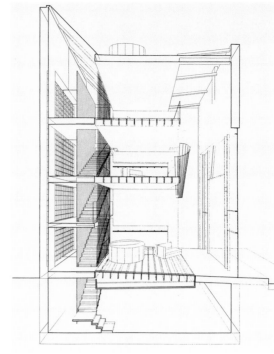

A COMPUTER DRAWING SHOWS ALL THE LAYERS THAT LING USED. ALTHOUGH THE OCULUS HAD GONE (ON GROUNDS OF COST), THE TWO ROOF-LIGHTS STAYED AND THE STAIRS WERE SANDWICHED BETWEEN TWO LAYERS OF FIRE-RETARDANT SCRIM FABRIC AND A LAYER OF SANDBLASTED MIRROR. IN THE SLOPING FLOOR WAS THE GENTLY CASCADING WATERFALL. THE MAIN DIFFERENCE BETWEEN THIS DRAWING AND THE FINAL SHOP WAS THE TWO UPPER FLOORS.

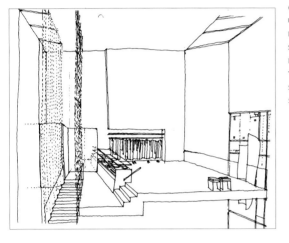

(LEFT) A SKETCH OF THE UPPER FLOOR IN WHICH LING PROPOSED SPLITTING THE FLOOR INTO TWO LEVELS, WITH THREE LAYERS OF SHELVING AND THREE STEPS.

Ling had studied and admired Ferretti's clothes. "I liked the strong influence of modernism, with crafted, clean, pure lines and a reduction of ornaments. They were sewn together and fitted by hand with a crafted, modernist approach," he says. "And she was known for her layering—transparent over opaque. That's my look as well."

Explaining his design process, the architect says: "I usually work fairly quickly, almost out of habit. People normally want to see a spatial plan, and visual space and light are the crucial elements. It's developing the detail and crafting it that takes time. Aspects of the space are normally fairly apparent at the outset," he continues. "I try to create a flowing space and take advantage of potential sources of light." Ling had two weeks to come up with a scheme, which he presented to Stein and Dr Vanzini, the CEO from the Italian parent company. "I got an initial thumbs-up on that level, but it's ultimately Alberta who calls the shots."

His presentation included a model and plan drawings. "No alternatives," says Ling. His solution involved glazing almost the entire façade, adding two glass roof-lights and putting the stairs to the two upper levels at the back of the store. "It's such a departure for us," says Vanzini. "Can you find an alternative approach using a curved stair?" The space was so tight that Ling thought it would not work, but he did it

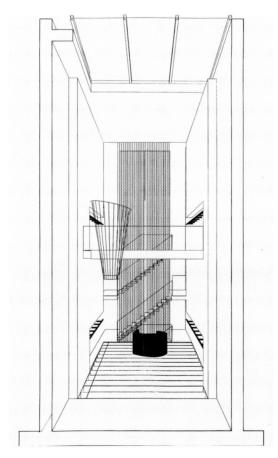

IN THE REVISED LAYOUT ONLY ONE MEZZANINE REMAINS, AND THE GLASS FLOOR RUNS THE WHOLE WIDTH OF THE SPACE. THE NICHES FOR MERCHANDISE ON EACH SIDE WERE LIT FROM ABOVE, INSPIRED BY A JAMES TURRELL INSTALLATION.

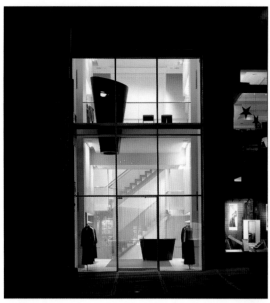

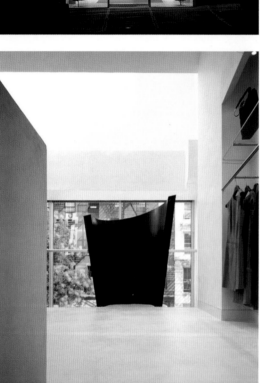

ONE OF THE ARCHITECT'S INSPIRATIONS FOR THE STORE WAS A SURREALIST SCULPTURE IN THE NATURE OF ALBERTO GIACOMETTI'S *THE PALACE AT 4 A.M.* "SOHO COMES ALIVE AT NIGHT," SAYS LING, "SO I WANTED THE INTERIOR TO BE SO BRIGHT THAT PEDESTRIANS WOULD NEED SUNBLOCK TO WALK IN FRONT OF IT." IN FACT, THERE WERE SEVERAL ALTERNATIVES FOR LIGHTING—THE CLOTHES DISCREETLY LIT, THE STAIRS SILHOUETTED FROM BEHIND AND THE SPACE LIT WITH AQUATIC REFRACTION FROM BELOW THE WATER. "THE CALLA LILY NICHE HAS NO FUNCTION; IT'S PURELY SURREALIST THEATER." SAYS DAVID LING. "BUT IT PROVIDES A CONTRAST FOR THE FAIRLY SHARP EDGES OF THE INTERIOR AND STOPS IT BEING A STRIPPED DOWN ICE-BOX."

(*RIGHT*) THE FINAL FLOOR PLAN SHOWS THE SIMPLICITY OF THE LAYOUT, THE REVISED WIDTH OF THE GLASS FLOOR AND THE 'FOETUS-SHAPED' CASHWRAP.

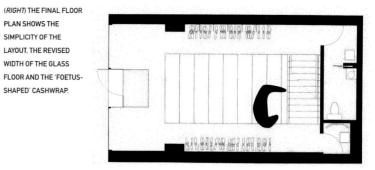

anyway. A week later he had produced a curved stair inset that converted the model from one option to the other.

To present the scheme to Alberta Ferretti, Ling went to Italy "for the day,"and he recalls: "I looked at their store and then went to their offices. It's a huge operation. In addition to her own collections, she also handles the production and marketing for Jean-Paul Gaultier, Moschino, Rifat Ozbek, Narciso Rodriquez, and has more than 1,200 employees. Nevertheless, she was incredibly friendly and made it very easy for me to like her. I laid out the options, showed her the two-version model and mapped out every aspect in esthetic terms, in functional terms and in technical terms. It was a three-hour meeting. We went over the materials I'd brought along. On the first floor I'd sloped the floor, like a stage, inspired by Palladio's Teatro Olympico in Vicenza, and under a sandblasted glass floor, I had a waterfall. I showed her a video of a residential job I'd done that had a running water ceiling. She's a true esthete, with a passion for the visual that will take priority."

Having got the go-ahead for the stairs-at-the-back solution, Ling returned to New York to get on with the job. And that, he confesses, is when the troubles started. The first problem was the exposed staircase to the upper levels. The planning officers refused permission on the grounds of fire hazard, so Ling proposed some alternatives: "I put them at one side; I put them across the front; I then tried to purchase part of the parking lot next door to put them out there, but they wouldn't sell. We even put them behind fire-rated glass. It all cost a lot and took away from the crucial aspects of the design. In the end, it suddenly occurred to me that if we had just one projecting mezzanine, it would classify as a one-story building, allowing the stair concept I wanted."

Meanwhile, work had begun onsite, where things were far from well. "Now the nightmare really began," confides Ling. "As they began the demolition and structural work, they discovered that the not-so-old building was completely unsound. We had to rebuild it from the inside out—first one side wall, then the other, then the roof, then the mezzanine. The schedule not only went out of the window, but it went down the street and across the Hudson. Running it all, I was in the firing line." In the end, they managed to make up some of the lost time— "with a great deal of patience"—the shop finally opened six weeks late.

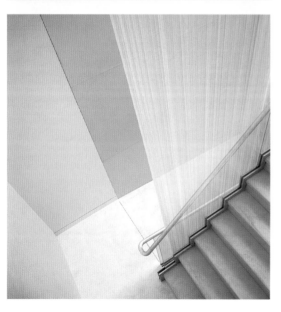

THE STAIRS, THE SOURCE OF SO MUCH APPREHENSION AND AGONY, SEEM A MASTERPIECE OF SIMPLICITY, WITH A COMBINATION OF MARBLE, CONCRETE, SANDBLASTED MIRROR, AND AN ANODIZED ALUMINUM HANDRAIL. THE SCRIM FABRIC DROPS INTO A 4-INCH GAP IN THE FLOOR, AND THE WALL BEHIND IS LINED WITH SANDBLASTED MIRROR. "THIS LAYERING EPITOMIZED THE BRIDGE BETWEEN MYSELF AND ALBERTA," SAYS LING.

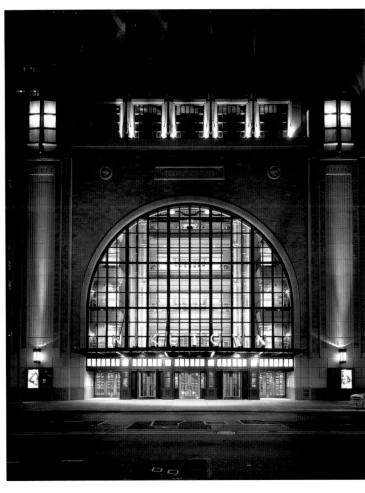

(BELOW LEFT) THE STORE'S SPECTACULAR CENTRAL ATRIUM. A TOTAL OF 26 "SHOE TUBES" ARE USED TO TRANSPORT NIKE SHOES VISIBLY FROM THE BASEMENT STOCK ROOM TO THE FIVE RETAIL FLOORS, AND 400 STAFF ARE ON HAND TO GIVE SPECIALIZED SALES ASSISTANCE.

(BELOW) SEEN FROM THE GROUND FLOOR, THE GIANT SCREEN ROLLS DOWN EVERY 15 MINUTES FOR INSTORE SCREENINGS, AND THE MULTIPLE VIDEO MONITORS BROADCAST SPORTING EVENTS. THE NIKE DIGITAL CLOCK COUNTS DOWN THE TIME TO THE NEXT FILM.

(OVERLEAF) SOME 200 FOOTWEAR ITEMS ARE SHOW-CASED IN THE GALLERY, WHERE THE INSET, UPLIT CEILING REFLECTS THE ELONGATED GLOBE SET INTO THE TERRAZZO FLOOR.

(LEFT) THE EXTERIOR OF THE STORE, COMPARED WITH THE MODEL, (ABOVE) WAS CONCEIVED AS A SPORTS ARENA OF INFORMATION ABOUT NIKE PRODUCTS AND AN INSPIRATION FOR EVERYBODY. THE LEGEND P.S. 6453 STANDS FOR PUBLIC SCHOOL 6453 AND SPELLS NIKE ON THE TELEPHONE KEYS. COURAGE, VICTORY, TEAM WORK, AND HONOR ARE UNIVERSAL VALUES ETCHED INTO THE EXTERIOR.

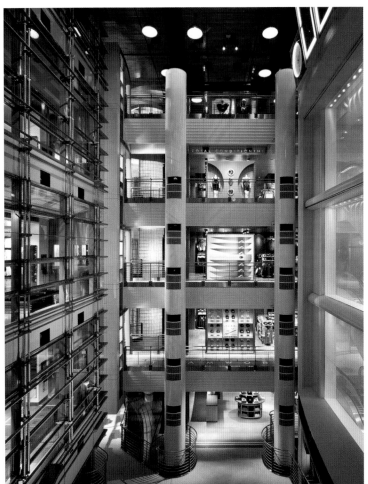

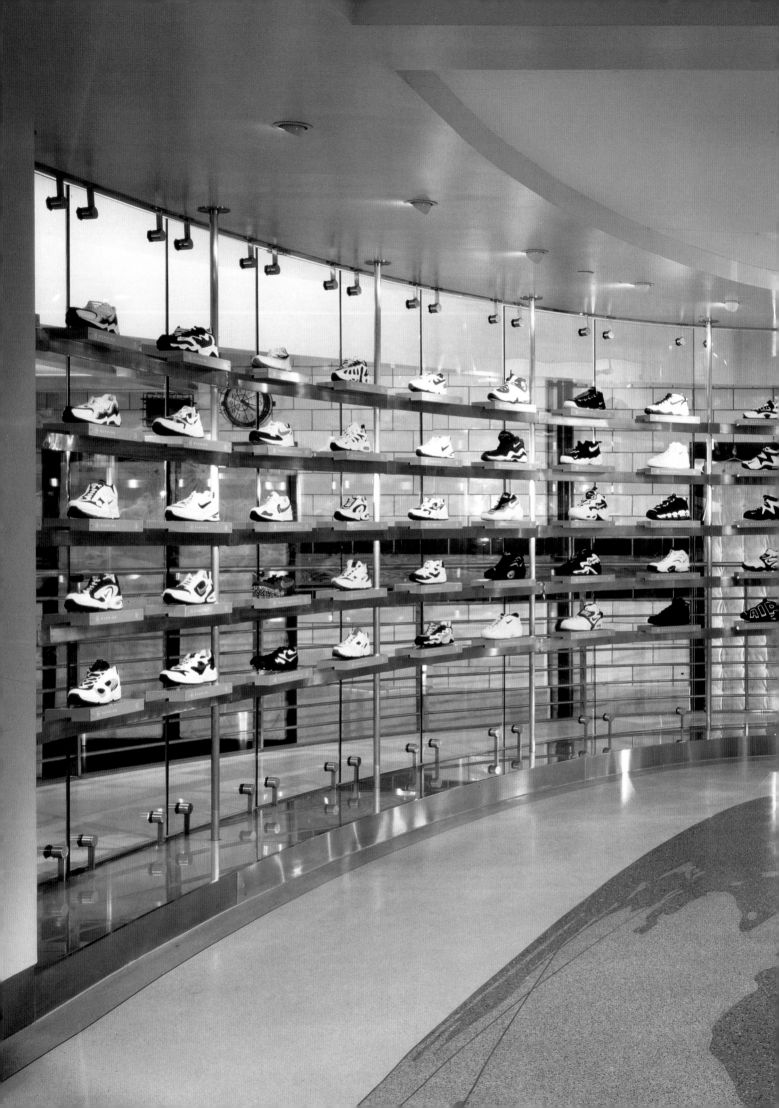

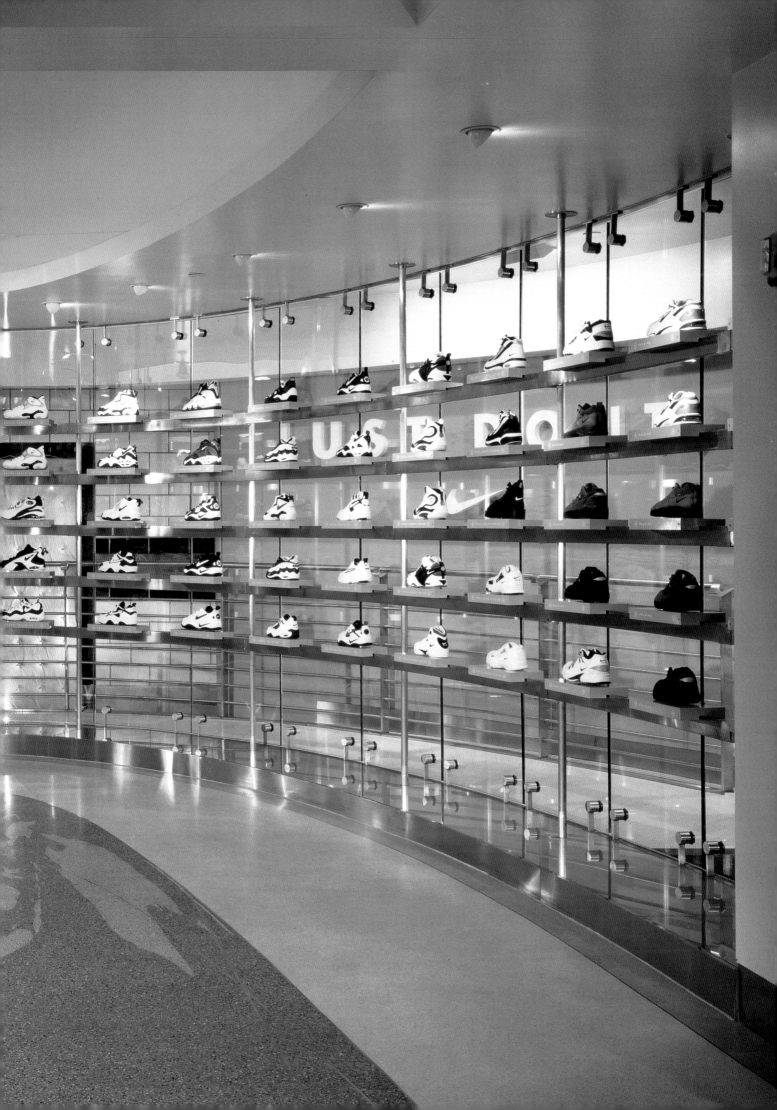

Mizani

The third in a chain of stores which have evolved with the demands of the market, while retaining the same principles. In each new site, **modular components were used to create order, although the individual results looked totally different**

In 1991, Jensen & Macy were approached by Zaino Mizani, a young men's wear manufacturer and importer, and asked to create a small showcase at the Crocker Galleria in San Francisco for this range of pret-a-porter and made-to-measure suits. The store's layout assisted the understanding of this product mix by creating two distinct and almost classical spaces: a circular room in front for the off-the-peg merchandise and a luxurious rectangular room to the rear for the more exclusive custom-made suits.

Working to a very small budget, the architects knew from the outset that construction projects such as this one can run into money trouble because both designers and clients often fail to understand the fundamental nature of the modern building process. They unwittingly proceed to design in an unnecessarily complex and expensive way by making decisions that require the involvement of either too many or the wrong type of construction trades.

For instance, approached conventionally, a typical retail interior would normally require at least nine subcontractors: rough framing, drywall, painting, flooring, air-conditioning, electrical, finish carpentry, woodwork, and perhaps metalwork. Jensen & Macy know that the "more cooks in the kitchen" there were would inevitably lead to a more expensive project. Accordingly, from the very start, they decided to design the store to minimize the number of necessary trades and ultimately they pared it down to a mere three: a wood/metal craftsman, an electrician, and a painter. "This really affected the design," explains Jensen. "We designed it as a kit of parts that were all built first and assembled in the store in a matter of days."

Four years later, Jensen & Macy carried the concept further, with Mizani's second store in Sutter Street, San Francisco, although it could not have looked more different.

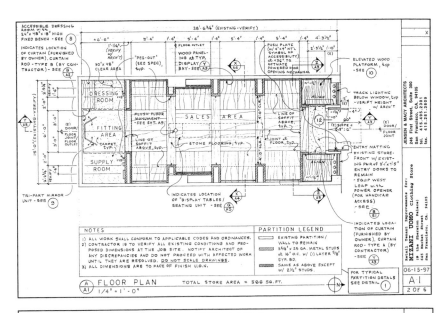

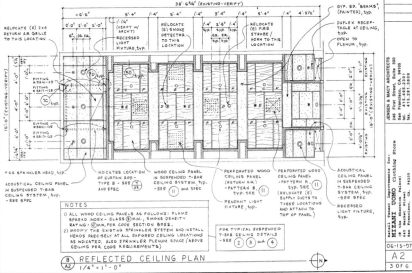

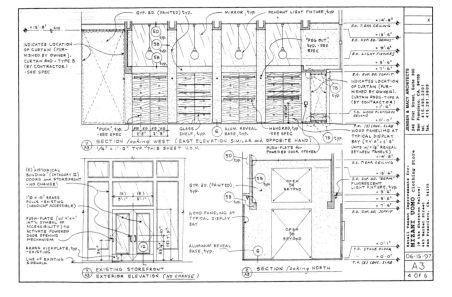

(*TOP LEFT*) A DETAILED PLAN OF THE STORE SHOWS THE WAYS THE ARCHITECTURAL LAYOUT DIVIDED THE WALLS INTO DEEP BAYS. THE FITTING ROOM WITH ITS STATUTORY WHEELCHAIR-WIDTH CAPACITY AND TWO BOXED-IN WINDOW BAYS WHICH WERE CREATED TO PROVIDE A MORE FORMAL ENTRANCE AREA.

(*CENTER LEFT*) AS AN ECHO OF THE FLOOR, THE CEILING PLAN DEPENDED ON THE ARCHITECTS' USE OF A STANDARD T-BAR CEILING SYSTEM, WITH THE USUAL WHITE ACOUSTIC PANELS REPLACED BY SHEETS OF MAHOGANY-PLYWOOD, PERFORATED AT KEY POINTS FOR AIR CONDITIONING AND OTHER SERVICES.

(*BOTTOM LEFT*) THIS WALL PROFILE SHOWS THE PROPORTION OF RIBS TO MERCHANDISE BAYS. THE POSITION OF MIRRORS AND PENDANT LIGHT FITTINGS AND THE EVENLY SPACED "PUCK" HOLES THAT SUPPORTED HANGING RODS OR GLASS SHELVES.

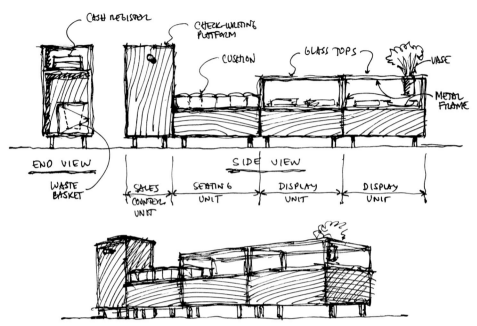

CASH REGISTER

CHECK-WRITING PLATFORM

CUSHION

GLASS TOPS

VASE

METAL FRAME

END VIEW

WASTE BASKET

SIDE VIEW

SALES COUNTER UNIT

SEATING UNIT

DISPLAY UNIT

DISPLAY UNIT

DISPLAY TABLES, SEATING, SALES COUNTER

MIZANI — Reporter

DOWN THE CENTER OF THE SPACE STOOD A UNIT THAT INCLUDED DISPLAY TABLES, SEATING AND SALES COUNTER FABRICATED FROM PLYWOOD WITH A HARDWOOD VENEER FINISH THAT MATCHED THE WALLS AND CEILING. THE INDIVIDUAL MODULES COULD BE SEPARATED AND USED ACROSS THE STORE AT A LATER STAGE IF WISHED.

A TRANSVERSE SECTION, LOOKING DOWN THE LENGTH OF THE STORE, SHOWS HOW EVERYTHING WAS RELATED TO THE ARCHITECTURE, INCLUDING FLORESCENT LIGHT FIXTURES, WHICH WERE USED TO "WASH" THE PRODUCT SHELVES AND SUPPLEMENT THE NON-DIRECTIONAL EFFECT OF THE PENDANTS.

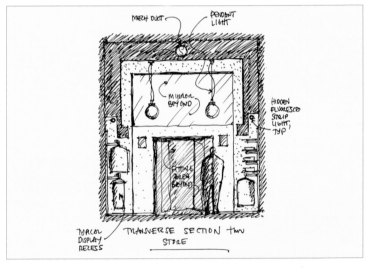

MECH DUCT

PENDANT LIGHT

MIRROR BEYOND

HIDDEN FLUORESCENT STRIP LIGHT, TYP.

FITTING AREA BEYOND

TYPICAL DISPLAY RECESS

TRANSVERSE SECTION THRU STORE

FROM THE ARCHITECT'S SKETCHBOOK, A STANDARD LIGHT FIXTURE WAS ADAPTED WITH CUSTOM-MADE FITTINGS AT LAMP AND CEILING LEVEL.

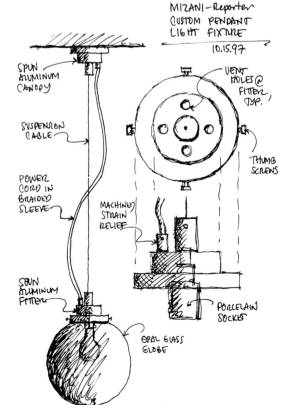

MIZANI — Reporter
CUSTOM PENDANT LIGHT FIXTURE
10.15.97

SPUN ALUMINUM CANOPY

SUSPENSION CABLE

POWER CORD IN BRAIDED SLEEVE

MACHINED STRAIN RELIEF

SPUN ALUMINUM FITTER

VENT HOLES @ FITTER, TYP.

THUMB SCREWS

PORCELAIN SOCKET

OPAL GLASS GLOBE

This time the budget was even smaller, but applying the same principles of a repetition of modular components, the architects designed a double-duty display system in which the fixtures became the environment. From an industrial supply catalog they chose a metal framing system, called "uni-strut," and erected a structure to hold shelves and articulate the space." It had three benefits: it was totally flexible and every component was interchangeable; it was inexpensive to manufacture and the repeated rhythm resulted in a strong spatial experience, a kind of aracade; a "merchandise promenade," adds Mark Macy.

Two years on, still with "limited funds," Mizani called upon his architects to design a third San Francisco location, in a very small street-front apace of the historic Sheraton Palace Hotel. While Jensen & Macy had by now established for their client variations on a very clear esthetic agenda, this time Mizani was teaming up with Reporter International, the large Italian clothing manufacturer, and a very different image was going to be required.

Once again they kept to their original principles: using geometry to create a strong visual order combined with their interest in honest material expression. They worked closely with the builder to limit the number of subcontractors and instead of concentrating on offsite or prefab techniques, this time around, "we decided to explore how we could reinterpret commonplace building systems, such as "T-bar" suspended ceilings, generic drywall and steel-stud framing, for maximum architectural results," says Jensen, adding, "over a plan of the site, we started sketching. At first we both worked on every project, batting ideas back and forth. Sometimes we could almost read each others minds, but we do have differences of opinion. This process challenges us to try to be as clear and concise as possible in order to explain

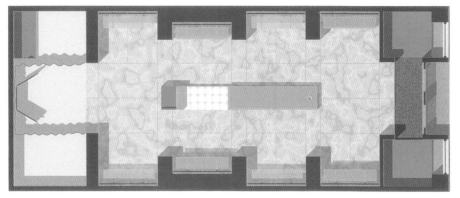

THE PLAN (*ABOVE*) AND A COMPUTER-RENDERED CUTAWAY PERSPECTIVE OF THE STORE (*BELOW*). THE BEAMS WERE KEPT WHITE, AND THEIR DIMENSION—AND THE WAY THE ARCHITECTS WANTED THEM TO "READ" AS WIDE UPRIGHTS RUNNING RIGHT THROUGH THE CROSSBEAMS AND EMPHASIZING THE LOFTY SPACE OVERHEAD—WAS THE SUBJECT OF HOURS OF DISCUSSION. "WE WANTED IT TO BE AN ABSTRACT FRAMEWORK—SO WE DIDN'T ASSIGN IT A COLOR," SAYS JENSEN. ALONG THE WALLS, THE RODS THAT SUPPORT THE CLOTHES STOP JUST SHORT OF THE BEAMS "TO PROVIDE A PAUSE, SO THEY CAN'T STACK THE MERCHANDISE RIGHT UP TO THE UPRIGHTS."

ideas to each other and ultimately to the client. This makes the projects stronger and we don't waste the client's time with weak or half-baked proposals."

Responding to the inherent geometry of the site, they divided it into bays forming rhythmic series of recessed display niches that would "frame" the merchandise and alternately provide a separating drywall "pillar" for face-out displays. They filled the bays above with mirrors that, by optical illusion, extended the tiny space almost to infinity. After a couple of weeks work refining the idea, they showed it to the client with the help of an outline plan, sketch elevations, and material samples. Mizani tended to rely more on verbal description and material samples than on renderings. The samples included mahogany plywood panels in the display niches, ceiling and furniture, honed French Beaumaniere limestone on the floors and a rich chocolate-colored moiré fabric for the fitting area and dressing room curtains.

"Perhaps one of the most individual aspects of the scheme was the use of pendant light fittings which we designed. We were looking at old photographs of men's clothiers from the early part of the century and liked the way they lit their spaces. Today, with track and recessed fixtures, one misses the soft warm glow that a traditional incandescent pendant fixer can create in a space. We wanted to make a subtle reference to the classic haberdashery, but in a thoroughly modern way," says Macy.

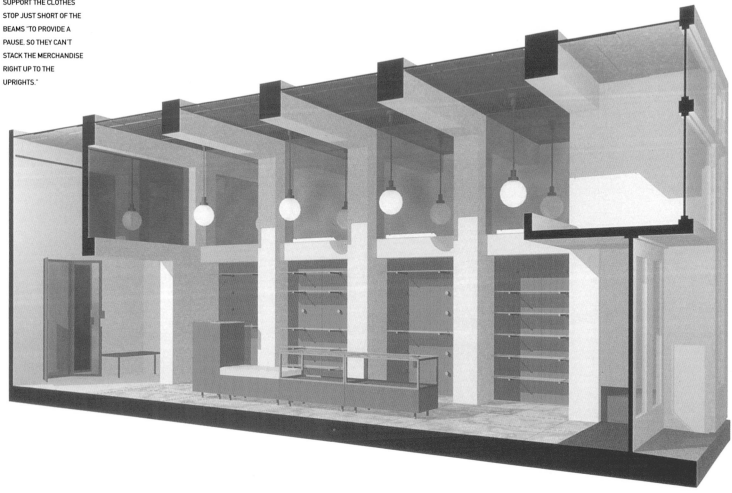

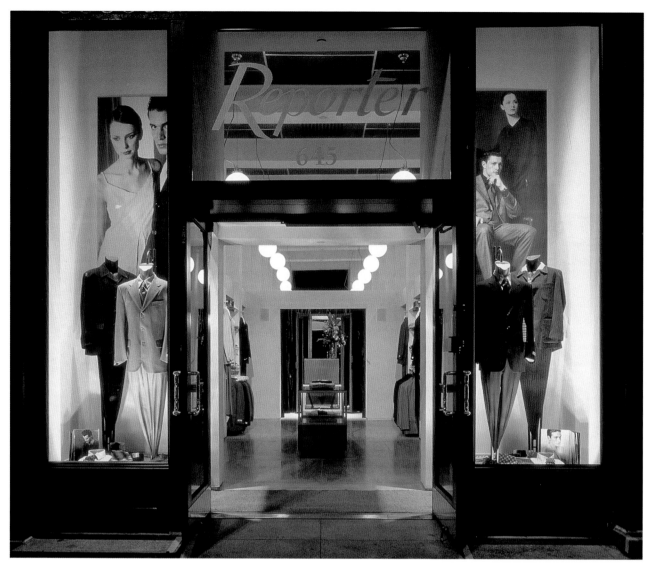

THE STORE EXTERIOR WAS A LISTED "CALIFORNIA HISTORICAL BUILDING, CATEGORY II," SO IT COULD NOT BE CHANGED. NEVERTHELESS THE ARCHITECTS WERE CONCERNED TO SPECIFY STRONG INTERNAL LIGHTING, EVEN DURING THE DAY, TO COMPENSATE FOR THE TINTED GLASS.

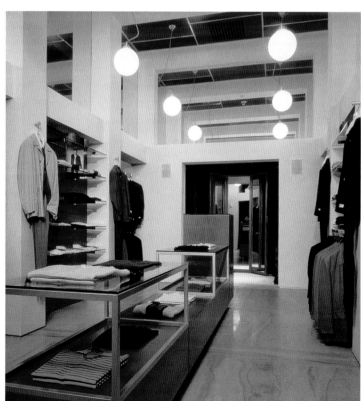

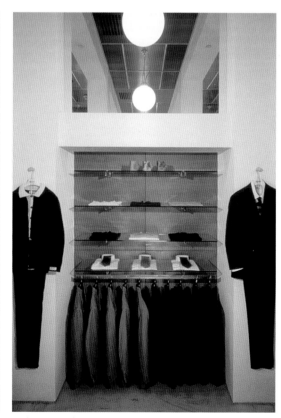

"CHANGING THE COLOR AND MATERIAL OF THE CEILING PANELS HAD A PROFOUND EFFECT ON THE LOOK OF THE SPACE AND GAVE A TOTALLY DIFFERENT SPIN ON THE MERCHANDISE," SAYS MARK JENSEN. BUT THEIR FIRST STEP HAD BEEN TO MAKE A CONNECTION BETWEEN THE OVERALL GEOMETRY AND THE WAY THE STORE WOULD BE CONSTRUCTED.

Watch2Watch

Designers and marketing consultants are often asked to predict new retailing concepts. On this occasion the team at Cobalt, a multi-disciplinary brand and communications agency, got an idea and were so convinced that it would work that they **went ahead without a client**

The idea for a store that specialized in selling only watches first came to Ian Woodhouse, chairman of fast-growing Cobalt, when he met a woman in a bar in the West Indies. Woodhouse realized that this was no ordinary encounter. The woman was Tracie Lamb, a watch and jewelry buyer for QVC, the 24-hour catalog cable channel, who had also designed her own ranges of jewelry. She had never started a business before, but when they were back in London, an hour-long meeting with her convinced Woodhouse that she could make it work. "If you have an idea, you can do anything," he explains.

It was December 1997 when Lamb moved into Cobalt's offices and started working on a business plan. "We paid her a salary and contributed our time and energy—and all the design work—for which we took a 33 percent share of the new business. But first, we needed the backing—£250,000 ($400,000) to be precise. We produced a scheme for a chain of niche-market shops specializing in fashionable watches, having first realized that the traditional retail concept of putting the product in glass cases—thus creating a barrier between the product and the customer—needed re-thinking," continues Woodhouse. "We presented our concept to 12 merchant bankers, and everyone loved it and they contributed it out of their personal money, he explains. "Doc" Thody, senior designer on the project, continues: "We put together a small team and started doodling. We wanted

THESE TWO VISUALS WERE PART OF THE INITIAL PRESENTATION TO INVESTORS. THE EXTERIOR HAS SINCE BEEN ADAPTED TO THE KING'S ROAD, LONDON, SITE BUT THE INTERIOR SHOWS THE DESIGNERS' FIRST DONUT FITTING, INTO WHICH CUSTOMERS WERE INVITED TO SLIP THEIR WRISTS.

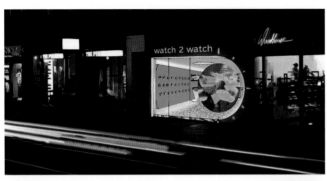

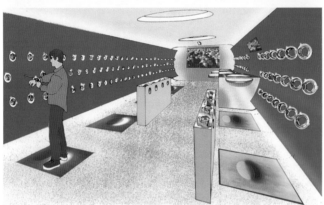

A CONTINUATION OF THE DESIGN PROCESS, THIS SERIES OF SKETCHES LOOKED AT WAYS TO FIX THE WATCHES IN POSITION FOLLOWING THE NEGATIVE RESPONSE TO THE DONUT. THE FIRST (RIGHT) WAS A SERIES OF SHAPES THAT THE DESIGNERS CALLED THE "PILL"; THE SECOND (FAR RIGHT) WAS LIKE A DOOR HANDLE WITH SPACE AT THE BOTTOM FOR A PRICE TAG.

(LEFT) ONCE THE IDEA OF THE CURVED BANANA SHAPE HAD EVOLVED, "DOC" THODY AND HIS TEAM STARTED TO REFINE THE DETAILING AND WORK OUT HOW THE WATCHES WOULD BE HELD IN PLACE

IN TRUE AIRCRAFT STYLE, THIS IDEA FOR THE WALL-MOUNTED CASH DESK HAD A FOLD-AWAY HATCH.

AMONG THE IDEAS FOR THE CENTRAL DISPLAY CABINET, THIS DESIGN FEATURES WATCHES HELD BY ROTATING PINS SO THAT CUSTOMERS COULD FLIP THEM UP AND TRY THEM ON THEIR WRISTS WITHOUT REMOVING THEM.

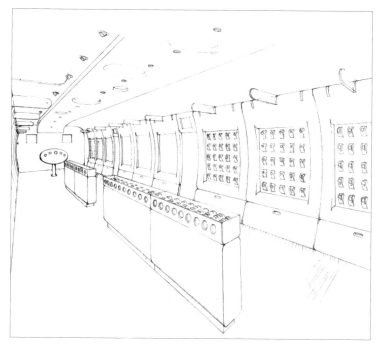

THIS PENCIL DRAWING OF THE SHOP INTERIOR SHOWS HOW ALL THE WATCHES WERE INTENDED TO BE DISPLAYED. THE CENTRAL FLOOR UNIT HAD AN ALTERNATIVE SIDE DETAIL—PERHAPS SO THAT CUSTOMERS COULD INSERT THEIR WRISTS INTO THE SHOW CASES—AND AT THE BACK A PILL-SHAPED CASH DESK WAS LATER MOVED AND INTEGRATED INTO THE WALL UNITS.

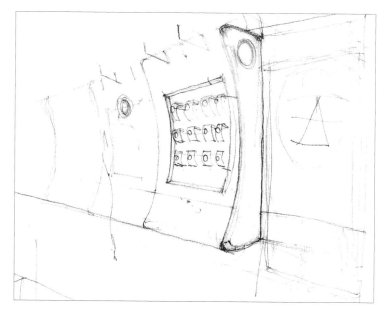

CURVED FINS (LATER ABANDONED) WERE DESIGNED TO DIVIDE EACH PRODUCT BAY WHILE FOLLOWING THE CONTOUR OF THE WALLS.

the shops to be very modern, new, accessible to the 25- to 39-year-old target customer."

They made two "shopping trips" to New York and San Francisco to look at watch retailing in general, and realized that everything was behind glass. "You had to ask a sales person if you wanted to look at anything or try it on. They needed a lot of staff to deal with customers quickly, or people got bored and walked out. In New York we saw shops that had 600 different styles, but all the brand names were mixed up together and cluttered up with a lot of point-of-sale material. It didn't work as a homogenous whole," says Thody.

The idea of being able to touch the watches—even to try them on your wrist—without taking them off the wall (or stealing them) became the focus of their new scheme and, perhaps, the secret of its success. In a two-hour brainstorming session, eight of their top designers started to work out the solution, and although it was not their top priority in fee terms, Thody says, "We worked on it whenever we had time. Everyone was so enthusiastic about the idea. We suddenly realized what we had and that it could be a successful business, not just a design fantasy."

By the end of April 1998 the project was being run by account handler Sarah Boycan, who spent half her time with Tracie Lamb, who was busy presenting to all the leading watch manufacturers and deciding which brands to include in the stores. "They were very positive and very keen," says Thody. "We had three graphic designers and two or three interior designers working on the scheme, and we held weekly reviews." Having decided that the watches would all be on open display, they had to calculate how much space 600 watches would take up—how many they would get to a square yard—and how much space they would need around each one. "The donut-shaped fitting that we showed to the banks was subsequently changed to a sort of banana-shaped fitting that held the watch securely." They also realized that one-sized fitting would not work for smaller models. "Tracie got samples and we took 10 of the most awkwardly shaped—the biggest man's and the finest woman's style—and tested them on a layered acrylic model that the manufacturers, T. Wright of Liverpool, had made. "We then started breaking it down into smaller sizes for smaller watches without losing any of the strength or the security." Meanwhile, M.E.L., a retail security systems company, contributed its expertise in devising an electronic tag, which would be integrated into each "banana" and attached to each watch.

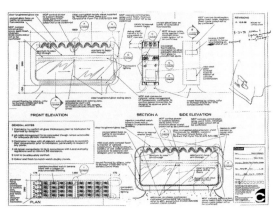

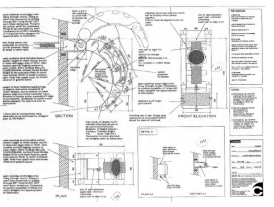

SEEN IN SIDE ELEVATION, THE FINAL DIMENSIONAL DRAWING OF THE CENTRAL FLOOR UNIT SHOWED ALL THE DETAILS, INCLUDING TINY MIRRORS AT EACH END (TO EXTEND THE APPARENT LENGTH OF THE DISPLAY) AND THE SPACE BELOW THE PRODUCTS, THROUGH WHICH CUSTOMERS CAN PASS THEIR ARMS.

THE BANANA FITTING, WITH ITS MANUFACTURING DETAILS, INCLUDING THE FOUR ELLIPTICAL FIXED PRONGS ACCOMMODATED TO SMALLER WATCH STRAPS AND THE STAINLESS STEEL "PIGGY NOSE" FIXING, WHICH ALLOWED THE COMPONENT TO PIVOT.

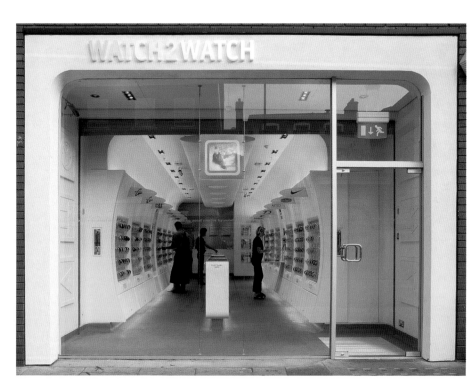

ONE OF THE GRAPHIC TEAM AT COBALT DEVELOPED A VIDEO THAT COULD BE PROJECTED ONTO A REFRACTION SCREEN THAT WAS ADAPTED TO ALLOW 90 PERCENT OF THE PROJECTED LIGHT TO PASS THROUGH THE SCREEN AND PROMOTE PRODUCTS, DAY OR NIGHT, AROUND THE CLOCK. A TECHNIQUE NEVER PREVIOUSLY USED IN A HIGH STREET RETAIL ENVIRONMENT. IN THIS PHOTOGRAPH, THE GRAPHIC SYMBOLS FOR WATCH2WATCH ARE IN PLACE ON THE LEFT, BUT THE DISPLAY CASE HAD NOT YET BEEN INSTALLED.

A VIEW OF THE FIRST SHOP IN LONDON'S KING'S ROAD, WHERE THE IMPETUS FOR THE CURVED, FLOWING MOVEMENT OF THE SHAPES CAME FROM WATCH FACE STYLING AND WENT RIGHT THROUGH TO THE GRAPHICS. THE LIGHTING—A COMBINATION OF HALOGEN DOWN-LIGHTERS AND CONCEALED FLUORESCENT TUBES—WAS BALANCED BY *INTO LIGHTING LTD.* TO MAKE THE ENTIRESPACE "FLOAT AND GLOW".

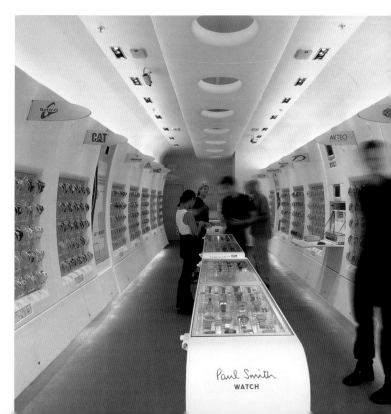

TRADE SECRETS OF GREAT DESIGN

THE TEAM AT AERO HAD DONE QUITE A LOT OF PREPARATORY THINKING BEFORE THEY SENT IN THEIR PRESENTATION BOX, INCLUDING THESE IDEAS FOR FURNITURE AND FITTINGS, MANY OF WHICH REFLECTED THOMAS O'BRIEN'S THEME OF HORIZONTAL STRIPES.

THIS PHOTOGRAPH OF A 1928 BENCH BY GERRIT RIETVELD BECAME THE BASIS FOR THE UPHOLSTERED SEATING IN THE SHOW AREA, AS WELL AS THE CAFE BANQUETTES.

SHOWING OPTIONS FOR THE LAYOUT OF THE MADISON AVENUE BUILDING, THESE PLANS PROPOSED TWO POSSIBILITIES, ONE MEANDERING, CENTRAL ROUTE, AND ONE (*BELOW RIGHT*) SYMMETRICAL LAYOUT, "TO PROMPT A RESPONSE". ARMANI CHOSE THE LATTER.

From that key encounter several important elements emerged, which would give the scheme its unique flavor. The spatial feeling in a photograph of a Josef Hoffmann interior; a 1930s staircase by New York architect Paul Frankl; Loos' striped walls in an early modern dining room; an executive office by Gio Ponti; and a dramatically patterned floor from a 1930s movie set by Robert Mallet Stevens.

Back in New York the designers had to present their ideas—albeit in a more conventional sample board format—to the Armani staff, including the North American director of stores and the buyers from both the Emporio and the Collections divisions. "The image of their company is very clear to all their employees—it's very impressive," says Sclaroff, who, in a second presentation, developed planning options and two models, a larger one of the ground floor and a smaller one of the whole building. "It was exciting to go through the whole design process," he says. "There was no manual for us to work to, but we were asked to look at runway cassettes and review books of the new season's collections. There's an enormous number of lines, we had to make sure it didn't look too crowded while at the same time satisfying the capacity requirements. Over time, we learned their merchandising standards—which clothes they like to stack and which products go in trays. Every item needed its own place.

All the shop fitting was based upon images from the initial presentation of classic pieces of furniture by Paul Frankl, Eileen Gray, and others, with new proportions.

"We surveyed the building and analyzed the capacity of each floor," explains Sclaroff. "Once we'd assessed the scheme, the plans were sent to Milan for approval. We were working to a very ambitious schedule and there was a lot of structural work involved." Aero approved all the building drawings and liaised with the builders, and had a project manager on site all the time.

Armani came over for the final stages, and was very involved in all the last minute details. Since then the architects have continued to work for him on five other stores, including Houston and Las Vegas, and on a renovation scheme in Beverly Hills.

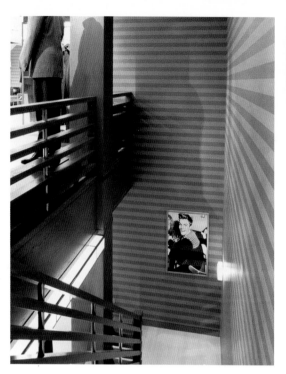

(*ABOVE*) THE HANDRAILS OF THE STAIRCASE, WHICH WERE MADE IN LIMED OAK, CAN BE TRACED BACK DIRECTLY TO THE PHOTOGRAPH OF A STAIR BY PAUL FRANKL IN THE FIRST PRESENTATION.

(*RIGHT*) THE SAME FITTING AS THE WOMEN'S FLOOR, AND A SLIGHTLY DARKER COLORED STRIPE WERE USED ON THE MEN'S FLOOR. AT NIGHT THE FLOOR-TO-CEILING CANVAS CURTAINS ARE CLOSED AND UNIFORMLY LIT TO "MAKE THE BUILDING APPEAR MORE MONOLITHIC AND TO RENDER NIGHT TIME MAINTENANCE AND REMERCHANDIZING INVISIBLE," SAYS THE AERO ARCHITECT.

THE STRIPE HAD BECOME THE KEY TO THE WHOLE SCHEME. THE DESIGNERS CHOSE A "TRADITIONAL ENTRANCE HALL WALLPAPER FROM CLARENCE HOUSE IN NEW YORK AND USED IT IN GRAYS, BLACK, CREAM AND KHAKI. THE DIFFERENCE WAS THAT THEY HAD IT HUNG SIDEWAYS SO THE STRIPES RAN HORIZONTALLY.

ON THE WOMEN'S FLOOR THE COLORS WERE PALE, AND THE FITTINGS WERE A MIXTURE OF STAINED OAK AND BRUSHED CHROME. ALL THE TALL UNITS HAD THEIR OWN LIGHTING, AND THE SIDES WERE ENCLOSED BY FROSTED GLASS WITH A HORIZONTAL RIBBED TEXTURE. THE FLOOR WAS IN RIFT-CUT OAK, WITH A COLOR WASH.

(*RIGHT*) THE ORIGINAL FRANKL DESIGN FOR THE SALON CHAIRS WAS RE-MADE TO SLIGHTLY MORE GENEROUS PROPORTIONS AND UPHOLSTERED IN ROGERS & GOFFIGON LTD'S STRIPED TABITHA LICORICE WOVEN FABRIC ON THE WOMEN'S FLOOR.

DIRECTORY